中国出土壁画全集

徐光冀／主编

科学出版社

北京

图书在版编目（CIP）数据

中国出土壁画全集／徐光冀主编.—北京：科学出版社，2011
ISBN 978-7-03-030720-0

Ⅰ．①中... Ⅱ．①徐... Ⅲ．①墓室壁画-美术考古-中国-图集
Ⅳ．①K879.412

中国版本图书馆CIP数据核字（2011）第058079号

审图号：GS（2011）76号

责任编辑：闫向东／封面设计：黄华斌　陈　敬
责任印制：赵德静

科 学 出 版 社 出版
北京东黄城根北街16号
邮政编码：100717
http://www.sciencep.com

北京天时彩色印刷有限公司印刷
科学出版社发行　各地新华书店经销

*

2012年1月第 · 版　　开本：889×1194　1/16
2012年1月第一次印刷　印张：160
印数：1-2 000　　字数：1280 000

定价：3980.00元
（如有印装质量问题，我社负责调换）

THE COMPLETE COLLECTION OF MURALS UNEARTHED IN CHINA

Xu Guangji

Science Press

Beijing

Science Press

16 Donghuangchenggen North Street, Beijing,

P.R.China, 100717

Copyright 2011, Science Press and Beijing Institute of Jade Culture

ISBN 978–7–03–030720–0

《中国出土壁画全集》编委会

凡　例

1. 《中国出土壁画全集》为"中国出土文物大系"之组成部分。

2. 全书共10册。出土壁画资料丰富的省区单独成册，或为上、下册；其余省、自治区、直辖市根据地域相近或所收数量多寡，编为3册。

3. 本书所选资料，均由各省、自治区、直辖市的文博、考古机构提供。选入的资料兼顾了壁画所属时代、壁画内容及分布区域。所收资料截至2009年。

4. 全书设前言、中国出土壁画分布示意图、中国出土壁画分布地点及时代一览表。每册有概述。

5. 关于图像的编辑排序、定名、时代、尺寸、图像说明：

编辑排序： 图像排序时，以朝代先后为序；同一朝代中纪年明确的资料置于前面，无纪年的资料置于后面。

定　名： 每幅图像除有明确榜题外，均根据内容定名。如是局部图像，则在原图名后加"（局部）"；如是同一图像的不同部分，则在图名后加"（一）（二）（三）……"；临摹图像均注明"摹本"。

时　代： 先写朝代名称，再写公元纪年。

尺　寸： 单位为厘米。大部分表述壁画尺寸，少数表述具体物像尺寸，个别资料缺失的标明"尺寸不详"。

图像说明： 包括墓向、位置、内容描述。个别未介绍墓向、位置者，因原始资料缺乏。

6. 本全集按照《中华人民共和国行政区划简册·2008》的排序编排卷册。卷册顺序优先排列单独成册的，多省市区合卷的图像资料亦按照地图排序编排。编委会的排序也按照图像排序编定。

<div style="text-align: right;">

《中国出土壁画全集》编委会

</div>

前　言

壁画是专指画在壁面或地面上的绘画，在遗址和墓葬中均有发现。它区别于与其内容相似的画像石、画像砖和壁面雕砖。其性质与古代社会的祭祀、礼俗、信仰相关。

壁画在我国有悠久的历史，内容丰富多彩，是研究古代社会极为宝贵的图像资料。经考古发现，早在仰韶文化晚期在甘肃秦安大地湾遗址的房址中有黑色地画；在辽宁牛河梁红山文化"女神庙"遗址有彩色壁画残块；在陕西、河南、湖北的西周、东周时期的个别墓葬中也发现过残存的壁画。文献资料记载商周时期即在宫殿、祠庙、明堂绘制壁画，宣扬礼制。

大量壁画的发现，是在秦汉时期及其以后的时期。自20世纪20年代以来，特别是1949年以后，随着考古工作的开展，有许多重要发现，多数发现于墓葬中，少数发现于宫殿和寺庙（含塔基）遗址中。对其研究已超出壁画功能的本身，而扩展到研究古代社会的政治经济、生产生活、信仰习俗、礼仪制度、艺术发展等各方面。20世纪80年代，宿白先生曾主编《中国美术全集·绘画编12·墓室壁画》一书，收集了当时已发现的重要的墓葬壁画。随着时间的推移，壁画资料不断有新的发现，积累了大量的资料，有必要再编辑一套出土壁画全集，提供给研究者和爱好者查阅、研究、观赏和收藏。这是一件十分有意义的事。

本书收集的是经考古发掘出土的壁画，其年代范围，从秦代"咸阳宫"开始，经两汉、魏晋南北朝、隋唐五代、至宋辽金元。本来议定收到元代，但在收集过程中，有些分编委会将壁画收到明代，个别也有到清代的，审稿过程中觉得画面精彩，就予以保留了。年代跨度由公元前3世纪至公元14世纪，经历了1700年。如果延伸到清代则达2200年。秦汉时期的壁画已相当成熟，其前期必有一个发生发展的过程，由于保存和工作的原因，目前我们了解甚少。

经初步统计目前已发掘的有壁画的墓葬和遗址577处。主要分布于河北、山西、内蒙古、山东、河南、陕西6省区；其次分布于辽宁、吉林、甘肃、宁夏、新疆、北京6省市区；黑龙江、四川、福建、江苏、安徽、江西、湖南、湖北、西藏、云南、浙江、重庆、广东13省市区也有少量发现。其余天津、上海、广西、贵州、青海、海南6省市区及台湾、港、澳地区尚未发现。壁画分布地域达到25个省市区，但从数量上看，主要分布于陕西、河南和北方诸省区，这是分布的地域特点，应与其历史背景和自然环境有关。一些已经或刚刚发掘的未发表简报的墓葬和遗址的壁画资料，也收入了本书。资料收集至2009年，共收集到壁画364处，其中墓葬壁画337处，遗址壁画27处，约占近577处出土壁画的五分之三。未能收入的主要是因画面漫蚀不清或已被毁。同时，也酌情选用了一些壁画摹本。全书共收集壁画2153幅。

本书编辑方法是以省市区为单位，编辑成册。全书在第一册设前言、出土壁画分布示意图、出土壁画分布地点及时代一览表。每册各有概述、凡例，图片按时代排序，同一时代内，将有明确纪年的排列在前。每幅壁画均注明名称、年代、出土年份、尺寸、出土地点、保存状况和存放地点，以及方向和位置，并作简要文字说明，以方便读者查阅。我们曾设想以时代为单位编排，并以年代先后的顺序排列，这样或更方便读者查阅研究。但考虑到"中国出土文物大系"的统一体例，斟酌再三还是决定采用前一种编辑方法。根据省市区出土壁画的数量和状况，决定出版十册。陕西出土的壁画数量最多编为两册；河北、山西、内蒙古、山东、河南各编一册；辽宁、吉林、黑龙江三省合编一册；甘肃、宁夏、新疆三省区合编一册；北京、江苏、浙江、福建、江西、湖北、广东、重庆、四川、云南、西藏十一省市区合编一册。安徽、湖南新近出土的壁画未及收入。

以时代划分，发现秦汉时期（前221～公元220年）壁画73处。本书收入壁画45处，其中墓葬壁画44处，秦"咸阳宫"遗址壁画1处。墓葬壁画主要分布于河南、陕西、辽宁、内蒙古、山西、山东、河北、甘肃等北方诸省区，以洛阳、西安最为密集。四川、江苏、广东也有发现。以河南永城柿园西汉梁王墓（前136～前118年）和广州象岗山南越王墓（前112年）年代最早。墓主身份有诸侯王，多为中等官吏和地方豪强。魏晋南北朝时期（220～589年)发现壁画128处。本书收入69处，其中墓葬壁画65处，寺庙遗址壁画4处。壁画墓主要分布于河北、山西、河南、山东、甘肃、辽宁、吉林等省，南方地区仅有云南省1处。寺庙遗址壁画分布于新疆。至北朝时期，壁画墓墓主身份主要限于皇室和高官显贵，并形成一定的制度。隋唐五代时期（581～960年）发现壁画96处。本书收入67处，其中墓葬壁画65处，寺庙遗址壁画2处。墓葬壁画主要分布于陕西、河南、山西、宁夏、新疆、河北、吉林、黑龙江等省区。寺庙遗址壁画分布于新疆。唐代壁画墓大多集中在西安地区，墓主身份延续北朝时期主要限于皇室和高官显贵。其他地区发现的壁画墓情况类似。宋辽金元时期（907～1368年），发现壁画280处。本书收入183处，其中壁画墓163处，寺庙遗址壁画20处。墓葬壁画主要分布于河北、内蒙古、山西、山东、河南、辽宁、陕西、北京等省市区，寺庙遗址壁画分布于河北、山西和西藏。宋代壁画墓墓主身份与唐代相比有些变化，主要是地主、富商。辽金元壁画墓墓主身份主要是皇室、贵族和汉族的官吏、地主。随着社会的

发展，壁画内容也随着社会的变化而发展，使之成为我国丰富多彩的文化宝库。

随着古代壁画的出土，研究工作也随之逐步开展。特别是近20余年来，大量壁画墓的发掘简报和发掘报告的出版，研究壁画墓的专门著作的刊行，和众多研究论文的发表，使古代壁画的研究取得了可喜的成果。今后在基础资料方面需加速发掘报告的整理出版，并对我国壁画的起源和发展历程进行深入的研究，在对壁画内容、布局、分区、分期研究的基础上，应深入开展对各时期的壁画所反映的社会生产、生活、制度、艺术（技法）、信仰等进行分门别类的研究，用形象的资料，丰富对社会历史的研究。同时对壁画的长期保护和保存，也必须积极采取有力的措施。

本书经过近四年的努力，终于要与读者见面了。怀着喜悦的心情，我们感谢各省市区文物考古部门领导的支持、本书顾问们的指导、出版社的领导和各位编辑的辛勤工作。编写完成这样一部著作，主要依靠团队的力量，是编委会和各册分编委会的同仁，以及具体撰写概述、说明、摄影、临摹的各位先生的共同努力完成的。同时还有编制地图、英文翻译各位先生的辛勤劳动。每一册的编写均经过几上几下的审阅修改，反复核对。在此，向为本书做过工作的所有同仁们和朋友们，致以深深地敬意和衷心地感谢。由于我们水平有限，不当和错误之处，请予批评指正。

徐光冀

2011年11月

Preface

Ancient mural, which refers to ancient paintings on walls or grounds, is found both in residential remains as well as burials. It is distinguished from the pictorial stones, impressed bricks and brick carvings which have similar motifs and functions. The natures of ancient murals are relevant to the sacrifices, rites and etiquettes and beliefs of ancient societies.

Murals had long-lasting history in China, their rich and diversified contents are invaluable visual materials for the researches on ancient societies. The archaeological data showed that black floor paintings were found in the house foundations of Dadiwan Site of late Yangshao Age in Qin'an County, Gansu Province. In the remains of the "Goddess Temple" of Hongshan Culture in Niuheliang Site, Liaoning Province, fragments of multicolored mural were recovered. From some tombs of the Western Zhou Dynasty and Eastern Zhou Period in Shaanxi, Henan and Hubei Provinces, traces of patterns like murals were also seen. The historic literatures recorded that in the Shang and Zhou Dynasties, murals were painted on the walls of palaces, temples and Mingtang (Hall of Enlightenment, the location for important ceremonies) for advocating ritual systems.

Most of the murals discovered to date are painted in the Qin and Han Dynasties and the following periods. Since the 1920s, especially since 1949, large quantities of murals have been recovered along with the development of archaeological work. Of these important artworks, most were unearthed from burials and some from remains of palaces and temples (including pagoda foundations). The researches on the murals are not limited to the functions of the murals but expanded to the politics, economy, production, lifestyles, beliefs and customs, ritual systems and art developments, and so on.

In 1980s, the Vol. 12 of Painting Portion (Tomb Murals) of Zhongguo Meishu Quanji (Treasury of Chinese Fine Arts) edited by Professor Su Bai collected the important tomb murals discovered at that time. As time goes by, many new discoveries of murals raised the demand of compiling a complete collection of unearthed murals for the researchers and aficionados to study, appreciate and collect. It will be a very meaningful event.

All of the murals collected in this book are the ones unearthed archaeologically, the dates of which are from that of the Xianyang Palace of the Qin Dynasty, through the Han Dynasty, Three-Kingdoms Period and the Southern and Northern Dynasties, the Sui, Tang, Five-Dynasties, to the Song, Liao, Jin and Yuan Dynasties. Our original plan was that the latest cases were limited to the Yuan Dynasty, but when we were reviewing the materials, we found some wonderful pieces of the Ming even Qing Dynasties which are not suitable to exclude and therefore we kept them. Because of this, the temporal scope of our collection was as long as 2200 years, even by our original plan, it was also as long as 1700 years, from 3rd century BCE to 14th century CE. The mural art in the Qin and Han Dynasties had been in a very mature stage, there must have been an emerging and developing period before, but we have very scarce understanding to it for the reasons on the preservation and our work.

In total, there have been about 577 burials and sites yielding murals excavated archaeologically to date in China. The province-level administrative regions with the densest distribution of unearthed murals are Hebei, Shanxi, Inner Mongolia, Shandong, Henan and Shaanxi; the ones following them are Liaoning, Jilin, Gansu, Ningxia, Xinjiang and Beijing. Some cases are also found in Heilongjiang, Sichuan, Fujian, Jiangsu, Anhui, Jiangxi, Hunan, Hubei, Tibet, Yunnan, Zhejiang, Chongqing and Guangdong; at present, no reports about murals unearthed in Tianjin, Shanghai, Guangxi, Guizhou, Qinghai, Hainan, Taiwan, Hong Kong and Macau have been seen yet. Murals are found archaeologically in as many as 25 province-level administrative regions, but most of them are found in the North, especially Shaanxi and Henan; this distribution feature would be related to the historic background and natural environment. Some mural materials which have been discovered recently and not published yet are also collected in this book; the closing date of the materials is the end of 2009, the murals found later than which are not collected. 364 sites and burials bearing murals are selected into this

book, including 337 burials and 27 ardlitectural remains, taking three fifth of all of those yielding murals. The main reason for excluding the other two fifth is that the murals of those sites or burials were severely smeared or damaged; meanwhile, some mural replicas are also collected in this book for keeping a comprehensive collection. The whole book collects 2153 items in sum.

The murals collected in this book are categorized by province-level administrative regions; the first Volume has the preface, the map of the distribution of the mural sites and the full list of the sites with murals and the dates of the murals. Each volume has the general introduction and notes on the use of the book at the beginning and the murals included are arranged by period in temporal sequence; in the same period, the murals with exact dates are arranged before those without exact dates. Each image has the title, date, unearthing date, size, original location and present location, as well as orientation and position in the tomb or site and a concise description for the viewer to have a comprehensive understanding. We have planned to arrange all of the murals by period, and in each period by date; however, considering the unified format of A Treasury of Unearthed Cultural Relics of China, we at last decided to apply the first format which arranges the items by administrative region first. Based on the quantities and qualities of the murals unearthed from the province-level administrative regions, this book is edited as ten volumes: two volumes are for Shaanxi Province, where the most murals have been unearthed; one volume is for each of Hebei, Shanxi, Inner Mongolia, Shandong and Henan; one volume is for Liaoning, Jilin and Heilongjiang Provinces; one is for Gansu, Ningxia and Xinjiang; one volume is edited for the eleven province-level administrative regions, which are Beijing, Jiangsu, Zhejiang, Fujian, Jiangxi, Hubei, Guangdong, Chongqing, Sichuan, Yunnan and Tibet. Recently, murals are unearthed in Anhui and Hunan Provinces, but these discoveries are too late to collect into this book.

Categorized by period, 73 sites and burials of the Qin and Han Dynasties (221 BCE - 220 CE) with murals are discovered to date. In this book, 45 of them are collected, including 44 tomb murals and one architectural mural from Xianyang Palace of the Qin Dynasty. The tomb murals of this period are mainly unearthed in the north, such as Henan, Shaanxi, Liaoning, Inner Mongolia, Shanxi, Shandong, Hebei and Gansu; Xi'an and Luoyang are two centers where tomb murals of this period are distributed the most densely; in Sichuan, Jiangsu and Guangdong, murals of this period are also found. The earliest ones of them are that in Liang Prince's tomb at Shiyuan in Yongcheng County, Henan Province (136-118 BCE) and that in Nanyue King's Tomb at Xianggang Hill in Guangzhou (112 BCE). The highest-ranked occupants of these mural tombs were feudatory princes, but most of them were middle-ranked officials and local rich and powerful people. 128 sites and burials of the Three-Kingdoms to the Southern and Northern Dynasties Periods bearing murals have been found to date, 69 of which are selected in this book, including 65 burials and four architectural remains. The mural tombs of this period are mainly distributed in the north, such as Hebei, Shanxi, Henan, Shandong, Gansu, Liaoning and Jilin; the only case in the south was one in Yunan Province. The remains of architectural murals of this period are mainly found in Xinjiang. During this period, the occupants of the mural tombs were mainly imperial family members and high-ranked officials and aristocrats, and the using of murals formed a relatively firmed system. 96 sites and burials of the Sui, Tang and the Five-Dynasties Period (581-960 CE) bearing murals have been found to date, 67 of which are selected in this book, including 65 burials and two architectural remains. The tomb murals are mainly distributed in the north, such as Shaanxi, Henan, Shanxi, Ningxia, Xinjiang, Hebei, Jilin, Heilongjiang and so on; the architectural murals, most of which are that of Buddhist temples, are mainly distributed in Xinjiang. The mural tombs of the Tang Dynasty are mainly concentrated in the greater Xi'an area, the occupants of which were still mainly the imperial family members and high-ranked officials and aristocrats like those of the Northern Dynasties, so as the mural tombs of this period found in other regions. 280 sites and burials of the Song, Liao, Jin and Yuan Dynasties (907-1368 CE) bearing murals have been found to date, 183 of which are selected in this book, including 163 burials and 20 architectural remains. The tomb murals are mainly distributed in Hebei, Inner Mongolia, Shanxi, Shandong, Henan, Liaoning, Shaanxi, Beijing and so on; the architectural murals are mainly found in

Hebei, Shanxi and Tibet. In the Song Dynasty, the statuses of the occupants of the mural tombs were somewhat different from that of the Tang Dynasty; most of them were rich landlords and merchants. The occupants of the mural tombs of the Liao, Jin and Yuan Dynasties were mostly the imperial family members and the officials and local rich and powerful people. Along with the development of the societies, the themes and contents of the murals were also developing and changing, forming a colorful and diversified cultural treasury of our country.

With the discoveries of the ancient murals, the research works on them are also developed gradually. Especially in the recent two decades, the publishing of excavation reports, monographs and large amounts of theses reflected the wonderful achievements of ancient mural researches. From now on, the editing and publishing of primary materials and the in-depth explorations to the origins and developing routes of murals in China will be strengthened; based on the research results on the themes, layouts, regionalization and periodization of the ancient murals, the social production, lifestyle, political systems, art (techniques), religious beliefs and so on are going to be studied from multiple aspects. Utilizing these pictorial materials, the researches on the social history will be enriched. Meanwhile, effective methods will be applied on the long-lasting preservation and protection of these ancient murals.

With efforts of almost four years, our work is going to be presented to our readers. We deeply appreciate the supports of the leaders of the administrations and institutions of the relevant province-level administrative regions, the instructions of the advisors of our book and the hard and unselfish work of the leaders and editors of Science Press. To fulfill the job of compiling such a huge collection, the teamwork of the editing board of the entire work and the sub-boards of the volumes, as well as the colleagues in charge of the introduction and caption writing, the artworks photographing and tracing, the map making and English translating, and so on. The compiling of every volume has experienced several times of reviewing, modifying, examining and verifying. Hereby, please allow us to pay our admiration and gratitude to all of the colleagues and friends who have given us help on this book. Limited by our knowledge, we may have errors and flaws in our work and we hope our readers to give us critiques and corrections.

Xu Guangji

Nov. 2010

中国出土壁画地点分布示意

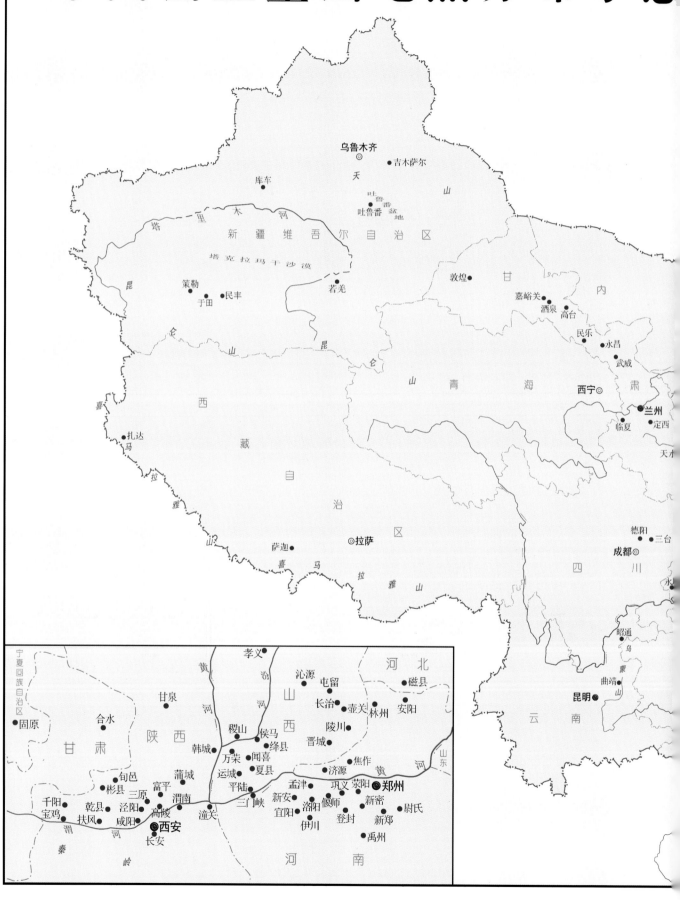

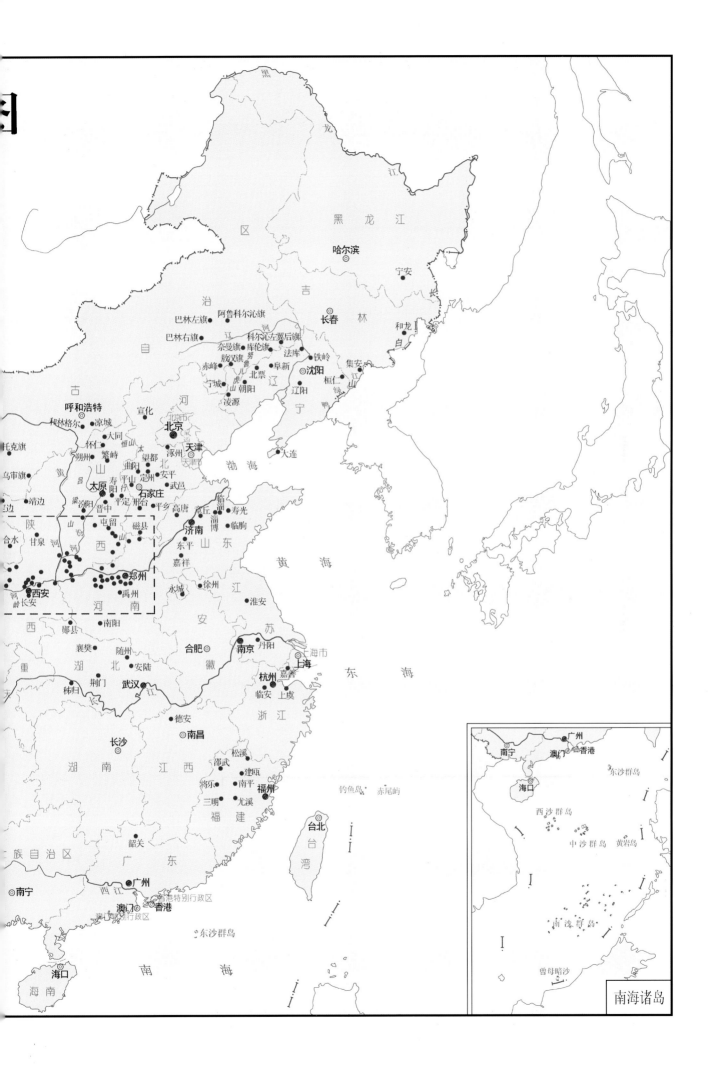

黑龙江

哈尔滨
宁安

巴林左旗
阿鲁科尔沁旗
长春
和龙
科尔沁左翼后旗
巴林右旗
奈曼旗 库伦旗 法库 铁岭 集安
敖汉旗 北票 阜新
赤峰 朝阳 沈阳 桓仁
宁城 凌源 辽阳
呼和浩特
宣化
和林格尔 凉城 北京市
托克旗 大同 北京
乌审旗 怀仁 恒山 天津
朔州 繁峙 曲阳 涿州 大连
靖边 寿阳 定州 安平
太原 平山 武邑 渤海
边 汾阳 晋中 石家庄 邢台
合水 甘泉 屯留 磁县 平遥 高唐 寿光
临沂 淄博 临朐
济南
郑州 东平 嘉祥
西安 禹州 永城 徐州
长安
南阳 淮安
郧县
襄樊 随州 合肥 南京 丹阳
上海市
荆门 武汉 杭州 嘉兴 上海
秭归 安陆 临安 上虞
德安 东海
长沙 南昌
松溪
邵武 建瓯
将乐 南平
三明 尤溪 福州
钓鱼岛 赤尾屿
台北
台湾
韶关
广州
南宁 西江
澳门 香港特别行政区
澳门特别行政区 香港
东沙群岛

海口 南海
海南

黄海

黑龙江

吉林

辽宁

河北

山西

陕西

河南

山东

江苏

安徽

湖北

湖南

江西

浙江

福建

广东

广西壮族自治区

重庆

古

区

南海诸岛

广州
南宁 澳门 香港
东沙群岛
海口
西沙群岛
中沙群岛 黄岩岛
南沙群岛
曾母暗沙

中国出土壁画分布地点及时代一览表

分册	秦汉	魏晋南北朝	隋唐五代	宋辽金元
1. 河北	安平 望都 定州	磁县 景县	曲阳	武邑 宣化 井陉 涿州 平乡 定州 平山 邢台
2. 山西	平陆 夏县	大同 寿阳 太原 怀仁	太原 晋中 万荣	太原 平定 侯马 长治 屯留 稷山 汾阳 运城 大同 晋城 陵川 朔州 繁峙 沁源 壶关 闻喜 孝义 绛县
3. 内蒙古	和林格尔县 鄂托克旗 乌审旗	——	——	赤峰 阿鲁科尔沁旗 巴林左旗 巴林右旗 敖汉旗 宁城县 库伦旗 奈曼旗 科尔沁旗左翼后旗 凉城县
4. 山东	济南 东平	济南 临朐 寿光 临淄	嘉祥	济南 高唐 章丘 淄博 临淄
5. 河南	洛阳 新安 偃师 永城 荥阳 新密 宜阳	洛阳 孟津 南阳	洛阳 安阳	巩义 郑州 登封 禹州 新密 林州 焦作 伊川 三门峡 荥阳 新郑 新安 安阳 济源 尉氏
6、7. 陕西（上）、（下）	咸阳 扶风 宝鸡 西安 定边 靖边 旬邑 千阳	西安 咸阳	潼关 西安 咸阳 长安 礼泉 富平 三原 高陵 乾县 蒲城 彬县 宝鸡	甘泉 韩城 渭南 定边 蒲城 西安
辽宁	大连 辽阳	朝阳 桓仁 辽阳 北票	——	铁岭 阜新 法库 朝阳 凌源
8. 吉林		集安	和龙	
黑龙江			宁安	
甘肃	武威	酒泉 敦煌 嘉峪关 永昌 民乐 高台	合水	兰州 临夏 定西 天水
9. 宁夏		固原	固原	
新疆	——	吐鲁番 若羌 库车 于田 尼雅 策勒	吐鲁番 尼雅 于田 策勒	吉木萨尔
北京	——	——	宣武 海淀 丰台	海淀 大兴 丰台 门头沟 延庆 石景山
江苏	徐州	南京 丹阳	南京	淮安
浙江		上虞	临安 杭州	嘉善
福建				尤溪 南平 将乐 三明 福州 建瓯 邵武 松溪
江西				德安
10. 湖北			安陆 郧县	荆门 随州 秭归 襄樊 武汉
广东	广州	——	韶关	——
重庆				巫山 永川
四川	德阳 绵阳	德阳 绵阳		
云南	曲靖 昆明	昭通		
西藏				扎达 萨迦

中国出土壁画全集

— 1 —

河北
HE BEI

主　编：曹　凯　韩立森
Edited by Cao Kai, Han Lisen

科学出版社
Science Press

河北卷编委会名单

编　委

王丽敏　车战英　乔登云　杨卫东　刘海文　张文青　张献中　沈铭杰　杜鲜民
贺　勇　侯　璐　赵忠杰　赵学峰

参编人员（以姓氏笔画为序）

冯玲　刘海文　狄云兰　张羽　郝建文　席玉红　曹凯　韩立森

河北卷参编单位

河北省文物研究所　　　　　　　　定州市文物保护管理所

石家庄市文物研究所　　　　　　　涿州市文物保护管理所

张家口市文物考古研究所　　　　　曲阳文物保护管理所

保定市文物研究所　　　　　　　　磁县文物保护管理所

邯郸市文物研究所　　　　　　　　安平县文物保护管理所

衡水市文物管理处　　　　　　　　望都县文物保护管理所

宣化区文物保护管理所　　　　　　井陉县文物保护管理所

河北省出土壁画概述

曹 凯 韩立森

河北省自20世纪50年代以来，陆续发现并清理了上迄东汉、下至元明的壁画墓等遗迹，出土壁画涉及内容丰富多样，形象生动传神[1]。皇室贵胄、平民百姓的生活，天界神话、市井传说的故事，山川河流、日月星辰等自然景观以及飞禽走兽、花鸟鱼虫等都通过不知名的古代画匠之手，穿过千百年的时光呈现在我们面前。迄今为止，河北省共发现壁画墓41座以上，佛教地宫壁画1处。

1. 东汉墓葬壁画

河北省重要的东汉壁画墓主要有安平逯家庄壁画墓[2]和望都一号壁画墓[3]。

安平东汉壁画墓位于现安平县城南2.5公里处的逯家庄附近，1971年发现清理。该墓由墓门、甬道、前室、中室和后室组成，前、中、后室还分别有侧室。壁画主要分布在前室右侧室、中室、中室右侧室，发现时已有不同程度的剥落。墓室内"熹平五年"题记为我们提供了判断时代的依据。墓葬中室描绘的是墓主人生前出行场面，车乘侍卫前呼后拥，冠盖如云，仪仗威严。画面分为上下四层，从四层画的排列情况看，每一层前后相互连接构成一个单元，上下层之间又有某种先后联系。壁画绘步行仪仗96人，步行者均为地位不高的小吏或士卒。绘骑吏94骑，有前列持戟骑吏、后从骑吏、持弩缇骑、骑侍等，均为壁画主人的近侍或僚佐之类的人物。绘车82辆，均双辕黑轮，但形制有别：有白盖轺车、斧车、皂盖朱镳轺车、赤盖舆车、辎车、大车等。东汉时制度，乘坐皂盖朱镳轺车者，应为中二千石或二千石官员；赤盖舆车是第四层的主车，乘者"头戴红冠，身穿红袍，坐于后部，似为一高级武吏"[4]。依《后汉书·舆服志》，乘者应是二千石以上官员，而二千石是当时地方官吏中的最高官级；辎车内绘一妇女和一儿童，应为主车乘者的家属。对于四层出行图的内涵，从表现形式上看，整个出行图规模宏大，场面壮观，气氛热烈。安

平逯家庄东汉墓壁画另一引人入胜的画面，绘于中室右侧室北壁西侧，为一座大型庭院的建筑鸟瞰图。此图用写实的手法描画了一座规模庞大的院落，大院中套着一个个小院，层层叠叠，蔚为壮观。这座建筑既有居住功能，又有军事防御功能。

望都一号壁画墓位于望都县城东所药村，1952年村民烧砖取土时发现，经河北省文物管理委员会组织考古人员清理发掘，壁画得以面世。望都一号壁画墓前室及通中室券门内西侧壁面的下部绘有壁画，壁画内容上下分栏。下栏为鸟兽，上栏为人物，除北券门过道券上的云气鸟兽外，不论人物或鸟兽都有墨书题记。在色彩上是用墨描轮廓，再以朱、青、黄三色加彩。望都一号东汉墓的壁画人物或鸟兽与墨书题记互相印证，是难得的历史信息。如在前室南壁墓门两侧，各绘一男子，墓门东侧男子双手持杖，右上方墨书"寺门卒"，西侧男子腰部佩剑，头部左上方墨书"门亭长"，二人身份、地位一目了然。望都东汉壁画墓所绘人物墨书标明的身份有："主记史"、"主薄"、"门下功曹"、"门下贼曹"、"门下史"、"辟车五佰（伯）八人"、"侍阁"、"白事吏"、"勉劳谢史"等。身份不同，其衣着佩持亦不同，身体姿态和面容表情也有区别，或卑微、或矜持、或庄重，形象生动地勾画出东汉时期森严的封建等级制度。望都东汉墓壁画所绘动物有獐子、鸡、鹭、羊、鸾鸟、白兔、鸳鸯、凤凰等，它们不仅有墨书标注名称，有的还对其寓意做了进一步阐释。

河北东汉墓葬壁画为我们提供了极为丰富的历史信息，对于研究当时的官制和社会风俗、经济形态以及建筑形制都具有十分重要的史料价值。

2. 北朝墓葬壁画

北朝后期的东魏、北齐王朝以邺城为都城，并在邺城之西北郊逐渐建立了皇家贵族的陵寝区，即今天位于磁县的全国重点文物保护单位磁县北朝墓群。这

里发现了近10座北朝壁画墓，重要的资料有东魏茹茹公主墓[5]、东魏元祐墓[6]、北齐尧峻墓[7]、北齐高润墓[8]、北齐高孝绪墓、湾漳北朝壁画墓[9]等。

河北省的东魏北齐壁画墓一般规模较大、墓主人身份较高。壁画墓的结构一般包括斜坡墓道、甬道和墓室，等级较低的壁画墓仅仅在甬道和墓室绘制壁画，等级较高的壁画墓则将壁画绘制在斜坡墓道的两壁，高等级的壁画墓甚至还在墓道斜坡地面上绘装饰图案。

东魏茹茹公主墓是磁县北朝壁画墓中资料完整、年代明确的一座。出土墓志记载了高湛之妻茹茹邻和公主葬于东魏武定八年（550年）。该墓由墓道、甬道、墓室组成，总长约35米。斜坡墓道长约23米。墓道、甬道、墓室均绘制壁画。墓道东西两壁分别绘制14人组成的仪仗队列，仪仗队列的上方有神兽、羽人等形象，斜坡墓道的地面上绘有地画。甬道入口上方的挡土墙上绘画伫立在莲花宝珠上的朱雀。墓室壁画分上下两栏布局，其中上栏有依方位绘制的四神图和天象图等，下栏壁画描绘了墓主人的生活场景。

磁县湾漳北朝墓是迄今发现规模最大的北朝壁画墓。该墓葬的地面部分原有高大封土，墓南神道一侧尚存近4米高的石人像。地下部分由斜坡墓道、甬道、墓室组成，南北总长约52米。湾漳北朝墓墓道、甬道、墓室均装饰绘制了壁画，以墓道壁画保存最好。37米长的墓道东西两壁分别绘制了由53人组成的仪仗队列，壁画人物与真人相当。在仪仗队列上方的天空位置，绘有各类祥禽瑞兽、流云、莲花等图像，东西两壁画面构图对称。墓道地画由大莲花与忍冬莲花装饰纹样构成，犹如巨幅地毯。甬道南端挡土墙面上绘制的大朱雀高达5米，两侧有神兽、羽兔、莲花，气势恢宏。甬道、墓室也绘制壁画，但保存状况很差。内容有人物、神兽、动物等内容。墓室顶部绘天河、星宿组成的天象图。发掘者从墓葬的形制规模、壁画内容、随葬品组合等因素综合推断，湾漳北朝壁画墓应为北齐文宣帝高洋的义平陵。

北朝壁画墓在河北省比较集中的出土，其中既有规制宏伟的帝王陵寝，也有贵族、官吏的墓葬，对于

研究壁画装饰的时代特征十分重要。河北省北朝壁画墓涉及的内容丰富，有的壁画人物刻画细致入微，为南北朝考古学、艺术史研究提供了难得的资料。

3. 五代王处直墓壁画

五代王处直墓位于曲阳县灵山镇西燕川村西约2公里处，1995年清理发掘[10]。据出土的墓志记载，王处直卒于唐天祐二十年（后梁龙德三年，923年），次年葬于河北曲阳县敦信仰盘山之内。王处直墓以青石构筑，墓葬有墓道、甬道、前室和后室组成，全长12.5米。墓室中除了后室顶部没有壁画外，其余壁面皆以壁画装饰。

王处直墓壁画中云鹤、花鸟占有很大比重。此墓前室上部绘有8幅云鹤图，均是先勾划出轮廓，然后用墨线描绘，最后涂上颜色。五代是传统花鸟画走向成熟的时期，在王处直墓壁画中花鸟画极为精彩。其前室东西两壁各绘4幅屏风式花鸟画，所绘花卉有牡丹、月季、牵牛、蔷薇、菊花。其后室的三幅花鸟画也颇有意趣。东西两壁画幅大小相似，绘湖石、翠竹、小草、鸟雀、蜂蝶。后室北壁是一幅通景式壁画，占据整个壁面。画面中央绘一块湖石一株牡丹。湖石空灵，牡丹硕大繁茂，"枝头有15朵盛开的牡丹花。根用褐色勾勒，叶子用墨线勾边，绿色晕染，花朵也是用墨线勾出轮廓，用深浅不一的红色晕染"[11]。画面两侧各绘一株蔷薇，枝头都盛开着12朵鲜花。围绕着这三株花卉，上方有四只绶带鸟，相向对飞，下方有四只鸽子正在觅食。

王处直墓前室北壁的水墨山水画，是我国目前出土壁画中年代确切而且时代最早的水墨山水画。此画高1.8、宽2.22米，惜右上角被盗墓者破坏，画面残损近四分之一。

王处直墓东耳室东壁与西耳室西壁所绘壁画风格一致。东耳室东壁上部绘一幅山水画。下部所绘长案上，左边画一帽架，支脚为"丁"字形，上部为圆筒形，上置黑色展脚幞头。右边画一镜架，三足支撑，因透视关系准确。帽架右边绘一带座方盒和一带座圆盒，另有两件瓷器，为白釉瓷碗和瓷盒。在右边绘一长方形箱子，前面绘一把扫帚，一件瓷质葵口瓶。长

案上所绘之物应是墓主人生前所用，壁画似描写了男主人的日常起居生活。西耳室两壁上部绘一幅花鸟画。画面中央是6朵盛开的牡丹，排列成金字塔形。花朵左上方绘一只蜜蜂、一只绶带鸟；右上方绘一只蝴蝶、一只绶带鸟。两只均为黑顶红喙红爪，色彩艳丽，十分醒目。下部与东耳室东壁下部一样，也绘一长案，案上也摆着华美的镜架和形状各异、纹饰不同的箱盒及瓷器，其中有一件瓷枕，上面绘满花纹，显得雍容华贵。

王处直墓壁画不仅对于研究晚唐至五代时期的绘画艺术提供了实物证明，同时也为研究当时的服饰、瓷器、金银器工艺等以及人们的生活情趣、审美认知都提供了十分珍贵的资料。

4. 宋辽金元墓葬壁画

河北省发现的宋辽金元时代的壁画墓有武邑龙店北宋壁画墓、宣化下八里辽代壁画墓[12]、井陉柿庄和北孤台金代墓地[13]、涿州元代壁画墓[14]、平乡元代壁画墓[15]等。

河北宋代壁画墓出现了砖砌仿木结构彩绘和壁画，共同组成饶有时代特色的墓葬装饰。武邑县龙店村发现了3座北宋壁画墓，其中的二号墓有墨书纪年——"庆历二年"，即1042年。三座墓的建造方法与结构基本相同，均为砖构圆形单室墓，墓葬由墓道、甬道和墓室组成。壁画的画法、内容大致相同。以保存尚好的三号墓为例，墓室北壁为相对墓门的正壁，以砖砌出仿木结构的假门，部分结构以墨绘表现，如门钉、门环等，两门柱外侧及门额等处有墨绘装饰图案，两门柱内侧各绘一人物。东西两壁以砖砌出桌椅形状，配合桌椅绘制出人物、酒具及其他日常用具。南壁为甬道进入墓室的位置，入口两侧的壁面绘制有手执骨朵、杠棒的人物。

宣化辽代壁画墓群，位于张家口市宣化区城西下八里村东北台地上，为辽代晚期张氏和韩氏家族墓地。从出土的墓志铭得知，其中张氏墓地以张匡正辈份最长，葬于辽道宗大安九年（1093年），最晚为张恭诱，葬于辽天祚帝七年（1117年），时间仅相距不过二十三四年。以张世卿地位最高，为辽国右班殿直、检校国子祭酒兼监察御史、云骑尉。他生前得到了辽天祚帝的赏识，结交辽国上层贵族，据良田千顷，左右地方官府，势力极大。张氏一族家人也因此而获荫福，壁画内容是张氏一族生前生活的真实写照。

宣化辽墓已发现的九座均有壁画，壁画分布于墓室的四壁和顶部，总面积达300余平方米，其中一号墓的面积最大，为87.5平方米，一般双室墓壁画约40平方米，九号墓遭破坏，仅存壁画9.7平方米。

宣化辽墓壁画内容丰富，其壁画内容包括：出行图、散乐图、备经图、备茶图、宴饮图等生活享乐场面，有汉装持杖门吏、胡装持杖门吏、契丹装骨朵门吏和持钵、持箱、温酒、持扇、持巾、持镜、妇人启门等侍者，金刚像、双头人像、神荼和郁垒像、五鬼图、三老对弈等佛教和神话传说中的人物，儿童跳绳童趣图，壁画中共出现人物208个，另外还绘有山石、仙鹤、花卉等自然景物和双凤、双龙图，垂莲藻井以及彩绘星图等。

壁画墓中有三幅出行图。张世卿墓的出行壁画中绘一白马，金鞍银辔，马的前后和侧身有五名侍者，前有驭者，其后是持伞、托帽、持衣、顶盘等侍者，场面隆重，反映了辽国贵族出行时，仪卫前呼后拥的场景。而韩师训墓的出行壁画，则画一匹高大的骆驼，拉一长辕，庑殿式车厢，前后挂有门帘，上覆白色凉棚的驼车出行，反映了官商的出行情况。散乐图在七座壁画墓中均有发现。每幅中乐器、人数的多寡、乐器的配置等都有变化，以张世卿墓散乐班子人数最多，达12人，最少者也有5人，每幅图均有一至二名舞蹈者，乐器有横笛、箫、排箫、腰鼓、大鼓、笙、琵琶等。乐人和舞人头戴幞头，身着官服或红、紫、绿色长袍，足蹬皂靴，或舞、或吹打，为墓主人生前演奏伎乐的情景。备茶图是辽墓壁画中的又一重要内容。在九座墓中，有八座墓发现了与饮茶有关的壁画，展现了一系列备茶的操作程序，如选茶、碾茶、烹汤、点茶等，有的画面还加入了故事情节，特别是7号墓的童嬉图最为丰富。图中共8人，左面4人，右一男童跪坐地上，另一童子站其肩上，双手伸

向吊篮取桃。另有一契丹男童正提衣襟兜接掷下的桃子,旁边站的一位青年女子,左手指向取桃的童子。地上有茶碾、茶炉、朱漆盘。在桌前有食盒,四童子蹲藏在食盒、方桌后窥探。画面生动传神,嬉戏风趣场面令人遐想。宣化辽壁画墓,内容丰富,题材多样,色彩鲜艳,技艺纯熟,线条优美,殊为罕见。无论从丰富的壁画内容本身,还是绘画的艺术风格、绘画的技巧和中国古代特别是辽代中晚期中国北方绘画艺术史的发展方面,都揭示了新的内容和篇章。

井陉柿庄金墓群,位于河北井陉县城西南群山环抱之中,分为柿庄和北孤台两个区,共清理墓葬14座,除一座为砖石混筑外,余为仿木结构建筑单室砖墓,并施彩绘。据发掘者推测,该处墓地当为当地的富豪家族墓。

墓中壁画,分布于墓室四壁,多保存不完整。内容或表现墓主人生前生活和享乐场面,如宴饮图、供养图、伎乐图;或表现当时生产活动,如耕获图、捣练图、放牧图等;或表现美丽的田园风光,如芦雁图等;或表现当地民俗,如门神和四像图等。其中六号墓的"捣练图"保存完整,内容丰富,是各墓壁画中绘制最精美的一幅。全图由担水、熨帛、晒衣三部分构成。画面的右边有一担水人,粉面,头系帛巾,身穿窄袖蓝花襦,下着白裤,右肩挑一担红色水桶。居中有三女子熨帛,均梳高髻,中间一人身穿绛衫、浅蓝裙,右手按帛,左手执熨斗;右边一人身穿白衫,裙上有蓝色小花,两手拉帛轴,上身向右后仰;左边一人身穿蓝色衫,上饰小花,蓝色裙,姿态与右者相同。左边为晒衣二女子,其中一人开柜取衣,一人作捶衣状。开柜人身穿紫红色衫,粉白色裙;捶衣人身穿粉白色衫,白裤。井陉柿庄壁画墓,非专业人士所绘,属于地区性的民间艺人的作品,代表了该地区那个时代的民间艺术水平,丰富了金墓壁画的内容。

元代纪年壁画墓是十分罕见的。2004年河北省文物研究所在平乡县西郭桥村抢救性发掘了两座元墓,其中二号墓为元大德八年(1304年)。二号墓由墓道、门楼、甬道、墓室4部分组成,为仿木结构。墓室平面为八角形。墓壁基部以叠涩式砌法并装饰一

门,柱头枋上的拱眼壁间砌小铺作,结构如同门楼式建筑。各建筑上层斗拱的拱眼壁之间皆有题记,其中西南壁有砖质刻铭,记载了墓主郭达的籍贯、卒年等内容。墓壁上粉刷有很薄的白灰为壁画地衣。柱子、桌子、凳子、粮仓、假窗等白灰外刷土红色。门楼的斗拱、檐椽等构件上,皆在面部用单墨线随形勾勒出轮廓,拱心处填土红色。墓壁角柱、普柏枋及柱头枋之间的阑额上墨绘有大朵的牡丹。柱头枋上为莲花。门楼阑额上绘莲花和牡丹。壁画大都绘在每面墙壁门楼的外侧,以人物、墨竹、花草、鹤、鹿等内容为主。壁画内容丰富,如北壁东为男子饲鹤图,西为墓主人图。绘画手法写意,以墨色为主,配以赭石、淡青,格调淡雅,具有鲜明的时代特征。郭桥元墓的发现,对研究元人葬俗、葬制、服饰演变等具有重要的价值。

元至顺二年(1331年)的涿州市元代李仪墓是另一座纪年元墓。墓葬由竖穴式墓道、甬道、角形墓室组成,墓室壁画保存较为完好。墓室东西两侧写有墨书题记,东侧记载墓主人生平,西侧为其子撰写的悼文。壁画绘于墓门、墓室和墓顶。墓门门楣上隐约可见绿色、赭色绘成的花卉。墓室壁上绘有孝子故事图。墓壁上还绘有宴乐图、墨竹云雀等。

综上所述,河北古代出土壁画时代跨度长,自东汉直至元明,出土遗迹内涵广泛,上至封建帝王,下至地方豪绅的壁画墓都有发现,还有佛教地宫壁画的出土。此外,壁画内容丰富,技法精湛,基本能够勾画出河北省古代壁画艺术的发展脉络和演变的轨迹。为研究中华民族的传统文化,特别是艺术史提供了珍贵的第一手材料。"不仅是河北古墓壁画的精粹,就全国发现的古墓壁画来讲,它们的重要性也是很突出的。"[16]

注 释

[1] 河北省文物研究所:《河北古代墓葬壁画》,文物出版社,2000年。

[2] 河北省文物研究所:《安平东汉壁画墓》,文物出版社,1990年。

[3] 北京历史博物馆、河北省文物管理委员会：《望都汉墓壁画》，中国古典艺术出版社，1955年。

[4] 河北省文物研究所编：《安平东汉壁画墓》，文物出版社，1990年。

[5] 磁县文化馆：《河北磁县东魏茹茹公主墓发掘简报》，《文物》1984年第4期。

[6] 中国社会科学院考古研究所河北工作队：《河北磁县北朝墓群发现东魏皇族元祜墓》，《考古》2007年第11期。

[7] 磁县文化馆：《河北磁县东陈村北齐尧峻墓》，《文物》1984年第4期。

[8] 磁县文化馆：《河北磁县北齐高润墓》，《考古》1979年第3期。

[9] 中国社会科学院考古研究所、河北省文物研究所：《磁县湾漳北朝壁画墓》，科学出版社，2003年。

[10][11] 河北省文物研究所、保定市文物管理处：《五代王处直墓》，文物出版社，1998年。

[12] 河北省文物研究所：《宣化辽墓壁画》，文物出版社，2001年。

[13] 河北省文化局文物工作队：《河北井陉县柿庄宋墓发掘报告》，《考古学报》1962年第2期。

[14] 河北省文物研究所、保定市文物管理处、涿州市文物保管所等：《河北涿州元代壁画墓》，《文物》2004年第3期。

[15] 樊书海、赵战护：《河北平乡发现元代仿木结构纪年壁画墓》，《中国文物报》2004年7月14日第1版。

[16] 宿白：《关于河北四处古墓的札记》，《文物》1996年第9期。

Murals Unearthed From Hebei Province

Cao Kai, Han Lisen

Since 1950s, 41 mural tombs and one Buddhist underground palace with murals were excavated in Hebei province. The span of these tombs' burial date is from the Eastern Han dynasty to the Yuan and Ming dynasties. The subjects of these vivid paintings, which were made by anonymous artists, include legends of royal families、nobles and common people's daily life；fairy tales about Heaven and legends；natural sceneries such as rivers and mountains, the Sun, Moon and stars；animals and plants including flying birds, running beasts, flowers, and fishes[1].

1. Eastern Han mural tombs

The important mural tombs of the Eastern Han dynasty in Hebei include the mural tomb at Lujiazhuang in Anping[2] and tomb M1 at Wangdu[3].

The Anping Eastern Han mural tomb, which was excavated in 1971, is located at Lujiazhuang, a village 2.5 kilometers to the south of the county town of Anping. The tomb is composed of the gate, entryway, front chamber, central chamber and rear chamber. Each tomb chamber has its own side chambers. The murals, partially damaged, were distributed in the right side chamber of the front chamber, central chamber and its right side chamber. The tomb was dated to 176 CE for the inscriptions "the 5th year of the Xiping Reign (176 CE)" written on the mural. The paintings in the central chamber mainly depict the tomb occupant's procession scene which contains long attendant carriages and cavalrymen in four rows. Each row is comparatively an independent unit. The portraits in the mural include 96 pedestrian ceremonial guards and 94 cavalrymen. Foot soldiers or lower ranking officials walking in the front. Behind them are mounted officials who hold halberds, mounted officials who hold bows, and mounted attendants. These people are all the closing attendants or subordinate officials of the tomb occupant. The 82 carriages in the mural all have double rafts and black wheels. The types of the carriages include Yao light carriage with white canopy, Ox cart, red Yao carriage with black canopy, red canopy carriage, Zi wagon, and big carriage. According to the official regulation of the Eastern Han dynasty, only a full 2000 Bushels official or a 2000 Bushels official, who is the highest ranking official in the local government, was allowed to take a Yao carriage with black canopy and red flag, or a red canopy carriage. The red dressing passenger in the red canopy carriage, which is the center in the fourth row, might be a 2000 Bushels official of the local government[4]. The woman and the kid, who sit in a Zi wagon, might be his family members.

Another splendid painting in the Anping tomb is the bird view of a courtyard complex which is in the western section on the northern wall in the right side chamber of the central chamber. The painting depicts the detail of a courtyard including several small yards with different functions. The courtyard, which might be the residential complex of the tomb occupant, also has defensive function.

The mural tomb M1 of Wangdu, which is located at Dongsuoyaocun near the county town, was found by villagers in the process of bricks making in 1952. It was then excavated by archaeologists organized by the Management Committee of Cultural Relics in Hebei province. Its murals were distributed in the front chamber and the lower section on the western wall of the corridor leading to the central chamber. The mural was divided into two sections. The lower section depicts the birds and the animals; the upper section depicts people's portraits. Drawn by ink and colored red, green and yellow, most portraits have ink inscriptions except for the clouds and animals which were painted in the arch of the entryway. The inscriptions are the most important historical information of the Eastern Han dynasty. For example, there is a male on both sides of the door on the southern wall in the front chamber. The male on the east side, who is holding a staff in hands,

has an inscription "Door guard of the Court". The male on the west side, who is carrying a sword on the waist, has an inscription "Managing clerk at the gate". It made their status and official title clear. Other official titles of portraits which could be identified through the inscriptions include "Recording Secretary", "Recorder", "Head of labor section", "Head of Police section", "Headquarters Clerk", "Eight Squad Leaders", "Pavilion Attendant", "Memorial Clerk", and "Consoling Clerk". Their status could also be identified from different dressings, decorations, postures, or even facial expressions. All these aspects depict the strict hierarchy system in the Eastern Han dynasty. Moreover, there are also many animals including river deer, chicken, duck, goat, fabulous bird, white hare, mandarin duck, and phoenix. The inscriptions not only show their names, some of them were even given the explanation of the implied meanings.

With abundant historical information, the Eastern Han mural tombs found in Hebei are valuable for the research of the official ranking system, social custom, economic structure, and architecture types in the Han dynasty.

2. Northern Dynasties mural tombs

In the late Northern dynasties, both the Eastern Wei (534-549) and the Northern Qi (549-577) chose Ye as their capital. The imperial cemetery of both dynasties, the Tombs of Northern Dynasties at Cixian, which was located to the northwest of Ye, was listed as the cultural relics unit under the state protection. Since 1970s, around 10 important mural tombs were excavated in this cemetery including the Eastern Wei tomb of Princess Ruru at Cixian[5], Eastern Wei tomb of Yuan Hu[6], Northern Qi tomb of Yao Jun[7], Northern Qi tomb of Gao Run[8], and Northern dynasties mural tomb at Wanzhang in Cixian[9].

All mural tombs at Cixian were composed of the passageway, entryway, and single tomb chamber. The occupants of these tombs belong to the highest hierarchy of the Eastern Wei or Northern Qi. Their murals were not only painted in the entryway and tomb chambers, the walls and the ground in the passageway were also full of painting.

The Eastern Wei tomb of Princess Ruru is famous for its archaeological materials and the known burial date and its occupant. The epitaph found in the tomb records that Princess Ruru Linhe, wife of Gao Zhan, was buried at the 8th year of the Wuding Era in the Eastern Wei dynasty (550 CE). This 35 meters long tomb, which composed of the sloping passageway, entryway, and tomb chamber, were all painted with murals. A 14 people ceremonial procession scene was painted on both walls in the 23 meters long sloping passageway. Above the procession scene are mythical animals and winged human beings. The slope of the passageway was decorated with ground painting. At the north end of the entryway, a Scarlet Bird was painted in the center of a huge screen wall which is erected above the arch. The murals in the tomb chamber were divided into two sections. The upper section depicts the Four Supernatural Beings according to their own directions. The square-domed roof was also painted with astronomical patterns. The murals of the lower section depict the scene of the tomb occupant's lifetime.

The Northern dynasties mural tomb at Wanzhang is so far the biggest excavated mural tomb of the Northern dynasties. With a huge grave mound in original, a stone image, which is almost 4 meters high, is still remaining beside the spirit road in front of the tomb. The 52 meters underground structure, which includes the sloping passageway, entryway, and tomb chamber, were all decorated with murals. The well preserved murals on both walls of the 37 meters long passageway depict the ceremonial procession scene with 53 life-sized portraits on each wall. Above the procession scene, it is auspicious birds, mythical animals, clouds, and lotus rushing or floating in the sky. The slope of the passageway, which is painted with big lotuses and acanthus patterns, looks like a huge carpet leading to the tomb chamber. On the northern end of the passageway, a huge screen wall was erected on the arch of the entryway. A 5 meters high Scarlet Bird was painted on the center of the screen wall with mythical animals, winged hares and lotuses decorated symmetrically on both sides. The walls of the entryway and tomb chamber are full of murals. Although most Murals in the lower section were damaged, some human portraits, mythical animals and decorating patterns still could be identified. The square-domed roof was painted with

astronomical patterns including the Milky Way and stars. Based on the construction's scale, the subjects of the murals and the combination of the burial objects, the archaeologists speculated this tomb as Mausoleum Yiping, the tomb of Emperor Wenxuan (Gao Yang) of the Northern Qi dynasty.

Hebei is one of the most distributed districts of the Northern dynasties mural tombs. The tombs' occupants include imperial family members, nobles, and officials. The various burial materials unearthed from these mural tombs provide important evidence for the archaeological and art historical studies of the Northern dynasties.

3. The Five Dynasties murals of Wang Chuzhi's tomb

Wang Chuzhi's tomb, which was excavated in 1995, is located 2 kilometers to the west of Xiyanchuancun at Lingshanzhen in Quyang[10]. According to the epitaph, the tomb occupant, Wang Chuzhi, was dead at the 20th year of the Tianyou Era in the Tang dynasty, also the 3rd year of the Longde Era in the Late Liang dynasty (923 CE). He was buried the next year in the Yangpanshan mountain of Dunxinxiang of Quyang. Constructed by blue stones, the 12.5 meters long tomb is composed of the passageway, entryway, front chamber and rear chamber. Murals were distributed on most walls except for the ceiling of the rear chamber.

Clouds-and-cranes and flowers-and-birds are the most popular motifs in Wang Chuzhi's tomb. There are eight clouds-and-cranes patterns in the upper section of the front chamber. Their drawing procedures are the same: drafting the outline, drawing with ink and adding colors. Five dynasties is the period for the traditional flowers-and-birds painting to become mature. Wang Chuzhi's tomb shows exquisite examples of flowers-and-birds painting. Four flowers-and-birds screens were painted on the eastern and western wall in the front chamber. The patterns include peony, monthly rose, morning glory, rose and chrysanthemum. Three flowers-and-birds paintings were distributed in the rear chamber including two equal size paintings on the western and eastern walls, a panoramic view painting on the rear wall. Two equal size paintings depict lake stone, green bamboos, birds, bees, and butterflies. The mural on the northern wall depicts a lake stone and a luxuriant plant peony which has 15 flowers in full blossom on its branches. The roots of the plant were drawn by brown color; its leaves were outlined by ink and added with green color. Peony flowers were also outlined with ink and colored red[11]. Two rose trees, which have 12 rose flowers on the branches for each, were painted on both sides of the peony plant. Four paradise flycatchers are flying opposite surrounding the plants; four pigeons are pecking on the ground.

The northern wall of the front chamber depicts an ink landscape painting which is 1.8 meters in height and 2.22 meters in width. As the earliest ink landscape painting with know date, it was already damaged by grave robber. Its right upper section was gone.

Two paintings with the same style were distributed on the eastern wall of the eastern side chamber and the western wall of the western side chamber. The upper section on the eastern wall in the east side chamber is a landscape painting. The painting of the lower section depicts a long table with articles on it in perspective. On the left of the table it is a hat stand with a T shape foot and a round head. A stretching tail black Futou hat was placed on the stand. Next to the hat stand is a rectangular case and a round case. A white porcelain bowl and a round porcelain case were placed behind them. On the right side of the table is a three legged mirror stand standing next to a square box. A broom and a porcelain long neck vase were placed on the front. All of these depict the occupant's articles for daily use. The upper section on the western wall of the west side chamber is a flower-and-bird painting with six full blossomy peony flowers distributing in a triangle shape. On the left above the flowers it is a bee and a paradise flycatcher; a butterfly and a paradise flycatcher are on the opposite. Two paradise flycatchers, all with black top, red beak, and red paws, are eye-catching for their bright colors. Similar to the counterpart in the east side chamber, the lower section also depicts articles on a long table. The articles include luxury mirror stand, cases and porcelains with various shapes and design.

The murals of Wang Chuzhi's tomb not only provide the important examples on the painting art of the late Tang and the

Five dynasties, it is also the important material for the study of the costumes and accessories, porcelains, gold and silver handi craft, people's life style and their appreciation on beauty.

4. Tomb murals of the Song, Liao, Jin and Yuan Dynasty

The main discoveries of the mural tombs during the Song, Liao, Jin and Yuan dynasty include the Northern Song mural tomb at Longdian in Wuyi, Liao mural tombs at Xiabali in Xuanhua[12], Jin tombs at Shizhuang and Beigutai in Jingxing[13], Yuan mural tomb at Zhuozhou[14], and Yuan mural tomb at Pingxiang[15].

The dynastic feature of Song mural tombs in Hebei is the emergence of the imitation of wooden construction built by bricks with painting. The Longdian mural tombs in Wuyi for example, three tombs are all composed of the passageway, entryway, and single round tomb chamber built by bricks. The painting style and technique of three tombs are similar. Through the ink inscriptions "the 2nd year of the Qingli Era (1042)" on the wall of tomb M2, we can learn the exact burial date of these tombs. In the well preserved tomb M3, a brick built imitation door was placed on the northern wall, the opposite of tomb's entryway. Ink decorations were added on the door including discs, knockers, pattern surrounding the frame and lintel, and two people inside the frames. On the eastern wall and western wall, it is brick carved table and chairs combined with murals including humanfigures, wine utensils and other articles of daily use. On the southern wall, two guards, who hold spiked mace or staff, were painted on both sides of the exit of the entryway.

Located on the tableland to the northeast of Xiabalicun, which is to the west of Xuanhua district of Zhangjiakou city, the Xuanhua Liao mural tombs are the cemetery of Zhang family and Han family in the late Liao dynasty. According to the epitaph, the earliest tomb in the Zhang family's cemetery belongs to Zhang Kuangzheng, who was buried in the 9th year of the Daan Era (1093). The latest tomb belongs to Zhang Gongyou, who was buried at the 7th year of the Tianzuo Era (1117). Of these tomb occupants, Zhang Shiqing, who was the Palace Eunuch of the Right Duty Group, Acting Chancellor of the national university, Investigating Censor, Commandant of Cavalry, had the highest social status in his family. Favored by the Tianzuo emperor, he was powerful in both the imperial court and local government. His family were benefited from his power and influence and owned thousands hectares of fertile farmland. The murals found in their tombs are the true description of their lifetime.

The total murals excavated from all nine tombs in Xuanhua is over 300 square meters. The murals were painted on the walls and the roofs. Normally a double chamber tomb has about 40 square meters murals. Tomb M1, the largest tomb found in the cemetery, has 87.5 square meters murals. Tomb M9, which was damaged, has only 9.7 square meters murals left.

The themes of the murals excavated from Xuanhua are various including daily life scene such as the procession scene, music band, sutras preparing scene, tea preparing scene, and banquet. There are 208 portraits of all status in the murals including the Han dressing door guard holding stick, Barbarian dressing door guards holding stick, Khitan dressing door guards holding spiked mace, and servants carrying bowl, case, wine utensil, fan, towel, mirror, and women who open a door; Religious and mythical portraits such as Vajrabodhisattva, double head people, door god Shentu and Yulei, five devils, and three seniors playing chess, and children rope skipping. There are also natural scenery such as stones, cranes, flowers; auspicious patterns such as double phoenix, double dragons, lotus ceiling, and stars.

Three procession scenes were found in the murals. The procession scene from Zhang Shiqing's tomb, with one white horse and five attendants, depicts the retinue of a Liao nobleman. The horse was fitted with gold saddle and silver bridle. Five attendants are leading the horse or holding umbrella, hat, cloth, and plate. The procession scene from Han Shixun's tomb depicts a camel cart which has long rafts, a wagon with hip roofed canopy and double curtains, and a white awning. It depicts the scene of a long trip by an official businessman. Depicting the music playing and dance performing scene of tomb occupant's lifetime, the music band is another popular subject which was found in seven tombs. The combination of the musical instrument and the number in each tomb are varying. The music band painting in Zhang Shiqing's tomb has

the most 12 members. The least member of a music band is five. Usually one or two dancers appear in each music band painting. The musical instruments they play include flute, vertical bamboo flute, panpipe, waist drum, big drum, Chinese reed pipe, and pipa. The music players and dancers all wear Futou hats, official dressing or red, purple, and green robes, and black boots. Tea preparing scene is another popular theme in the murals. Eight of the nine tombs have tea preparing related paintings which depict the procedure of tea making including tea selecting, tea grinding, water boiling, and tea making. Some tea making paintings even accompanied with complicate circumstance. The children playing scene in the tomb M7 for example. In this painting, eight people were divided into two sections by two tables and food box which were placed in the center of the picture. In the left section, a boy is stepping on another boy's shoulders to pick up peach from a hanging basket. The third boy, who holds the front of his garment to contain peaches, is watching on the peach picking boy. A woman, who is holding a peach in her left hand, is pointing her right hand to the peach picking boy. Some tea making utensils including a tea roller, a tea stove, and a lacqure tray were placed on the ground. In the right section, four smart boys are hiding behind the food box and the tables, watching at the peach picking boy. The whole picture is full of smack of daily life. With plenty of details, various themes, bright colors, and smooth lines, the murals in the Xuanhua tombs provide important materials for the study on the development of the art style and painting skill in the mid and late Liao dynasty.

Surrounded by hills, the Shizhuang Jin tombs, which consist of 14 tombs, are located to the southwest of the county town of Jingxing. These tombs were distributed in two districts, Shizhuang and Beigutai. Most of these tombs have a brick made single chamber with the imitation of wooden construction and painting. The occupants of these tombs were members of the local rich and powerful families.

The murals of Shizhuang Jin tombs mainly depict the living and the pleasure of occupants' lifetime such as banquet, scene of serving, and musicians; various working scenes such as plowing and harvesting, Preparing for Newly-woven Silk, and scene of herding; countryside scene such as reed and wild geese; and local costumes such as door gods and Four Supernatural Beings. The painting of preparing for Newly-woven Silk, which was found in tomb M6, is an outstanding picture. The picture consists of three sections including water carrying, silk ironing, and clothes drying. The left section depicts a young male carrying a pole and a pair of red barrels on his right shoulder. He wraps a turban on head and wears a blue garment and a white pant. The central section depicts three women who are ironing the silk. The woman in the middle, who wears a brown garment and a light blue skirt, is holding an iron in her left hand and pressing the opening silk with right hand. Two women beside her are holding the silk rollers. The woman on her right wears a white garment and a skirt with blue flower patterns. The woman on the left wears a blue garment and a blue skirt. The right section depicts two women who are drying clothes. One woman, who wears a purple garment and light pink pant, is opening a cabinet to take clothes out. Another woman, who wears a light pink garment and white pant, is squatting on the ground and beating the clothes. It is obviously that the mural painters of Shizhuang Jin tombs are not professionals but local artisans. The paintings provide important materials on the development of the folk art in Hebei area during the Jin dynasty.

Yuan tombs with exact burial date are rare. However, two important Yuan mural tombs which have intact brick construction and known burial date were excavated in Hebei recent years. One is tomb M2 at Pingxiang, which was buried in "the 8th year of the Dade Era (1304)". Another one is the tomb at Zhuozhou, which was buried in "the 2nd year of the Zhishun Era (1331)". The Pingxiang Yuan tomb M2, which was located at Xiguoqiaocun and accompanied with tomb M1, was excavated by the Institute of Cultural Relics in Hebei province. Composed of the passageway, arch, entryway, and an octagonal tomb chamber, tomb M2 is made of bricks with imitation of wooden structure. The foot of walls was made with the technique of corbelling. An imitation door was made on the center of each wall. The bracket sets above the brick columns were arches type. Inscriptions were written between all the bracket sets. A brick carved inscription on the southwestern wall records the hometown, death date, and other information of the tomb occupant Guo Da. The walls of the tomb chamber were whitewashed before painting. The brick carved parts, such as the columns, table, stool, barn, and

imitation windows, were added extra dark Brown on the white base. The bracket sets and the eave-rafters were filled dark brown after ink outlined. The architectural components were decorated with flowers. For example, large peonies were painted on the corner columns, plates, and architraves between ties above the top of columns; Lotuses were painted on the ties; above the architraves it was painted with lotuses and peonies. The paintings on the walls mainly depict human portraits, ink bamboos, flowers and plants, cranes and deer. The painting of each wall was distributed on both sides of the imitation door. For example, on the east side of the northern wall it is a male who is feeding a crane; on the west side it is the portrait of the tomb occupant. The artisan used freehand brushwork technique combined with plain color tint such as ink, ocher, and light green. Guoqiao Yuan tomb provides important materials on the studies of the burial custom and system, and the development of the costume and accessories in the Yuan dynasty.

The tomb of Li Yi, which was buried in "the 2nd year of the Zhishun Era (1331)" in Zhuozhou, is another important Yuan tomb with known burial date. The tomb was composed of the vertical passageway, entryway, and octagonal tomb chamber. Its murals, which were distributed on tomb's door, walls of the tomb chamber, and roof, were well preserved. Long ink inscriptions were written on the eastern and western wall of the tomb chamber. The inscription on the eastern wall recounts the life of Li Yi. The western inscription is the memorial words written by his son. Its murals mainly depict filial piety stories, scene of banquet, flowers and plants, and birds. Decoration patterns in green and ocher color were also found above the lintel of the door.

Dated between the Eastern Han dynasty and Ming dynasty, the murals discovered in Hebei not only have a long time span, the occupants are also related to many social statuses such as the imperial clan, officials, nobles, and local rich families. The murals from the Buddhist underground palaces are also masterpieces. With rich themes and outstanding skills, the murals discoveries in Hebei sketch the development of the ancient mural art of this area, provide the important first hand materials for the studies of local history and culture, especially for the history of art. "It is not only the quintessence of the murals in Hebei area, compare to the murals discovered in the nationwide, its importance is also prominent"[16].

References

[1] Institute of Cultural Relics in Hebei Province. 2000. Wall paintings in the ancient tombs in Hebei province, Beijing: Cultural Relics Press.

[2] Institute of Cultural Relics in Hebei Province.1990. Eastern Han wall paintings tomb at Anping.Beijing: Cultural Relics Press.

[3] Beijing history Museum, Management Conmmette of Cultural Relics in Hebei. 1955. Han painting tomb at Wangdu, Beijing: Chinese Classical Art, Press.

[4] Institute of Cultural Relics in Hebei Province.1990. Eastern Han wall paintings tomb at Anping, Beijing: Cultural Relics Press.

[5] Cixian Cultural Institute. 1984. Brief report on excavation of the Eastern wei tomb of Princess Ruru at Cixian. Wenwu (Cultural Relics), 4.

[6] Institute of Archaeology, Chinese academy of social sciences. 2007. The Eastern Wei royal member Yuan Hu's tomb was excavated at the Northern dynasties cemetery in Cixian, Hebei. Kaogu (Archaeology), 11.

[7] Cixian Cultural Institute. 1984. Tomb of Yao Jun of Northern Qi dynasty at Dongchencun in Cixian in Hebei. Wenwu, 4.

[8] Cixian Cultural Institute. 1979. Tomb of Gao Run of Northern Qi dynasty at Cixian in Hebei. Kaogu, 3.

[9] Institute of Archaeology, Chinese academy of social sciences, Institute of Cultural Relics in Hebei Province. 2003. Northern dynasties mural tomb at Wanzhang in Cixian. Beijing: Science Press.

[10][11] Institute of Cultural Relics in Hebei Province, Department of Cultural Relics in Baoding. 1998. Wang Chuzhi's Tomb of Five dynasties. Beijing: Cultural Relics Press.

[12] Institute of Cultural Relics in Hebei Province. 2001. Xuanhua Liao Mural Tombs, Beijing: Cultural Relics Press.

[13] Cultural Relics Team of Hebei Cultural Bureau. 1962. Excavation report of Shizhuang Song tombs at Jingxing in Hebei. Kaoguxuebao(ACTA Archaeological Sinica), 2.

[14] Institute of Cultural Relics in Hebei Province, Department of Cultural Relics in Baoding, Department of Cultural Relics in Zhuozhou. 2004. The Yuan mural tomb at Zhuozhou in Hebei. wenwu, 3.

[15] Fan Shuhai, Zhao Zhanhu. 2004. A Yuan mural tomb with imitation of wooden structure and burial date was found at Pingxiang in Hebei. Chinese Cultural Relics Newspaper, July 14, Page 1.

[16] Su Bai. 1996. Notes on four ancient tombs excavated in Hebei. Wenwu, 9.

目 录 CONTENTS

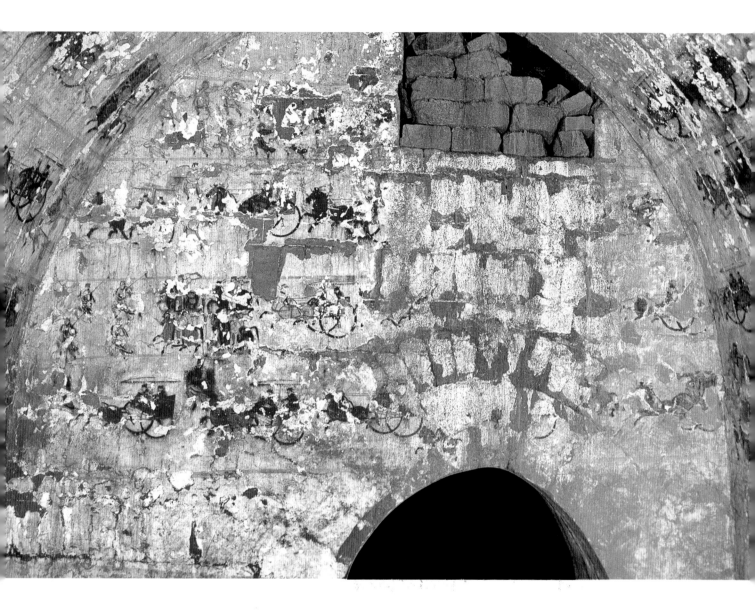

1. 出行图（一）

东汉熹平五年（176年）

高143～173厘米

1971年河北省安平逯家庄东汉壁画墓出土。原址保存。

墓向92°。位于中室东壁，描写的是墓主人出行的场景。壁画剥落严重，从残存的画面看，分四层，有车、骑及步行之类的导从仪仗等。

（撰文：郝建文　摄影：冯玲）

Procession Scene (1)

5th Year of Xiping Era, Eastern Han (176 CE)

Height 143-173 cm

Unearthed from the Eastern Han painting tomb at Lujiazhuang in Anping, Hebei, in 1971. Preserved on the original site.

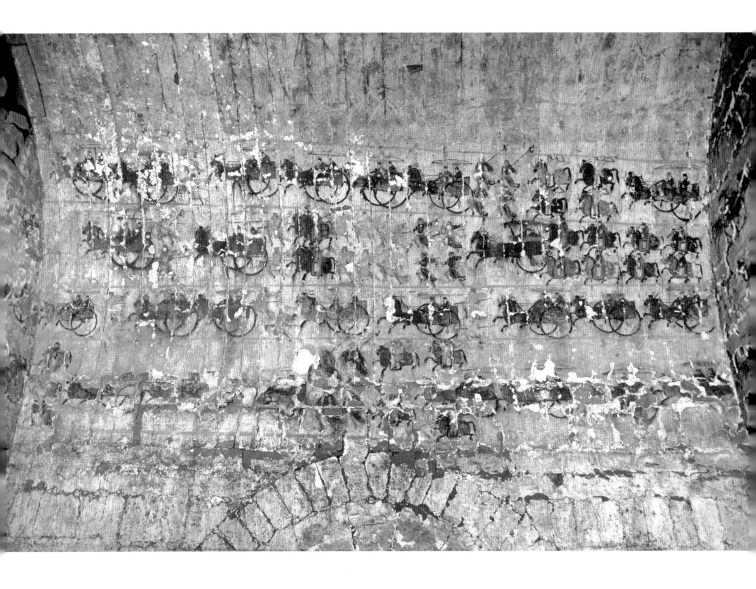

2. 出行图（二）

东汉熹平五年（176年）

高143～173厘米

1971年河北省安平逯家庄东汉壁画墓出土。原址保存。

墓向92°。位于中室南壁，描写墓主人出行的场景。画面分为四层，各层均绘有大量的车、骑及步行之类的导从和一辆主车。

（撰文：郝建文　摄影：冯玲）

Procession Scene (2)

5th Year of Xiping Era, Eastern Han (176 CE)

Height 143-173 cm

Unearthed from the Eastern Han painting tomb at Lujiazhuang in Anping, Hebei, in 1971. Preserved on the original site.

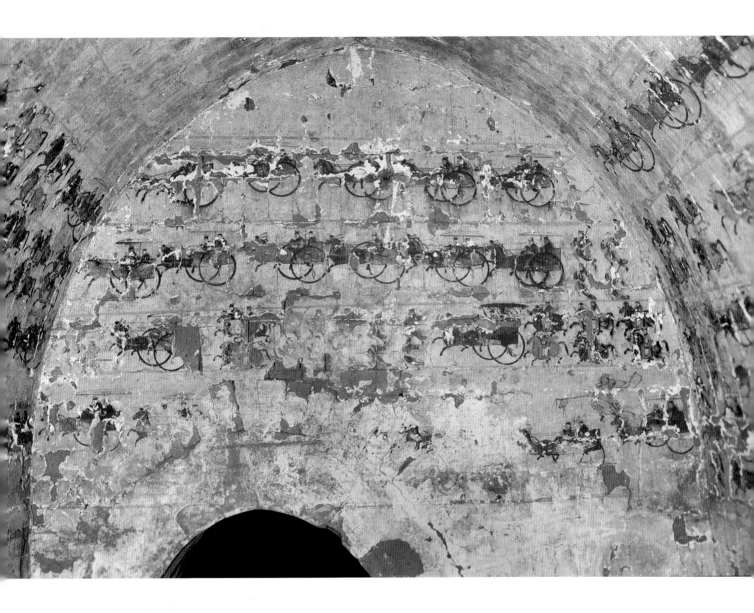

3. 出行图 (三)

东汉熹平五年（176年）

高143～173厘米

1971年河北省安平逯家庄东汉壁画墓出土。原址保存。

墓向92°。位于中室西壁，是墓主人出行的场景。画面分为四层，各层均绘有大量的车、骑及步行之类的导从仪仗和一辆主车。

（撰文：郝建文　摄影：冯玲）

Procession Scene (3)

5th Year of Xiping Era, Eastern Han (176 CE)

Height 143-173 cm

Unearthed from the Eastern Han painting tomb at Lujiazhuang in Anping, Hebei, in 1971. Preserved on the original site.

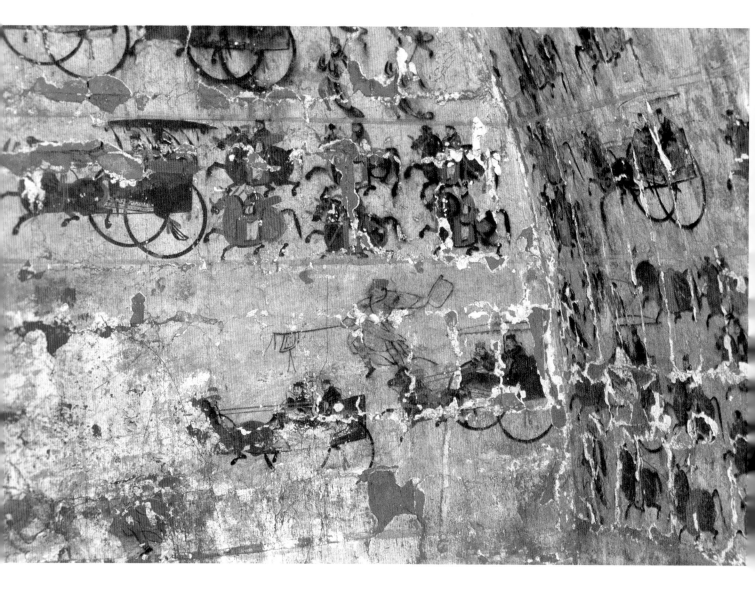

4. 出行图（三）（局部）

东汉熹平五年（176年）

第三层格宽约24厘米

1971年河北省安平逯家庄东汉壁画墓出土。原址保存。

墓向92°。位于中室西壁北侧，壁画从上向下分为四层，该图片为第三、四层局部。从左向右，第三层：主车、骑吏八骑（最后两骑绘到了北壁的西端）；第四层：门下贼曹和门下督盗贼各乘的一辆白盖轺车、及执戟伍伯。

（撰文：郝建文　摄影：冯玲）

Procession Scene (3) (Detail)

5th Year of Xiping Era, Eastern Han (176 CE)

Width of the third row ca. 24 cm

Unearthed from the Eastern Han painting tomb at Lujiazhuang in Anping, Hebei, in 1971. Preserved on the original site.

5.出行图（四）

东汉熹平五年（176年）

高143～173厘米

1971年河北省安平逯家庄东汉壁画墓出土。原址保存。

墓向92°。位于中室北壁。描写的是墓主人出行的场景。画面分为四层，各层均绘有大量的车、骑及步行之类的导从仪仗和一辆主车。

（撰文：郝建文　摄影：冯玲）

Procession Scene (4)

5th Year of Xiping Era, Eastern Han (176 CE)

Height 143-173 cm

Unearthed from the Eastern Han painting tomb at Lujiazhuang in Anping, Hebei, in 1971. Preserved on the original site.

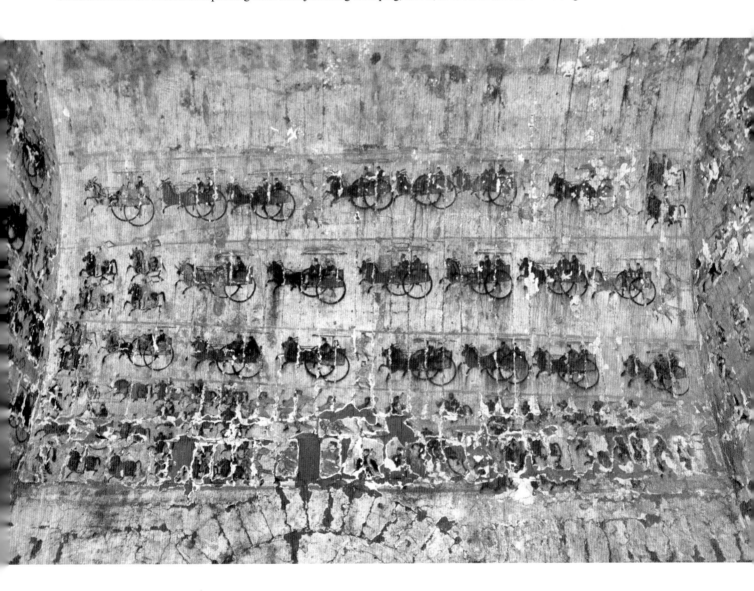

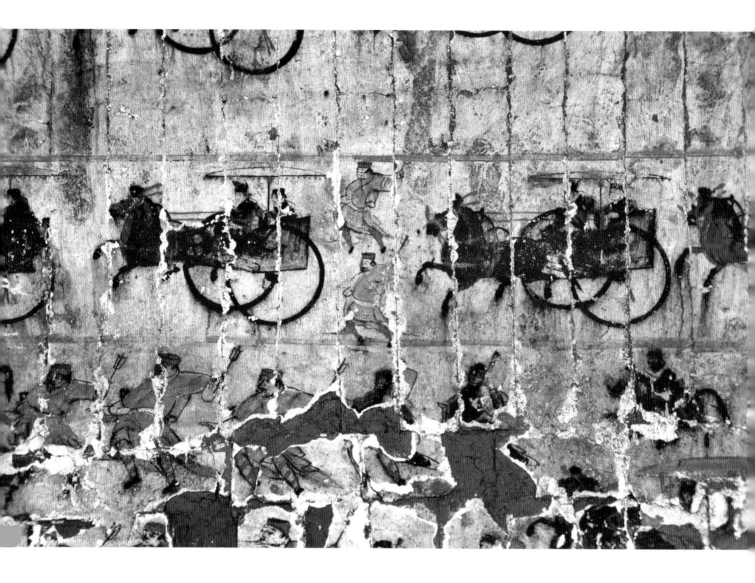

6.出行图（四）（局部一）

东汉熹平五年（176年）

第三层格宽约30～36厘米

1971年河北省安平逯家庄东汉壁画墓出土。原址保存。

墓向92°。位于中室北壁中下部，为壁画的第三、四层。从左向右，第三层绘浅黑色黑花马白盖轺车、左手举箭的伍佰二人、黑马白盖轺车；第四层绘车前弩伍佰三人、辟车二人。

（撰文：郝建文　摄影：冯玲）

Procession Scene (4) (Detail 1)

5th Year of Xiping Era, Eastern Han (176 CE)

Width of the third row ca. 30-36 cm

Unearthed from the Eastern Han painting tomb at Lujiazhuang in Anping, Hebei, in 1971. Preserved on the original site.

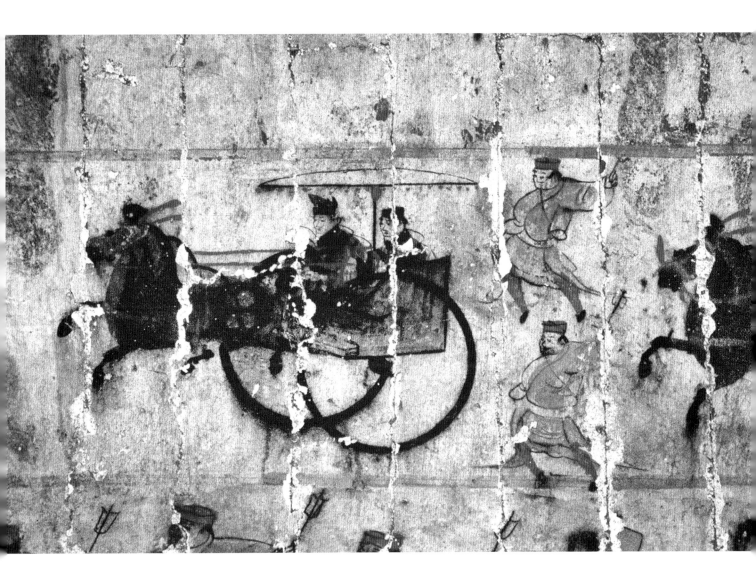

7. 出行图（四）（局部二）

东汉熹平五年（176年）

1971年河北省安平逯家庄东汉壁画墓出土。原址保存。

墓向92°。位于中室北壁中下部，为壁画的第三层浅黑色黑花马白盖辎车、左手举箭的伍佰二人。

（撰文：郝建文　摄影：冯玲）

Procession Scene (4) (Detail 2)

5th Year of Xiping Era, Eastern Han (176 CE)

Unearthed from the Eastern Han painting tomb at Lujiazhuang in Anping, Hebei, in 1971. Preserved on the original site.

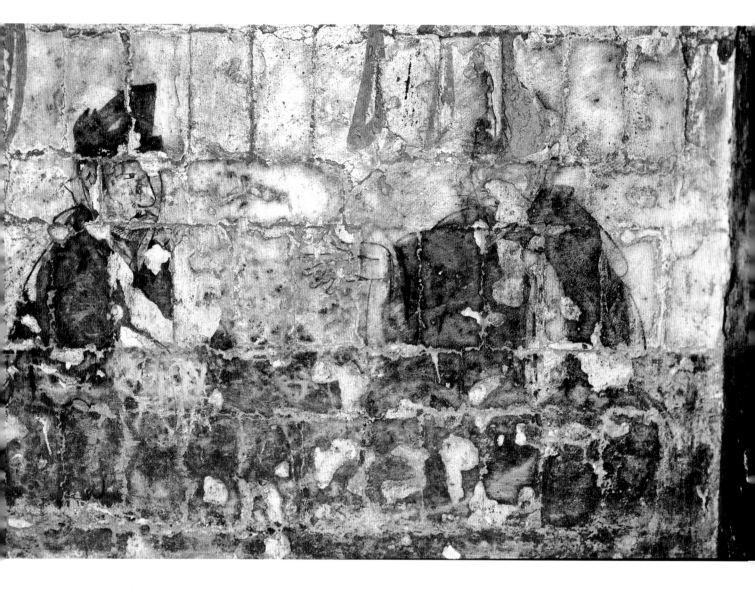

8.属吏图（一）

东汉熹平五年（176年）

人物高66厘米

1971年河北省安平逯家庄东汉壁画墓出土。原址保存。

墓向92°。位于前右侧室东壁。红色垂幔下，两个头戴黑色进贤冠、身穿浅黑长袍的官吏坐着交谈，其中右侧人物伸着右手，表现出正在说话的神态。

（撰文：郝建文 摄影：冯玲）

Subsidiary Clerks (1)

5th Year of Xiping Era, Eastern Han (176 CE)

Figure height 66 cm

Unearthed from the Eastern Han painting tomb at Lujiazhuang in Anping, Hebei, in 1971. Preserved on the original site.

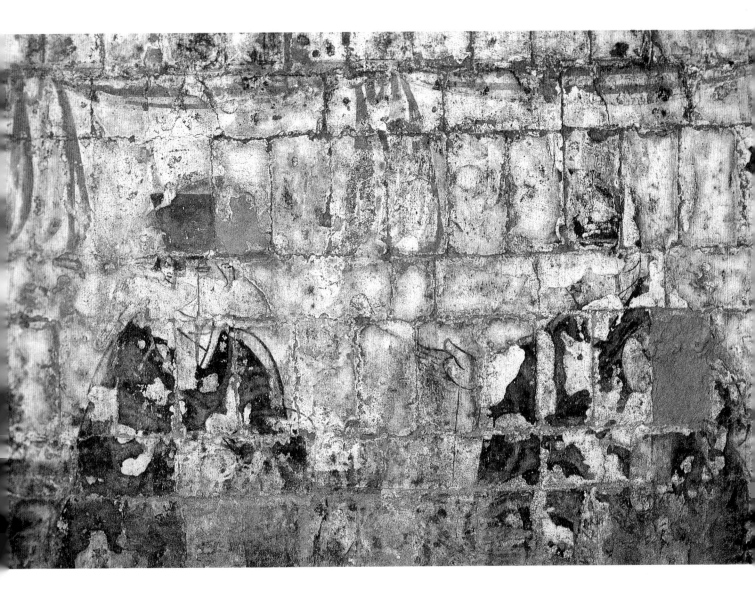

9.属吏图（二）

东汉熹平五年（176年）

人物高约66厘米

1971年河北省安平逯家庄东汉壁画墓出土。原址保护。

墓向92°。位于前右侧室南壁。红色垂幔下，两个头戴进贤冠、身穿浅黑长袍的官吏坐着交谈。

（撰文：郝建文　摄影：冯玲）

Subsidiary Clerks (2)

5th Year of Xiping Era, Eastern Han (176 CE)

Figure height ca. 66 cm

Unearthed from the Eastern Han painting tomb at Lujiazhuang in Anping, Hebei, in 1971. Preserved on the original site.

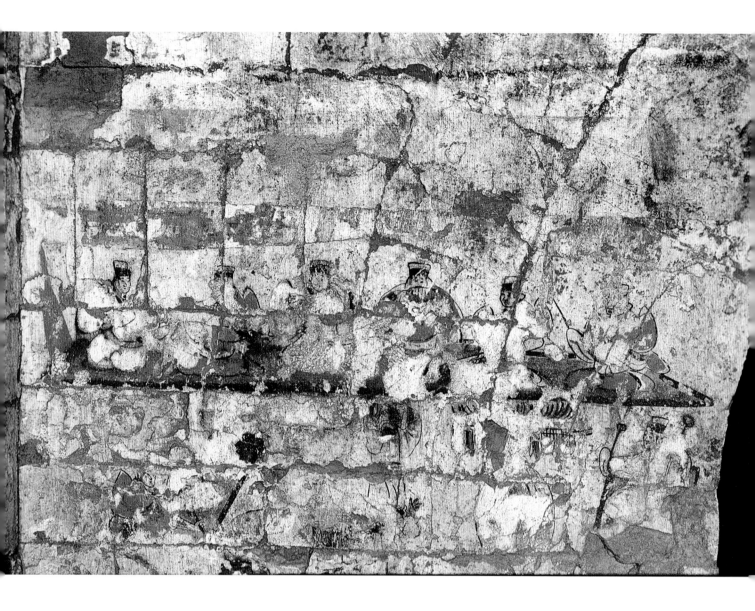

10. 伎乐图

东汉熹平五年（176年）

宽100厘米

1971年河北省安平逯家庄东汉壁画墓出土。原址保存。

墓向92°。位于中室右侧室西壁。表现的是垂幔下，坐在青灰边土黄色长条形簟蓆上，头戴黑冠，身穿红袍或黄袍的演奏者六人。因剥落严重，有的乐器已辨别不清，可辨识的有吹箫者、弹琴者和击鼓者。

（撰文：郝建文　摄影：冯玲）

Musicians

5th Year of Xiping Era, Eastern Han (176 CE)

Width 100 cm

Unearthed from the Eastern Han painting tomb at Lujiazhuang in Anping, Hebei, in 1971. Preserved on the original site.

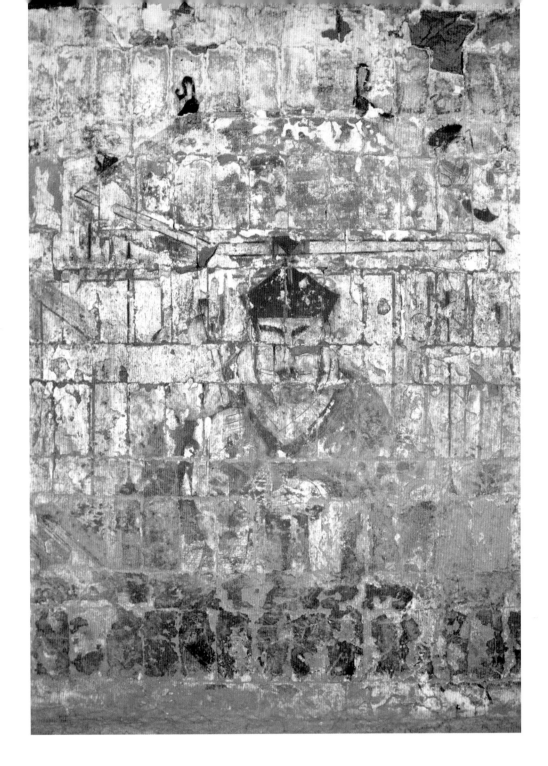

11. 墓主人坐帐图

东汉熹平五年（176年）

画高180厘米

1971年河北省安平逯家庄东汉壁画墓出土。
原址保存。

墓向92°。位于中室右侧室南壁。墓主人头
戴黑冠、身穿红袍，端坐帐中，其右手持黄
色便面，左手置于胸前。下面的黑色因地下
水的浸湿已混漫一片，应是一长几。帐后绘
一侍女，头戴巾帼，左手端三足圆盘。

（撰文：郝建文　摄影：冯玲）

Tomb Occupant Seated in Tent

5th Year of Xiping Era, Eastern Han (176 CE)
Height 180 cm
Unearthed from the Eastern Han painting tomb
at Lujiazhuang in Anping, Hebei, in 1971.
Preserved on the original site.

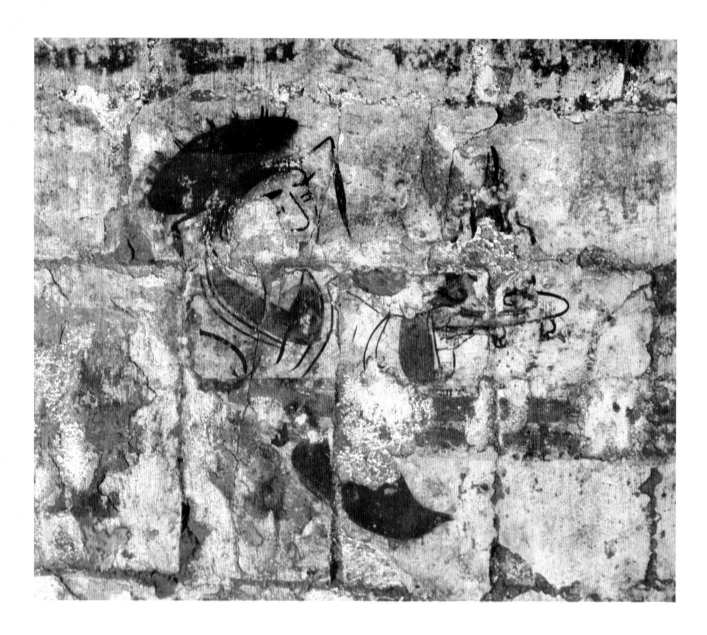

▲12.侍女图

东汉熹平五年（176年）

头部长约9厘米

1971年河北省安平逯家庄东汉壁画墓出土。原址保存。墓向92°。位于中室右侧室南壁。为墓主人坐帐图的一个局部。该侍女头戴巾帼，左手端三足圆盘，盘上放的好像是香熏之物。

（撰文：郝建文　摄影：冯玲）

Maid

5th Year of Xiping Era, Eastern Han (176 CE)

Height of head ca. 9 cm

Unearthed from the Eastern Han painting tomb at Lujiazhuang in Anping, Hebei, in 1971. Preserved on the original site.

13.府舍图 ▶

东汉熹平五年（176年）

1971年河北省安平逯家庄东汉壁画墓出土。原址保存。墓向92°。位于中室右侧室北壁西侧。宅邸外有围墙，内有多重院落，房屋为木构瓦顶，下有台基。画面中最突出的建筑为一座望楼，楼体为方柱形，庑殿式顶上有旗杆，彩旗和长带随风飘扬，檐下立一扁圆形大鼓。

（撰文：郝建文　摄影：冯玲）

Official Residence

5th Year of Xiping Era, Eastern Han (176 CE)

Unearthed from the Eastern Han painting tomb at Lujiazhuang in Anping, Hebei, in 1971. Preserved on the original site.

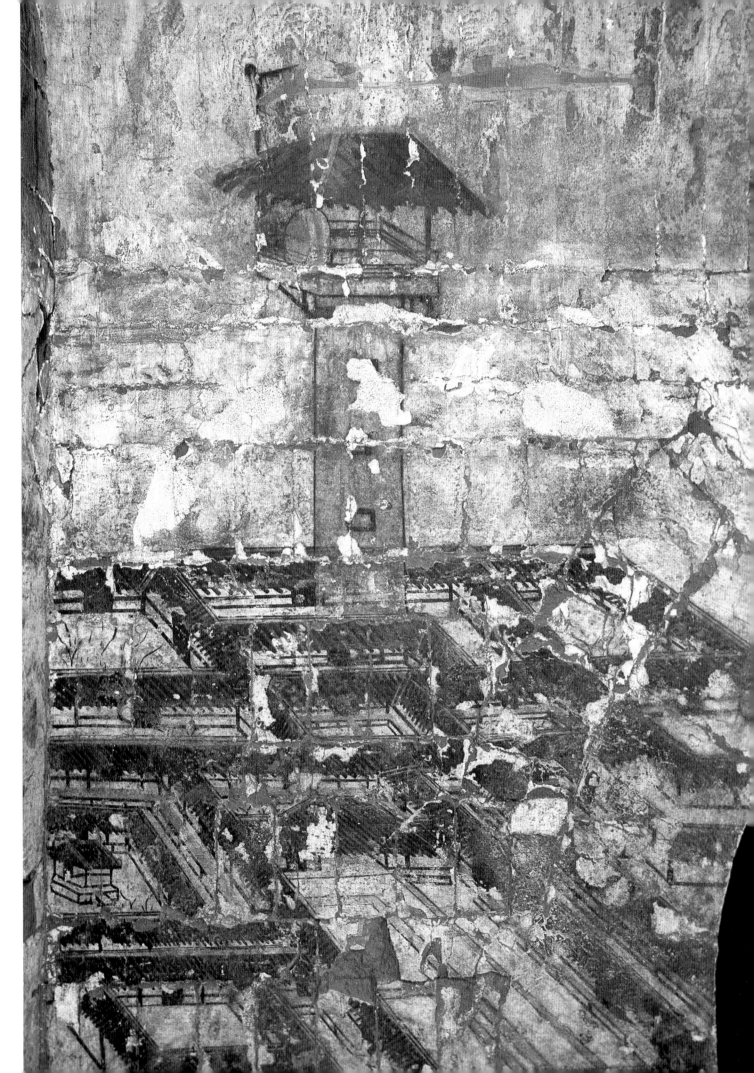

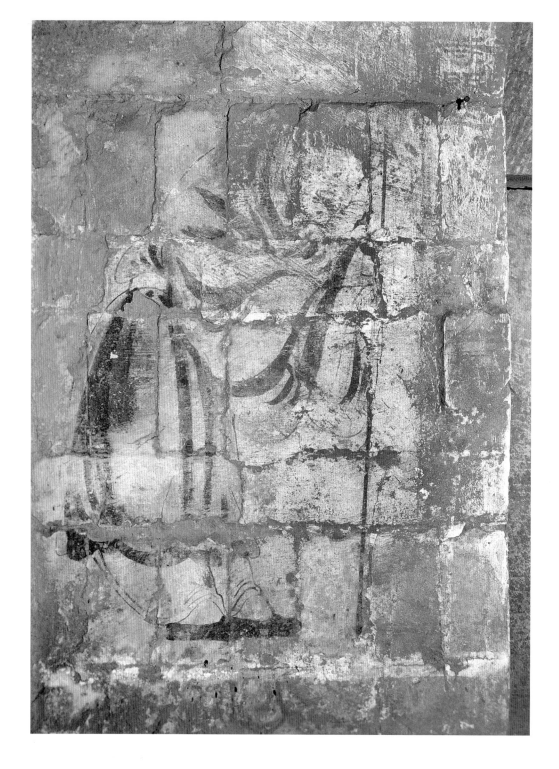

14. 寺门卒

东汉（25～220年）

人物高约84厘米

1952年河北省望都县一号汉墓出土。原址保存。

墓向190°。位于前室南壁墓门东侧。描绘的是头戴赤帻，身穿黑袍，脚穿鞋，双手持帚，躬身而立的人物，旁题"寺门卒"三字。

（撰文：郝建文　摄影：冯玲）

Gate Guard of the Court

Eastern Han (25-220 CE)

Figure height ca. 84 cm

Unearthed from Tomb M1 at Wangdu, Hebei, in 1952. Preserved on the original site.

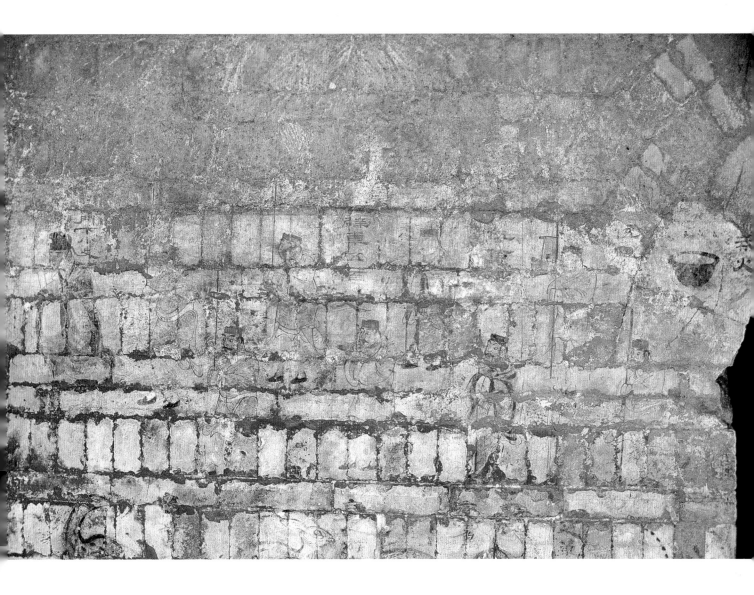

15. "门下小史" 等人物

东汉（25～220年）

宽约275厘米

1952年河北省望都县一号汉墓出土。原址保存。

墓向190°。位于前室东壁券门北侧。壁画由上下两部分组成，上部绘人物11人。由北向南：第一人跪，旁题"门下小史"，随后依次为"辟车五佰（伯）八人"。下部为鸟兽。从左向右，依次为"鸳鸯"、"白兔游南山"、"鸾鸟"、"芝草"。

（撰文：郝建文　摄影：冯玲）

Headquarters Clerk

Eastern Han (25-220 CE)

Width ca. 275 cm

Unearthed from Tomb M1 at Wangdu, Hebei, in 1952. Preserved on the original site.

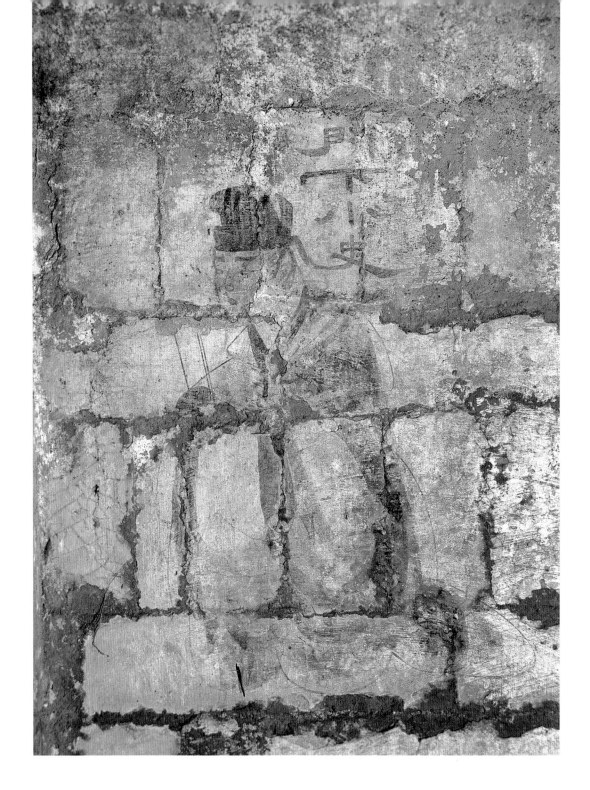

16. "门下小史"等人物（局部一）

东汉（25～220年）

人物高约60厘米

1952年河北省望都县一号汉墓出土。原址保存。

墓向190°。位于前室东壁。画中人物头戴黑冠，身着黑袍，双手捧笏。呈跪拜状，其头后有榜题"门下小史"。

<div align="right">（撰文：郝建文　摄影：冯玲）</div>

Headquarters Clerk (Detail 1)

Eastern Han (25-220 CE)

Figure height ca. 60 cm

Unearthed from Tomb M1 at Wangdu, Hebei, in 1952. Preserved on the original site.

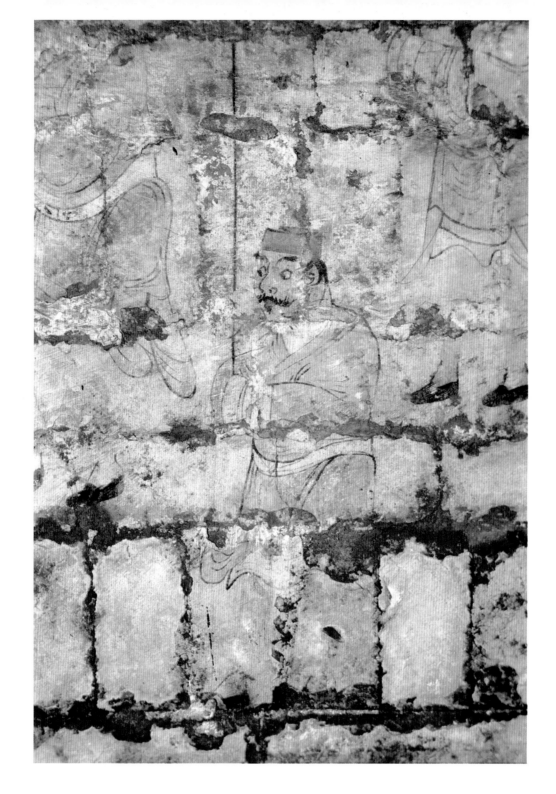

17. "门下小史"等人物（局部二）

东汉（25～220年）

人物高约55厘米

1952年河北省望都县一号汉墓出土。原址保存。

墓向190°。位于前室东壁，头戴赤帻，身穿黄衣，束腰，着黑鞋，面向北，持杖而立。为"辟车五佰（伯）八人"中的一人。

（撰文：郝建文　摄影：冯玲）

Headquarters Clerk (Detail 2)

Eastern Han (25-220 CE)

Figures height ca. 55 cm

Unearthed from Tomb M1 at Wangdu, Hebei, in 1952. Preserved on the original site.

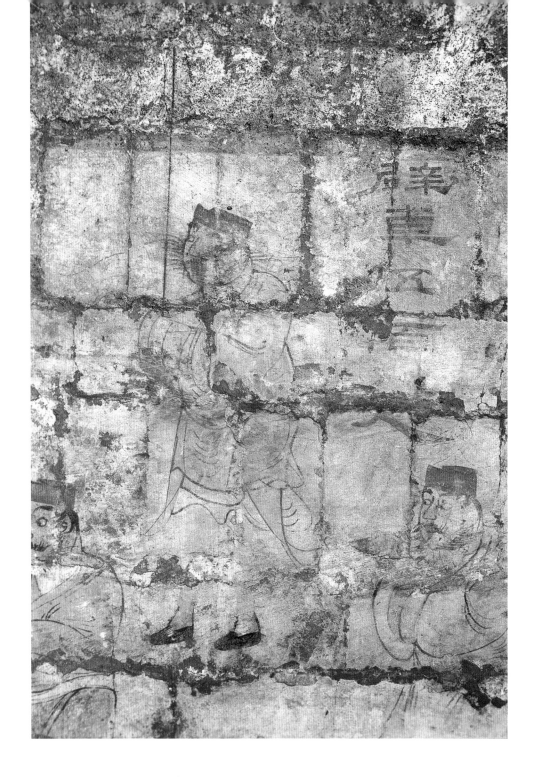

18. "门下小史"等人物（局部三）

东汉（25～220年）

人物高约55厘米

1952年河北省望都县一号汉墓出土。原址保存。

墓向190°。位于前室东壁。画面上三个人物，头戴赤帻，身穿黄衣，束腰，着黑鞋，面向北，持梃杖或棨戟而立，榜题"辟车五佰八人"。

（撰文：郝建文　摄影：冯玲）

Headquarters Clerk (Detail 3)

Eastern Han (25-220 CE)

Figures height ca. 55 cm

Unearthed from Tomb M1 at Wangdu, Hebei, in 1952. Preserved on the original site.

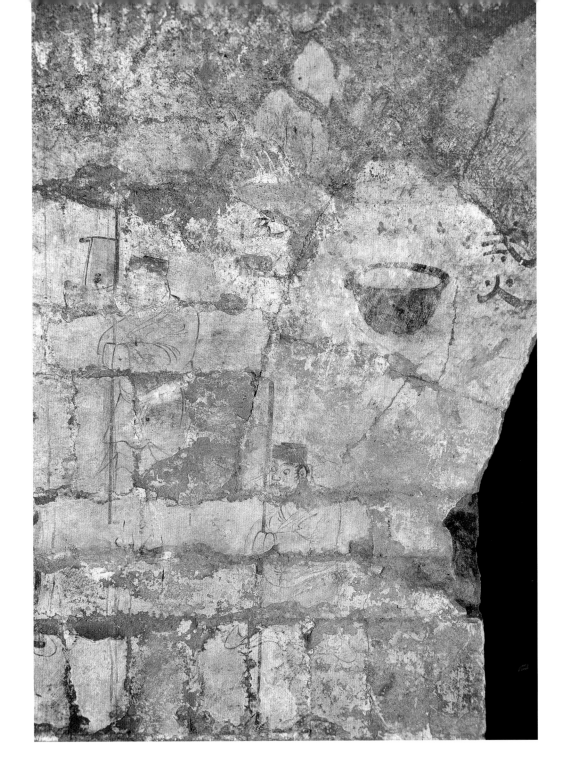

19. "门下小史" 等人物（局部四）

东汉（25～220年）

人物高约55厘米

1952年河北省望都县一号汉墓出土。原址保存。

墓向190°。位于前室东壁券门北侧。画中人物，头戴赤帻或黑帻，身穿黄衣或黑衣，束腰，着黑鞋，面向北，持杖或棨戟而立。他们身后绘净水一盆，内插红花，旁题"戒火"二字。黄衣人物旁题"伍佰"二字。

<div align="right">（撰文：郝建文　摄影：冯玲）</div>

Headquarters Clerk (Detail 4)

Eastern Han (25-220 CE)

Figures height ca. 55 cm

Unearthed from Tomb M1 at Wangdu, Hebei, in 1952. Preserved on the original site.

20. "贼曹"等人物

东汉（25～220年）

人物高约60厘米

1952年河北省望都县一号汉墓出土。原址保存。

墓向190°。位于前室东壁券门南侧。从北向南依次为"贼曹"、"仁恕掾"。两人身穿黑色长袍，腰间佩剑，双手执笏，躬身站立。

（撰文：郝建文 摄影：冯玲）

Officials of Police

Eastern Han (25-220 CE)

Figures height ca. 60 cm

Unearthed from Tomb M1 at Wangdu, Hebei, in 1952. Preserved on the original site.

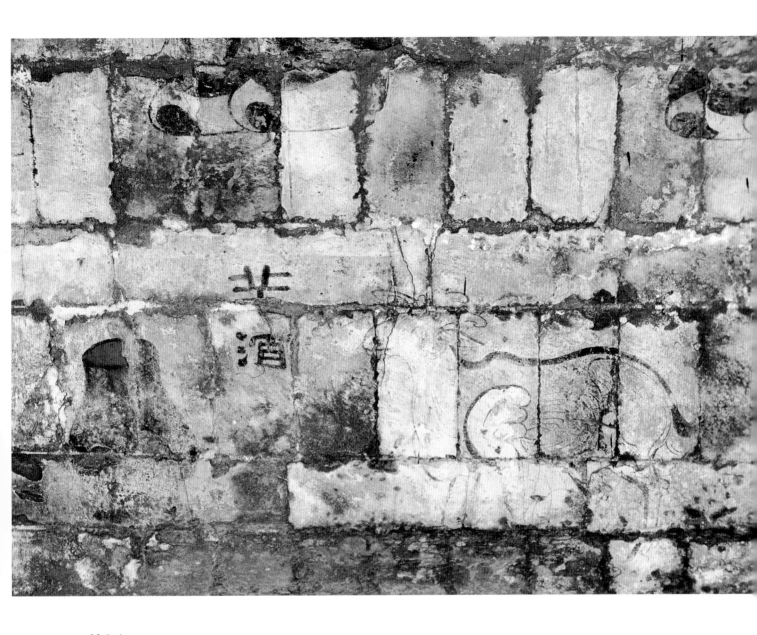

21. 羊酒

东汉（25～220年）

羊身长约50厘米

1952年河北省望都县一号汉墓出土。原址保存。

墓向190°。位于前室东壁券门南侧下方。羊身生羽翼，其左边是一黑色圆壶，壶口内呈红色，榜题"羊酒"二字。

<div align="right">（撰文：郝建文　摄影：冯玲）</div>

Goat and Wine

Eastern Han (25-220 CE)

Goat length ca. 50 cm

Unearthed from Tomb M1 at Wangdu, Hebei, in 1952. Preserved on the original site.

22. 主簿图

东汉（25～220年）

人物高约（踞坐）52厘米

1952年河北省望都县一号汉墓出土。原址保存。

墓向190°。位于前室北壁西侧，该人物头戴进贤冠，身穿黑袍，踞坐于榻上。他左手持笏，右手执笔，榻前有一砚台。旁题"门下功曹"四字，后补题"主簿"二字。

（撰文：郝建文　摄影：冯玲）

Recorder

Eastern Han (25-220 CE)

Figure height (in keeling) ca. 52 cm

Unearthed from Tomb M1 at Wangdu, Hebei, in 1952. Preserved on the original site.

23. 主记史

东汉（25～220年）

人物高约（踞坐）52厘米

1952年河北省望都县一号汉墓出土。原址保存。

墓向190°。位于前室北壁东侧。人物头戴进贤冠，身穿黑袍，踞坐于矮足方榻上。榻前有一砚，左侧的十字形架上有一水盂，旁题"主记史"三字。

（撰文：郝建文　摄影：冯玲）

Recording Secretary

Eastern Han (25-220 CE)

Figure height (in keeling) ca. 52 cm

Unearthed from Tomb M1 at Wangdu, Hebei, in 1952. Preserved on the original site.

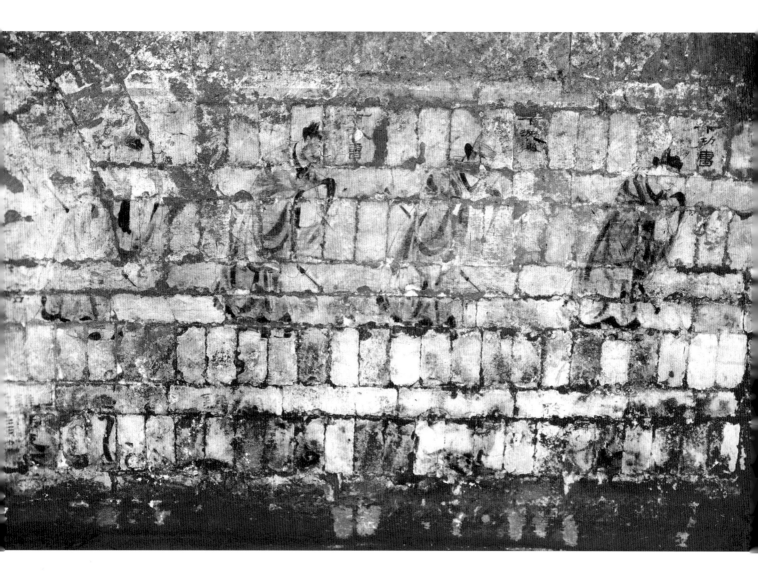

24. "门下功曹"等人物

东汉（25～220年）

人物高约76厘米

1952年河北省望都县一号汉墓出土。原址保存。

墓向190°。位于前室西壁。壁画由上下两部组成，上部绘人物共六人。自右向左按题字依次为"门下功曹"、"门下游徼"、"门下贼曹"、"门下史"、"追（槌）鼓掾"、"□□掾"。下部绘鸟兽，由南向北为"獐子"一、"鸡"二、"鹜"二。此为西壁北部四属吏。

（撰文：郝建文　摄影：冯玲）

Officials of Labor

Eastern Han (25-220 CE)

Figure height ca. 76 cm

Unearthed from Tomb M1 at Wangdu, Hebei, in 1952. Preserved on the original site.

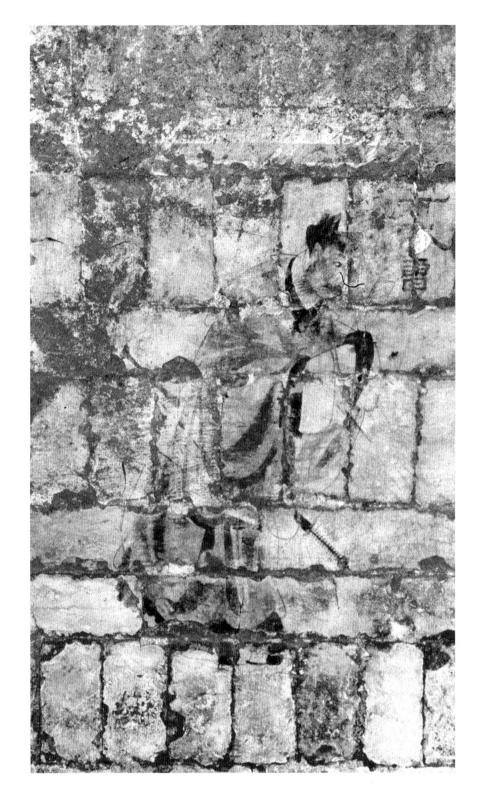

25. "门下功曹"等人物（局部）

东汉（25～220年）

人物高约76厘米

1952年河北省望都县一号汉墓出土。原址保存。

墓向190°。位于前室西壁。壁画由上下两部分组成，上部绘人物共六人。自右向左按题字依次为"门下功曹"、"门下游徼"、"门下贼曹"、"门下史"、"追（槌）鼓掾"、"□□掾"。下部绘鸟兽，由南向北为"獐子"一、"鸡"二、"鹜"二。此为西壁北部四属吏之从北数第三者。

（撰文：郝建文　摄影：冯玲）

Officials of Labor (Detail)

Eastern Han (25-220 CE)

Figure height ca. 76 cm

Unearthed from Tomb M1 at Wangdu, Hebei, in 1952. Preserved on the original site.

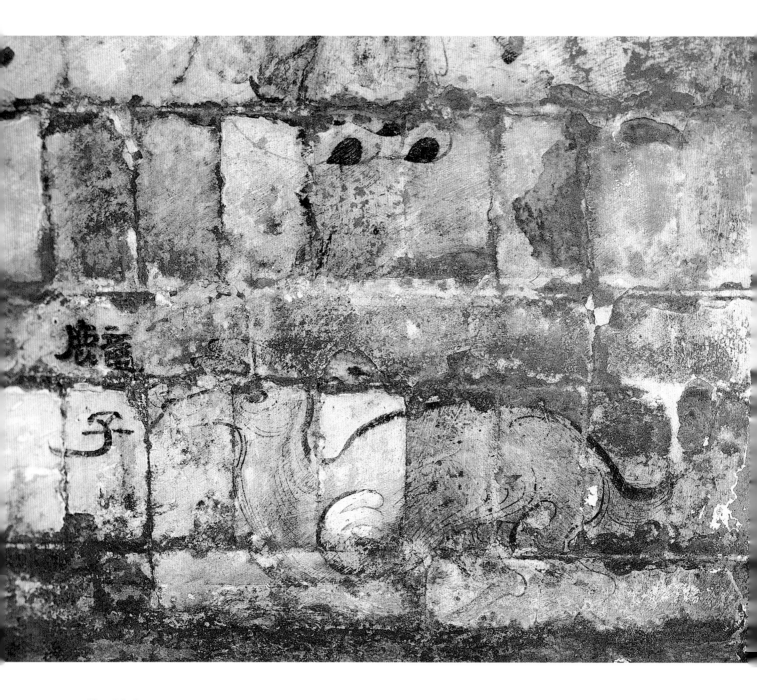

26.獐子图

东汉（25～220年）

身长约65厘米

1952年河北省望都县一号汉墓出土。原址保存。

墓向190°。位于前室西壁券门南侧下部。獐子昂首，双耳前倾，呈向前行走状，旁题"獐子"二字。

<div align="right">（撰文：郝建文　摄影：冯玲）</div>

River Deer

Eastern Han (25-220 CE)

River deer length ca. 65 cm

Unearthed from Tomb M1 at Wangdu, Hebei, in 1952. Preserved on the original site.

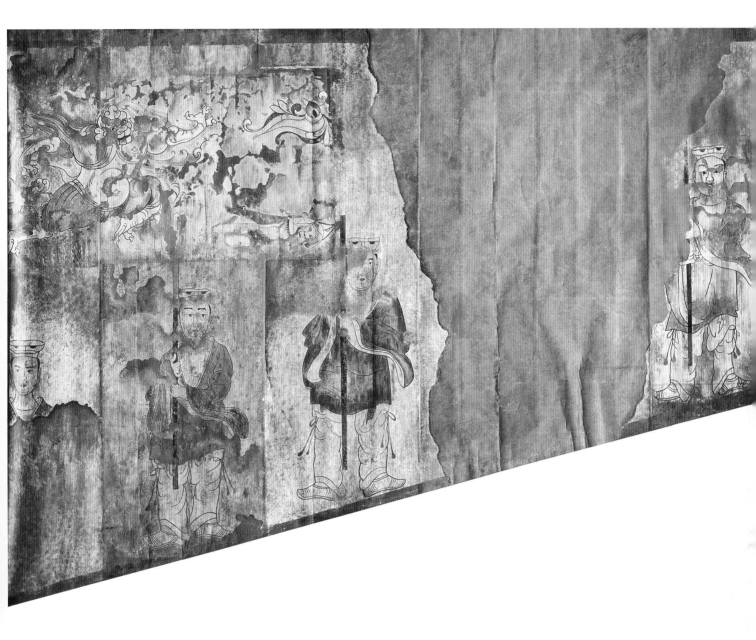

27.神兽和仪仗人物（摹本）

东魏武定八年（550年）

人物高约180厘米

1976年河北省磁县大冢营村茹茹公主墓出土。原址保存。摹本现存于河北省文物研究所。

墓向190°。位于墓道东壁中部，下面是手持仪仗站立的人物，上面是天空中飞舞的莲花和奔腾的神兽。

（临摹：王定理、苑陵、薛玉川　撰文：郝建文　摄影：冯玲）

Mythical Animals and Ceremonial Guards (Replica)

8th Year of Wuding Era, Eastern Wei (550 CE)

Figure height ca. 180 cm

Unearthed from the tomb of Princess Ruru at Dazhongyingcun in Cixian, Hebei, in 1976. Preserved on the original site. Its copy is in Cultural Relics Institute of Hebei Province.

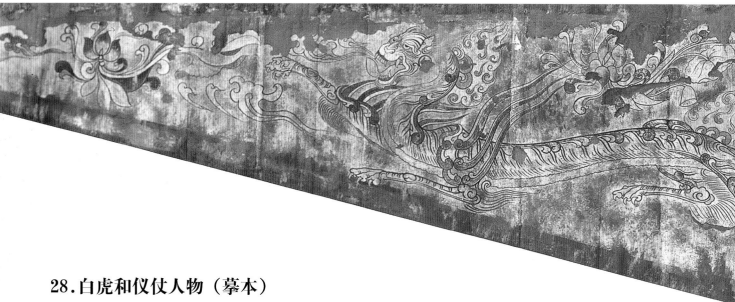

28. 白虎和仪仗人物（摹本）

东魏武定八年（550年）

画幅长约1300厘米

1976年河北省磁县大冢营村茹茹公主墓出土。原址保存。摹本现存于河北省文物研究所。

墓向190°。位于墓道西壁。前面绘莲花纹和白虎。后面绘14人组成的仪卫行列，其中八人手持仪仗站立，六人持盾坐于戟架后，本图为墓道西壁壁画的部分画面。

（临摹：王定理、苑陵 撰文：郝建文 摄影：冯玲）

White Tiger and Ceremonial Guards (Replica)

8th Year of Wuding Era, Eastern Wei (550 CE)

Length ca. 1300 cm

Unearthed from the tomb of Princess Ruru at Dazhongyingcun in Cixian, Hebei, in 1976. Preserved on the original site. Its copy is in Cutural Relics Institute Hebei Province.

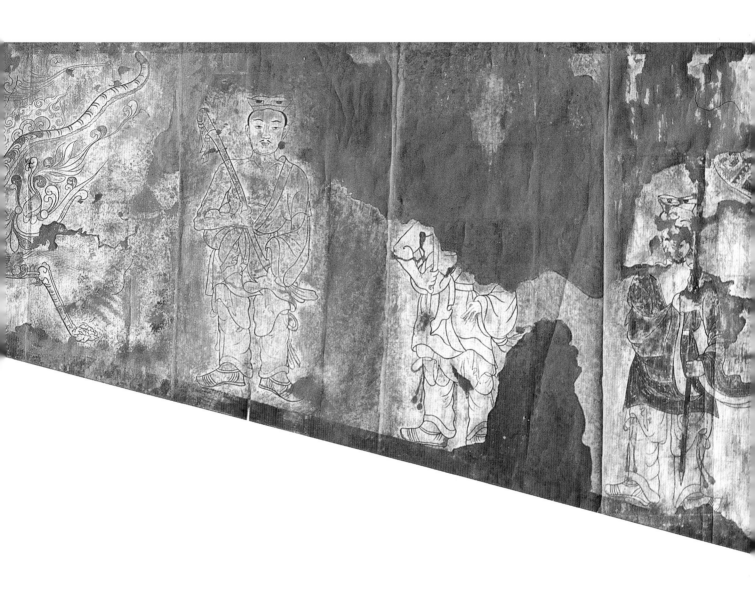

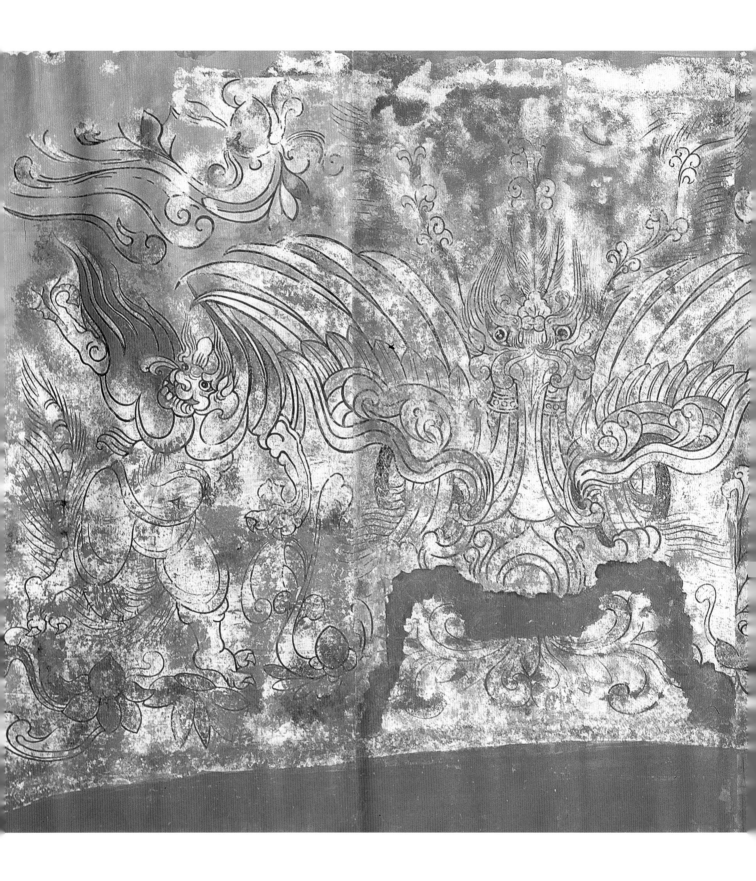

29.朱雀图（摹本）

东魏武定八年（550年）

高198、宽443厘米

1976年河北省磁县大冢营村茹茹公主墓出土。原址保存。摹本现存于河北省文物研究所。

墓向190°。位于甬道南端券拱上方。画面中部为一大朱雀的形象，口衔瑞草，颈佩绶带。其下方绘摩尼宝珠，两侧各绘一兽面人身、袒胸露腹的神兽。画面周围饰莲花纹和云纹。

（临摹：王定理、苑陵、薛玉川　撰文：郝建文　摄影：冯玲）

Scarlet Bird (Replica)

8th Year of Wuding Era, Eastern Wei (550 CE)

Height 198 cm ; Width 443 cm

Unearthed from the tomb of Princess Ruru at Dazhongyingcun in Cixian, Hebei, in 1976. Preserved on the original site. Its copy is in Cultural Relics Institute of Hebei Province.

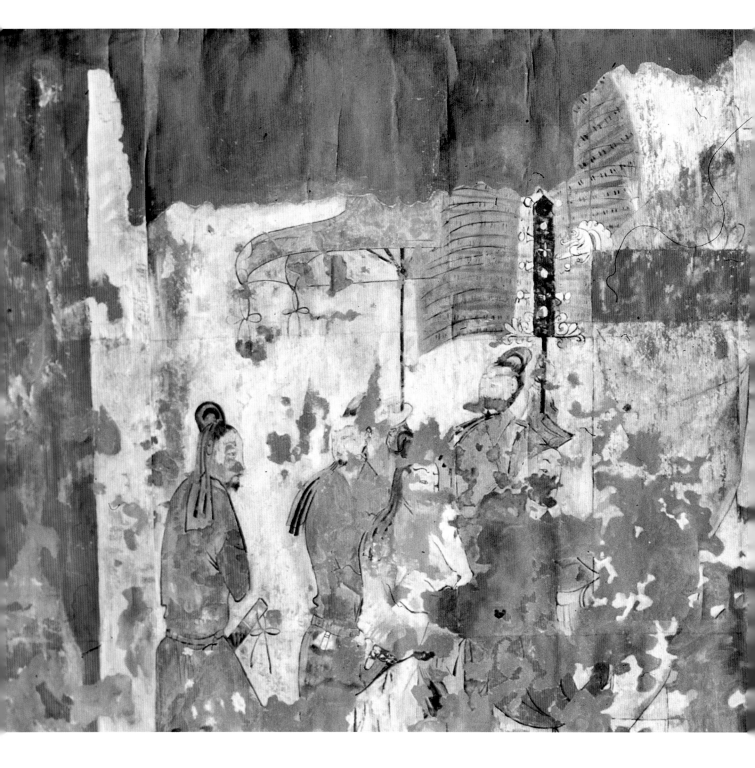

30.墓主人图（摹本）

北齐隆化元年（576年）

高285、宽645厘米

1975年河北省磁县东槐树村高润墓出土。原址保存。摹本现存于河北省文物研究所。

墓向188°。位于墓室北壁。壁画残损较为严重，但可看出墓主人端坐帷帐之中，两旁各绘六位男女侍从，男侍举羽葆、伞盖等，女侍似捧物。

<div align="right">（临摹：陆鸿年　撰文：郝建文　摄影：冯玲）</div>

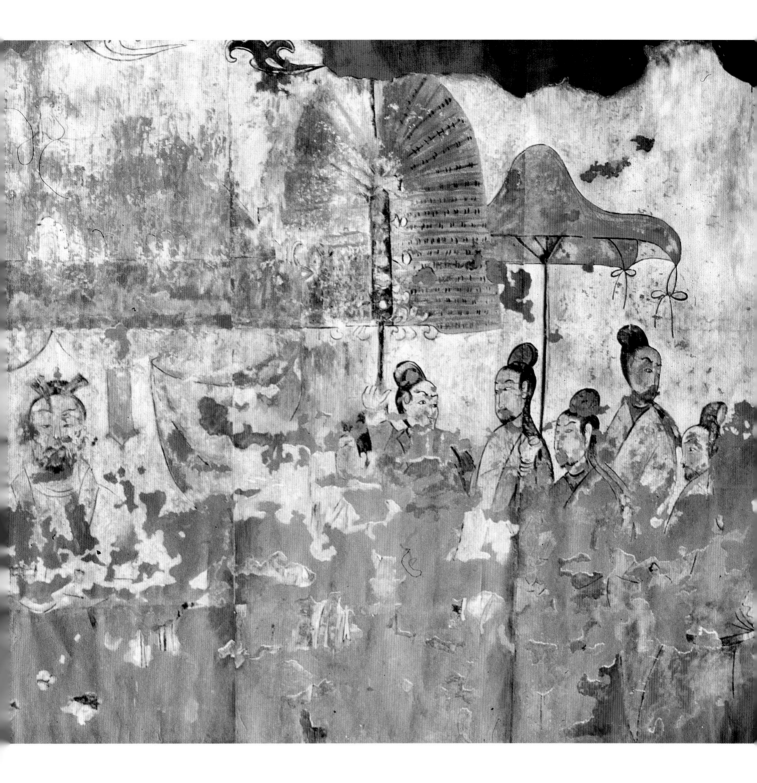

Portrait of Tomb Occupant (Replica)

1st Year of Longhua Era, Northern Qi (576 CE)

Height 285 cm; Width 645 cm

Unearthed from the tomb of Gao Run at Donghuaishucun in Cixian, Hebei, in 1975. Preserved on the original site. Its copy is in Cultural Relics Institute of Hebei Province.

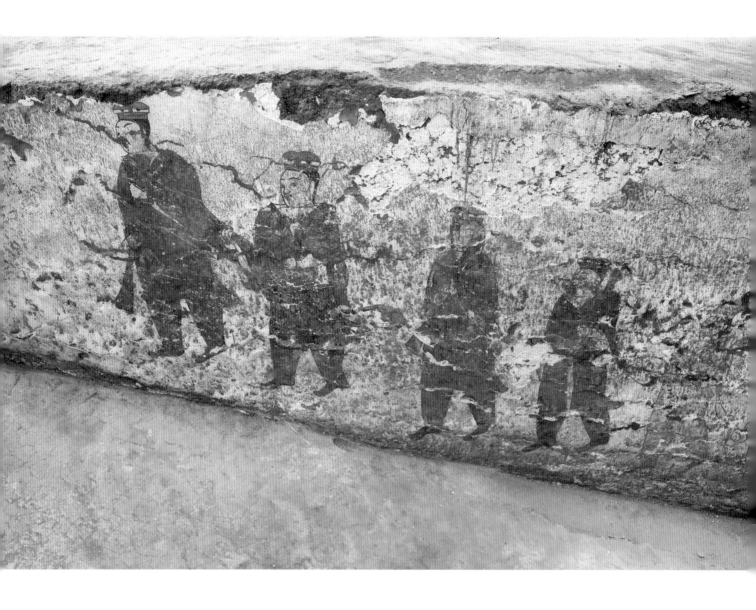

31. 仪仗人物（一）

北齐（550～577年）

高150～230、长220厘米

2009年河北省磁县刘庄村高孝绪墓出土。现存于磁县博物馆。

墓向194°。位于墓道西壁壁画得最前端。为墓道西壁第1～4仪仗人物，壁画残损严重。人物头戴红色平巾帻，上身穿红色右衽褶服，下着红色小口裤，脚穿黑色鞋，手执红色鼓吹。

（撰文：张晓峥　摄影：张小沧）

Ceremonial Guards (1)

Northern Qi (550-577 CE)

Height 150-230 cm; Length 220 cm

Unearthed from the tomb of Gao Xiaoxu at Liuzhuangcun in Cixian, Hebei, in 2009. Preserved in Cixian Museum.

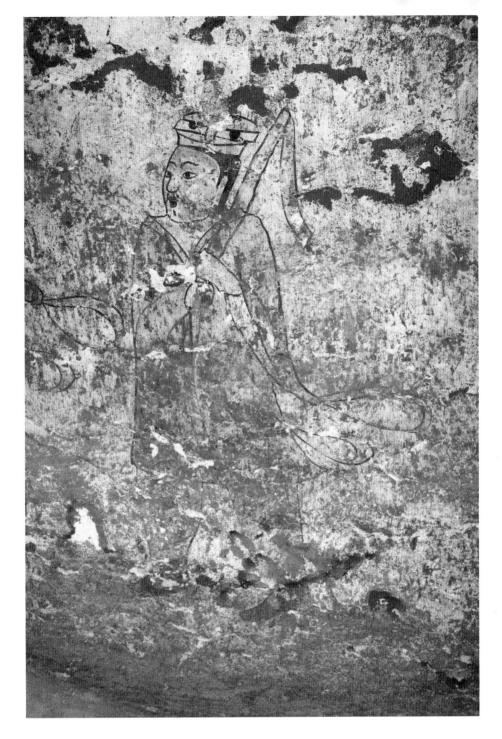

32. 仪仗人物（二）

北齐（550～577年）

高127、宽27厘米

2009年河北省磁县刘庄村高孝绪墓出土。现存于磁县博物馆。

墓向194°。为墓道西壁第7仪仗人物，壁画残损严重。人物头戴浅蓝色平巾帻，圆脸，细弯眉，朱唇微张，唇上留髭，唇下胡须点绘成一撮；上身穿浅蓝色右衽褶服，袖口系结，随风飘绕身后，下着浅蓝色小口裤，脚穿红色鞋，双手执仪仗置于左肩。

（撰文：张晓峥　摄影：张小沧）

Ceremonial Guards (2)

Northern Qi (550-577 CE)

Height 127 cm; Width 27 cm

Unearthed from the bomb of Gao Xiaoxu at Liuzhuangcun in Cixian, Hebei, in 2009. Preserved in Cixian Museum.

33. 仪仗人物（三）

北齐（550～577年）

高136、宽37厘米

2009年河北省磁县刘庄村高孝绪墓出土。现存于磁县博物馆。

墓向194°。为墓道东壁第9仪仗人物，壁画残损严重。人物头戴黑色软巾风帽，长条幅巾向下飘垂，长方脸，粗眉外展，高颧骨，阔口朱唇，唇上留髭，外撇呈"八"字形，唇下胡须点绘成一撮；身着红色对襟窄袖长袍，腰系带，带上装有缀饰，脚蹬黑色鞠靴，手持黑色旗杆，上飘彩色三旒旗。

（撰文：张晓峥　摄影：张小沧）

Ceremonial Guards (3)

Northern Qi (550-577 CE)

Height 136 cm; Width 37 cm

Unearthed from the tomb of Gao Xiaoxu at Liuzhuangcun in Cixian, Hebei, in 2009. Presered in Cixian Museum.

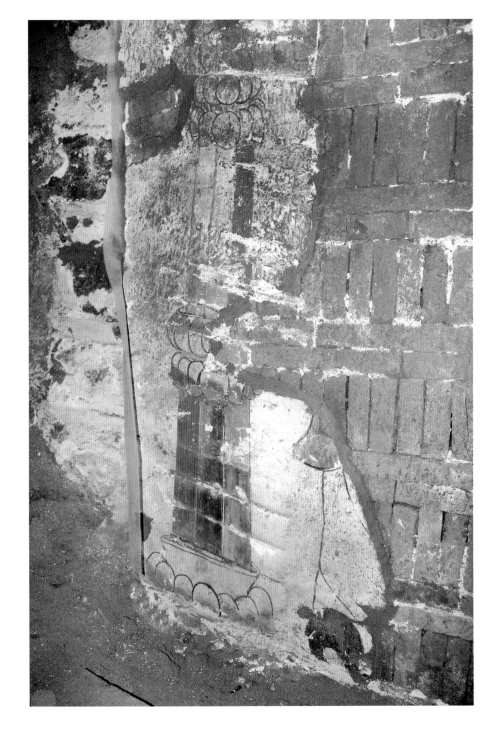

34. 束莲棱柱图案（一）

北齐（550～577年）

高156厘米

2009年河北省磁县刘庄村高孝绪墓出土。现存于磁县博物馆。

墓向194°。位于西侧甬道南侧，壁画残损较为严重。棱柱下为覆莲花柱础，棱柱为上、下两个八棱体组成，外露棱面分别涂红色、黑色和橘色，柱体之间用仰莲、覆莲纹衔接，上棱柱饰仰莲、覆莲纹，上托火焰纹宝珠，已残缺。

（撰文：张晓峥　摄影：张小沧）

Lotus Prism Pillar (1)

Northern Qi (550-577 CE)

Height 156 cm

Unearthed from the tomb of Gao Xiaoxu at Liuzhuangcun in Cixian, Hebei, in 2009. Preserved in Cixian Museum.

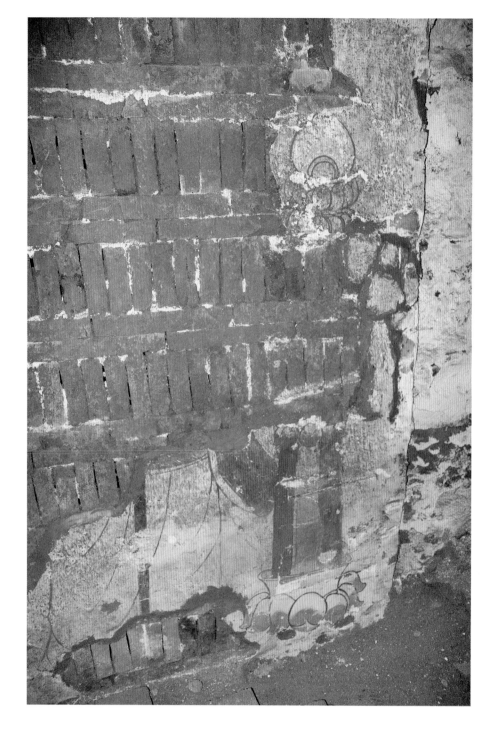

35.束莲棱柱图案（二）

北齐（550～577年）

高164厘米

2009年河北省磁县刘庄村高孝绪墓出土。现存于磁县博物馆。

墓向194°。位于东侧甬道南侧，壁画残损较为严重。棱柱下为覆莲花柱础，棱柱为上、下两个八棱体组成，外露棱面分别涂红色、黑色和橘色，柱体之间用仰莲、覆莲纹衔接，上棱柱残缺，仅存上托火焰纹宝珠。

（撰文：张晓峥　摄影：张小沧）

Lotus Prism Pillar (2)

Northern Qi (550-577 CE)

Height 164 cm

Unearthed from the tomb of Gao Xiaoxu at Liuzhuangcun in Cixian, Hebei, in 2009, Preserved in Cixian Museum.

36.仪仗队列人物（一）

北齐（550～577年）

人物身高142~151厘米

1989年河北省磁县湾漳村北朝壁画墓出土。现存于河北省文物研究所。

墓向185°。位于墓道东壁，是仪仗行列的第1~7人。东壁第1~4人构成整个仪仗队列的第一单元，4人分为两列两排。他们位居于外列。第一单元的4人位于东壁53人仪仗队列之首，成为仪仗行列的导引。第5~7人属于仪仗队列第二单元的一部分，其中第5人地位特殊。

<div align="right">（撰文：朱岩石　摄影：邺城考古队）</div>

Guards of Honor (1)

Northern Qi (550-577 CE)

Figures height 142-151 cm

Unearthed from the Northern dynasties painting tomb at Wanzhangcun in Cixian, Hebei, in 1989. Preserved in the Cultural Relics Institute of Hebei Province.

37.仪仗队列人物（一）（局部一）

北齐（550～577年）

人物通高约150厘米

1989年河北省磁县湾漳村北朝壁画墓出土。现存于河北省文物研究所。

墓向185°。位于墓道东壁，是仪仗行列的第3、4人局部。两人均手执仪仗，头戴帽。第3人回首，鼻略高，其半袖衣和帽均为暗红色；第4人上衣和帽则为朱红色。

<div align="right">（撰文：朱岩石　摄影：邺城考古队）</div>

Guards of Honor (1) (Detail 1)

Northern Qi (550-577 CE)

Figures height ca. 150 cm

Unearthed from the Northern dynasties painting tomb at Wanzhangcun in Cixian, Hebei, in 1989. Preserved in the Cultural Relics Institute of Hebei Province.

38. 仪仗队列人物（一）（局部二）

北齐（550～577年）

人物通高147厘米

1989年河北省磁县湾漳村北朝壁画墓出土。现存于河北省文物研究所。

墓向185°。位于墓道东壁，是仪仗队列第5人。该人物居于仪仗队列第二单元的首位，其服饰、仪仗有别于他人。头戴平巾帻，上身外披对襟袍服，内穿窄袖衣，下身穿白色大口裤，手执剑。形态刻划生动。

<div align="right">（撰文：朱岩石　摄影：邺城考古队）</div>

Guards of Honor (1) (Detail 2)

Northern Qi (550-577 CE)

Figures height 147 cm

Unearthed from the Northern dynasties painting tomb at Wanzhangcun in Cixian, Hebei, in 1989. Preserved in the Cultural Relics Institute of Hebei Province.

39.仪仗队列人物（二）

北齐（550～577年）

画面原壁宽度约348厘米

1989年河北省磁县湾漳村北朝壁画墓出土。现存于河北省文物研究所。

墓向185°。位于墓道东壁，是仪仗行列的第6～13人以及其上方天空神兽。东壁第5～15人构成整个仪仗队列的第二单元。外列共5人，即第6、8、10、12、14人，他们分执弓或盾，相间排列，其服饰类别相同。内列亦5人，即第7、9、11、13、15人，他们手执三种仪仗。内列人物的服饰类别与外列基本相同，唯东壁第13、15人外多披一件对襟袍服。仪仗队列上方天空有神兽和各色流云。

（撰文：朱岩石　摄影：邺城考古队）

Guards of Honor (2)

Northern Qi (550-577 CE)

Width ca. 348 cm

Unearthed from the Northern dynasties painting tomb at Wanzhangcun in Cixian, Hebei, in 1989. Preserved in the Cultural Relics Institute of Hebei Province.

40.仪仗队列人物（二）（局部一）

北齐（550～577年）

人物通高127~144厘米

1989年河北省磁县湾漳村北朝壁画墓出土。现存于河北省文物研究所。

墓向185°。位于墓道东壁，是仪仗行列的第8~13人。这些人物基本都是头戴帽，上身穿窄袖衣，下穿大口裤。其中第9人负鼓，第11人紧随其后作敲击状。第10人肩负大弓，手执盾牌的第12人紧随其后。

（撰文：朱岩石 摄影：邺城考古队）

Guards of Honor (2) (Detail 1)

Northern Qi (550-577 CE)

Figures height 127-144 cm

Unearthed from the Northern dynasties painting tomb at Wanzhangcun in Cixian, Hebei, in 1989. Preserved in the Cultural Relics Institute of Hebei Province.

41.仪仗队列人物（二）（局部二）

北齐（550～577年）

人物通高127~144厘米

1989年河北省磁县湾漳村北朝壁画墓出土。现存于河北省文物研究所。

墓向185°。位于墓道东壁，是仪仗行列的第10~13人。其中的第11人衣帽均为暗红色，右手执红色鼓槌作敲击状；第12人身着朱红色衣帽，右手执盾牌；第13人头戴风帽，回首凝望。

（撰文：朱岩石　摄影：邺城考古队）

Guards of Honor (2) (Detail 2)

Northern Qi (550-577 CE)

Figures height 127-144 cm

Unearthed from the Northern dynasties painting tomb at Wanzhangcun in Cixian, Hebei, in 1989. Preserved in the Cultural Relics Institute of Hebei Province.

42. 仪仗队列人物（三）

北齐（550~577年）

人物通高136~144厘米

1989年河北省磁县湾漳村北朝壁画墓出土。现存于河北省文物研究所。

墓向185°。位于墓道东壁，是仪仗行列的第13~15人。其中第13、15人服饰类别基本一致，颜色有所区别，均头戴风帽，上身外披对襟袍服，内穿窄袖衣。

<div align="right">（撰文：朱岩石　摄影：邺城考古队）</div>

Guards of Honor (3)

Northern Qi (550-577 CE)

Figures height 136-144 cm

Unearthed from the Northern dynasties painting tomb at Wanzhangcun in Cixian, Hebei, in 1989. Preserved in the Cultural Relics Institute of Hebei Province.

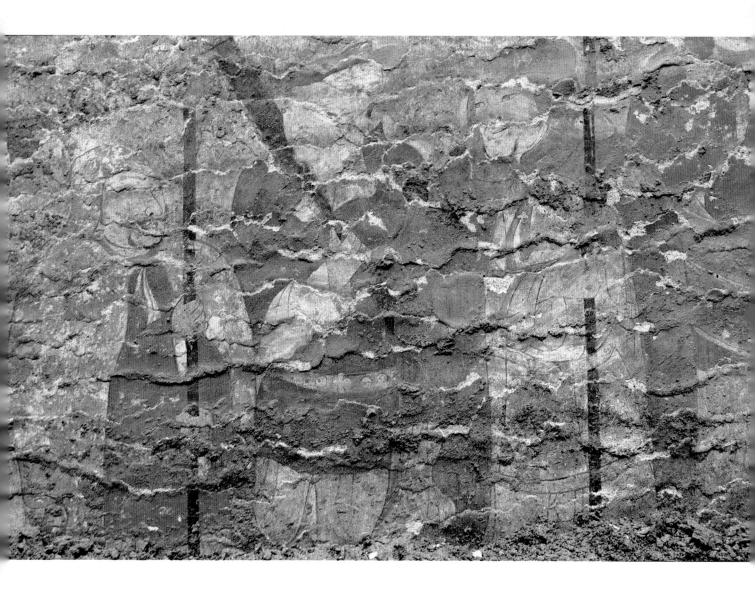

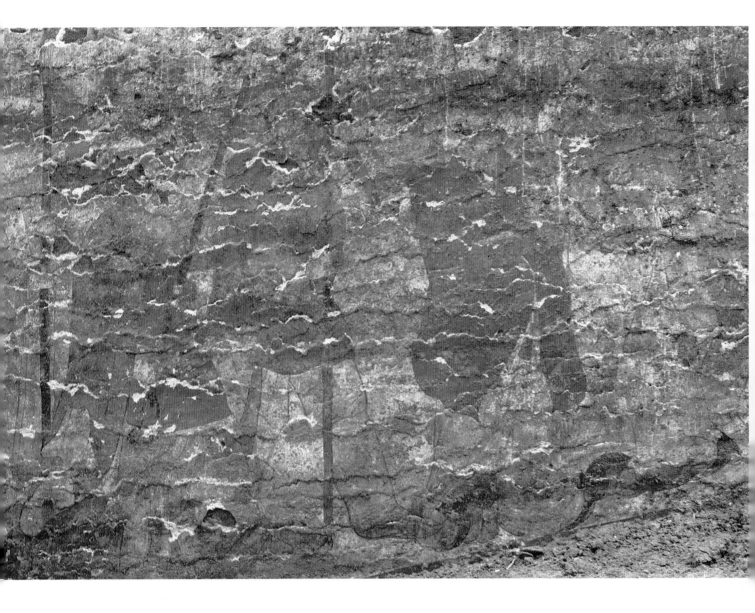

43.仪仗队列人物（四）

北齐（550～577年）

人物身高151~154厘米

1989年河北省磁县湾漳村北朝壁画墓出土。现存于河北省文物研究所。

墓向185°。位于墓道东壁，是仪仗行列的第16~19人。这四个人物构成了仪仗行列的第三单元。从透视关系看，这四个人物两排两列。前排的第16、17人手执笏板，身着褶服；第18、19人手执的仪仗分别为兽面幡旗和仪剑。

（撰文：朱岩石 摄影：邺城考古队）

Guards of Honor (4)

Northern Qi (550-577 CE)

Figures height 151-154 cm

Unearthed from the Northern dynasties painting tomb at Wanzhangcun in Cixian, Hebei, in 1989. Preserved in the Cultural Relics Institute of Hebei Province.

44. 仪仗队列人物（五）

北齐（550～577年）

人物通高150~164厘米

1989年河北省磁县湾漳村北朝壁画墓出土。现存于河北省文物研究所。

墓向185°。位于墓道东壁，是仪仗行列的第21~28人。东壁仪仗行列的第四单元总计4人，由东壁第20~23人组成，为两列两排。每人各执一种高大的卤簿仪仗，类别属皇帝专用，是整个仪仗队列最重要的部分。第24~30人组成东壁仪仗行列的第五单元，均上衣下裳。

（撰文：朱岩石　摄影：邺城考古队）

Guards of Honor (5)

Northern Qi (550-577 CE)

Figures height 150-164 cm

Unearthed from the Northern dynasties painting tomb at Wanzhangcun in Cixian, Hebei, in 1989. Preserved in the Cultural Relics Institute of Hebei Province.

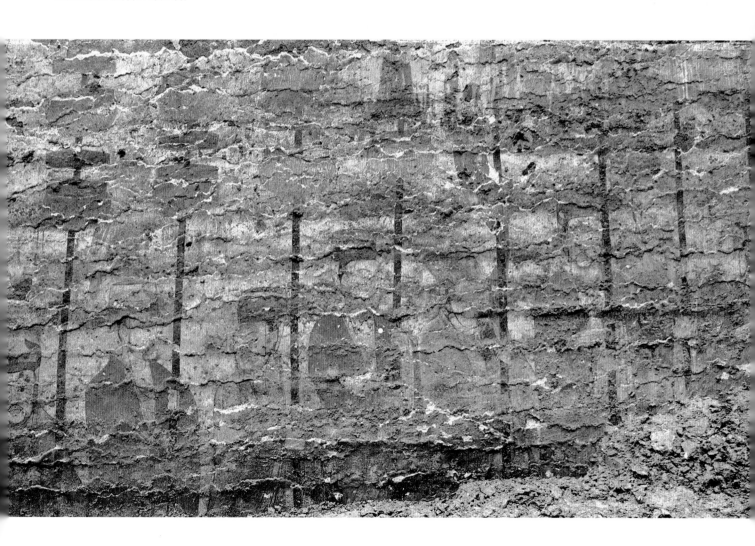

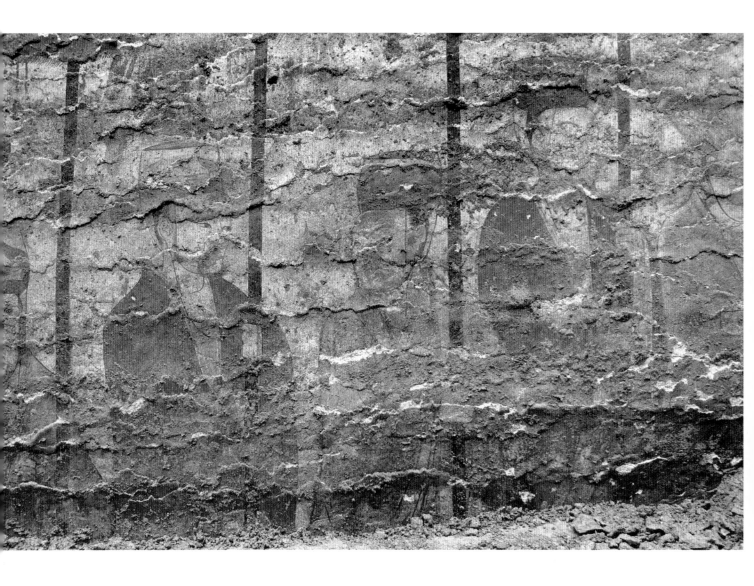

45. 仪仗队列人物（五）（局部）

北齐（550～577年）

人物通高158~163厘米

1989年河北省磁县湾漳村北朝壁画墓出土。现存于河北省文物研究所。

墓向185°。位于墓道东壁，是仪仗行列的第25~27人。这四个人物均头戴漆纱笼冠，内戴平巾帻，身着上衣下裳的深衣，束大带。手执节，表情凝重。

（撰文：朱岩石　摄影：邺城考古队）

Guards of Honor (5) (Detail)

Northern Qi (550-577 CE)

Figures height 158-163 cm

Unearthed from the Northern dynasties painting tomb at Wanzhangcun in Cixian, Hebei, in 1989. Preserved in the Cultural Relics Institute of Hebei Province.

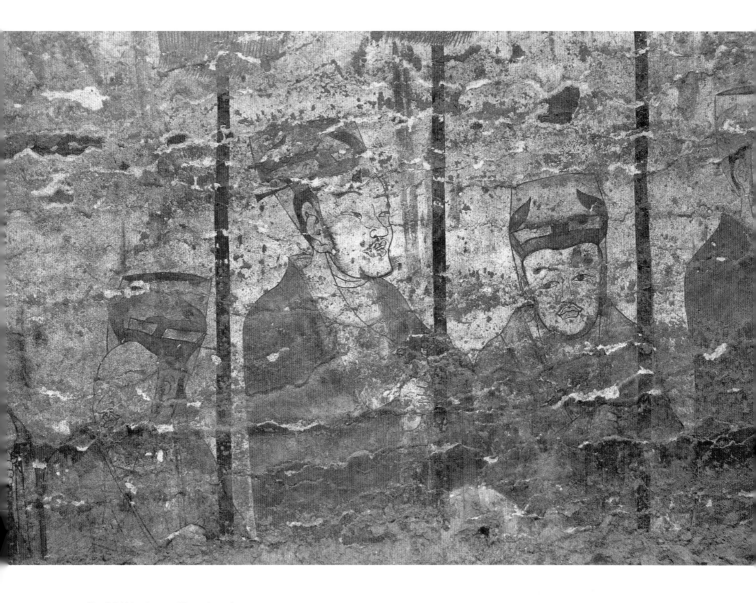

46.仪仗队列人物（六）

北齐（550～577年）

人物身高164～176厘米

1989年河北省磁县湾漳村北朝壁画墓出土。现存于河北省文物研究所。

墓向185°。位于墓道东壁，是仪仗行列的第28～30人。仪仗队列第五单元中的最后三人，均手执节。其服饰类别一致，头戴漆纱笼冠，身着上衣下裳的深衣。每个人物的形象性格鲜明，十分写实。

（撰文：朱岩石　摄影：邺城考古队）

Guards of Honor (6)

Northern Qi (550-577 CE)

Figures height 164-176 cm

Unearthed from the Northern dynasties painting tomb at Wanzhangcun in Cixian, Hebei, in 1989. Preserved in the Cultural Relics Institute of Hebei Province.

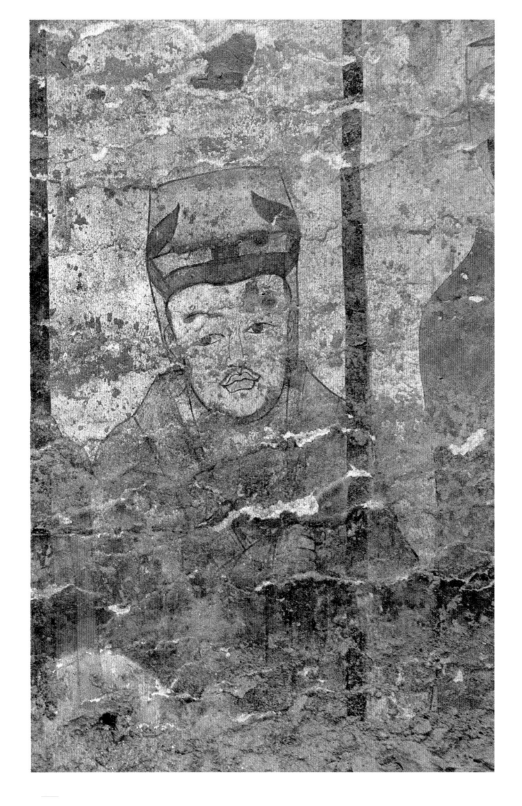

47. 仪仗队列人物（六）（局部）

北齐（550～577年）

1989年河北省磁县湾漳村北朝壁画墓出土。现存于河北省文物研究所。

墓向185°。位于墓道东壁，是仪仗行列的第28~30人。仪仗队列第五单元中的最后三人，均手执节。其服饰类别一致，头戴漆纱笼冠，身着上衣下裳的深衣。每个人物的形象性格鲜明，十分写实。此为东壁仪仗队列第28人的局部。

（撰文：朱岩石　摄影：邺城考古队）

Guards of Honor (6) (Detail)

Northern Qi (550-577 CE)

Unearthed from the Northern dynasties painting tomb at Wanzhangcun in Cixian, Hebei, in 1989. Preserved in the Cultural Relics Institute of Hebei Province.

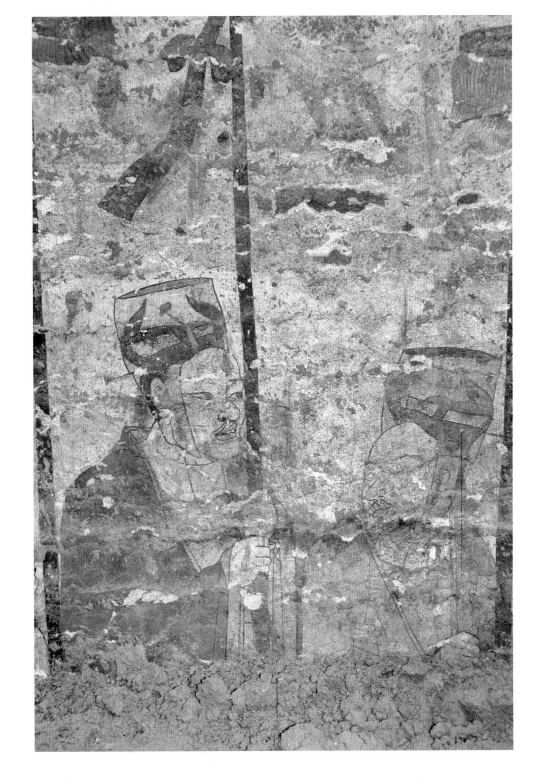

48. 仪仗队列人物 （七）

北齐（550～577年）

两人物身高分别为173.6、174.9厘米

1989年河北省磁县湾漳村北朝壁画墓出土。现存于河北省文物研究所。

墓向185°。位于墓道东壁，是仪仗行列的第30、31人上半身。其中第31人手执的仪仗为系带长戟，戟杆较长，达317.5厘米；其头戴漆纱笼冠、平巾帻、朱红色衣裳。第30人回首张望，鼻子略高。

（撰文：朱岩石　摄影：邺城考古队）

Guards of Honor (7)

Northern Qi (550-577 CE)

Figures height 173.6 cm and 174.9 cm

Unearthed from the Northern dynasties painting tomb at Wanzhangcun in Cixian, Hebei, in 1989. Preserved in the Cultural Relics Institute of Hebei Province.

49.仪仗队列人物（八）

北齐（550～577年）

四人执仗高达331~344厘米

1989年河北省磁县湾漳村北朝壁画墓出土。现存于河北省文物研究所。
墓向185°。位于墓道东壁，是仪仗行列的第30~33人上半身或头部以及所
执仪仗。其中第31~33人分别手执的仪仗为高大的戟、槊，并系有旌幡。

（撰文：朱岩石　摄影：邺城考古队）

Guards of Honor (8)

Northern Qi (550-577 CE)

Ceremonial sticks height 331-344 cm

Unearthed from the Northern dynasties painting
tomb at Wanzhangcun in Cixian, Hebei, in 1989.
Preserved in the Cultural Relics Institute of
Hebei Province.

50.仪仗用具（一）

北齐（550～577年）

画面宽约330厘米

1989年河北省磁县湾漳村北朝壁画墓出土。现存于河北省文物研究所。

墓向185°。位于墓道东壁，是仪仗行列的第39、41~43、45人所执仪仗的上半部，仪仗上方的天空中飘舞有各色祥云和忍冬莲花。

（撰文：朱岩石　摄影：邺城考古队）

Ceremonial Appliances (1)

Northern Qi (550-577 CE)

Width ca. 330 cm

Unearthed from the Northern dynasties painting tomb at Wanzhangcun in Cixian, Hebei, in 1989. Preserved in the Cultural Relics Institute of Hebei Province.

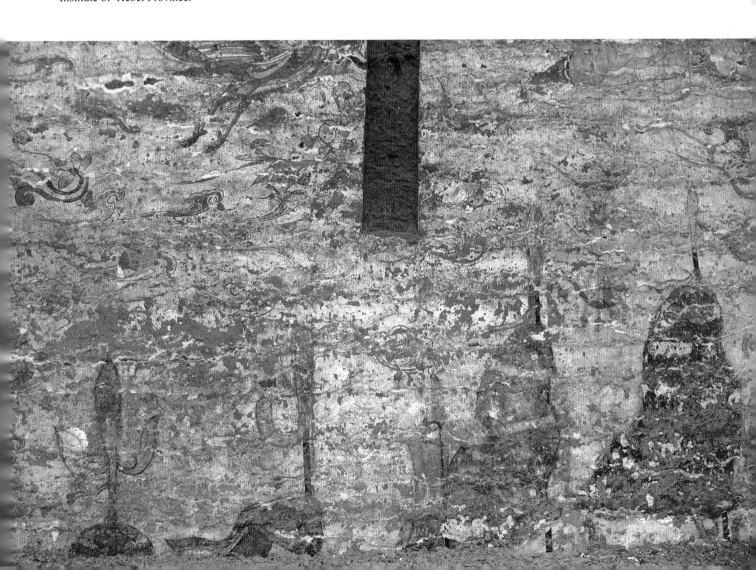

51. 仪仗队列人物（九）

北齐（550～577年）

两人物身高约170厘米

1989年河北省磁县湾漳村北朝壁画墓出土。现存于河北省文物研究所。

墓向185°。位于墓道东壁，是仪仗行列的第40、41人上半身。由于长期深埋，壁画颜色发生改变，如第40人身着的深衣原为红色，但现几乎变成黑色。

<div align="right">（撰文：朱岩石　摄影：邺城考古队）</div>

Guards of Honor (9)

Northern Qi (550-577 CE)

Figures height ca. 170 cm

Unearthed from the Northern dynasties painting tomb at Wanzhangcun in Cixian, Hebei, in 1989. Preserved in the Cultural Relics Institute of Hebei Province.

52.仪仗队列人物（十）

北齐（550～577年）

画面宽约190厘米

1989年河北省磁县湾漳村北朝壁画墓出土。现存于河北省文物研究所。

墓向185°。位于墓道东壁，是仪仗行列的第41～44人上半身或头部，壁画下半部发生黑灰色变化。其中第42人为身着甲胄的武将，正回首注目；第43人头戴平巾帻，手执的仪仗为一柄长戟，上系兽头幡。

（撰文：朱岩石　摄影：邺城考古队）

Guards of Honor (10)

Northern Qi (550-577 CE)

Width ca. 190 cm

Unearthed from the Northern dynasties painting tomb at Wanzhangcun in Cixian, Hebei, in 1989. Preserved in the Cultural Relics Institute of Hebei Province.

53.仪仗队列人物（十一）

北齐（550～577年）

画面宽约170厘米

1989年河北省磁县湾漳村北朝壁画墓出土。现存于河北省文物研究所。

墓向185°。位于墓道东壁，是仪仗行列的第49、50人的局部。东壁仪仗行列的第七单元总计五人，由东第49~53人组成，均站立在兵栏之后、廊庑式建筑之前。

<div align="right">（撰文：朱岩石　摄影：邺城考古队）</div>

Guards of Honor (11)

Northern Qi (550-577 CE)

width ca. 170 cm

Unearthed from the Northern dynasties painting tomb at Wanzhangcun in Cixian, Hebei, in 1989. Preserved in the Cultural Relics Institute of Hebei Province.

54. 仪仗队列人物（十二）

北齐（550～577年）

画面宽约170厘米

1989年河北省磁县湾漳村北朝壁画墓出土。现存于河北省文物研究所。

墓向185°。位于墓道东壁，是仪仗行列的第50、51人的上半身。两人站立于兵栏的横木之后，双手按仪剑，身前立仪仗。两人均头戴帽，上身外披对襟袍服，内穿窄袖衣，腰系革带。第50人帽、袍为白色，第51人则为朱红色。

（撰文：朱岩石　摄影：邺城考古队）

Guards of Honor (12)

Northern Qi (550-577 CE)

Width ca. 170 cm

Unearthed from the Northern dynasties painting tomb at Wanzhangcun in Cixian, Hebei, in 1989. Preserved in the Cultural Relics Institute of Hebei Province.

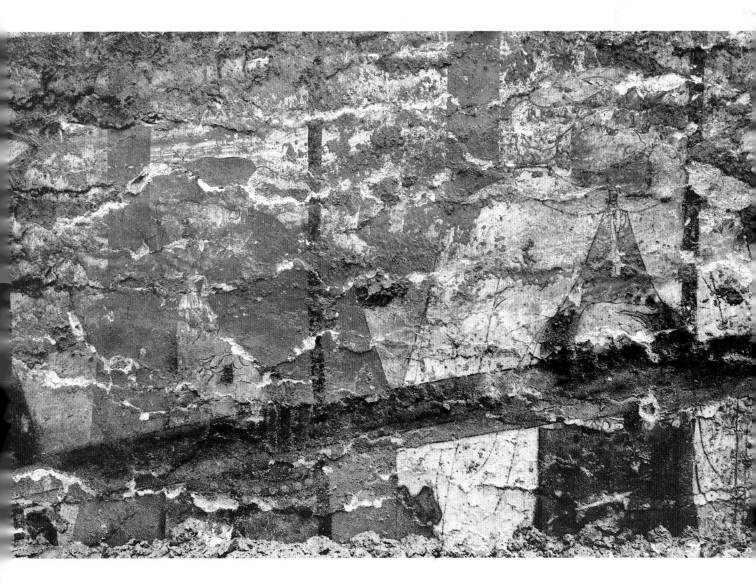

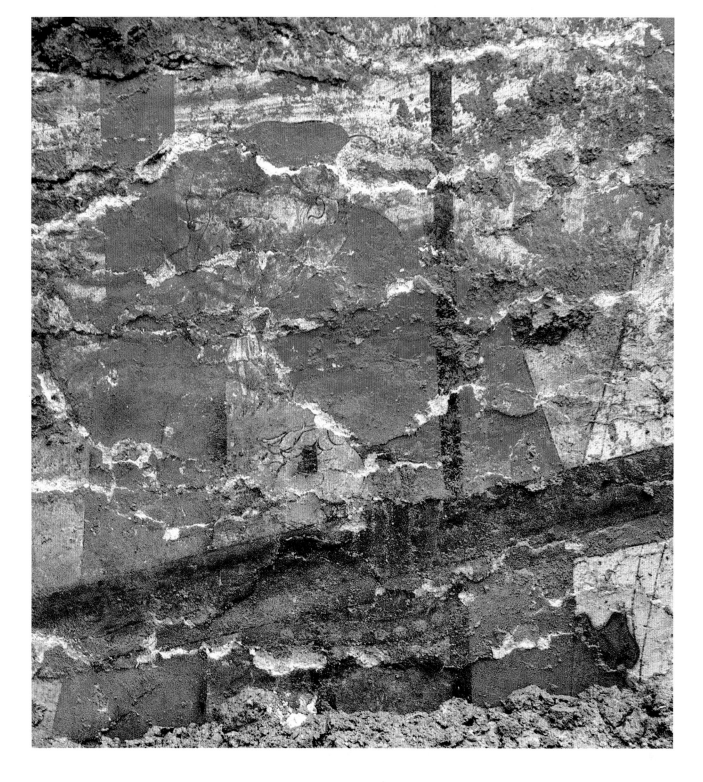

55. 仪仗队列人物（十二）（局部）

北齐（550～577年）

1989年河北省磁县湾漳村北朝壁画墓出土。现存于河北省文物研究所。

墓向185°。位于墓道东壁，是仪仗行列的第51人。其头戴朱红色帽，帽裙挽于脑后，里衬白色，外披朱红色对襟袍服，袍服里衬现为黑灰色，大圆翻领，领口系带，两袖空垂，腰束革带，上有带扣、带孔，下穿大口裤。

（撰文：朱岩石　摄影：邺城考古队）

Guards of Honor (12) (Detail)

Northern Qi (550-577 CE)

Unearthed from the Northern dynasties painting tomb at Wanzhangcun in Cixian, Hebei, in 1989. Preserved in the Cultural Relics Institute of Hebei Province.

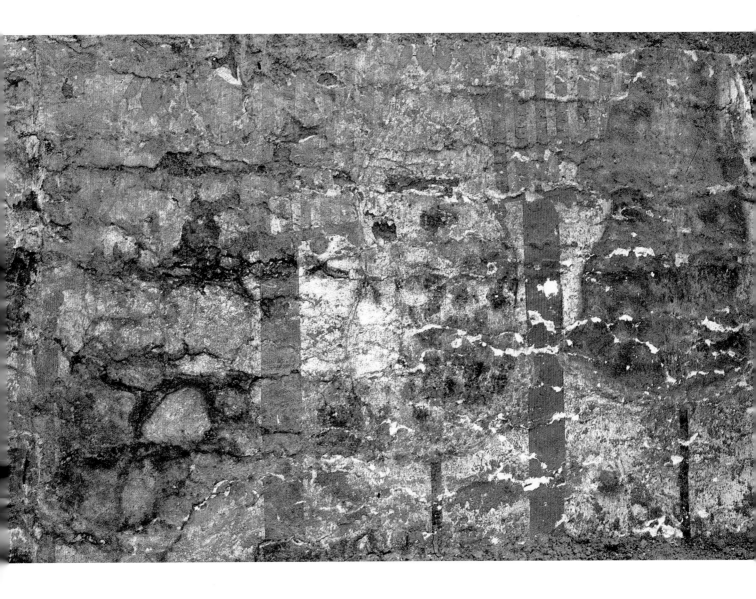

56.仪仗用具（二）

北齐（550～577年）

画面宽度约230厘米

1989年河北省磁县湾漳村北朝壁画墓出土。现存于河北省文物研究所。

墓向185°。位于墓道东壁，是仪仗行列的第49~51人手执仪仗的上半部。仪仗之后有红柱茸瓦建筑。

（撰文：朱岩石　摄影：邺城考古队）

Ceremonial Appliances (2)

Northern Qi (550-577 CE)

Width ca. 230 cm

Unearthed from the Northern dynasties painting tomb at Wanzhangcun in Cixian, Hebei, in 1989. Preserved in the Cultural Relics Institute of Hebei Province.

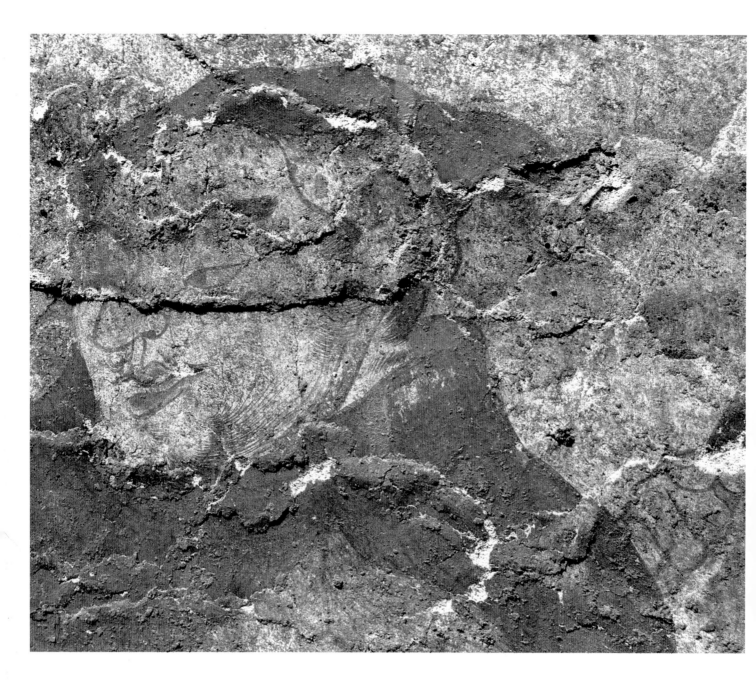

57.仪仗队列人物（十三）

北齐（550～577年）

1989年河北省磁县湾漳村北朝壁画墓出土。现存于河北省文物研究所。

墓向185°。位于墓道西壁，是仪仗行列的第10人的局部。其头戴暗红色帽，帽裙挽系于脑后，上身穿暗红色半袖衣，立领。其须发绘制飘逸，口唇的红色晕染技法清晰可辨。

<div align="right">（撰文：朱岩石　摄影：邺城考古队）</div>

Guard of Honor (13)

Northern Qi (550-577 CE)

Unearthed from the Northern dynasties painting tomb at Wanzhangcun in Cixian, Hebei, in 1989. Preserved in the Cultural Relics Institute of Hebei Province.

58.仪仗队列人物（十四）

北齐（550～577年）

人物原身高约140厘米

1989年河北省磁县湾漳村北朝壁画墓出土。现存于河北省文物研究所。

墓向185°。位于墓道西壁，是仪仗行列的第12人的上半身。其头戴暗红色帽，上身着暗红色半袖衣，右手执盾，左手执仪剑。该人物的眉须绘制一丝不苟，鼻子略高，口唇勾画生动。

（撰文：朱岩石　摄影：邺城考古队）

Guard of Honor (14)

Northern Qi (550-577 CE)

Figure height ca. 140 cm

Unearthed from the Northern dynasties painting tomb at Wanzhangcun in Cixian, Hebei, in 1989. Preserved in the Cultural Relics Institute of Hebei Province.

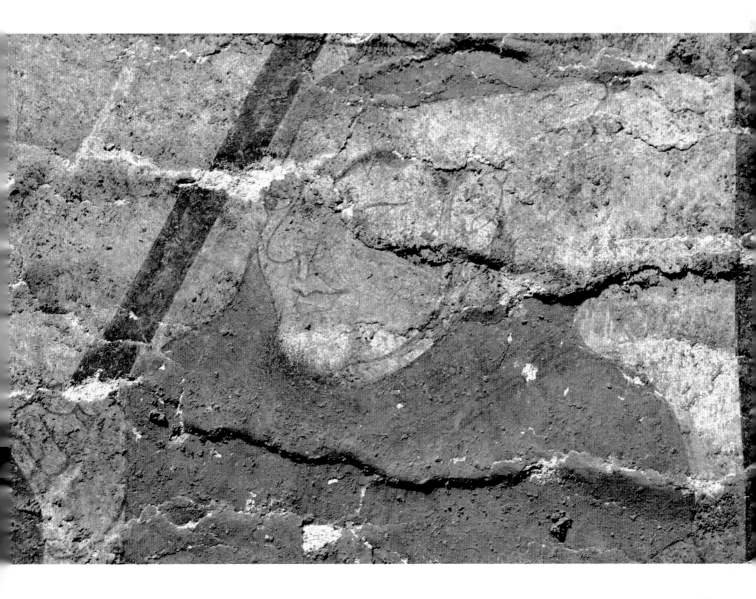

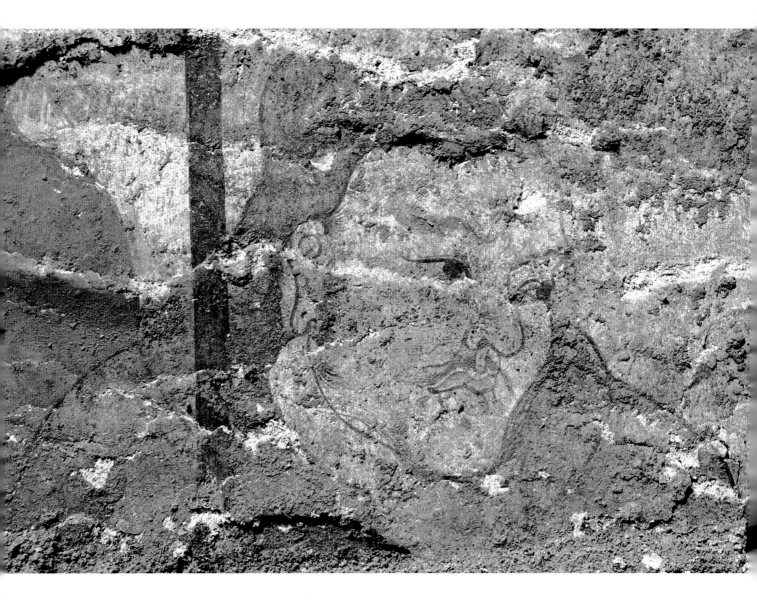

59. 仪仗队列人物（十五）

北齐（550~577年）

人物身高约152厘米

1989年河北省磁县湾漳村北朝壁画墓出土。现存于河北省文物研究所。

墓向185°。位于墓道西壁，是仪仗行列的第13人的局部。其头戴暗青灰色帽，帽裙盖耳至肩，上身外披暗青灰色对襟袍服，大圆翻领，领口系带。此人物形象表现了在徐徐前行的仪仗行列中回首凝眸的瞬间，该人两眉紧蹙，目光悲戚，双唇紧闭，堪称北朝壁画人物之佳作。

（撰文：朱岩石　摄影：邺城考古队）

Guard of Honor (15)

Northern Qi (550-577 CE)

Figure height ca. 152 cm

Unearthed from the Northern dynasties painting tomb at Wanzhangcun in Cixian, Hebei, in 1989. Preserved in the Cultural Relics Institute of Hebei Province.

60. 仪仗队列人物（十六）

北齐（550~577年）

人物身高134~145厘米

1989年河北省磁县湾漳村北朝壁画墓出土。现存于河北省文物研究所。

墓向185°。位于墓道西壁，是仪仗行列的第15~17人的上半身。其中第16、17人头戴平巾帻，上身着褶服，下穿大口裤，双手执笏板。

（撰文：朱岩石　摄影：邺城考古队）

Guards of Honor (16)

Northern Qi (550-577 CE)

Figures height 134-145 cm

Unearthed from the Northern dynasties painting tomb at Wanzhangcun in Cixian, Hebei, in 1989. Preserved in the Cultural Relics Institute of Hebei Province.

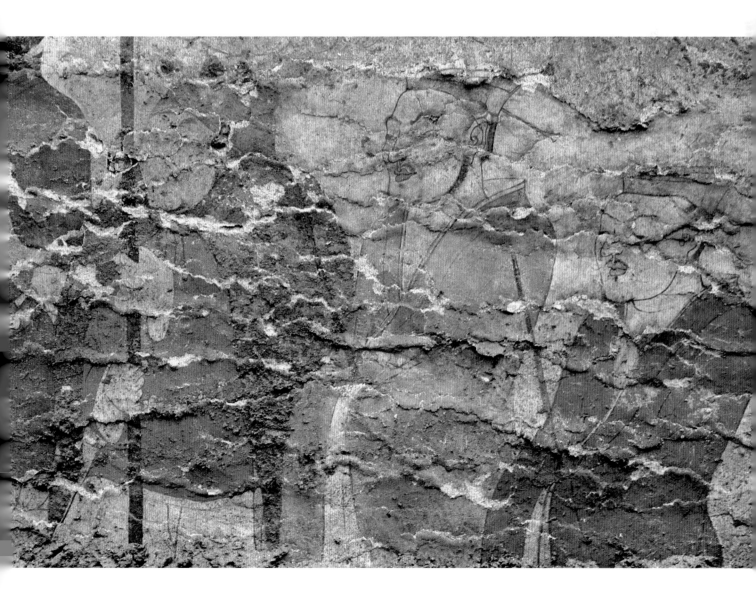

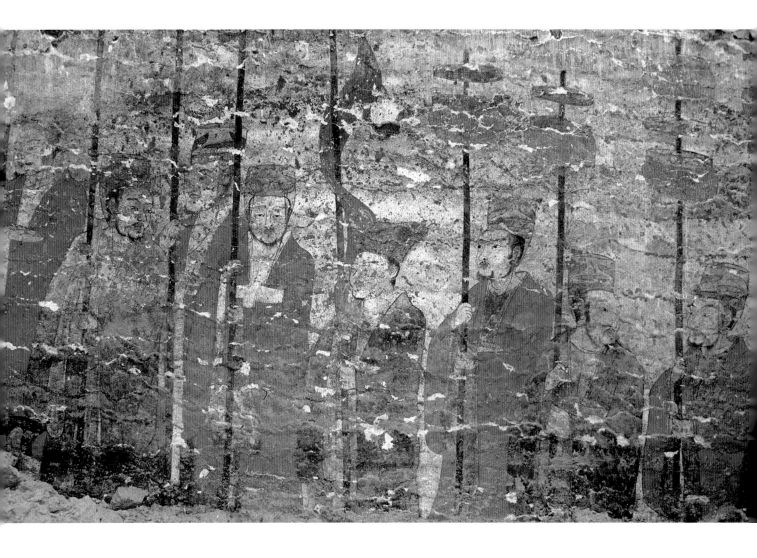

61.仪仗队列人物（十七）

北齐（550～577年）

人物身高161~181厘米

1989年河北省磁县湾漳村北朝壁画墓出土。现存于河北省文物研究所。

墓向185°。位于墓道西壁，是仪仗行列的第20~27人。西壁第20~23人属于仪仗行列的第四单元，他们各执一类高大的卤簿仪仗，类别属皇帝专用，是西壁仪仗队列的重心，其服饰为头戴笼冠、平巾帻，身穿上衣下裳的深衣。第24~27人属西壁仪仗行列的第五单元。

（撰文：朱岩石　摄影：邺城考古队）

Guards of Honor (17)

Northern Qi (550-577 CE)

Figures height 161-181 cm

Unearthed from the Northern dynasties painting tomb at Wanzhangcun in Cixian, Hebei, in 1989. Preserved in the Cultural Relics Institute of Hebei Province.

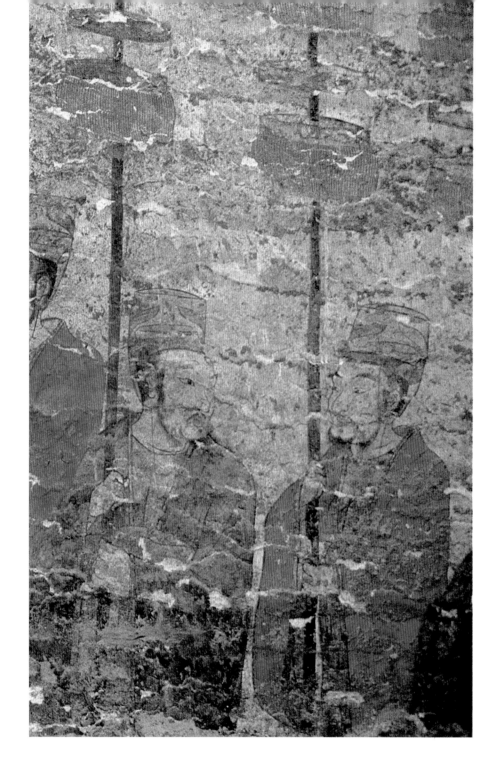

62.仪仗队列人物（十七）（局部一）

北齐（550～577年）

1989年河北省磁县湾漳村北朝壁画墓出土。现存于河北省文物研究所。

墓向185°。位于墓道西壁，是仪仗行列的第20~27人。西壁第20~23人属于仪仗行列的第四单元，他们各执一类高大的卤簿仪仗，类别属皇帝专用，是西壁仪仗队列的重心，其服饰为头戴笼冠、平巾帻，身穿上衣下裳的深衣。第24~27人属西壁仪仗行列的第五单元。此为前页图局部。

（撰文：朱岩石　摄影：邺城考古队）

Guards of Honor (17) (Detail 1)

Northern Qi (550-577 CE)

Unearthed from the Northern dynasties painting tomb at Wanzhangcun in Cixian, Hebei, in 1989. Preserved in the Cultural Relics Institute of Hebei Province.

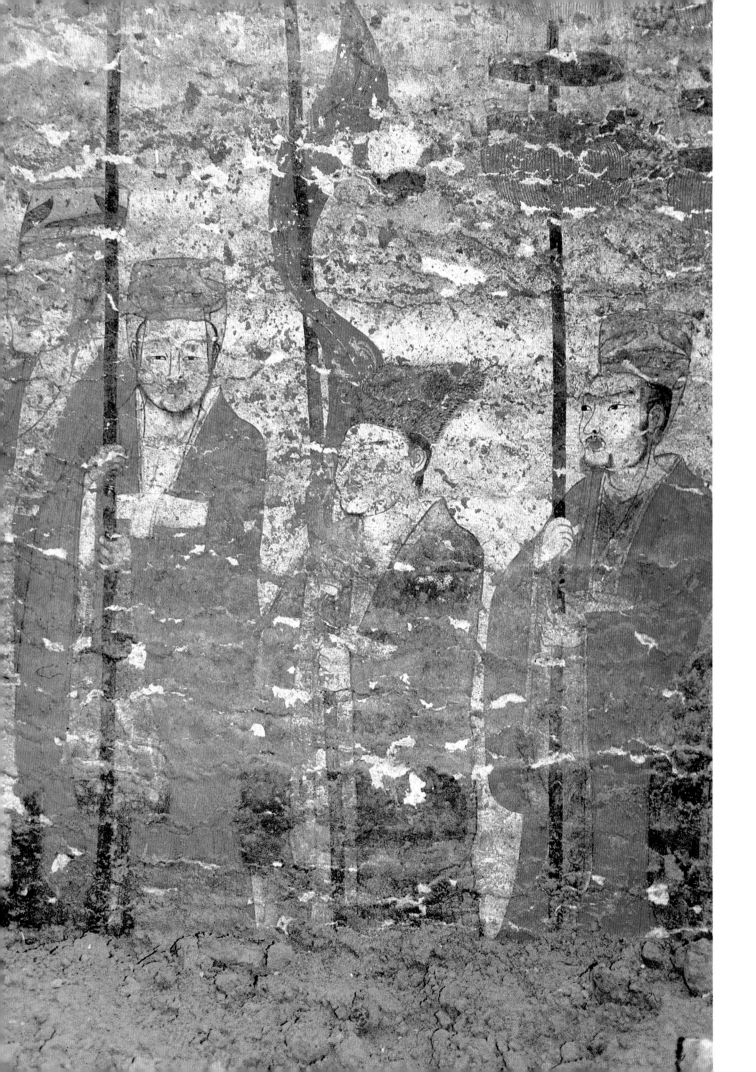

◀63.仪仗队列人物（十七）（局部二）

北齐（550～577年）

人物身高168~181厘米

1989年河北省磁县湾漳村北朝壁画墓出土。现存于河北省文物研究所。墓向185°。位于墓道西壁，是仪仗行列的第22~25人。西壁仪仗行列的第五单元由第24~30人组成，其服饰上衣下裳，其中的第24人为第五单元的第1人，其服饰和仪仗与他人不尽一致，其头戴皮质帽子，手执纛旌类仪仗，而第五单元的其他人均头戴笼冠，双手执节。

（撰文：朱岩石　摄影：邺城考古队）

▼64.仪仗用具（三）

北齐（550～577年）

画面宽约290厘米

1989年河北省磁县湾漳村北朝壁画墓出土。现存于河北省文物研究所。墓向185°。位于墓道西壁，是仪仗行列第35、37、39人所执仪仗。这种仪仗是高大的长槊，在槊头之下系有各色绣氅。

（撰文：朱岩石　摄影：邺城考古队）

Guards of Honor (17) (Detail 2)

Northern Qi (550-577 CE)

Figures height 161-181 cm

Unearthed from the Northern dynasties painting tomb at Wanzhangcun in Cixian, Hebei, in 1989. Preserved in the Cultural Relics Institute of Hebei Province.

Ceremonial Appliances (3)

Northern Qi (550-577 CE)

Width ca. 290 cm

Unearthed from the Northern dynasties painting tomb at Wanzhangcun in Cixian, Hebei, in 1989. Preserved in the Cultural Relics Institute of Hebei Province.

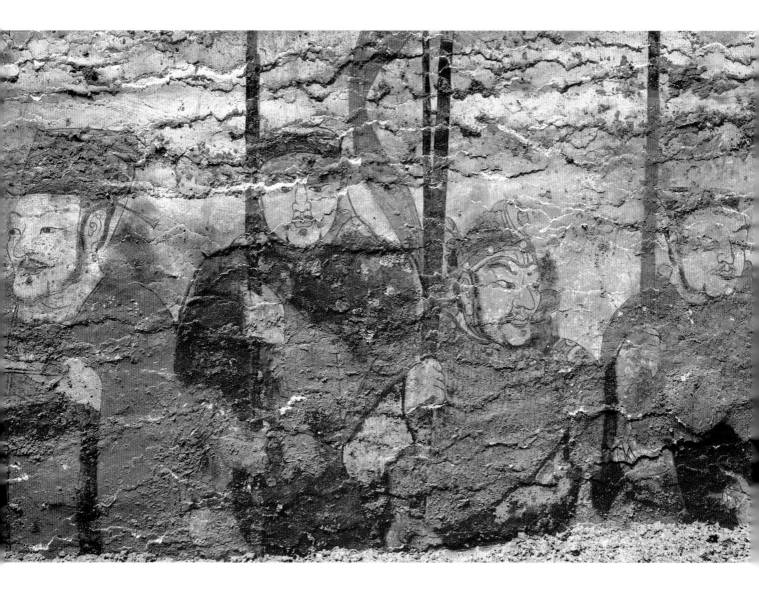

65. 仪仗队列人物（十八）

北齐（550～577年）

人物身高151～158厘米

1989年河北省磁县湾漳村北朝壁画墓出土。现存于河北省文物研究所。

墓向185°。位于墓道西壁，是仪仗行列的第40～43人上半身。第40人左手执手板，头戴笼冠、平巾帻，身着朱红色深衣。第42人为一武将，手握仪剑和幡旗。

<div align="right">（撰文：朱岩石　摄影：邺城考古队）</div>

Guards of Honor (18)

Northern Qi (550-577 CE)

Figures height 151-158 cm

Unearthed from the Northern dynasties painting tomb at Wanzhangcun in Cixian, Hebei, in 1989. Preserved in the Cultural Relics Institute of Hebei Province.

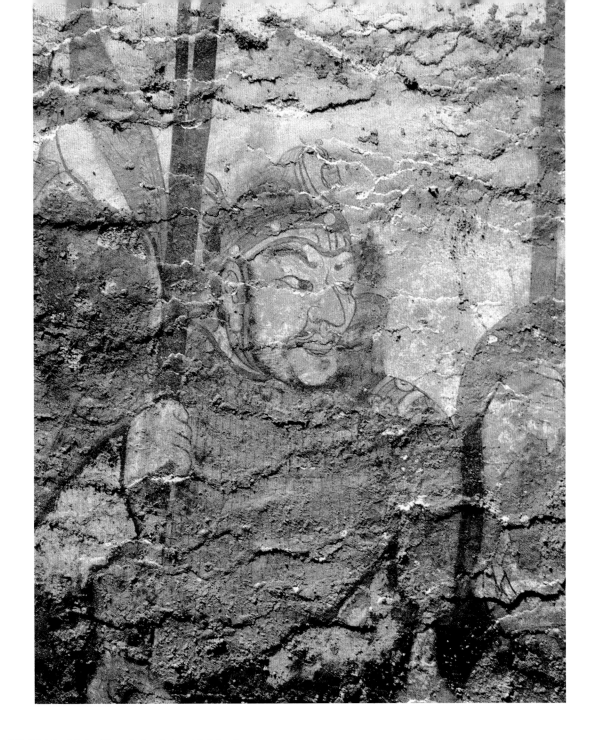

66.仪仗队列人物（十八）（局部）

北齐（550～577年）

人物身高158厘米

1989年河北省磁县湾漳村北朝壁画墓出土。现存于河北省文物研究所。

墓向185°。位于墓道西壁，是仪仗行列的第42人。其头戴鳞状甲片的护额，上身着两裆铠，两肩的扣带表现清晰，甲片自上而下约11排，颈部的护颈甲较高，两肩有披膊甲甲片。铠甲内穿窄袖衣。这名武将在行进中回首张望，神色庄严，剑眉紧蹙，高鼻高颧，口型较大，连鬓胡须虎虎生生，威武骠悍，是北朝壁画人物中罕见的佳作。

（撰文：朱岩石　摄影：邺城考古队）

Guards of Honor (18) (Detail)

Northern Qi (550-577 CE)

Figure height 158 cm

Unearthed from the Northern dynasties painting tomb at Wanzhangcun in Cixian, Hebei, in 1989. Preserved in the Cultural Relics Institute of Hebei Province.

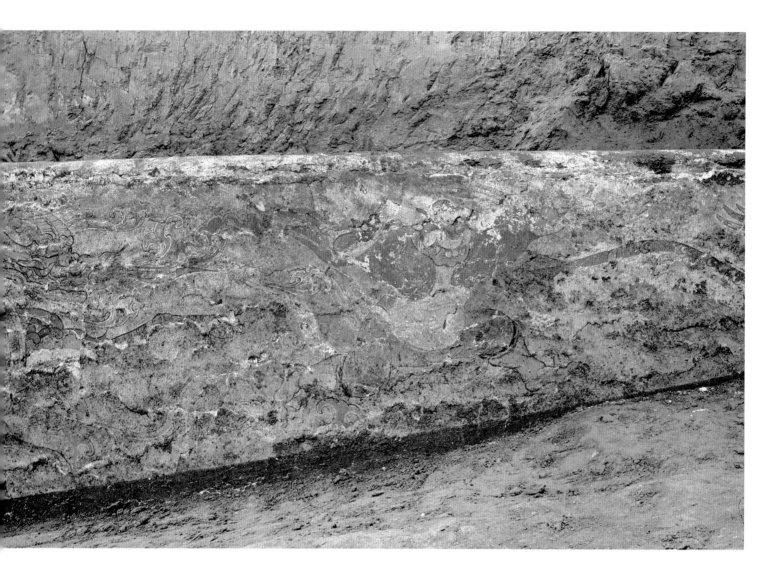

67. 神兽（一）

北齐（550～577年）

通长133厘米

1989年河北省磁县湾漳村北朝壁画墓出土。现存于河北省文物研究所。

墓向185°。位于墓道东壁，是仪仗行列之前的第2个神兽，形象为兽头人身、兽爪兽足。其头部青灰色，上唇附近白色，双目圆睁；背部青灰色，胸腹部白色；上下肢青灰色，以晕染技法表现隆起的肌肉。其两肩部飘扬红色长髦，下身穿过膝短裤。在其头、股、腿部还有长髦飞舞，加强了它紧随朱雀之后大步奔行的动态。

（撰文：朱岩石　摄影：邺城考古队）

Mythical Animal (1)

Northern Qi (550-577 CE)

Length 133 cm

Unearthed from the Northern dynasties painting tomb at Wanzhangcun in Cixian, Hebei, in 1989. Preserved in the Cultural Relics Institute of Hebei Province.

68.青龙

北齐（550～577年）

通长约450厘米

1989年河北省磁县湾漳村北朝壁画墓出土。现存于河北省文物研究所。

墓向185°。位于墓道东壁仪仗行列之前。具有引导其后仪仗行列的作用。青龙呈"S"形，腾跃奔行。青龙头部有角，龙口张开，两前腿近身部有飘扬的翼髦。其身、腿部分别以淡青、淡灰、淡褐色等予以表现，除腹部以外青龙通体以极细的墨线勾勒出龙鳞，精致工整。在其颈、尻、尾部各有一火焰宝珠。

<div align="right">（撰文：朱岩石　摄影：邺城考古队）</div>

Green Dragon

Northern Qi (550-577 CE)

Length ca. 450 cm

Unearthed from the Northern dynasties painting tomb at Wanzhangcun in Cixian, Hebei, in 1989. Preserved in the Cultural Relics Institute of Hebei Province.

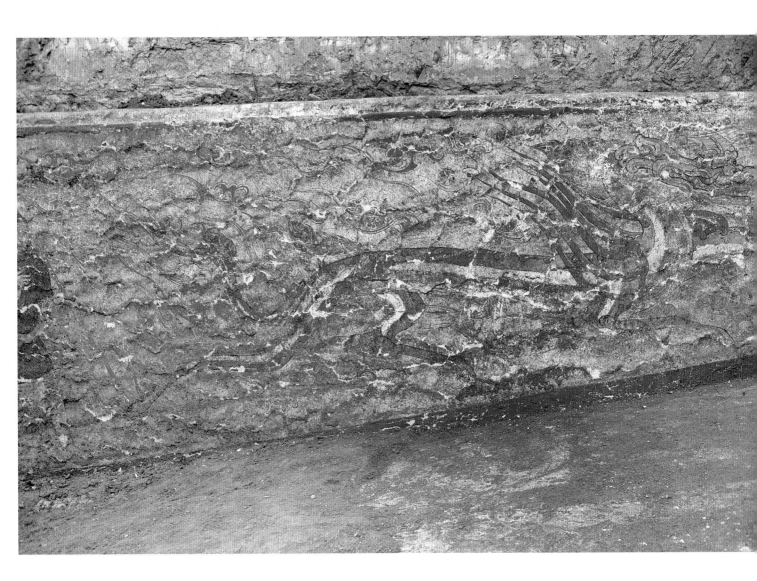

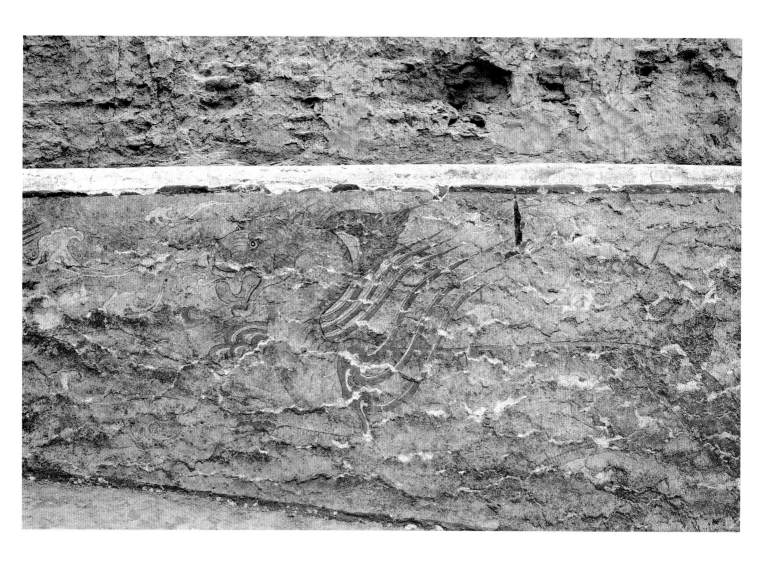

69. 白虎

北齐（550~577年）

通长446厘米

1989年河北省磁县湾漳村北朝壁画墓出土。现存于河北省文物研究所。

墓向185°。位于墓道西壁仪仗行列之前，其位置与东壁青龙对称。呈腾跃疾走状。白虎以白色、浅驼色为主，因浸渍较重，其后半身颜色变化很大，现多呈暗褐色。白虎其通体密布黑斑条纹，其脊背处饰有朱红色、浅青灰色的钩卷纹，白虎前腿近身部有飞扬的翼髦。在颈、尻、尾部各装饰一火焰宝珠。其体态匀称矫健，生机勃勃。

（撰文：朱岩石　摄影：邺城考古队）

White Tiger

Northern Qi (550-577 CE)

Length 446 cm

Unearthed from the Northern dynasties painting tomb at Wanzhangcun in Cixian, Hebei, in 1989. Preserved in the Cultural Relics Institute of Hebei Province.

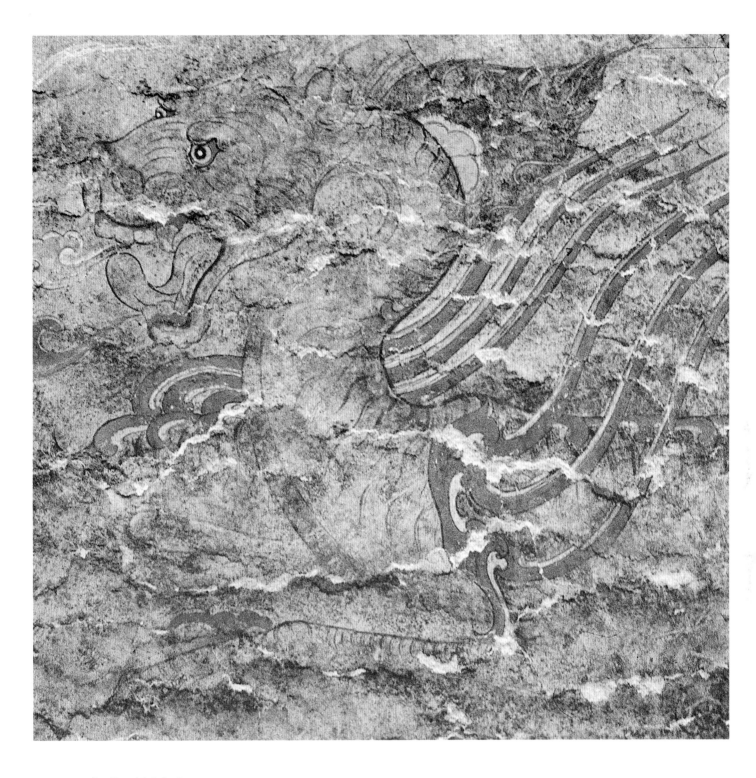

70. 白虎（局部）

北齐（550～577年）

1989年河北省磁县湾漳村北朝壁画墓出土。现存于河北省文物研究所。

墓向185°。位于墓道西壁仪仗行列之前。白虎虎鼻狭长，双耳于头后侧，头部有黑色斑条，其双目尤其描绘得出神入化，其口大张，淡粉色舌上卷，上下暴露出牙齿，口之两侧用细且硬的墨线勾绘出虎须。

<div align="right">（撰文：朱岩石　摄影：邺城考古队）</div>

White Tiger (Detail)

Northern Qi (550-577 CE)

Unearthed from the Northern dynasties painting tomb at Wanzhangcun in Cixian, Hebei, in 1989. Preserved in the Cultural Relics Institute of Hebei Province.

71. "万岁"神兽

北齐（550～577年）

通长156厘米

1989年河北省磁县湾漳村北朝壁画墓出土。现存于河北省文物研究所。

墓向185°。位于墓道东壁，是仪仗行列第7~10人上方天空中的"万岁"形象。其头部为一男子，头戴冠帻，面部粉红色，下颌有须，朱唇小口。头部以下与朱雀基本相同，有两翅，尾部有两条长翎，两爪各三趾，腿爪以朱红色晕染。

（撰文：朱岩石　摄影：邺城考古队）

"Long Live" Mythical Animal

Northern Qi (550-577 CE)

Length 156 cm

Unearthed from the Northern dynasties painting tomb at Wanzhangcun in Cixian, Hebei, in 1989. Preserved in the Cultural Relics Institute of Hebei Province.

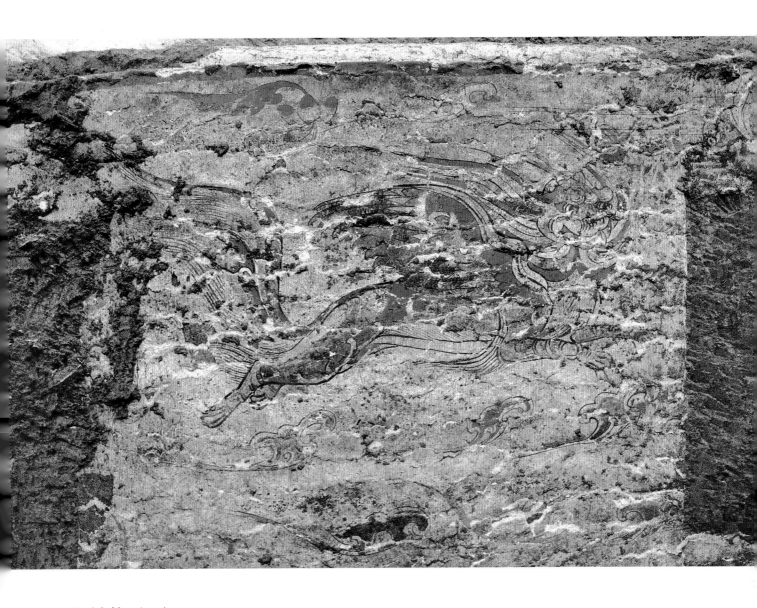

72. 神兽（二）

北齐（550～577年）

通长156厘米

1989年河北省磁县湾漳村北朝壁画墓出土。现存于河北省文物研究所。

墓向185°。位于墓道东壁，是仪仗行列第31~33人上方天空中的神兽。为有羽翼、兽头兽身的神兽。其大眼圆睁，大嘴，颈下有两组长髦分为左右向后飞扬，其身似虎，身背部有朱红、浅褐、白等色，腹部有浅粉色横条斑格，前后腿正奋力向前腾跃，爪有三趾，前腿上部的两翅翼展舒开来，尾部有长翎随风飘扬。

（撰文：朱岩石　摄影：邺城考古队）

Mythical Animal (2)

Northern Qi (550-577 CE)

Length 156 cm

Unearthed from the Northern dynasties painting tomb at Wanzhangcun in Cixian, Hebei, in 1989. Preserved in the Cultural Relics Institute of Hebei Province.

73.神兽（三）

北齐（550~577年）

通长135厘米

1989年河北省磁县湾漳村北朝壁画墓出土。现存于河北省文物研究所。

墓向185°。位于墓道东壁，是仪仗行列第37~39人上方天空中的神兽。形象为兽头人身、兽爪兽足。它的形态呈回首奔跑状，周围有各色祥云、莲花忍冬。

（撰文：朱岩石　摄影：邺城考古队）

Mythical Animal (3)

Northern Qi (550-577 CE)

Length 135 cm

Unearthed from the Northern dynasties painting tomb at Wanzhangcun in Cixian, Hebei, in 1989. Preserved in the Cultural Relics Institute of Hebei Province.

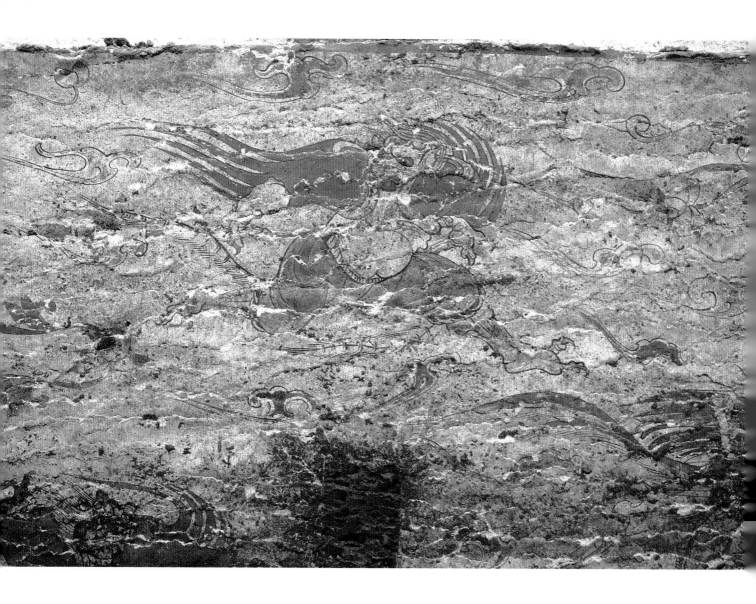

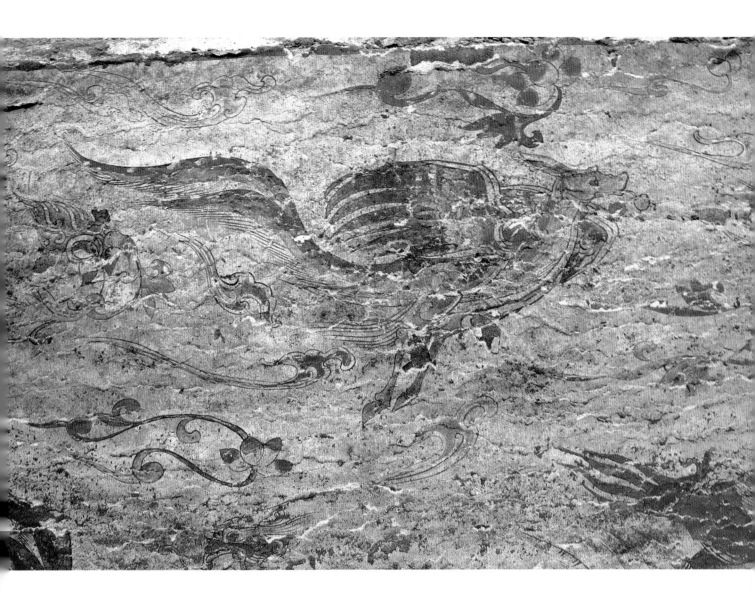

74. 神兽（四）

北齐（550～577年）

通长181厘米

1989年河北省磁县湾漳村北朝壁画墓出土。现存于河北省文物研究所。

墓向185°。位于墓道东壁，是仪仗行列第41~44人上方天空中的神兽。形象为鹿头、鹿足、鸟身。鹿头两角，口衔卷叶忍冬；鸟身以朱红、浅褐色为主，腹部有浅粉色横斑格纹，两翼舒展，尾部两条长翎；其两腿顺行于后，鹿蹄。它的形态呈展翅飞翔状，周围有各色祥云，身后有一宝珠莲花。

（撰文：朱岩石　摄影：邺城考古队）

Mythical Animal (4)

Northern Qi (550-577 CE)

Length 181 cm

Unearthed from the Northern dynasties painting tomb at Wanzhangcun in Cixian, Hebei, in 1989. Preserved in the Cultural Relics Institute of Hebei Province.

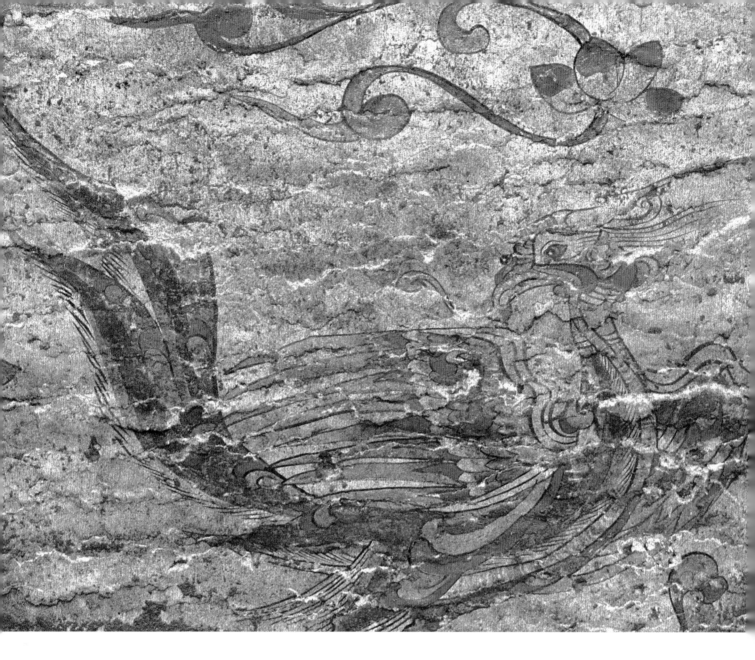

75.朱雀（一）

北齐（550～577年）

通长135厘米

1989年河北省磁县湾漳村北朝壁画墓出土。现存于河北省文物研究所。

墓向185°。位于墓道东壁，是仪仗行列第43~45上方天空中的神兽。为回首翱翔的朱雀，周围有各色祥云和莲花忍冬。

（撰文：朱岩石　摄影：邺城考古队）

Scarlet Bird (1)

Northern Qi (550-577 CE)

Length 135 cm

Unearthed from the Northern dynasties painting tomb at Wanzhangcun in Cixian, Hebei, in 1989. Preserved in the Cultural Relics Institute of Hebei Province.

76.神兽（五）

北齐（550～577年）

通长131.3厘米

1989年河北省磁县湾漳村北朝壁画墓出土。现存于河北省文物研究所。

墓向185°。位于墓道东壁，是仪仗行列第45~47人上方天空中的神兽。形象为兽头人身、兽爪兽足，其形态呈奋力奔跑状。周围有各色祥云、莲花忍冬。

（撰文：朱岩石　摄影：邺城考古队）

Mythical Animal (5)

Northern Qi (550-577 CE)

Length 131.3 cm

Unearthed from the Northern dynasties painting tomb at Wanzhangcun in Cixian, Hebei, in 1989. Preserved in the Cultural Relics Institute of Hebei Province.

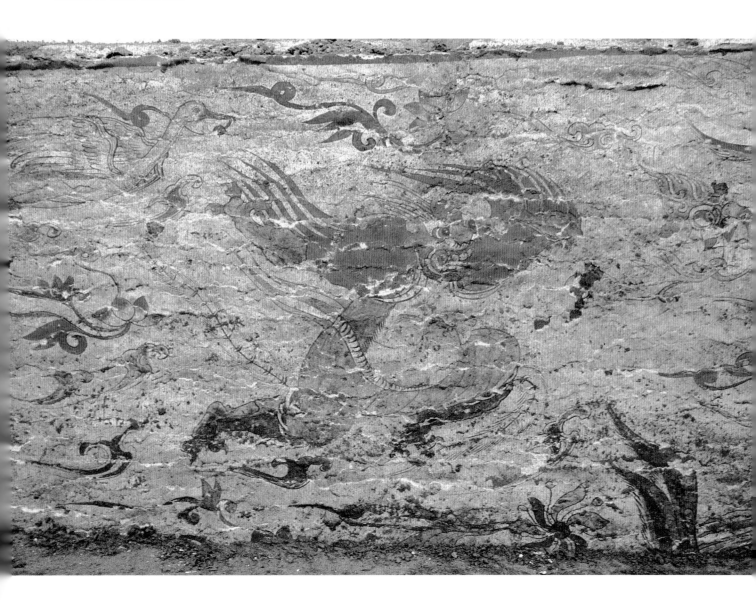

77.翔鹤与莲花、宝珠

北齐（550～577年）

通长135厘米

1989年河北省磁县湾漳村北朝壁画墓出土。现存于河北省文物研究所。

墓向185°。位于墓道东壁，是仪仗行列第48、49人上方天空中的神兽。形象犹如仙鹤，红嘴、红爪，通身洁白，呈飞翔状。周围有各色祥云、摩尼宝珠、莲花忍冬等。

（撰文：朱岩石　摄影：邺城考古队）

Flying Crane, Lotus and Pearl

Northern Qi (550-577 CE)

Length 135 cm

Unearthed from the Northern dynasties painting tomb at Wanzhangcun in Cixian, Hebei, in 1989. Preserved in the Cultural Relics Institute of Hebei Province.

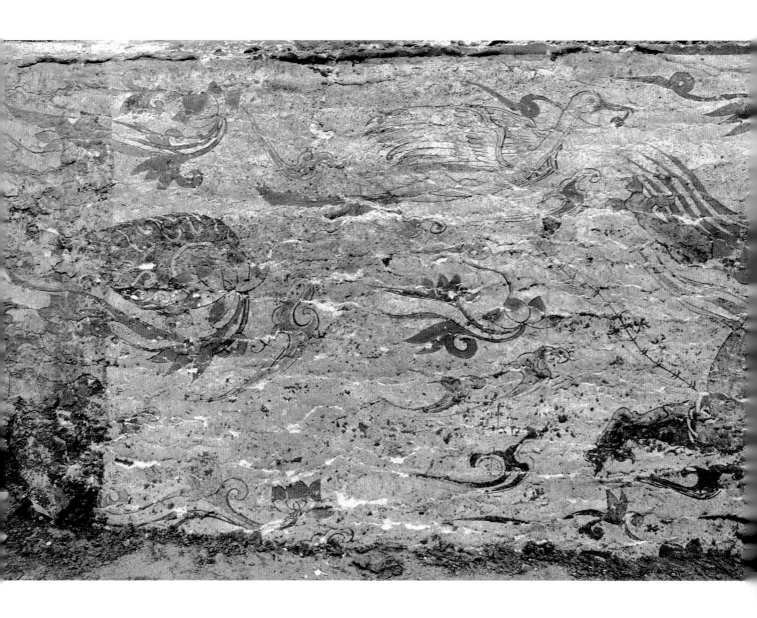

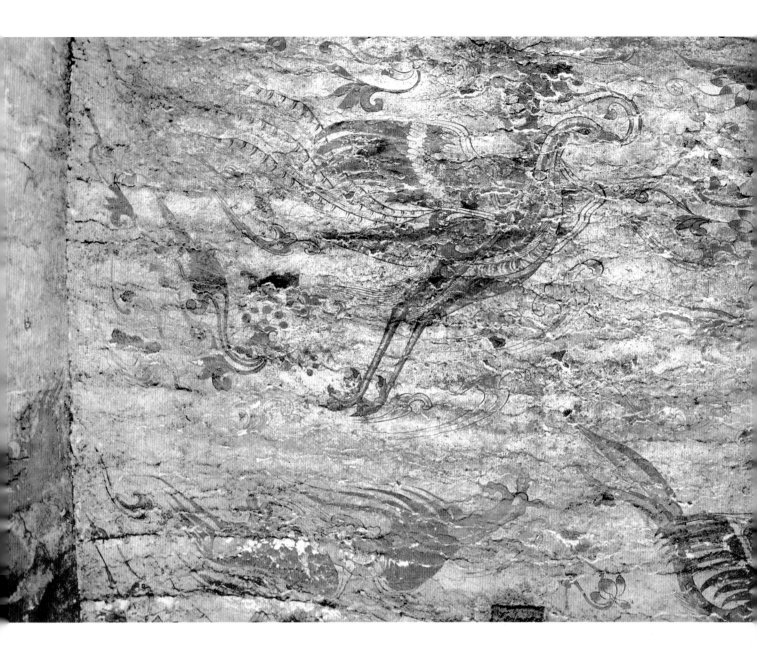

78.朱雀（二）

北齐（550～577年）

通长220厘米

1989年河北省磁县湾漳村北朝壁画墓出土。现存于河北省文物研究所。

墓向185°。位于墓道东壁，是仪仗行列第51、52人上方天空中的神兽。它是墓道两壁最大的朱雀形象之一，周围有各色祥云、摩尼宝珠、莲花忍冬等。

（撰文：朱岩石　摄影：邺城考古队）

Scarlet Bird (2)

Northern Qi (550-577 CE)

Length 220 cm

Unearthed from the Northern dynasties painting tomb at Wanzhangcun in Cixian, Hebei, in 1989. Preserved in the Cultural Relics Institute of Hebei Province.

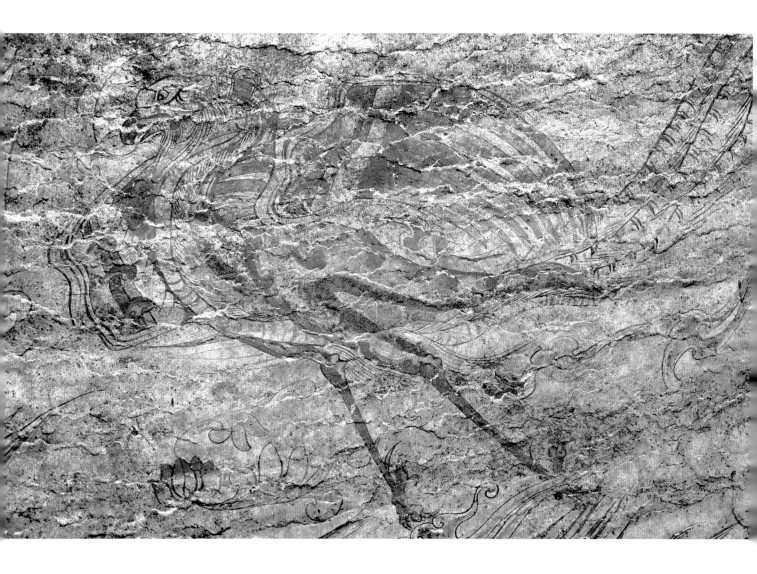

79. 朱雀（三）

北齐（550～577年）

通长220.1厘米

1989年河北省磁县湾漳村北朝壁画墓出土。现存于河北省文物研究所。

墓向185°。位于墓道西壁，是仪仗行列第51、52人上方天空中的神兽。为展翅翱翔的朱雀，其头顶无冠，喙似鹰，衔以卷叶忍冬，眼光犀利，凝视前方，巨大的双翅色彩丰富，尾部三条长翎飘扬，异常瑰丽。

（撰文：朱岩石　摄影：邺城考古队）

Scarlet Bird (3)

Northern Qi (550-577 CE)

Length 220.1 cm

Unearthed from the Northern dynasties painting tomb at Wanzhangcun in Cixian, Hebei, in 1989. Preserved in the Cultural Relics Institute of Hebei Province.

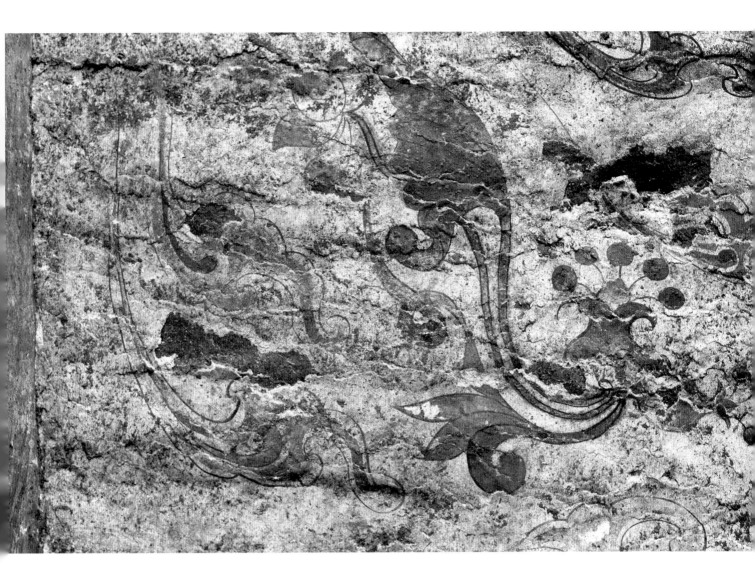

80.忍冬与莲花（一）

北齐（550~577年）

画面宽度106厘米

1989年河北省磁县湾漳村北朝壁画墓出土。现存于河北省文物研究所。

墓向185°。位于墓道东壁北端天空，第20神兽左下方，是宝珠、忍冬、莲花纹样。

（撰文：朱岩石　摄影：邺城考古队）

Acanthus Leaves and Lotus (1)

Northern Qi (550-577 CE)

Width 106 cm

Unearthed from the Northern dynasties painting tomb at Wanzhangcun in Cixian, Hebei, in 1989. Preserved in the Cultural Relics Institute of Hebei Province.

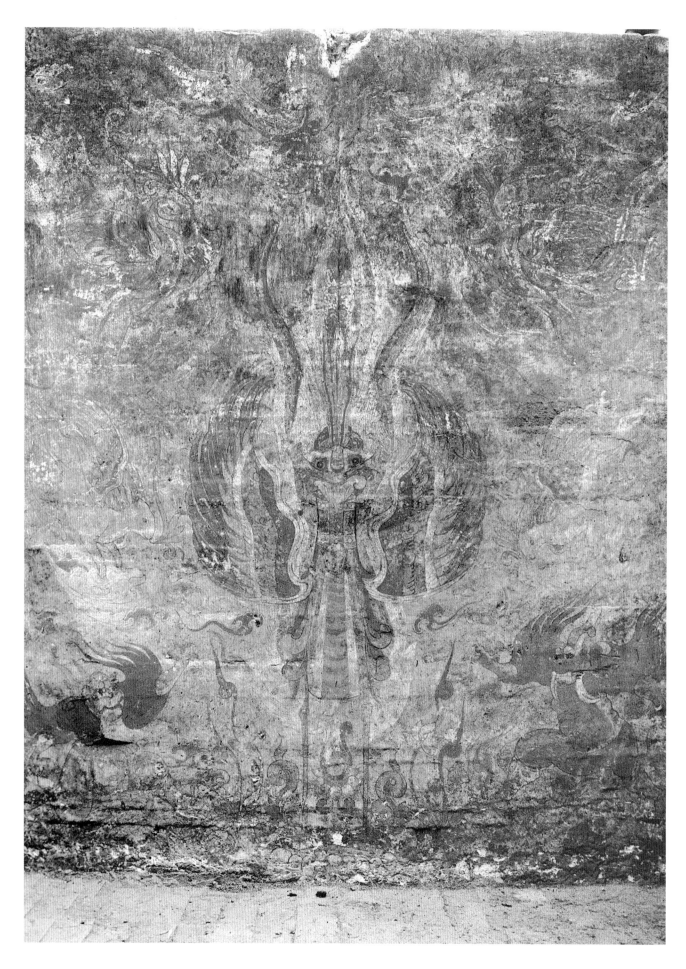

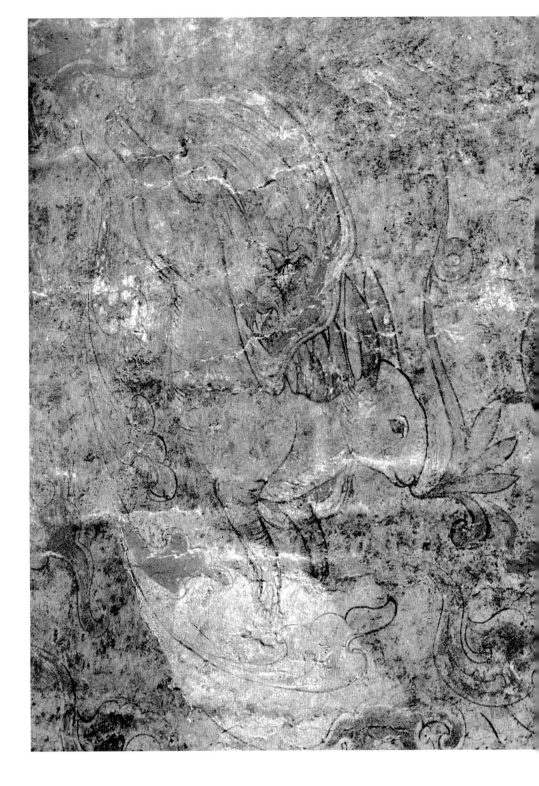

81. 大朱雀

北齐（550～577年）

通高504厘米

1989年河北省磁县湾漳村北朝壁画墓出土。现存于河北省文物研究所。

墓向185°。位于甬道上方的挡土墙壁画。壁画正中央伫立一大朱雀，其双足站在莲花之上，羽翼展开，其双目向南凝视墓道。大朱雀色彩丰富艳丽，线条精美，其两侧还对称分布有莲花忍冬、祥云、凤鸟、羽兔和神兽图案。

（撰文：朱岩石　摄影：
邺城考古队）

Jumbo Scarlet Bird

Northern Qi (550-577 CE)

Height 504 cm

Unearthed from the Northern dynasties painting tomb at Wanzhangcun in Cixian, Hebei, in 1989. Preserved in the Cultural Relics Institute of Hebei Province.

82. 羽兔

北齐（550～577年）

通长104厘米

1989年河北省磁县湾漳村北朝壁画墓出土。现存于河北省文物研究所。

墓向185°。位于甬道上方的挡土墙，是大朱雀西侧的羽兔。羽兔呈自上向下俯冲之状，其通体白色，长耳短尾，其背生双翼，口衔粉色卷叶忍冬。

（撰文：朱岩石　摄影：邺城考古队）

Winged Hare

Northern Qi (550-577 CE)

Length 104 cm

Unearthed from the Northern dynasties painting tomb at Wanzhangcun in Cixian, Hebei, in 1989. Preserved in the Cultural Relics Institute of Hebei Province.

83.忍冬与莲花（二）

北齐（550~577年）

每朵大莲花直径135厘米

1989年河北省磁县湾漳村北朝壁画墓出土。现存于河北省文物研究所。

墓向185°。位于墓道南端的地画。绘于墓道斜坡地面之上，墓道南端距地表较浅，保存尚好。墓道地画可分为左、中、右三纵列。居中一列绘巨大的莲花，在墓道自南而北均匀排列分布，墓道地画总计绘制14朵大莲花。左右两列地画较中列略窄，其内对称绘以二方连续装饰纹带，主题是缠枝忍冬莲花图案。左右两列装饰纹带整体构图对称、均衡，装饰效果强烈。墓道地画的艺术构想新颖，仿佛一幅巨大华丽的地毯。

（撰文：朱岩石　摄影：邺城考古队）

Acanthus Leaves and Lotus (2)

Northern Qi (550-577 CE)

Lotus diameter 135 cm

Unearthed from the Northern dynasties painting tomb at Wanzhangcun in Cixian, Hebei, in 1989. Preserved in the Cultural Relics Institute of Hebei Province.

84.侍女和屏风花鸟（一）

五代·唐同光二年（924年）

宽约480厘米

1994年河北省曲阳县西燕川村王处直墓出土。原址保存。

墓向159°。位于前室东壁。在东耳室门北侧下栏绘侍女和折扇屏风花鸟画，花鸟画从右到左依次为牡丹图、蔷薇图、蔷薇图和牵牛图。其中牵牛图跨东、北两壁，北壁东端牵牛花已被破坏掉。上栏绘几组云鹤。

<div align="right">（撰文：郝建文　摄影：冯玲）</div>

Maids and Flower-and-Bird Screens (1)

2nd Year of Tongguang Era, Later Tang of the Five dynasties (924 CE)

Width ca. 480 cm

Unearthed from Wang Chuzhi's tomb at Xiyanchuancun in Quyang, Hebei, in 1994. Preserved on the original site.

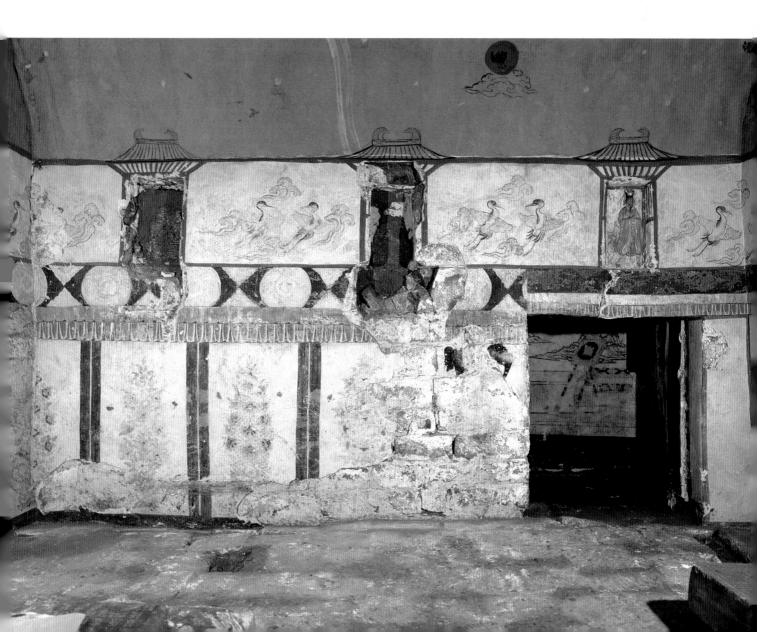

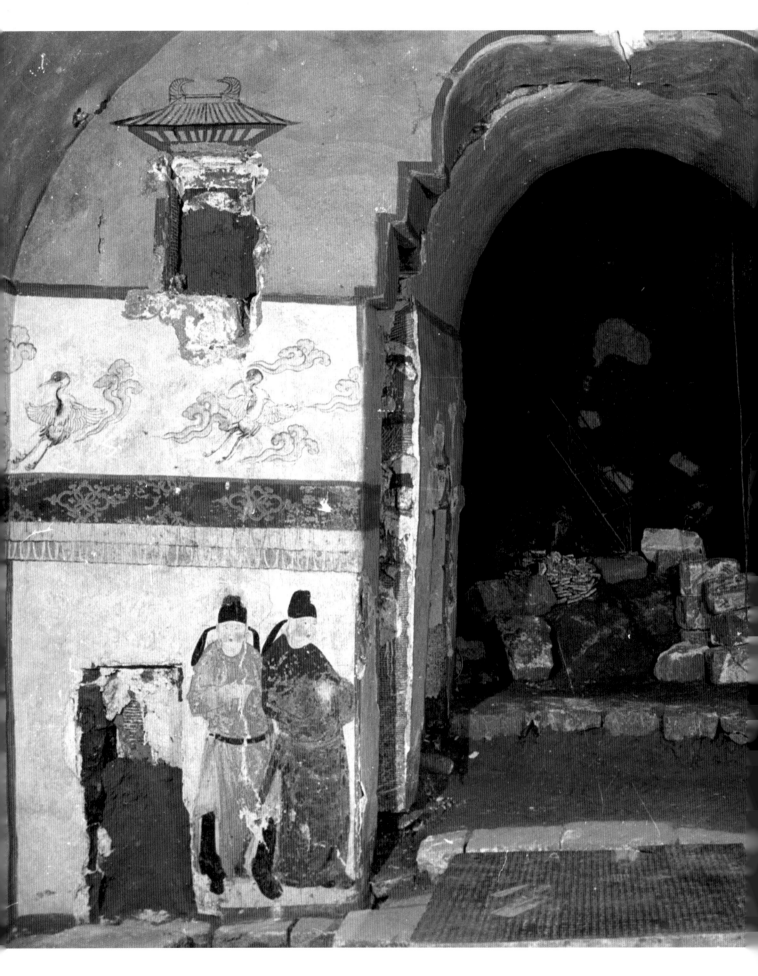

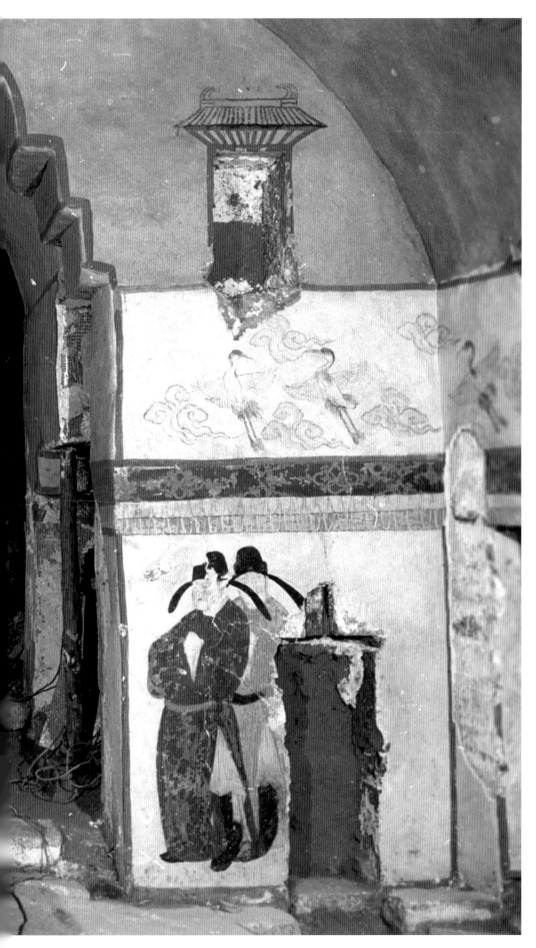

85. 侍者

五代·唐同光二年（924年）
宽约480厘米
1994年河北省曲阳县西燕川村
王处直墓出土。原址保存。
墓向159°。位于前室南壁。最
上面表现的是天空，有星象。
墓门两侧上栏绘云鹤，下栏各
绘一对男侍，男侍头戴黑色翘
脚幞头，脚穿长靴，着圆领红
色或褐色长袍。

（撰文：郝建文　摄影：冯玲）

Attendants

2nd Year of Tongguang Era,
Later Tang of the Five dynasties
(924 CE)
Width ca. 480 cm
Unearthed from Wang Chuzhi's
tomb at Xiyanchuancun in Quy-
ang, Hebei, in 1994. Preserved on
the original site.

86.侍女和屏风花鸟（二）

五代·唐同光二年（924年）

宽约480厘米

1994年河北省曲阳县西燕川村王处直墓出土。原址保存。

墓向159°。位于前室西壁。在西耳室门北侧下栏绘侍女和折扇屏风花鸟画，花鸟画从左到右依次为牡丹图、牡丹图、月季图和牵牛图。其中牵牛图跨西、北两壁。上栏绘几组云鹤。

（撰文：郝建文　摄影：冯玲）

Maid and Flower-and-Bird Screens (2)

2nd Year of Tongguang Era, Later Tang of the Five dynasties (924 CE)

Width ca. 480 cm

Unearthed from Wang Chuzhi's tomb at Xiyanchuancun in Quyang, Hebei, in 1994. Preserved on the original site.

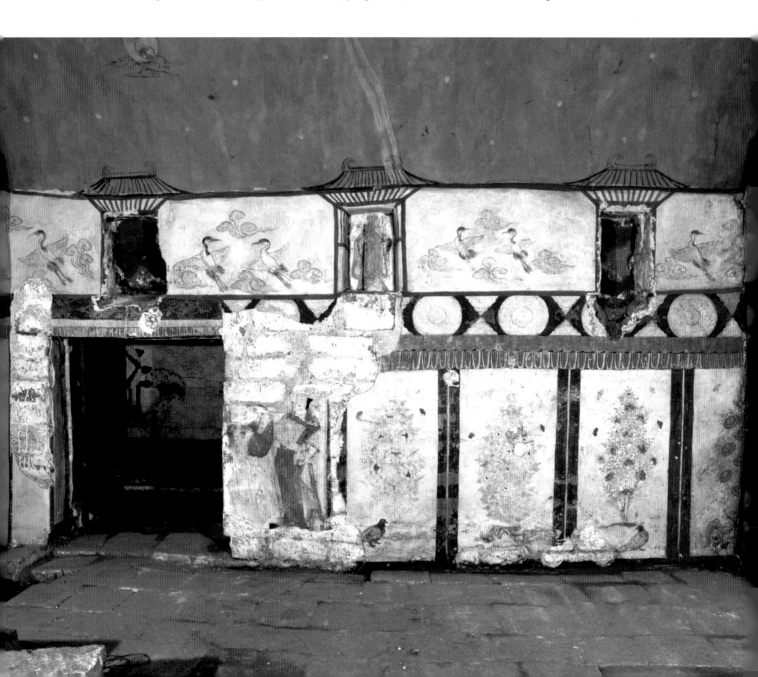

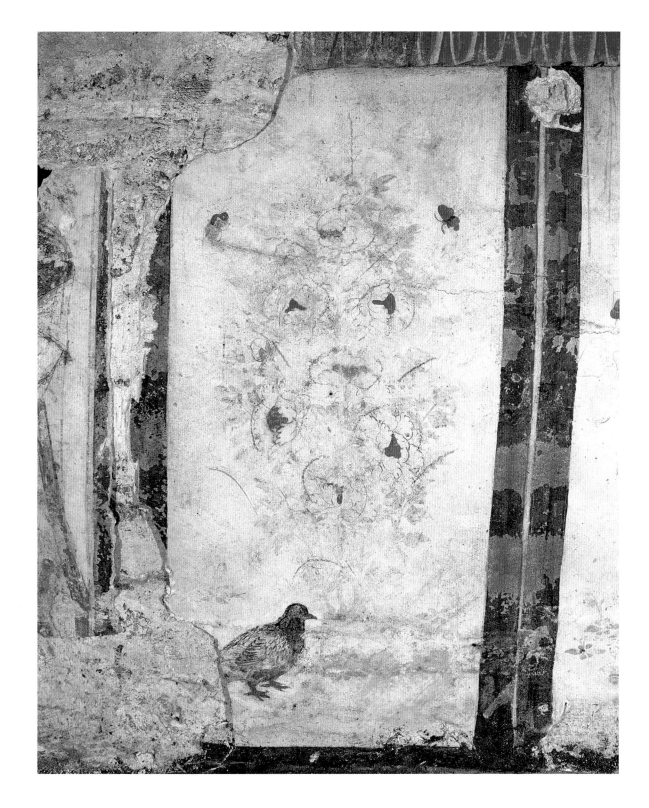

87.墓室西壁花鸟屏风（一）

五代·唐同光二年（924年）

高约118、宽约60、牡丹花高76厘米

1994年河北省曲阳县西燕川村王处直墓出土。原址保存。

墓向159°。位于前室西壁西耳室北侧、侍女人物的旁边。绘有正在盛开的七朵牡丹花和两只飞舞的蝴蝶，左下角是一只静立的鸽子。

（撰文：郝建文　摄影：冯玲）

Flower-and-Bird Screen (1)

2nd Year of Tongguang Era, Later Tang of the Five dynasties (924 CE)

Height ca. 118 cm; Width ca. 60 cm; Peony height 76 cm

Unearthed from Wang Chuzhi's tomb at Xiyanchuancun in Quyang, Hebei, in 1994. Preserved on the original site.

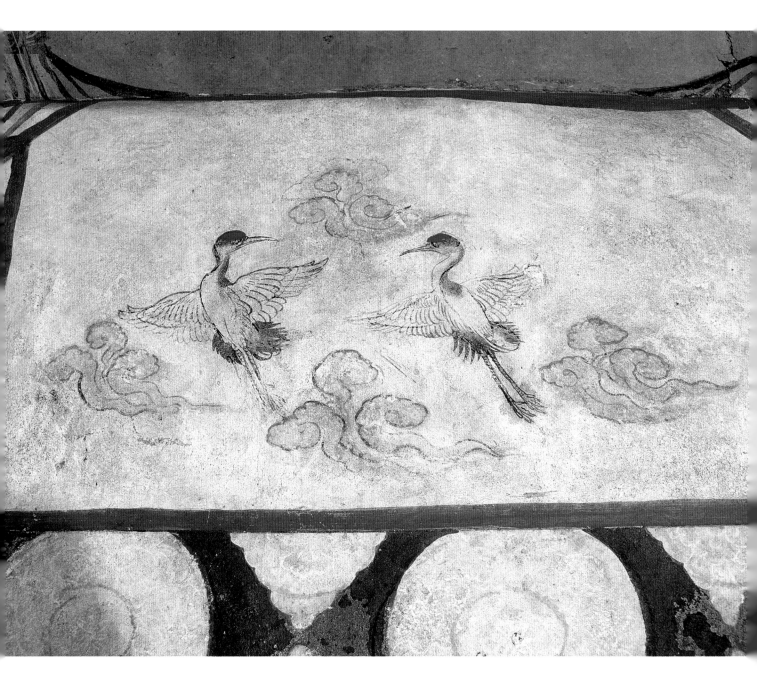

88.云鹤图（一）

五代·唐同光二年（924年）

高64、宽118厘米

1994年河北省曲阳县西燕川村王处直墓出土。原址保存。

墓向159°。位于前室西壁上栏北侧，绘的是引颈顾盼展翅飞翔的白鹤以及四组云朵。

<div align="right">（撰文：郝建文　摄影：冯玲）</div>

Clouds-and-Cranes (1)

2nd Year of Tongguang Era, Later Tang of the Five dynasties (924 CE)

Height 64 cm; Width 118 cm

Unearthed from Wang Chuzhi's tomb at Xiyanchuancun in Quyang, Hebei, in 1994. Preserved on the original site.

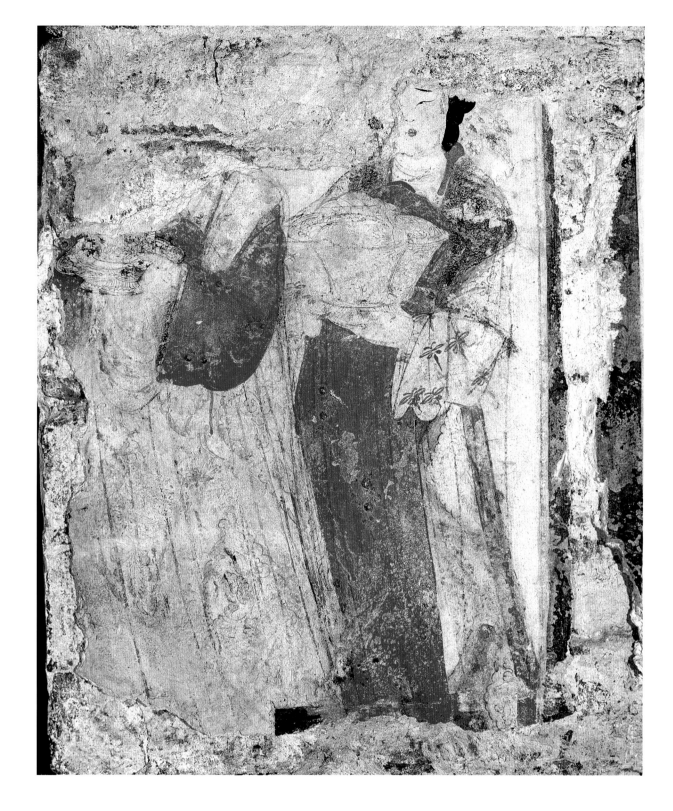

89.侍女图（一）

五代·唐同光二年（924年）

人物残高约71厘米

1994年河北省曲阳县西燕川村王处直墓出土。原址保存。

墓向159°。位于前室西壁下栏、西耳室门北侧。两侍女侧身站立，前者双手捧一酒樽，身着红襦白色长裙；后者双手捧葵口大酒樽，身着白襦红色长裙，两人都着绿色帔巾，襦裙上的图案主要为牡丹纹。前者面部已不存在。

（撰文：郝建文　摄影：冯玲）

Maids (1)

2nd Year of Tongguang Era, Later Tang of the Five dynasties (924 CE)

Remaining height ca. 71 cm

Unearthed from Wang Chuzhi's tomb at Xiyanchuancun in Quyang, Hebei, in 1994. Preserved on the original site.

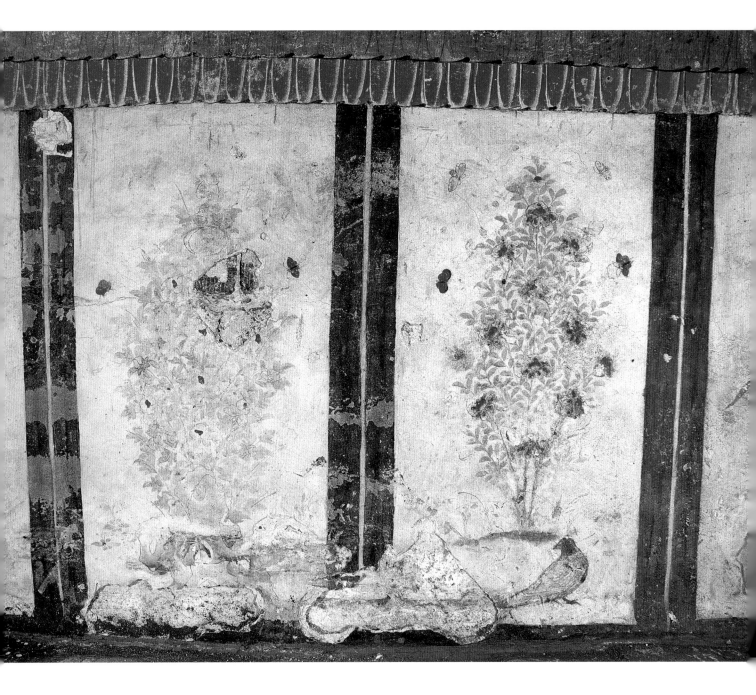

90. 墓室西壁花鸟屏风（二）

五代·唐同光二年（924年）

高118、宽约120厘米

1994年河北省曲阳县西燕川村王处直墓出土。原址保存。

墓向159°。位于前室西壁中部下栏。从左到右分别为牡丹图和月季图。盛开的牡丹花上方左右有蝴蝶飞舞，下面绘湖石。月季花的两旁绘有蝴蝶和蜜蜂，右下方一只鸽子正在觅食。

（撰文：郝建文　摄影：冯玲）

Flower-and-Bird Screen (2)

2nd Year of Tongguang Era, Later Tang of the Five dynasties (924 CE)

Height 118 cm; Width ca. 120 cm

Unearthed from Wang Chuzhi's tomb at Xiyanchuancun in Quyang, Hebei, in 1994. Preserved on the original site.

91.山水与屏风

五代·唐同光二年（924年）

宽约480厘米（其中山水画高180、宽222厘米）

1994年河北省曲阳县西燕川村王处直墓出土。原址保存。

墓向159°。位于前室北壁。正中绘一水墨山水画，这是此墓室壁画中最后完成的一幅作品。全画一气呵成，表现了很强的空间感和立体感。山水画的两侧上栏绘云鹤图，下栏绘花鸟屏风画。

（撰文：郝建文　摄影：冯玲）

Landscape Painting and Screens

2nd Year of Tongguang Era, Later Tang of the Five dynasties (924 CE)

Width ca. 480 cm (Landscape painting height 180 cm; width 222 cm)

Unearthed from Wang Chuzhi's tomb at Xiyanchuancun in Quyang, Hebei, in 1994. Preserved on the original site.

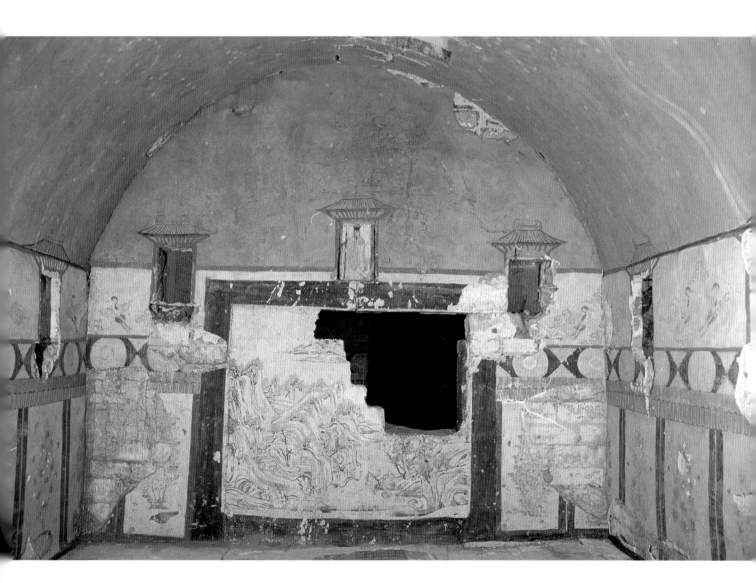

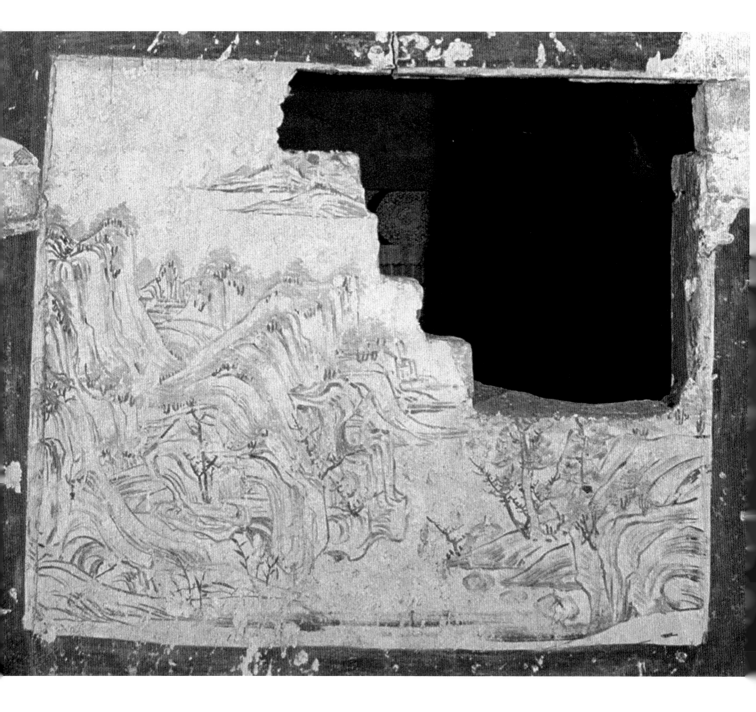

92.山水与屏风（局部）

五代·唐同光二年（924年）

1994年河北省曲阳县西燕川村王处直墓出土。原址保存。

墓向159°。位于前室北壁。正中绘一水墨山水画，这是此墓室壁画中最后完成的一幅作品。全画一气呵成，表现了很强的空间感和立体感。山水画的两侧上栏绘云鹤图，下栏绘花鸟屏风画。

（撰文：郝建文　摄影：冯玲）

Landscape Painting and Screens (Detail)

2nd Year of Tongguang Era, Later Tang of the Five dynasties (924 CE)

Unearthed from Wang Chuzhi's tomb at Xiyanchuancun in Quyang, Hebei, in 1994. Preserved on the original site.

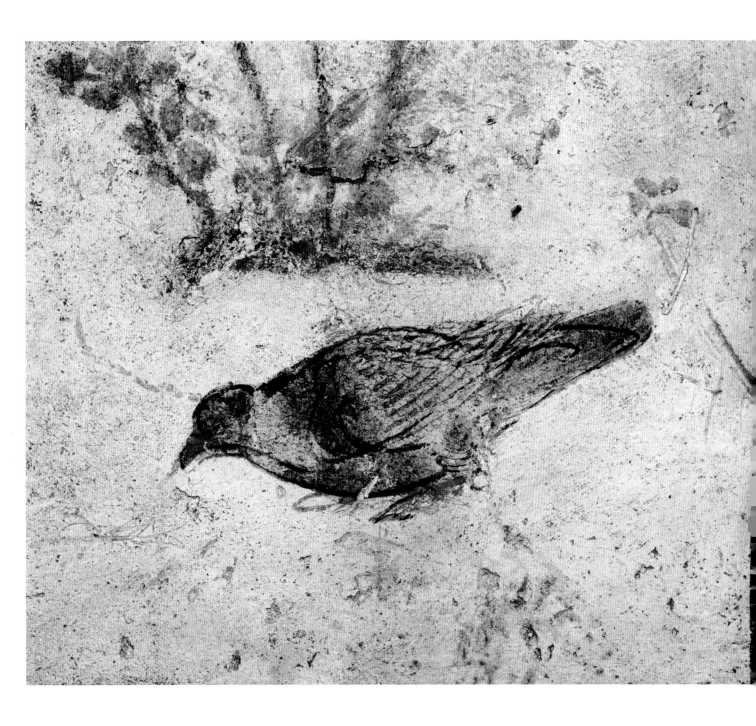

93.墓室北壁花鸟屏风

五代·唐同光二年（924年）

鸽子长约24厘米

1994年河北省曲阳县西燕川村王处直墓出土。原址保存。

墓向159°。位于前室北壁下栏西侧，是蔷薇图的一小局部。画面上是一正在低头啄食蚂蚱的灰鸽。

（撰文：郝建文　摄影：冯玲）

Landscape Painting and Screens

2nd Year of Tongguang Era, Later Tang of the Five dynasties (924 CE)

Length of pigeon ca. 24 cm

Unearthed from Wang Chuzhi's tomb at Xiyanchuancun in Quyang, Hebei, in 1994. Preserved on the original site.

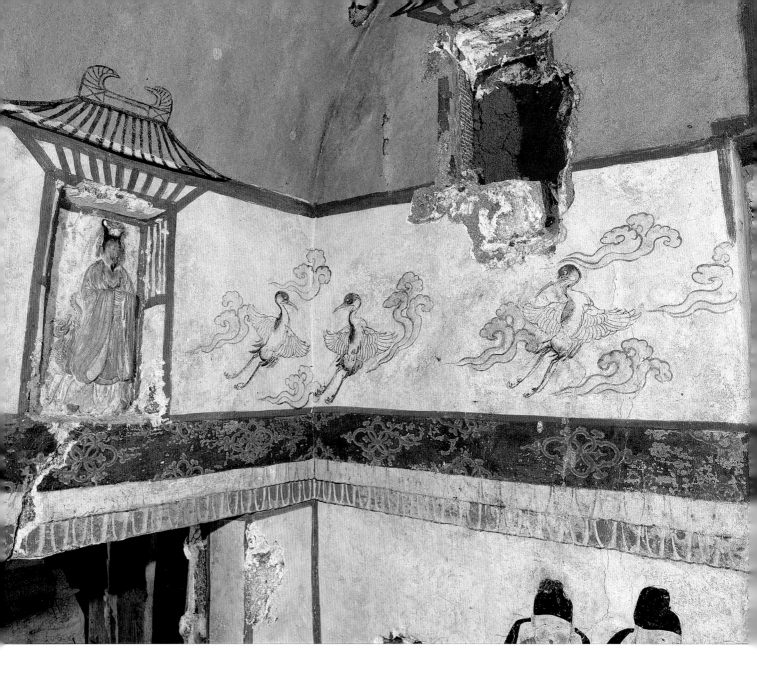

94.云鹤图（二）

五代·唐同光二年（924年）

高64、总宽197厘米（其中东壁60、南壁137厘米）

1994年河北省曲阳县西燕川村王处直墓出土。原址保存。

墓向159°。位于前室南壁和东壁拐角处上栏。东壁绘一白鹤，南壁绘两只，其中前面两只引颈回首，和后面的形成呼应。白鹤周围饰有八组云纹。

（撰文：郝建文　摄影：冯玲）

Clouds-and-Cranes (2)

2nd Year of Tongguang Era, Later Tang of the Five dynasties (924 CE)

Height 64 cm; Width 197 cm (Eastern wall length 60 cm; Southern wall length 137 cm)

Unearthed from Wang Chuzhi's tomb at Xiyanchuancun in Quyang, Hebei, in 1994. Preserved on the original site.

95.器皿图（一）

五代·唐同光二年（924年）

高136、总宽200厘米

1994年河北省曲阳县西燕川村王处直墓出土。原址保存。

墓向159°。位于西耳室西壁。表现的是一长案，案上有盒、架镜、木箱、瓷枕、颈瓶等，长案的后面以屏风画作背景，上绘牡丹、蝴蝶和绶带鸟。

（撰文：郝建文　摄影：冯玲）

Utensils (1)

2nd Year of Tongguang Era, Later Tang of the Five dynasties (924 CE)

Height 136 cm; Width 200 cm

Unearthed from Wang Chuzhi's tomb at Xiyanchuancun in Quyang, Hebei, in 1994. Preserved on the original site.

96.侍女图（二）

五代·唐同光二年（924年）

高135、宽约104厘米

1994年河北省曲阳县西燕川村王处直墓出土。原址保存。
墓向159°。位于西耳室南壁，侍女头梳高髻，外着红襦。系白色长裙，肩披白色帔巾，双手捧细颈瓶。

（撰文：郝建文　摄影：冯玲）

Maid (2)

2nd Year of Tongguang Era, Later Tang of the Five dynasties (924 CE)

Height 135 cm; Width ca. 104 cm

Unearthed from Wang Chuzhi's tomb at Xiyanchuancun in Quyang, Hebei, in 1994. Preserved on the original site.

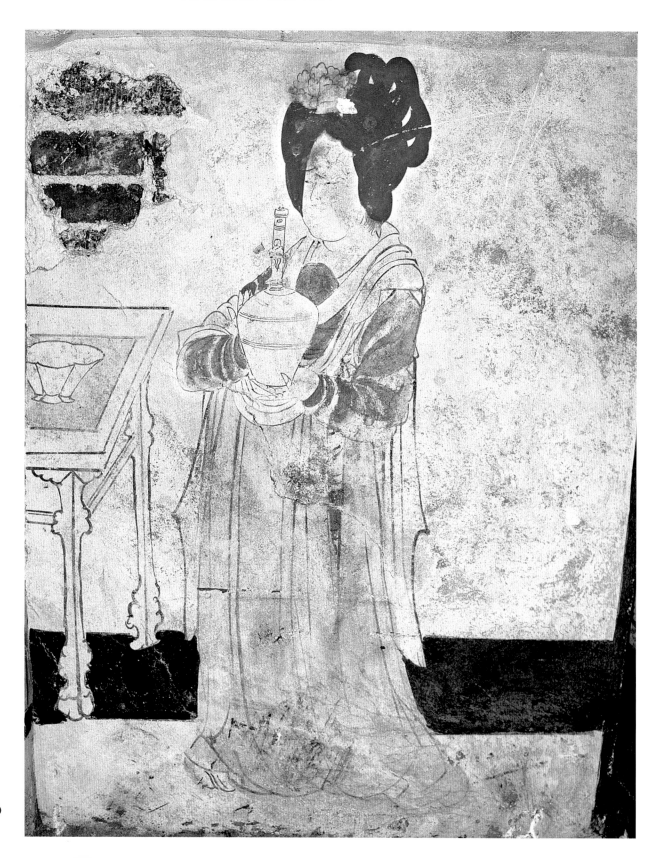

97.侍女图（三）

五代·唐同光二年（924年）

高133、宽100厘米

1994年河北省曲阳县西燕川村王处直墓出土。原址保存。

墓向159°。位于西耳室北壁。绘两个人物，前者头梳髻，外着白襦。系红色长裙，肩披白色帔巾，双手捧食盒。后者头梳双髻，双手抄在袖中。人物形象前者高大，衣着也华丽，和后者相比似有主仆关系，年龄也有大的差异。前者可能是墓主人妻妾。

（撰文：郝建文　摄影：冯玲）

Maids (3)

2nd Year of Tongguang Era, Later Tang of the Five dynasties (924 CE) Height 133 cm; Width 100 cm Unearthed from Wang Chuzhi's tomb at Xiyanchuancun in Quyang, Hebei, in 1994. Preserved on the original site.

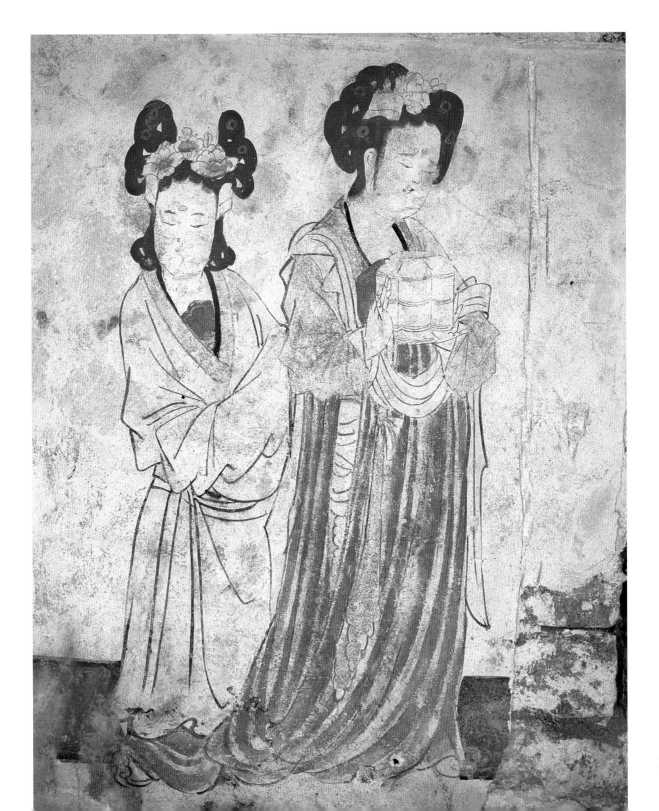

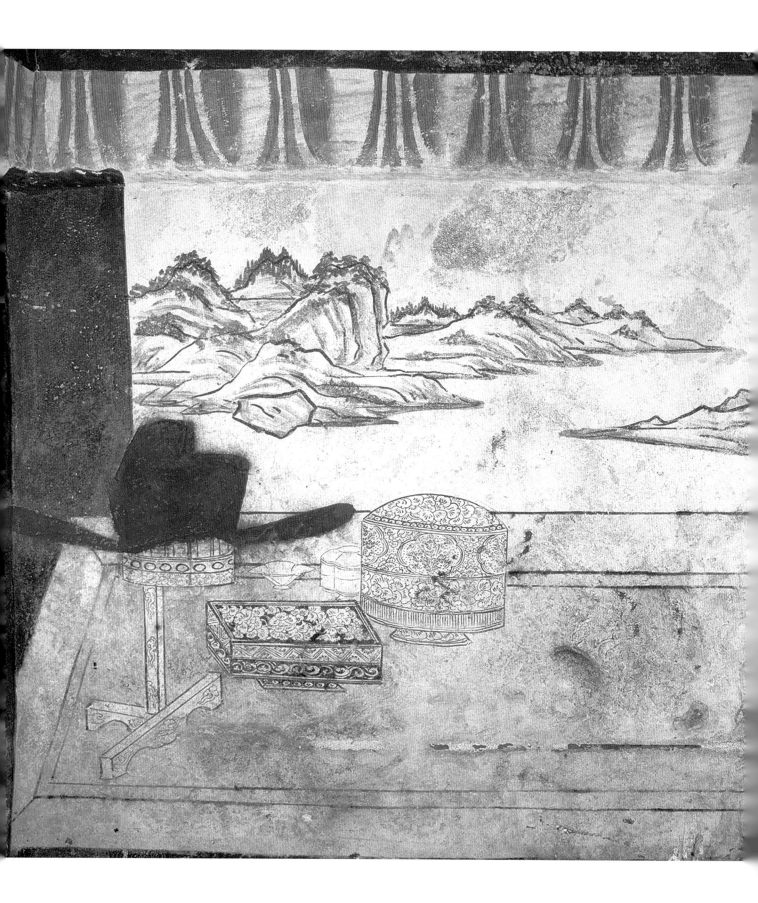

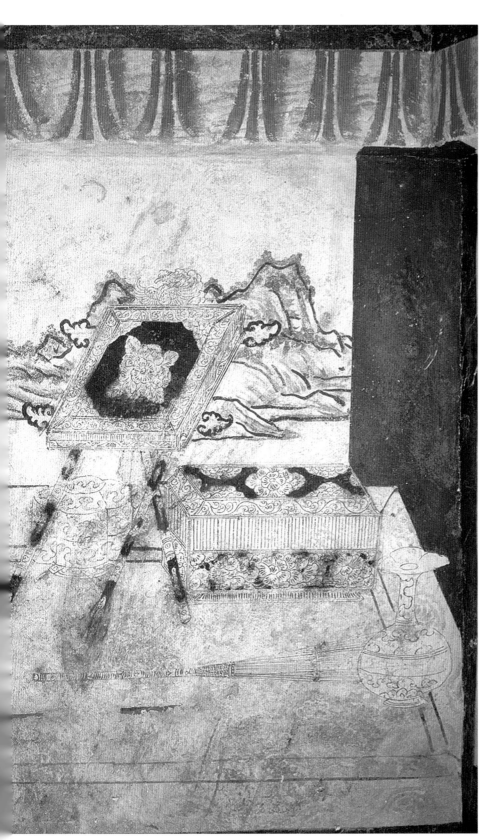

98. 器皿图（二）

五代·唐同光二年（924年）

高147、宽215厘米

1994年河北省曲阳县西燕川村王处直墓出土。原址保存。

墓向159°。位于东耳室东壁。画面是一长案，案上应是墓主人生前所用之物，有帽架、黑色幞头、三足镜架、盒、箱等。长案后面绘水墨山水屏风画。

（撰文：郝建文　摄影：冯玲）

Utensils (2)

2nd Year of Tongguang Era, Later Tang of the Five dynasties (924 CE)

Height 147 cm; Width 215 cm

Unearthed from Wang Chuzhi's tomb at Xiyanchuancun in Quyang, Hebei, in 1994. Preserved on the original site.

99.侍女图（四）

五代·唐同光二年（924年）

高145、宽101厘米

1994年河北省曲阳县西燕川村王处直墓出土。原址保存。墓向159°。位于东耳室南壁。侍女手持拂尘，头梳双髻，两股发辫下垂，着淡黄色交领窄袖长裙，足穿红色高头履。身后用写意的手法描绘了茂密的竹叶。

（撰文：郝建文　摄影：冯玲）

Maid (4)

2nd Year of Tongguang Era, Later Tang of the Five dynasties (924 CE)

Height 145 cm; Width 101 cm

Unearthed from Wang Chuzhi's tomb at Xiyanchuancun in Quyang, Hebei, in 1994. Preserved on the original site.

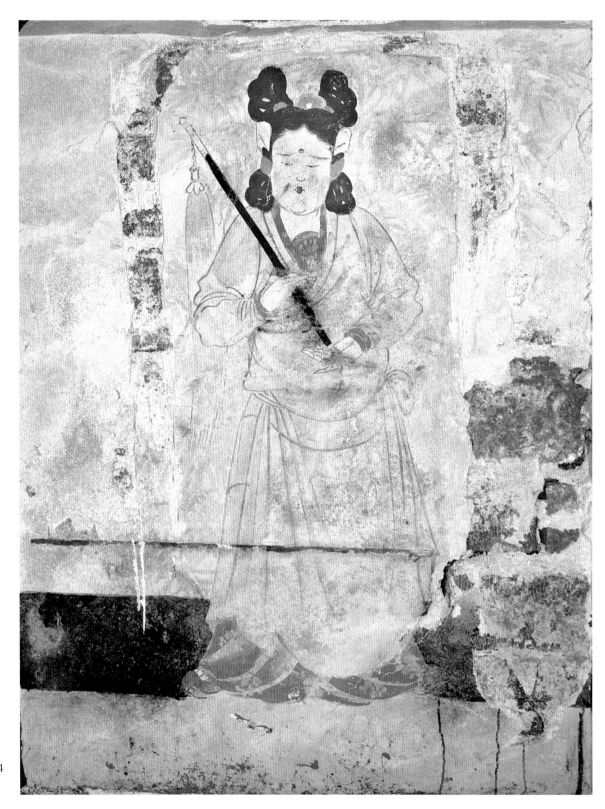

100.妇女和童子图

五代·唐同光二年（924年）

高140、宽102厘米

1994年河北省曲阳县西燕川村王处直墓出土。原址保存。

墓向159°。位于东耳室北壁。画面中妇女头梳高髻，外着红襦。系白色长裙，肩披白色帔巾，双手捧葵口碗，额心点花钿，耳垂点红。可能是墓主人妻妾形象。童子披发，着圆领缺胯袍，内穿长裤，叉手而立。

<p align="right">（撰文：郝建文　摄影：冯玲）</p>

Woman and Boy

2nd Year of Tongguang Era, Later Tang of the Five dynasties (924 CE)

Height 140 cm; Width 102 cm

Unearthed from Wang Chuzhi's tomb at Xiyanchuancun in Quyang, Hebei, in 1994.

Preserved on the original site.

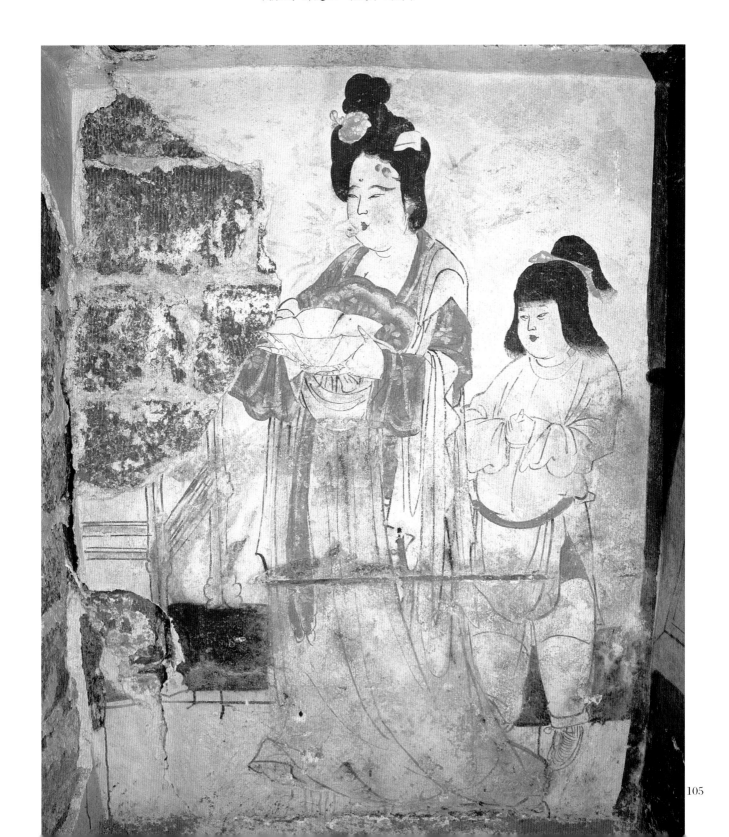

101. 花鸟屏风

五代·唐同光二年（924年）

高176、宽335厘米

1994年河北省曲阳县西燕川村王处直墓出土。原址保存。

墓向159°。位于后室北壁，是一幅通景式壁画。上部绘二方连续的团花图案和垂幔。下面中心位置绘湖石和牡丹，其上、下两侧绘有飞舞的绶带鸟觅食的鸽子以及蜂蝶。在画面的两侧各绘一株蔷薇，其左右亦绘蜂蝶。左侧那只鸽子正回头注视着一只蚂蚱，看上去非常生动。

（撰文：郝建文　摄影：冯玲）

Flower-and–Bird Screen

2nd Year of Tongguang Era, Later Tang of the Five dynasties (924 CE)

Height 176 cm; Width 335 cm

Unearthed from Wang Chuzhi's tomb at Xiyanchuancun in Quyang, Hebei, in 1994. Preserved on the original site.

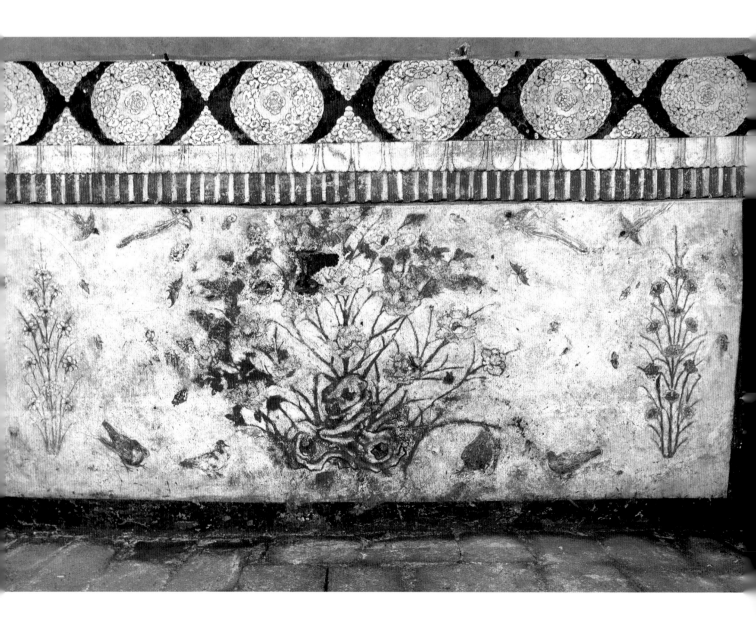

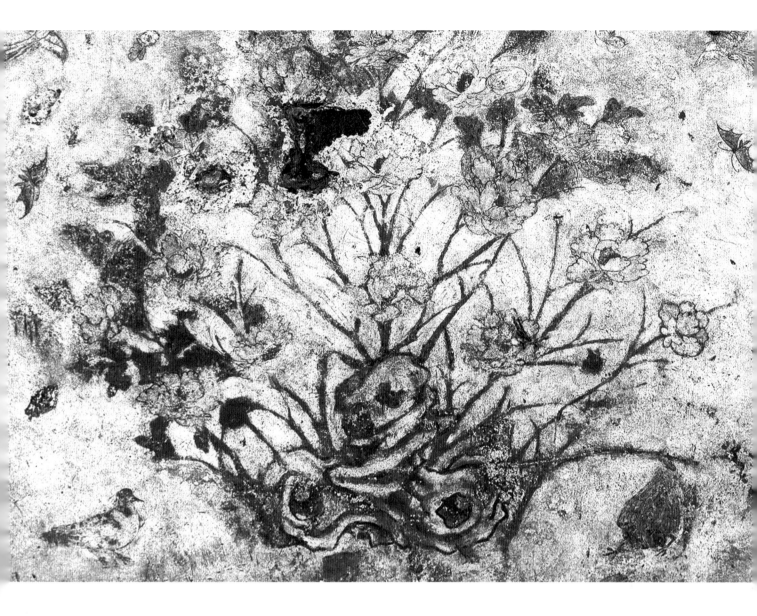

102.花鸟屏风（局部）

五代·唐同光二年（924年）

1994年河北省曲阳县西燕川村王处直墓出土。原址保存。

墓向159°。位于后室北壁，是一幅通景式壁画。上部绘二方连续的团花图案和垂幔。下面中心位置绘湖石和牡丹，其上、下两侧绘有飞舞的绶带鸟觅食的鸽子以及蜂蝶。在画面的两侧各绘一株蔷薇，其左右亦绘蜂蝶。左侧那只鸽子正回头注视着一只蚂蚱，看上去非常生动。此图为湖石和牡丹细部。

（撰文：郝建文　摄影：冯玲）

Flower-and–Bird Screen (Detail)

2nd Year of Tongguang Era, Later Tang of the Five dynasties (924 CE)

Unearthed from Wang Chuzhi's tomb at Xiyanchuancun in Quyang, Hebei, in 1994. Preserved on the original site.

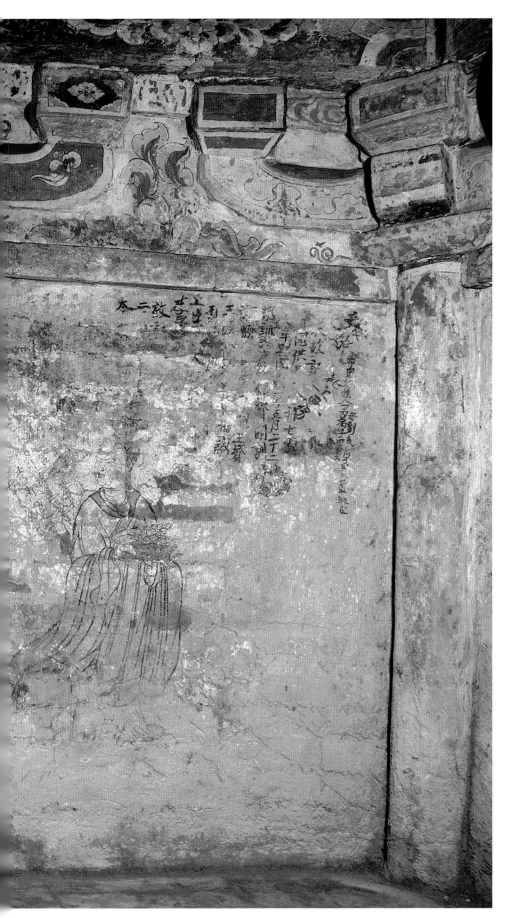

103.礼佛图（一）

北宋太平兴国二年（977年）

高约110、宽220厘米

1969年河北省定州市静志寺塔基地宫
出土。原址保存。

地宫门南向。位于塔基地宫东壁。为
礼佛图，图中梵王阔面大耳络腮胡，
目视前方，表情凝重，由二侍从搀扶
前行，前有另一侍从捧香花导引，去
朝拜释迦牟尼的情景。图上部和右上
角有大量墨书题记。

（撰文：狄云兰　摄影：郝建文）

Worshiping the Buddha (1)

2nd Year of Taipingxingguo Era,
Northern Song (977 CE)

Height ca. 110 cm; Width 220 cm

Unearthed from the underground palace
of the pagoda foundation at Jingzhisi
Temple in Dingzhou, Hebei, in 1969.
Preserved on the original site.

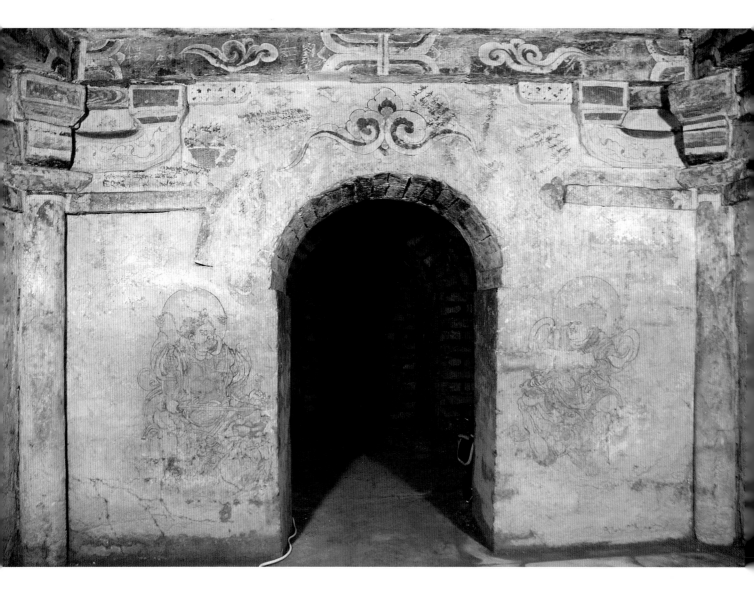

104.塔基地宫门

北宋太平兴国二年（977年）

高约115、宽67厘米

1969年河北省定州市静志寺塔基地宫出土。原址保存。

地宫门南向。此图位于地宫南壁券门，墓门上方以绿、黑、红彩描绘"品"字祥云一朵。墓门两侧各画一带背光的天王像，图上部有大量墨书题记。

<div align="right">（撰文：狄云兰　摄影：郝建文）</div>

Door of the Underground Palace

2nd Year of Taipingxingguo Era, Northern Song (977 CE)

Height ca. 115 cm; Width of door 67 cm

Unearthed from the underground palace of the pagoda foundation at Jingzhisi Temple in Dingzhou, Hebei, in 1969. Preserved on the original site.

105. 天王像（一）

北宋太平兴国二年（977年）

高约61、宽43.5厘米

1969年河北省定州市静志寺塔基地宫出土。原址保存。

地宫门南向。位于地宫门内右侧。天王身着盔甲，右手持剑，左手托塔，身后有背光，眼突眉蹙，咄咄逼人。

（撰文：狄云兰　摄影：郝建文）

Lokapala (1)

2nd Year of Taipingxingguo Era, Northern Song (977 CE)

Height ca. 61 cm; Width 43.5 cm

Unearthed from the underground palace of the pagoda foundation at Jingzhisi Temple in Dingzhou, Hebei, in 1969. Preserved on the original site.

106.天王像（二）

北宋太平兴国二年（977年）

高约61.5、宽46厘米

1969年河北省定州市静志寺塔基地宫出土。原址保存。

地宫门南向。位于地宫门内左侧。天王身着盔甲，右手握剑横立胸前，左手扶剑，身后有背光，西相威猛，威风凛凛，望而生畏。

（撰文：狄云兰　摄影：郝建文）

Lokapala (2)

2nd Year of Taipingxingguo Era, Northern Song (977 CE)

Height ca. 61.5 cm; Width 46 cm

Unearthed from the underground palace of the pagoda foundation at Jingzhisi Temple in Dingzhou, Hebei, in 1969. Preserved on the original site.

107.礼佛图（二）

北宋太平兴国二年（977年）

高约110、宽210厘米

1969年河北省定州市静志寺塔基地宫出土。原址保存。

地宫门南向。位于塔基地宫西壁。为礼佛图，图中帝释雍容华贵，面如银盆，体态丰腴，左手拿麈尾，由二女侍随从左右，前面有一僧捧瑞果导引，前去朝拜释迦牟尼的情景，图上部有大量墨书题记。

<div align="right">（撰文：狄云兰　摄影：郝建文）</div>

Worshiping the Buddha (2)

2nd Year of Taipingxingguo Era, Northern Song (977 CE)

Height ca. 110 cm; Width ca. 210 cm

Unearthed from the underground palace of the pagoda foundation at Jingzhisi Temple in Dingzhou, Hebei, in 1969. Preserved on the original site.

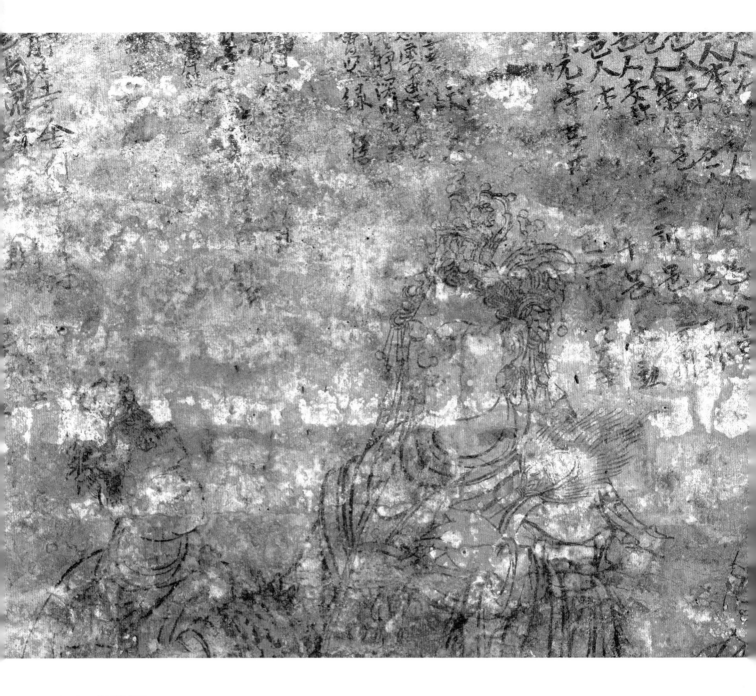

108. 帝释图

北宋太平兴国二年（977年）

高约75、宽60厘米

1969年河北省定州市静志寺塔基地宫出土。原址保存。

地宫门南向。位于塔基地宫西壁。为帝释形像（局部），头戴七宝冠，耳饰花钿，面部丰腴，神态端庄祥和。其头部上方写有"静志寺僧众攀前寺主持"等题款。

<div align="right">（撰文：狄云兰　摄影：郝建文）</div>

Sakra-devanam-Indra

2nd Year of Taipingxingguo Era, Northern Song (977 CE)

Height ca. 75 cm; Width 60 cm

Unearthed from the underground palace of the pagoda foundation at Jingzhisi Temple in Dingzhou, Hebei, in 1969. Preserved on the original site.

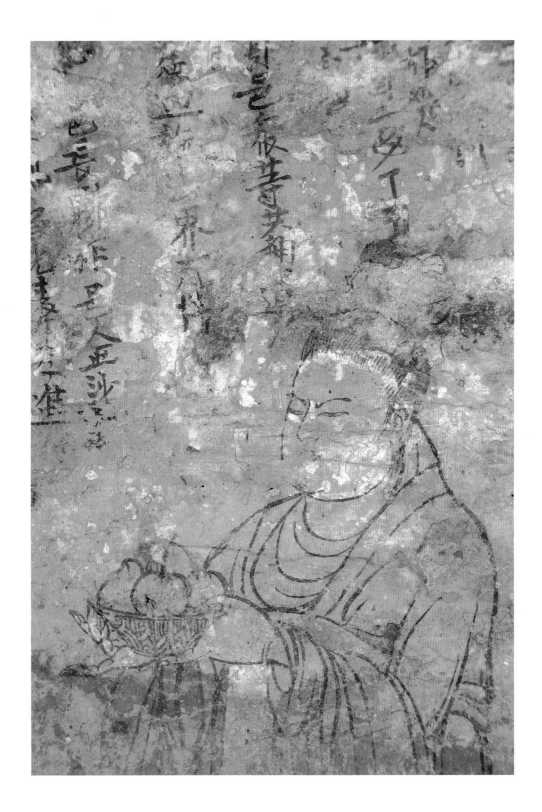

109．人物图

北宋太平兴国二年（977年）

高约59、宽29厘米

1969年河北省定州市静志寺塔基地宫出土。原址保存。
地宫门南向。位于塔基地宫西壁。为礼佛图中的僧侣形
像（局部），前方导引人物，梳高包髻，着圆领广袖
袍，手捧瑞果，神态淡然，上方墨书题记，写有供养人
的姓名及财物名称。

（撰文：狄云兰　摄影：郝建文）

Figure

2nd Year of Taipingxingguo Era,
Northern Song (977 CE)
Heigh ca. 59 cm; Width 29 cm
Unearthed from the underground
palace of the pagoda foundation
at Jingzhisi Temple in Dingzhou,
Hebei, in 1969. Preserved on the
original site.

110.建筑彩绘图

北宋 太平兴国二年（977年）

高约25、长210厘米

1969年河北省定州市静志寺塔基地宫出土。原址保存。

地宫门南向。位于塔基地宫西壁砖砌仿木斗拱。为彩绘图，塔基内部四角砌圆形砖柱，柱上四壁均做出一斗三升式仿木斗拱，斗拱上绘以祥云、莲花、箍头等图案。每壁各有一结构相同的补间斗拱，斗拱上承撩檐枋，其上为叠涩攒尖顶。

（撰文：狄云兰　摄影：郝建文）

Imitation Wooden Brackets with Painting

2nd Year of Taipingxingguo Era, Northern Song (977 CE)

Height ca. 25 cm; Width 210 cm

Unearthed from the underground palace of the pagoda foundation at Jingzhisi Temple in Dingzhou, Hebei, in 1969. Preserved on the original site.

111. "帝释"牌位图

北宋太平兴国二年（977年）

高约23、宽15厘米

1969年河北省定州市静志寺塔基地宫出土。原址保存。

地宫门南向。位于塔基地宫西壁，该图为一莲花托起的木盘，上写"帝释"二字，周围为信徒供养舍利及所记年月的墨书供养人题记。

（撰文：狄云兰　摄影：郝建文）

Tablet of Sakra-devanam-Indra

2nd Year of Taipingxingguo Era, Northern Song (977 CE)

Height ca. 23 cm; Width 15 cm

Unearthed from the underground palace of the pagoda foundation at Jingzhisi Temple in Dingzhou, Hebei, in 1969. Preserved on the original site.

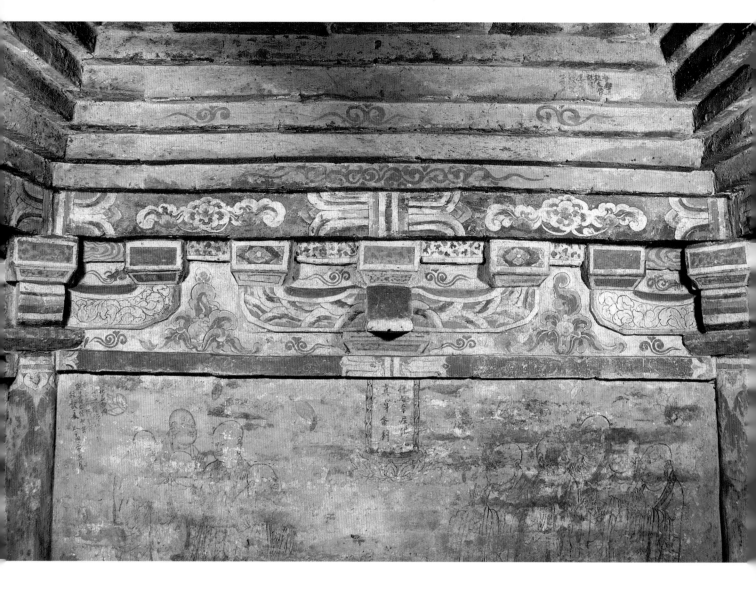

112.众弟子举哀图

北宋太平兴国二年（977年）

高约110、宽217厘米

1969年河北省定州市静志寺塔基地宫出土。原址保存。

地宫门南向。位于塔基地宫北壁。中间为莲花座牌，上写"释迦牟尼佛真身舍利"，两侧各有五个僧人，均双手合十，神态严肃悲戚，为释迦牟尼尸体火化后，他的10个弟子安葬举哀的情形。

（撰文：狄云兰　摄影：郝建文）

Buddha's Disciples Wailing in Mourning

2nd Year of Taipingxingguo Era, Northern Song (977 CE)

Height ca. 110 cm; Width 217 cm

Unearthed from the underground palace of the pagoda foundation at Jingzhisi Temple in Dingzhou, Hebei, in 1969. Preserved on the original site.

113.莲花座牌位图

北宋太平兴国二年（977年）

高约29、宽25厘米

1969年河北省定州市静志寺塔基地宫出土。原址保存。

地宫门南向。位于塔基地宫北壁。下端为一莲花座，座上供奉有书写"释迦牟尼佛真身舍利"的牌位。为众弟子举哀图的局部。

（撰文：狄云兰　摄影：郝建文）

Tablet on Lotus Pedestal

2nd Year of Taipingxingguo Era, Northern Song (977 CE)

Height ca. 29 cm; Width 25 cm

Unearthed from the underground palace of the pagoda foundation at Jingzhisi Temple in Dingzhou, Hebei, in 1969. Preserved on the original site.

114.墨书题记

北宋太平兴国二年（977年）

1969年河北省定州市静志寺塔基地宫出土。原址保存。
地宫门南向。位于塔基地宫北壁。内容为修建舍利阁的
静志寺头陀及主要僧人法号，记有"太平兴二年五月"
（977年）的纪年。为众弟子举哀图的局部。

<div align="right">（撰文：狄云兰　摄影：郝建文）</div>

Ink Inscriptions

2nd Year of Taipingxingguo Era,
Northern Song (977 CE)
Unearthed from the underground palace
of the pagoda foundation at Jingzhisi
Temple in Dingzhou, Hebei, in 1969.
Preserved on the original site.

120

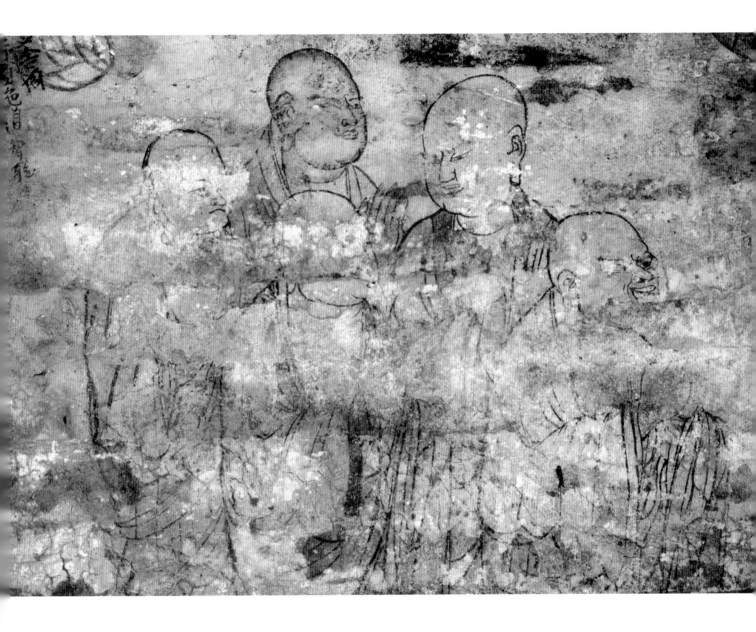

115.众弟子举哀图（局部）

北宋 太平兴国二年（977年）

高约71、宽55厘米

1969年河北省定州市静志寺塔基地宫出土。原址保存。

地宫门南向。位于塔基地宫北壁。为释迦牟尼10个弟子中的五个弟子祭拜释迦牟尼的情形，5人簇拥而立，着交领广袖僧袍，双手合十面向灵牌，神态悲戚。

（撰文：狄云兰　摄影：郝建文）

Buddha's Disciples Wailing in Mourning (Detail)

2nd Year of Taipingxingguo Era, Northern Song (977 CE)

Height ca. 71 cm; Width 55 cm

Unearthed from the underground palace of the pagoda foundation at Jingzhisi Temple in Dingzhou, Hebei, in 1969. Preserved on the original site.

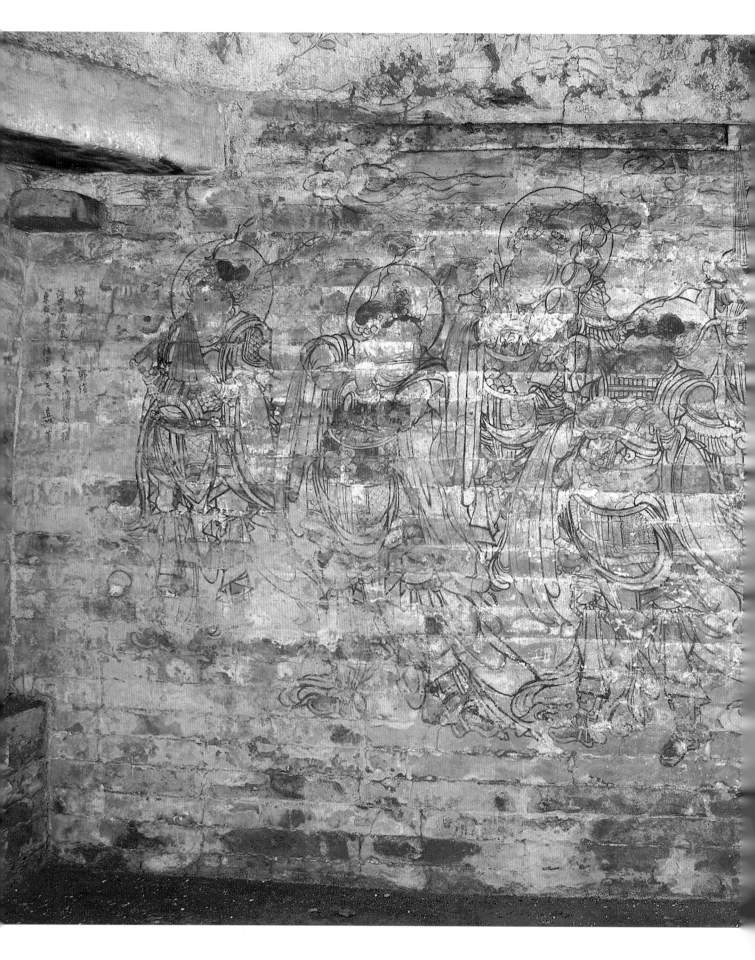

116.天部伎乐图（一）

北宋 至道元年（995年）

高约170、宽270厘米

1969年河北省定州市净众院塔基地宫出土。原址保存。

地宫门南向。位于地宫西壁。六位乐师，呈四前二后排列，各自演奏所持乐器，计有横笛、拍板、串鼓、排箫和笙。祥云四布，衣带飘拂。

（撰文：席玉红　摄影：郝建文）

Music Band (1)

1st Year of Zhidao Era, Northern Song (995 CE)

Height ca. 170 cm; Width 270 cm

Unearthed from the underground palace of the pagoda foundation at Jingzhongyuan Temple in Dingzhou, Hebei, in 1969. Preserved on the original site.

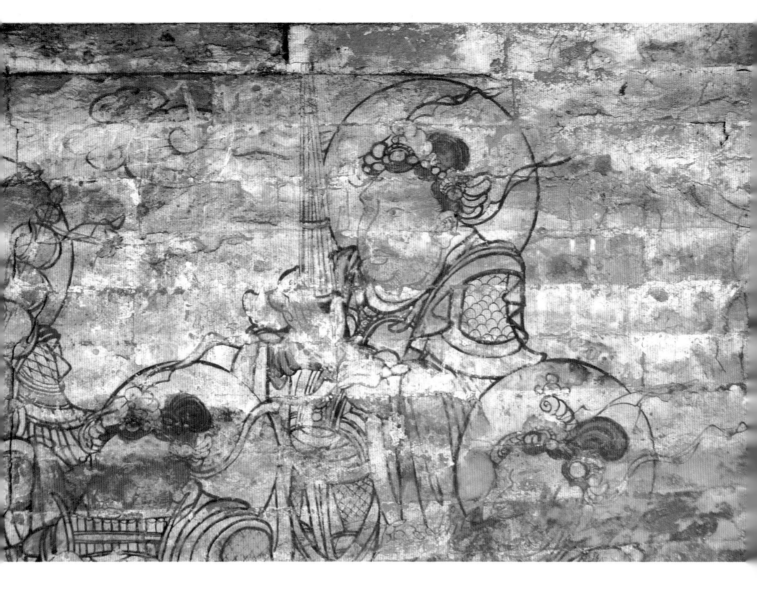

117. 天部伎乐图（一）（局部）

北宋至道元年（995年）

高约135、宽115厘米

1969年河北省定州市净众院塔基地宫出土。原址保存。

地宫门南向。位于地宫西壁，为乐队从北数第1~3位乐师，图中后部的乐师头戴花冠，内着广袖衫，外着铠甲，身后有圆形背光，正在吹笙。

<div style="text-align: right">（撰文：席玉红　摄影：郝建文）</div>

Music Band (1) (Detail)

1st Year of Zhidao Era, Northern Song (995 CE)

Height ca. 135 cm; Width 115 cm

Unearthed from the underground palace of the pagoda foundation at Jingzhongyuan Temple in Dingzhou, Hebei , in 1969. Preserved on the original site.

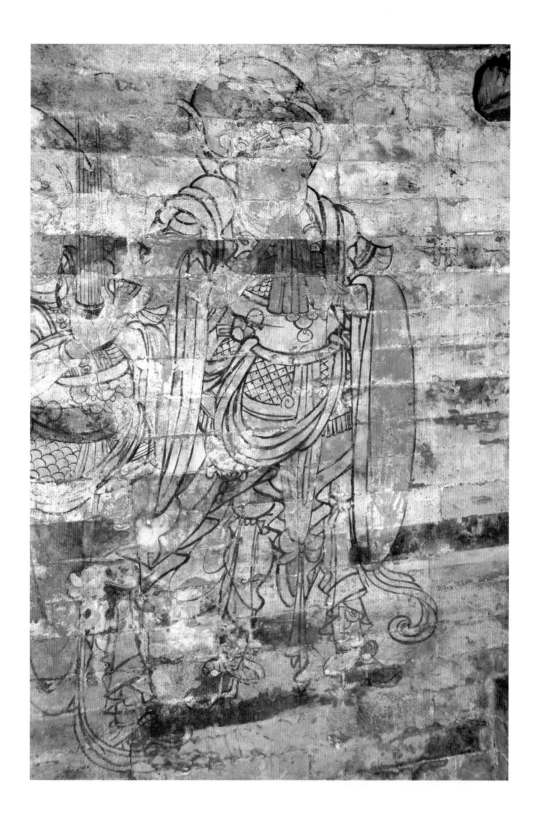

118. 天部伎乐园（二）（局部一）

北宋至道元年（995年）

高约135、宽35厘米

1969年河北省定州市净众院塔基地宫出土。原址保存。

地宫门南向。位于地宫东壁。为另一组乐伎，共六位乐师，呈四前二后排列。图中为右边第一人。内着广袖衫，外着铠甲，手持拍板，身后有圆形背光。

（撰文：席玉红　摄影：郝建文）

Music Band (2) (Detail 1)

1st Year of Zhidao Era, Northern Song (995 CE)

Height ca. 135 cm; Width 35 cm

Unearthed from the underground palace of the pagoda foundation at Jingzhongyuan Temple in Dingzhou, Hebei, in 1969. Preserved on the original site.

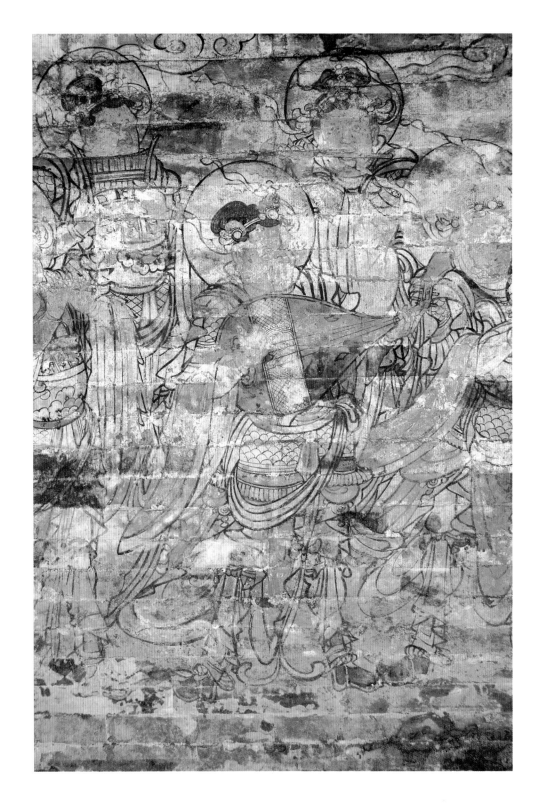

119. 天部伎乐图（二）（局部二）

北宋至道元年（995年）

高约165、宽260厘米

1969年河北省定州市净众院塔基地宫出土。原址保存。地宫门南向。位于地宫东壁。图中祥云四布，衣带飘拂，着色轻淡相宜，六位乐伎，呈四前二后排列，图为队列从右数第2~5人，各人手中均拿有乐器，计有横笛，琵琶和排萧。

（撰文：席玉红　摄影：郝建文）

Music Band (2) (Detail 2)

1st Year of Zhidao Era, Northern Song (995 CE)

Height ca. 165 cm; Width 260 cm

Unearthed from the underground palace of the pagoda foundation at Jingzhongyuan Temple in Dingzhou, Hebei, in 1969. Preserved on the original site.

120.祥云、丹凤

北宋至道元年（995年）

高约90、宽140厘米

1969年河北省定州市净众院塔基地宫出土。原址保存。

地宫门南向。位于地宫顶西侧。整体画面由祥云、息翅的孔雀和周围的牡丹、栀子等花卉构成，线条流畅，画工细腻，这种祥云、翎毛构成的图案常常象征吉祥舒适的上天境地。

<div align="right">（撰文：席玉红　摄影：郝建文）</div>

Auspicious Clouds and Peacock

1st Year of Zhidao Era, Northern Song (995 CE)

Height ca. 90 cm; Width 140 cm

Unearthed from the underground palace of the pagoda foundation at Jingzhongyuan Temple in Dingzhou, Hebei, in 1969. Preserved on the original site.

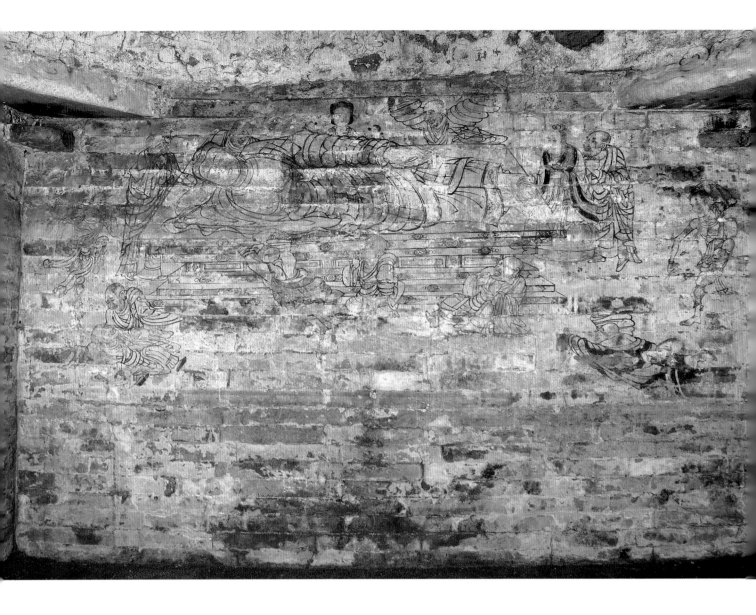

121.释迦牟尼涅槃图

北宋至道元年（995年）

高约170、宽270厘米

1969年河北省定州市净众院塔基地宫出土。原址保存。

地宫门南向。位于地宫北壁。为释迦牟尼涅槃后，十大弟子闻噩耗奔丧的场面。释迦曲肱代枕，侧身卧于须弥座棺床上，双目闭合，神态安祥，诸弟子各具悲情，整个画面哭天泪地，一片悲悼。

（撰文：席玉红　摄影：郝建文）

Nirvana of Sakyamuni

1st Year of Zhidao Era, Northern Song (995 CE)

Height ca. 170 cm; Width 270 cm

Unearthed from the underground palace of the pagoda foundation at Jingzhongyuan Temple in Dingzhou, Hebei, in 1969. Preserved on the original site.

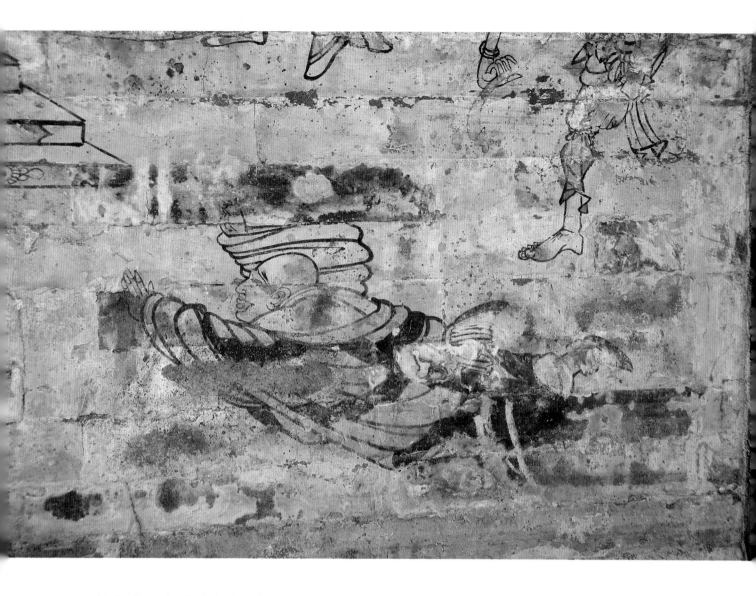

122.释迦牟尼涅槃图（局部一）

北宋至道元年（995年）

高约35、宽55厘米

1969年河北省定州市净众院塔基地宫出土。原址保存。

地宫门南向。位于地宫北壁东南角。为释迦牟尼涅槃后，弟子闻迅赶来，哭跌在地的场景。

<div align="right">（撰文：席玉红　摄影：郝建文）</div>

Nirvana of Sakyamuni (Detail 1)

1st Year of Zhidao Era, Northern Song (995 CE)

Height ca. 35 cm; Width 55 cm

Unearthed from the underground palace of the pagoda foundation at Jingzhongyuan Temple in Dingzhou, Hebei, in 1969. Preserved on the original site.

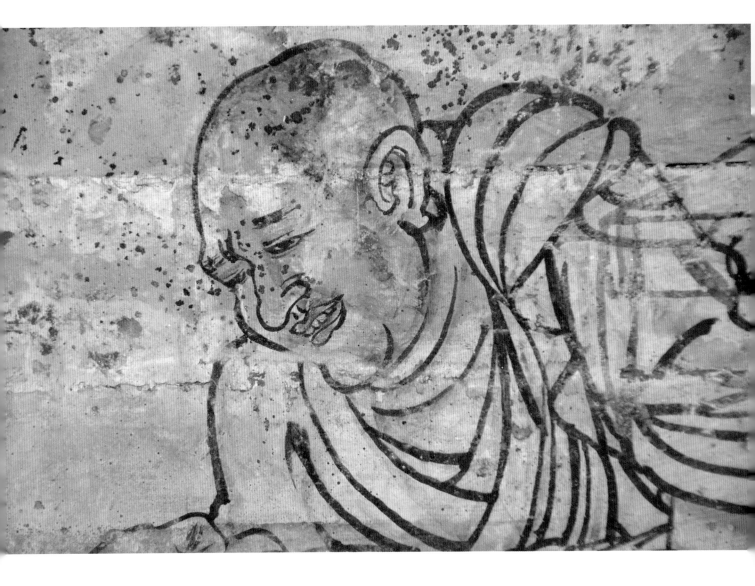

123.释迦牟尼涅槃图（局部二）

北宋 至道元年（995年）

高约35、宽55厘米

1969年河北省定州市净众院塔基地宫出土。原址保存。

地宫门朝南。位于地宫北壁西南角。为释迦牟尼涅槃后，一弟子昏厥倒地，另一弟子正在劝说的场景。

（撰文：席玉红 摄影：郝建文）

Nirvana of Sakyamuni (Detail 2)

1st Year of Zhidao Era, Northern Song (995 CE)

Height ca. 35 cm; Width 55 cm

Unearthed from the underground palace of the pagoda foundation at Jingzhongyuan Temple in Dingzhou, Hebei, in 1969. Preserved on the original site.

124.释迦牟尼涅槃图（局部三）

北宋 至道元年（995年）

高约35、宽55厘米

1969年河北省定州市净众院塔基地宫出土。原址保存。

地宫门南向。位于地宫北壁正中释迦牟尼遗体下方。为释迦牟尼涅槃后，一弟子俯前哀嚎，另一弟子在趺坐哭诉的场景。

（撰文：席玉红　摄影：郝建文）

Nirvana of Sakyamuni (Detail 3)

1st Year of Zhidao Era, Northern Song (995 CE)

Height ca. 35 cm; Width 55 cm

Unearthed from the underground palace of the pagoda foundation at Jingzhongyuan Temple in Dingzhou, Hebei, in 1969. Preserved on the original site.

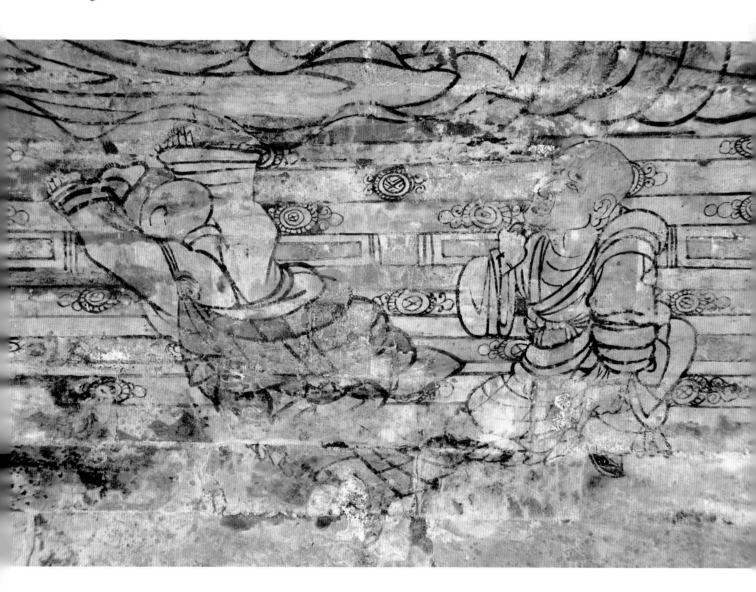

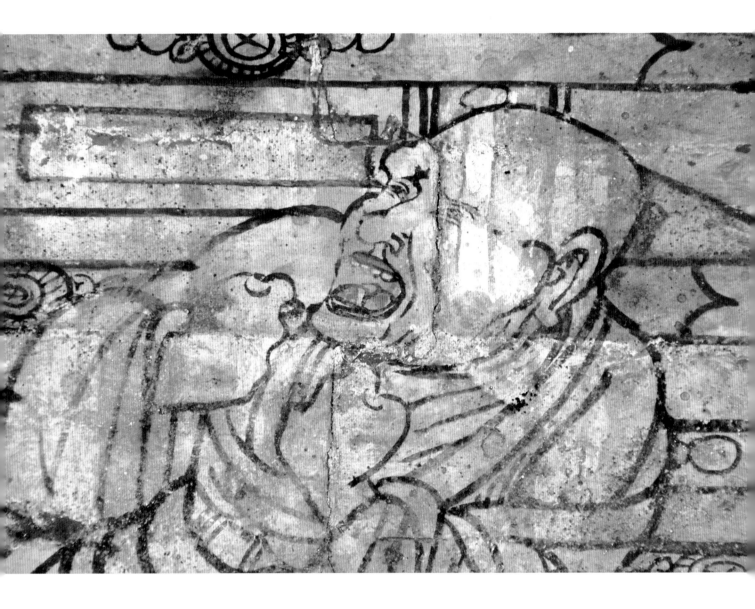

125.释迦牟尼涅槃图（局部四）

北宋至道元年（995年）

高约25、宽35厘米

1969年河北省定州市净众院塔基地宫出土。原址保存。

地宫门南向。位于地宫北壁正中，释迦牟尼遗体下方。为释迦牟尼涅槃后，弟子捶胸痛哭的场景。

（撰文：席玉红　摄影：郝建文）

Nirvana of Sakyamuni (Detail 4)

1st Year of Zhidao Era, Northern Song (995 CE)

Height ca. 25 cm; Width 35 cm

Unearthed from the underground palace of the pagoda foundation at Jingzhongyuan Temple in Dingzhou, Hebei, in 1969. Preserved on the original site.

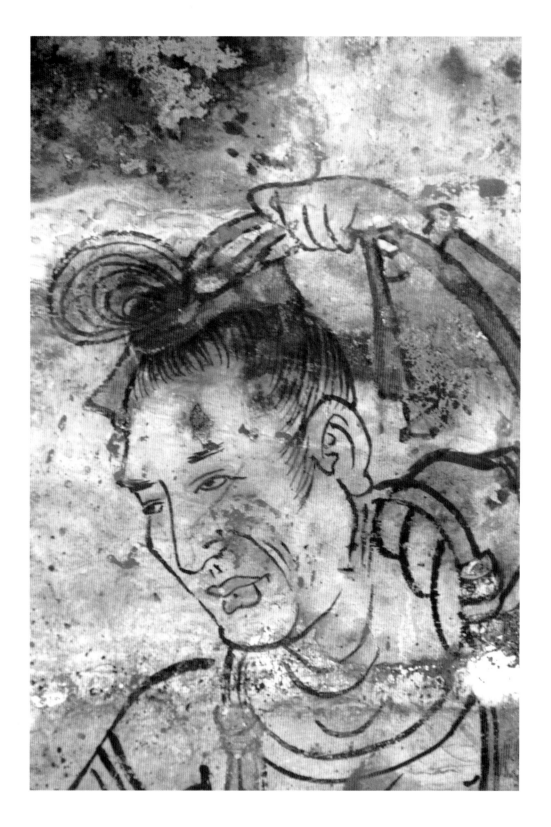

126.释迦牟尼涅槃图（局部五）

北宋至道元年（995年）

高约50、宽35厘米

1969年河北省定州市净众院塔基地宫出土。原址保存。

地宫门南向。位于地宫北壁东侧。为释迦牟尼涅槃后，前往举哀的诸国王子之一，头梳髻由于深感悲哀，流露出痛悼的神态。

(撰文：席玉红　摄影：郝建文)

Nirvana of Sakyamuni (Detail 5)

1st Year of Zhidao Era, Northern Song (995 CE)

Height ca. 50 cm; Width 35 cm

Unearthed from the underground palace of the pagoda foundation at Jingzhongyuan Temple in Dingzhou, Hebei, in 1969. Preserved on the original site.

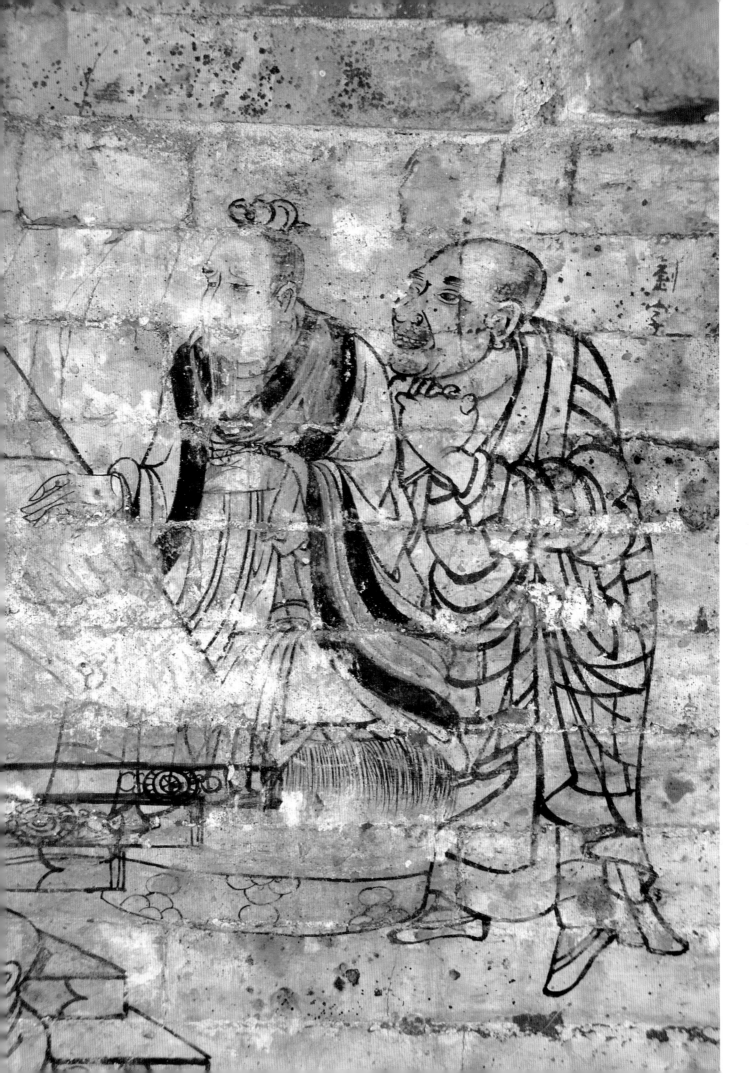

◀ 127. 释迦牟尼涅槃图（局部六）

北宋至道元年（995年）

高约45、宽40厘米

1969年河北省定州市净众院塔基地宫出土。原址保存。

地宫门南向。位于地宫北壁东侧，为释迦牟尼之父净梵王手抚其足腕作诊脉状，他神态沉静，尚存一些希望，不忍其子谢世。一弟子含悲作劝解状。

（撰文：席玉红　摄影：郝建文）

Nirvana of Sakyamuni (Detail 6)

1st Year of Zhidao Era, Northern Song (995 CE)

Height ca. 45 cm; Width 40 cm

Unearthed from the underground palace of the pagoda foundation at Jingzhongyuan Temple in Dingzhou, Hebei, in 1969. Preserved on the original site.

▼ 128. 释迦牟尼涅槃图（局部七）

北宋 至道元年（995年）

高约20、宽30厘米

1969年河北省定州市净众院塔基地宫出土。原址保存。

地宫门南向。位于地宫北壁正中，释迦牟尼尸体上方。为释迦牟尼涅槃后，弟子伏尸痛哭的场景。

（撰文：席玉红　摄影：郝建文）

Nirvana of Sakyamuni (Detail 7)

1st Year of Zhidao Era, Northern Song (995 CE)

Height ca. 20 cm; Width 30 cm

Unearthed from the underground palace of the pagoda foundation at Jingzhongyuan Temple in Dingzhou, Hebei, in 1969. Preserved on the original site.

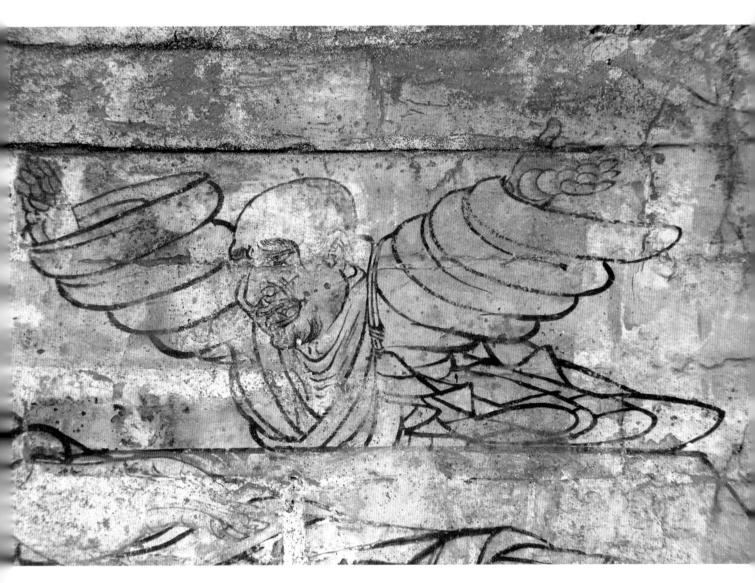

129. 释迦牟尼涅槃图（局部八）

北宋至道元年（995年）

高约12、宽30厘米

1969年河北省定州市净众院塔基地宫出土。原址保存。

地宫门南向。位于地宫北壁正中，释迦牟尼尸体后方。为释迦牟尼涅槃后，其母王后摩耶夫人守侯在身后，神态肃穆、悲悯。

（撰文：席玉红　摄影：郝建文）

Nirvana of Sakyamuni (Detail 8)

1st Year of Zhidao Era, Northern Song (995 CE)

Height ca. 12 cm; Width 30 cm

Unearthed from the underground palace of the pagoda foundation at Jingzhongyuan Temple in Dingzhou, Hebei, in 1969. Preserved on the original site.

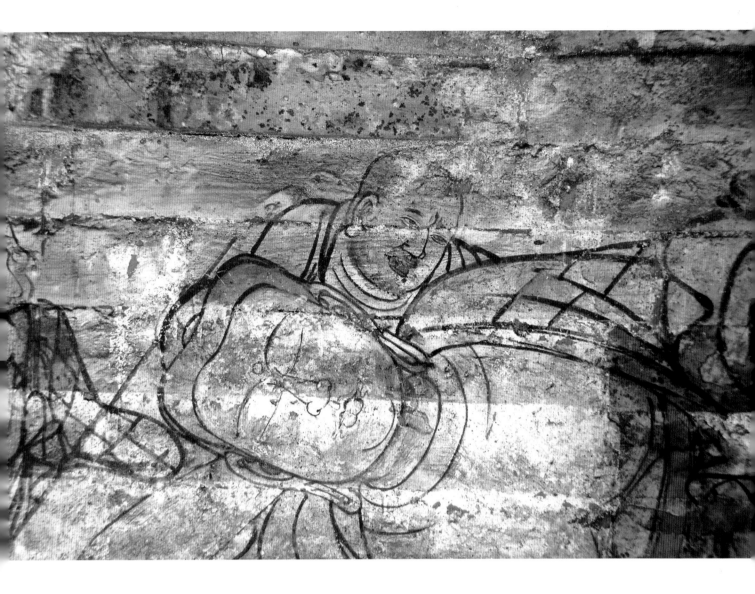

130. 释迦牟尼涅槃图（局部九）

北宋至道元年（995年）

高约45、宽40厘米

1969年河北省定州市净众院塔基地宫出土。原址保存。

地宫门南向。位于地宫北壁正中。释迦牟尼涅槃后，曲躬代枕，侧卧于高大棺床之上，两眼微闭，神态安祥。

（撰文：席玉红　摄影：郝建文）

Nirvana of Sakyamuni (Detail 9)

1st Year of Zhidao Era, Northern Song (995 CE)

Height ca. 45 cm; Width 40 cm

Unearthed from the underground palace of the pagoda foundation at Jingzhongyuan Temple in Dingzhou, Hebei, in 1969. Preserved on the original site.

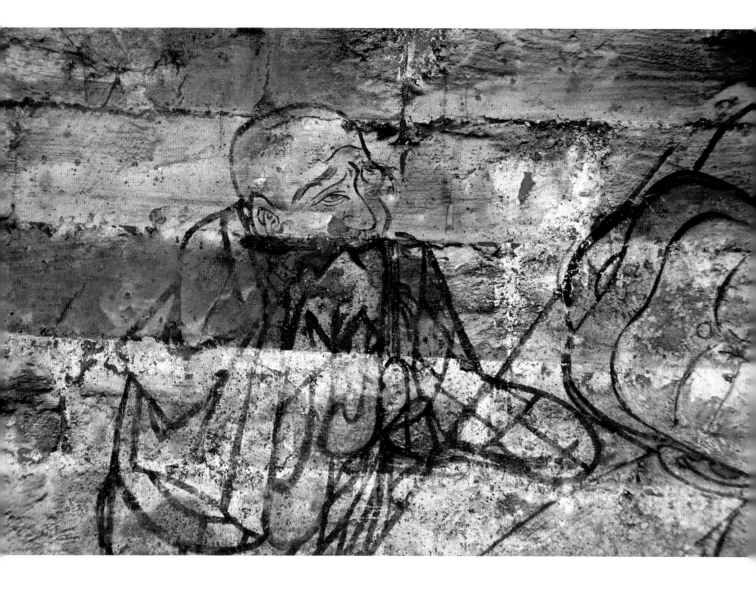

131.释迦牟尼涅槃图（局部十）

北宋至道元年（995年）

高约50、宽27厘米

1969年河北省定州市净众院塔基地宫出土。原址保存。

地宫门南向。位于地宫北壁西侧，释迦牟尼头前。为释迦牟尼涅槃后，弟子哭泣的场景。

（撰文：席玉红　摄影：郝建文）

Nirvana of Sakyamuni (Detail 10)

1st Year of Zhidao Era, Northern Song (995 CE)

Height ca. 50 cm; Width 27 cm

Unearthed from the underground palace of the pagoda foundation at Jingzhongyuan Temple in Dingzhou, Hebei, in 1969. Preserved on the original site.

132.侍女图

宋（960～1279年）

人物高约72厘米

1996年河北省平山县两岔村宋墓1号墓出土。原址保存。

墓向170°。位于墓室西南壁。画面为一卧犬、一侍女和几朵云。卧犬头朝墓门方向。侍女头梳双垂髻，上穿褙子，下着百折裙，手托盛在容器中的三个桃子，面向右侧。

<div align="right">（撰文：郝建文　摄影：张春长）</div>

Maid

Song (960-1279 CE)

Maid height ca. 72 cm

Unearthed from Song tomb M1 at Liangchacun in Pingshanxian, Hebei, in 1996. Preserved on the original site.

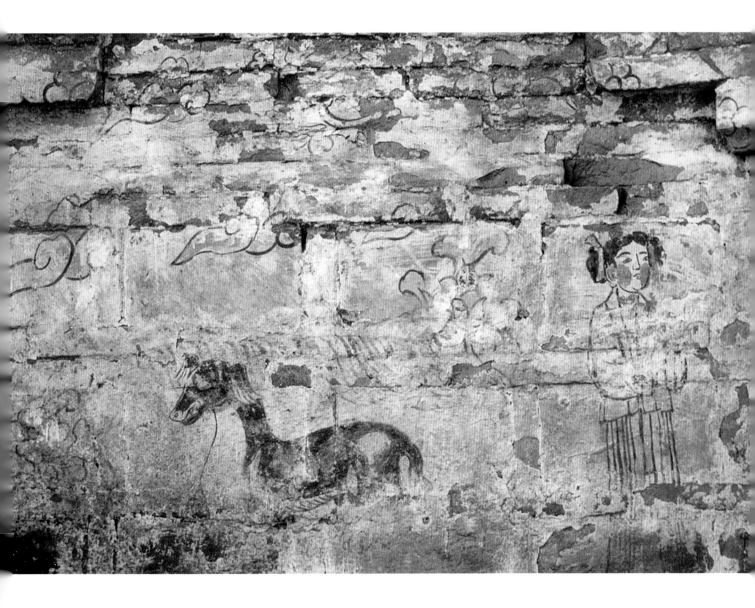

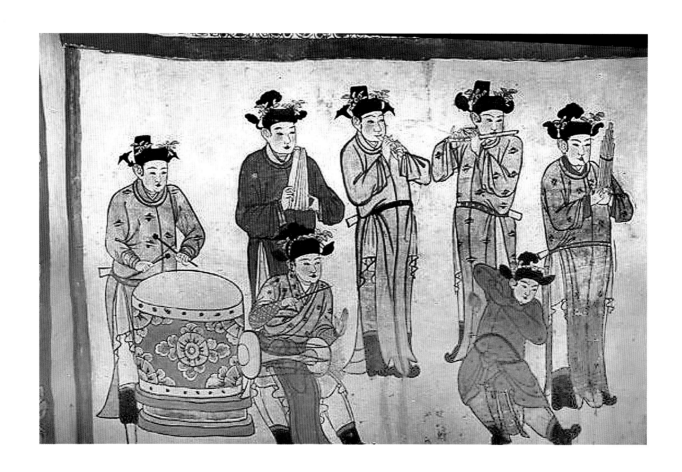

133.散乐图

辽大安九年（1093年）

高150、宽170厘米

1993年河北省宣化下八里7号张文藻墓出土。原址保存。

墓向200°。位于前室西壁。画面由7个人物组成，其中一人跳舞，一人边击腰鼓边跳舞。另外5人，从右向左依次为吹笙者、吹横笛者、吹觱篥者、击拍板者和击大鼓者。

（撰文：郝建文　摄影：张羽）

Music Band

9th Year of Da'an Era, Liao (1093 CE)

Height 150 cm; Width 170 cm

Unearthed from Zhang Wenzao's Tomb at Xiabali in Xuanhua, Hebei, in 1993. Preserved on the original site.

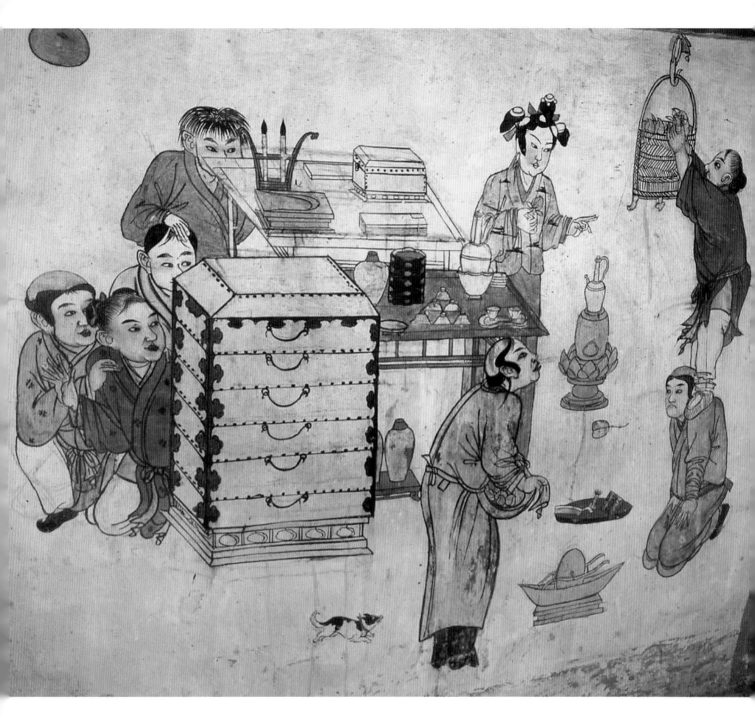

134.童嬉图

辽大安九年（1093年）

高150、宽170厘米

1993年河北省宣化下八里7号张文藻墓出土。原址保存。

墓向200°。位于前室东壁。画面由八个人物和相关的器具组成。以方桌和食盒为界，人物可分为两组。右面一组，一女子右手拿桃，左手指向踩在男子肩上伸手从吊篮中取桃子之人，另一名男子双手撩起盛有桃子的衣服前襟，仰头注视着取桃男子。他们四人中间放有茶碾、风炉、汤瓶和漆盘等；左面一组是四个俏皮的儿童，藏在食箱和方桌后面，窥视着取桃的男子。桌上放着注碗注壶一套、圆盘、瓷碗、砚台、笔架、经书等物。画面上有一奔跑的小狗。表现备祭场景。

（撰文：郝建文　摄影：张羽）

Children Playing

9th Year of Da'an Era, Liao (1093 CE)

Height 150 cm; Width 170 cm

Unearthed from Zhang Wenzao's Tomb at Xiabali in Xuanhua, Hebei, in 1993. Preserved on the original site.

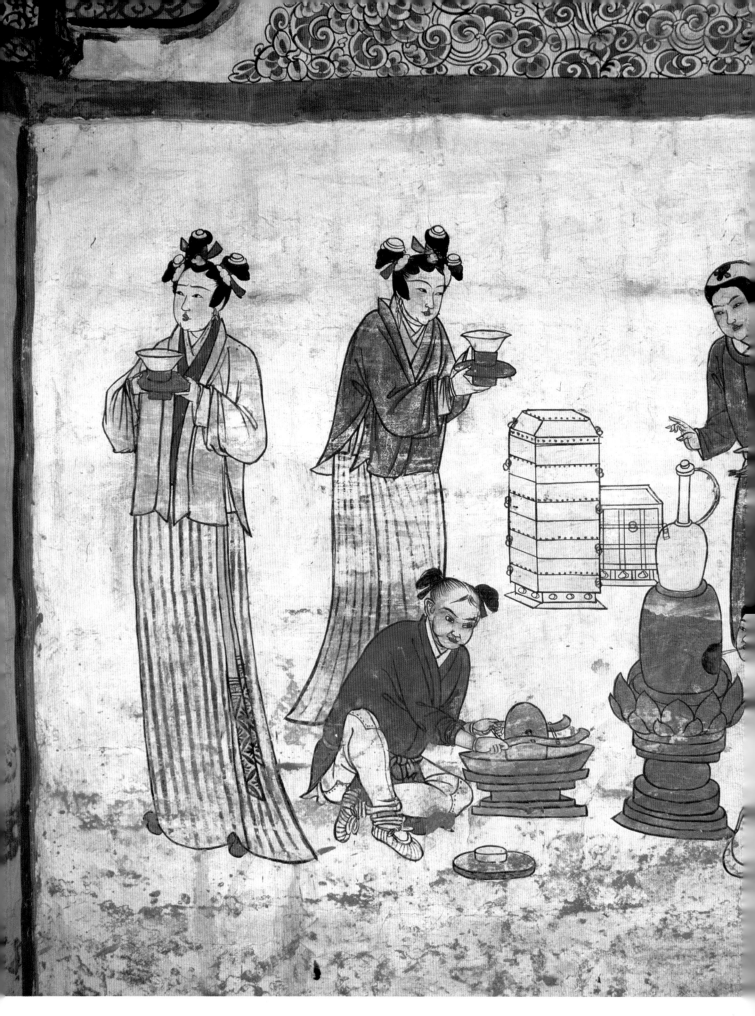

135.备茶图

辽大安九年（1093年）

高152、宽181厘米

1993年河北省宣化下八里10号张匡正墓出土。原址保存。

墓向200°。位于前室东壁。描绘的是备茶程序情景，由五个不同年龄、不同性别的人物组成。前面是碾茶女侍和向风炉内吹火的男侍，炉上坐一汤瓶。其后是右手扬起，左手向前似欲取汤瓶的男子。男子的左右是一大一小两个函盒和方桌。桌上有带藤套瓶、执壶、小函盒、茶筅、茶匙和茶钳等。和他们呼应的是头戴簪花的侍女，上着袄，下着百褶裙，双手捧托盏，徐步向前。另外一侍女，身穿袄和百褶裙，双手捧托盏，面北而立。

（撰文：郝建文　摄影：冯玲）

Preparing for Tea Reception

9th Year of Da'an Era, Liao (1093 CE)

Height 152 cm; Width 181 cm

Unearthed from Zhang Kuangzheng's Tomb (M10) at Xiabali in Xuanhua, Hebei, in 1993. Preserved on the original site.

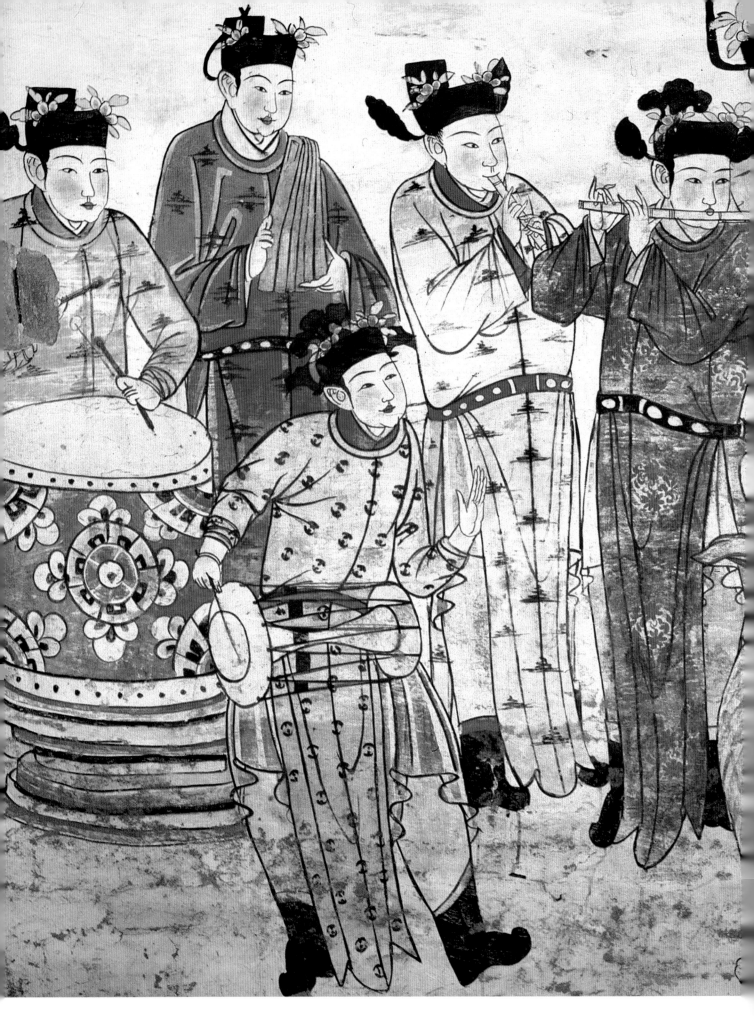

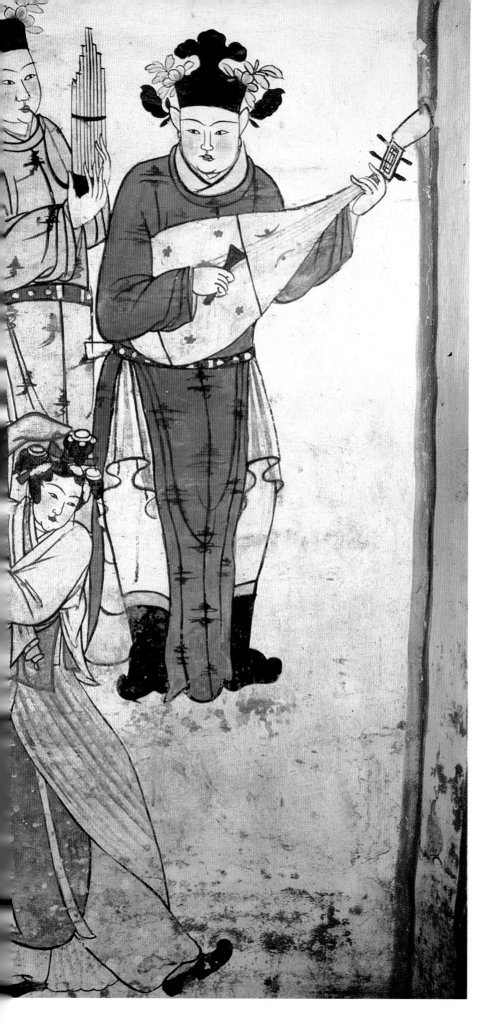

136. 散乐图

辽大安九年（1093年）

高152、宽181厘米

1993年河北省宣化下八里10号张匡正墓出土。原址保存。

墓向200°。位于前室西壁。描绘由7人的乐队和一个舞旋色组成的散乐场面。乐队从右至左依次为琵琶、笙、横笛、觱篥、腰鼓、拍板和大鼓，乐伎均戴幞头，左二为交脚幞头，右二为朝天幞头，余为短脚幞头；均着圆领开胯长袍。足登靴。舞旋色梳三髻，簪花，上着短袄，内着交领长衫，下着裤，足登尖头鞋，做旋舞状。

（撰文：郝建文 摄影：冯玲）

Music Band

9th Year of Da'an Era, Liao (1093 CE)

Height 152 cm; Width 181 cm

Unearthed from Zhang Kuangzheng's Tomb (M10) at Xiabali in Xuanhua, Hebei, in 1993. Preserved on the original site.

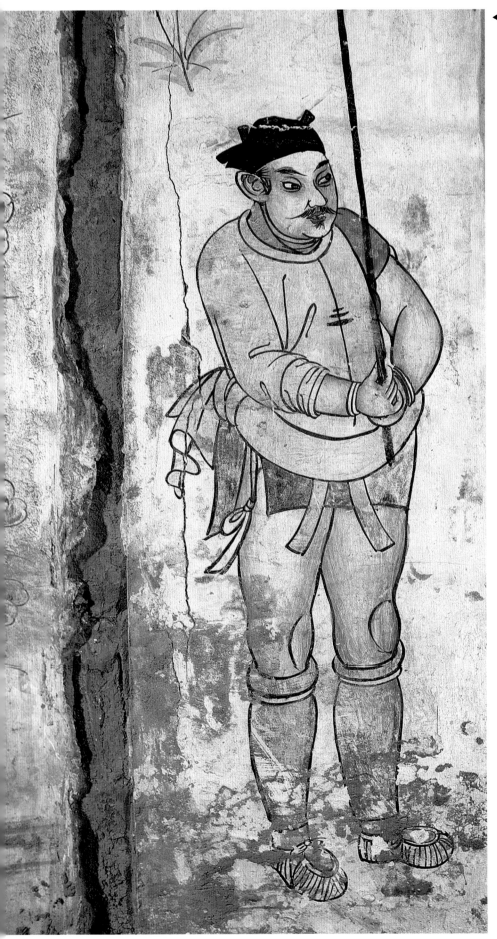

◀ 137.门吏图（一）

辽大安九年（1093年）

宽76厘米

1993年河北省宣化下八里10号张匡正墓出土。原址保存。

墓向200°。位于前室后甬道西壁。此人物头戴软巾，穿绿色紧袖四襈衫，衣襟撩起掖于腰间，无裤，赤裸大腿，小腿着膝裤，穿麻鞋，抱杖而立。

（撰文：郝建文　摄影：冯玲）

Door Guard (1)

9th Year of Da'an Era, Liao (1093 CE)

Width 76 cm

Unearthed from Zhang Kuangzheng's Tomb (M10) at Xiabali in Xuanhua, Hebei, in 1993. Preserved on the original site.

138.门吏图（二）▶

辽大安九年（1093年）

宽76厘米

1993年河北省宣化下八里10号张匡正墓出土。原址保存。

墓向200°。位于前室后甬道东壁。此人物头戴软巾，穿绿色紧袖四襈衫，衣襟撩起掖于腰间，无裤，赤裸大腿，小腿着膝裤，穿麻鞋，抱杖而立。

（撰文：郝建文　摄影：冯玲）

Door Guard (2)

9th Year of Da'an Era, Liao (1093 CE)

Width 76 cm

Unearthed from Zhang Kuangzheng's Tomb (M10) at Xiabali in Xuanhua, Hebei, in 1993. Preserved on the original site.

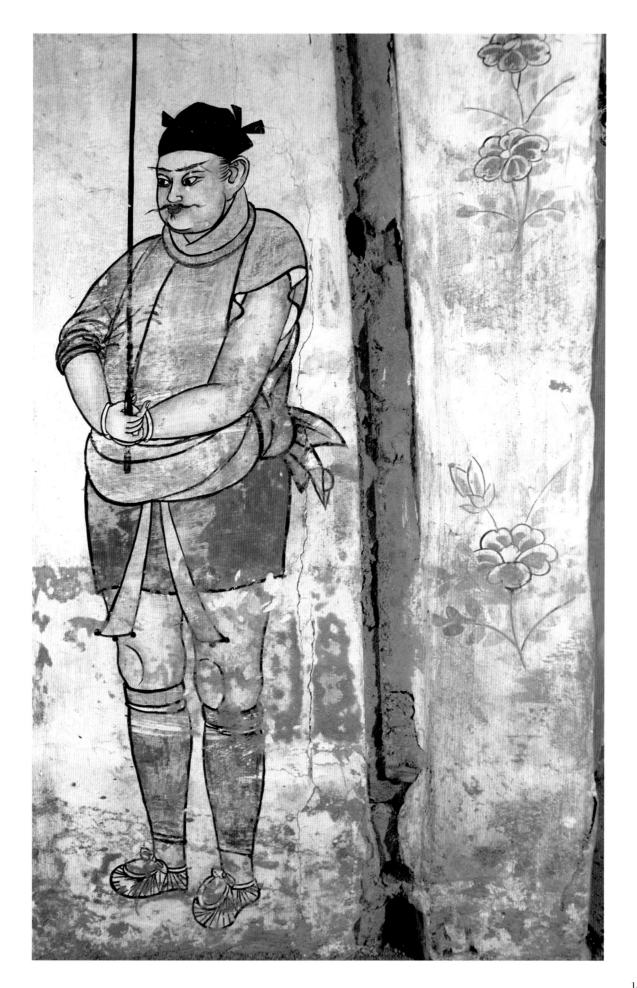

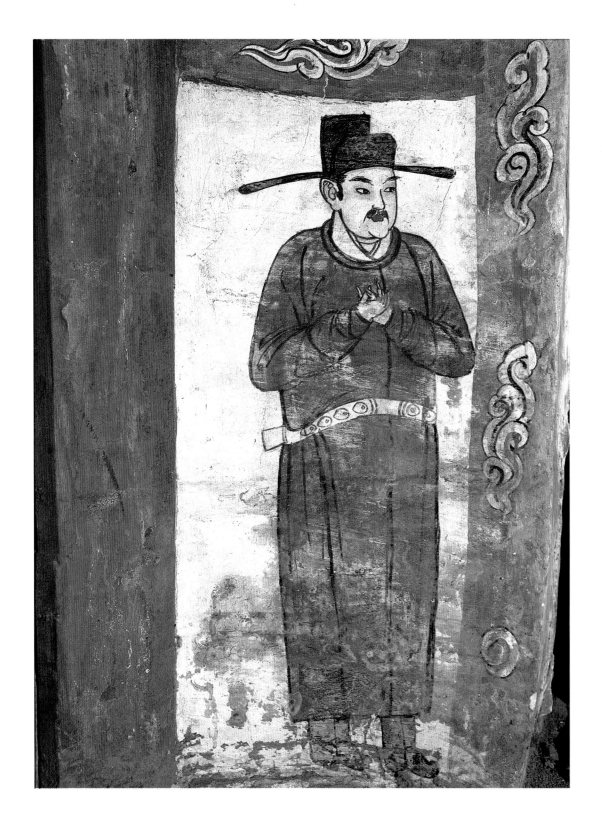

139.门吏图（三）

辽大安九年（1093年）

高100、宽40厘米

1993年河北省宣化下八里10号张匡正墓出土。原址保存。墓向200°。位于后室南壁拱门东侧。此人物头戴黑色展脚幞头，紫色圆领长袍，腰束带，足穿皂靴，叉手而立。

（撰文：郝建文　摄影：冯玲）

Door Guard (3)

9th Year of Da'an Era, Liao (1093 CE)
Height 100 cm; Width 40 cm
Unearthed from Zhang Kuangzheng's Tomb (M10) at Xiabali in Xuanhua, Hebei, in 1993. Preserved on the original site.

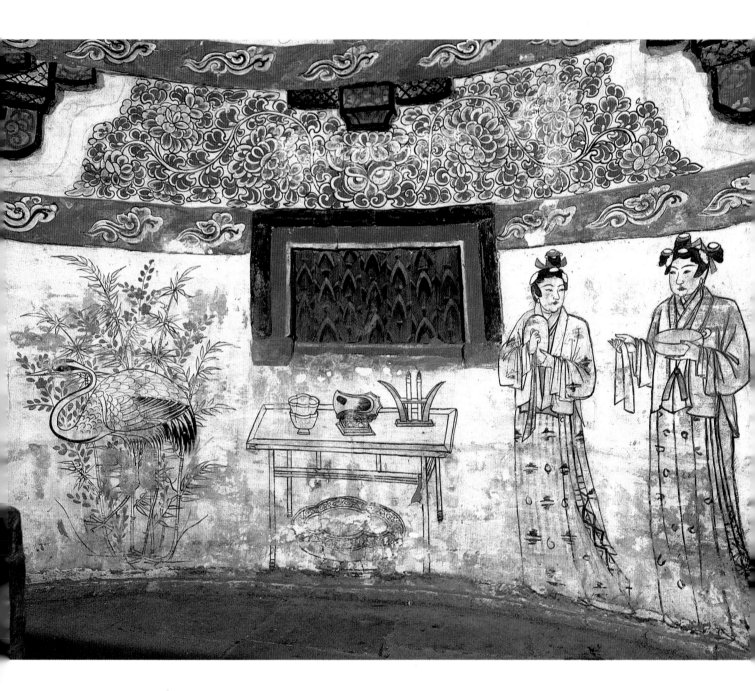

140.持镜、持巾侍女图

辽大安九年（1093年）

高100、宽240厘米

1993年河北省宣化下八里10号张匡正墓出土。原址保存。

墓向200°。位于后室东壁。画面由三部分组成，右侧为持镜、持巾的两位侍女，中部为窗和桌子。桌上有碗、砚和笔架，架上插置笔二支。左侧绘仙鹤、小红花和芦苇等水草。

（撰文：郝建文　摄影：冯玲）

Maids carrying Mirror and Towel

9th Year of Da'an Era, Liao (1093 CE)

Height 100 cm; Width 240 cm

Unearthed from Zhang Kuangzheng's Tomb (M10) at Xiabali in Xuanhua, Hebei, in 1993. Preserved on the original site.

141. 持镜、持巾侍女图（局部）

辽大安九年（1093年）

高100厘米

1993年河北省宣化下八里10号张匡正墓出土。原址保存。墓向200°。位于后室东壁。两侍女穿短袄和百褶长裙，右侧侍女，头梳三高髻，右手持巾，左手端錾耳洗。左侧侍女，头顶正中梳一高髻，左手托镜底，右手执镜背纽。

（撰文：郝建文 摄影：冯玲）

Maids carrying Mirror and Towel (Detail)

9th Year of Da'an Era, Liao (1093 CE)

Height 100 cm

Unearthed from Zhang Kuangzheng's Tomb (M10) at Xiabali in Xuanhua, Hebei, in 1993. Preserved on the original site.

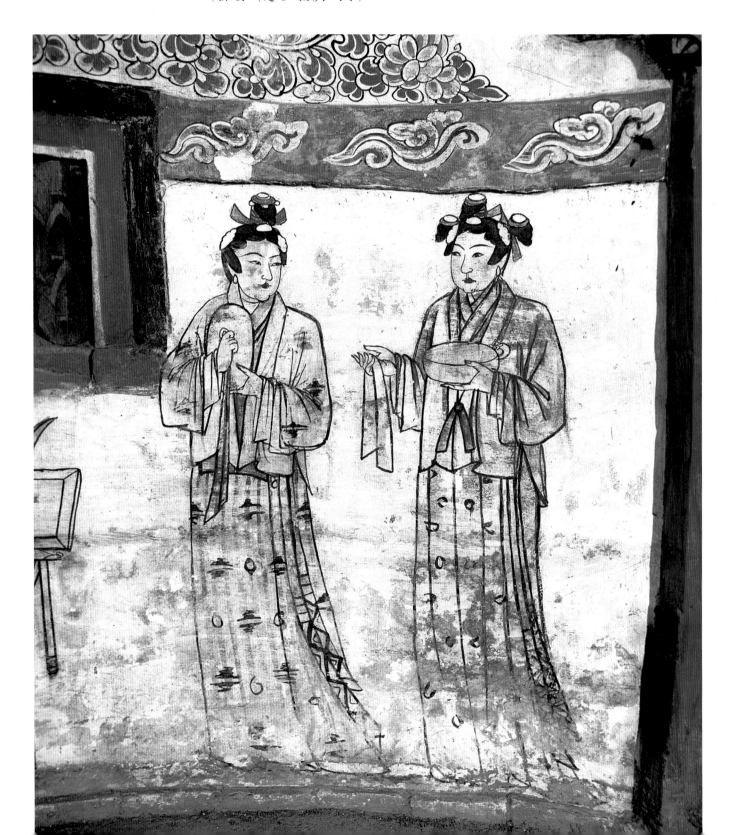

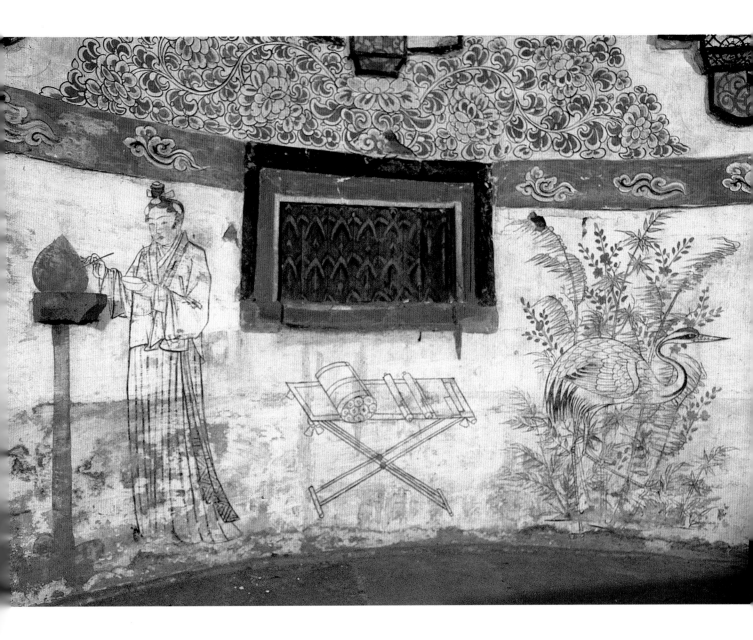

142. 燃灯侍女图

辽大安九年（1093年）

高100、宽240厘米

1993年河北省宣化下八里10号张匡正墓出土。原址保存。

墓向200°。位于后室西壁。画面由三部分组成，左侧为向灯中添油的侍女，头梳高髻，身着白色袄、黄色百褶裙，立于灯架旁。中部为窗和经案，案上放散经卷轴和装着卷轴的帙。右侧绘仙鹤、小红花和芦苇等水草。

（撰文：郝建文　摄影：冯玲）

Maid Picking a Lamp

9th Year of Da'an Era, Liao (1093 CE)

Height 100 cm; Width 240 cm

Unearthed from Zhang Kuangzheng's Tomb (M10) at Xiabali in Xuanhua, Hebei, in 1993. Preserved on the original site.

143.瓶花图

辽大安九年（1093年）

高100、宽240厘米

1993年河北省宣化下八里10号张匡正墓出土。原址保存。

墓向200°。位于后室北壁，门楼两侧绘透空的圆形花架，上绘两个大花瓶，瓶内插盛开的牡丹花。

（撰文：郝建文　摄影：冯玲）

Flower Vats

9th Year of Da'an Era, Liao (1093 CE)

Height 100 cm; Width 240 cm

Unearthed from Zhang Kuangzheng's Tomb (M10) at Xiabali in Xuanhua, Hebei, in 1993. Preserved on the original site.

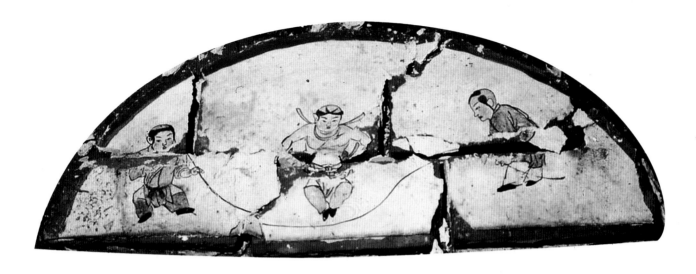

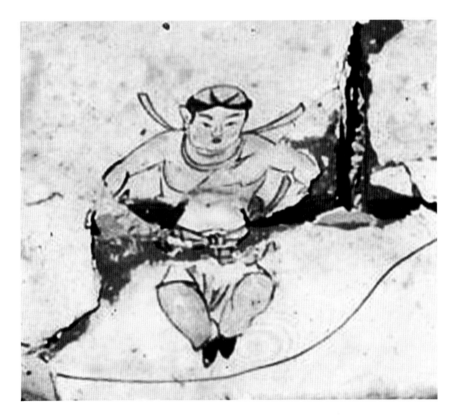

144. 婴戏图

辽大安九年（1093年）

高46、宽117厘米

1993年河北省宣化下八里10号张匡正墓出土。原址保存。

墓向200°。位于后室墓门上部。描绘的是三个儿童跳绳的场景。左右两个小孩在荡绳，中间小孩二足相并、两腿拳起，轻快地跳过荡绳。三个孩童均髡发。

（撰文：郝建文　摄影：张羽）

Playing Boys

9th Year of Da'an Era, Liao (1093 CE)

Height 46 cm; Width 117 cm

Unearthed from Zhang Kuangzheng's Tomb (M10) at Xiabali in Xuanhua, Hebei, in 1993. Preserved on the original site.

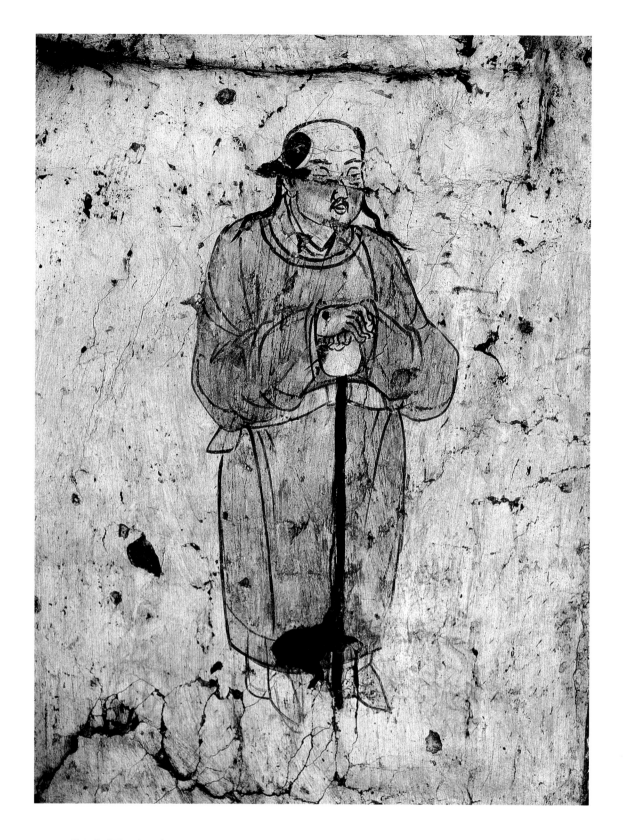

145.门吏图（一）

辽天庆元年（1111年）

高136、宽77厘米

1990年河北省宣化下八里4号韩师训墓出土。原址保存。

墓向178°。位于前室南壁券门东侧，侍者髡发，身穿黄色圆领窄袖长袍，脚穿白筒靴，侧身，双手叠压，拄瓜形骨朵。

（撰文：郝建文　摄影：冯玲）

Door Guard (1) (with Weapon)

1st Year of Tianqing Era, Liao (1111 CE)
Height 136 cm; Width 77 cm
Unearthed from Han Shixun's Tomb (M4) at Xiabali in Xuanhua, Hebei, in 1990. Preserved on the original site.

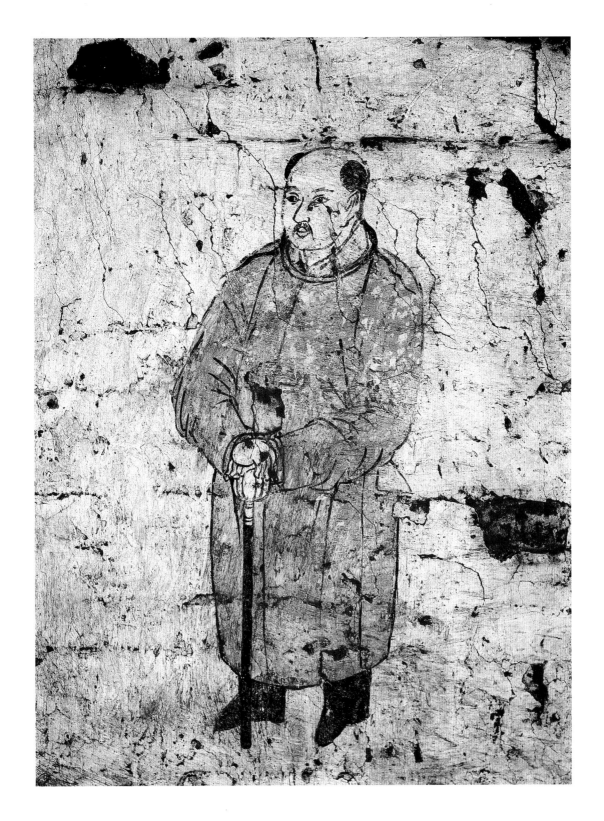

146.门吏图（二）

辽天庆元年（1111年）

高136、宽77厘米

1990年河北省宣化下八里4号韩师训墓出土。原址保存。墓向178°。位于前室南壁券门西侧。门吏髡发，身穿黄色圆领紧袖长袍，脚穿黑筒靴，侧身，双手叠压拄瓜形骨朵。

（撰文：郝建文 摄影：冯玲）

Door Guard (2)

1st Year of Tianqing Era, Liao (1111 CE)

Height 136 cm; Width 77 cm

Unearthed from Han Shixun's Tomb (M4) at Xiabali in Xuanhua, Hebei, in 1990. Preserved on the original site.

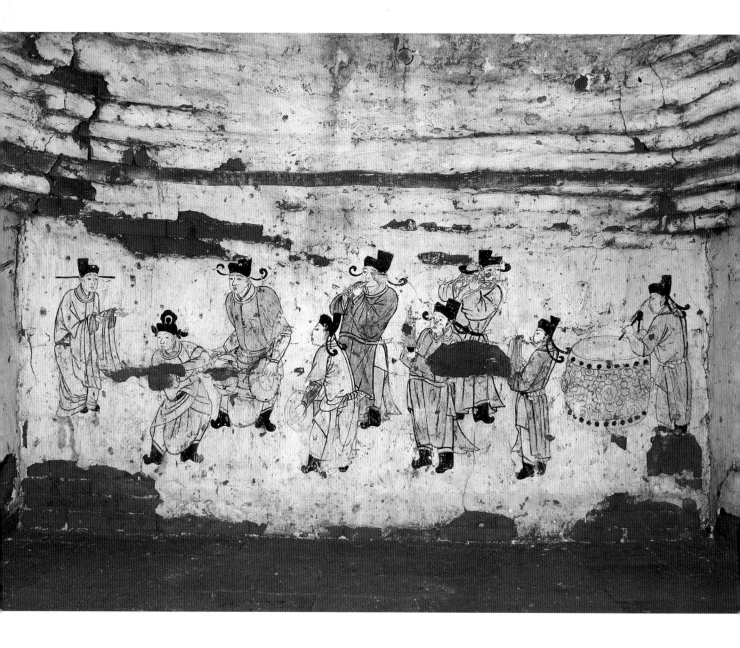

147.散乐图

辽天庆元年（1111年）

高135、宽264厘米

1990年河北省宣化下八里4号韩师训墓出土。原址保存。

墓向178°。位于前室东壁。从北向南依次为领班（指挥）、舞蹈者、腰鼓2、觱篥、笙、横笛、拍板和大鼓共九人。领班头戴展脚幞头，舞旋戴花脚幞头，其余均戴卷脚幞头。领班身穿广袖长袍，舞者穿窄袖长袍，其他各位均穿窄袖开胯长袍，均足穿黑靴。

（撰文：郝建文　摄影：冯玲）

Music Band

1st Year of Tianqing Era, Liao (1111 CE)

Height 135 cm; Width 264 cm

Unearthed from Han Shixun's Tomb (M4) at Xiabali in Xuanhua, Hebei, in 1990. Preserved on the original site.

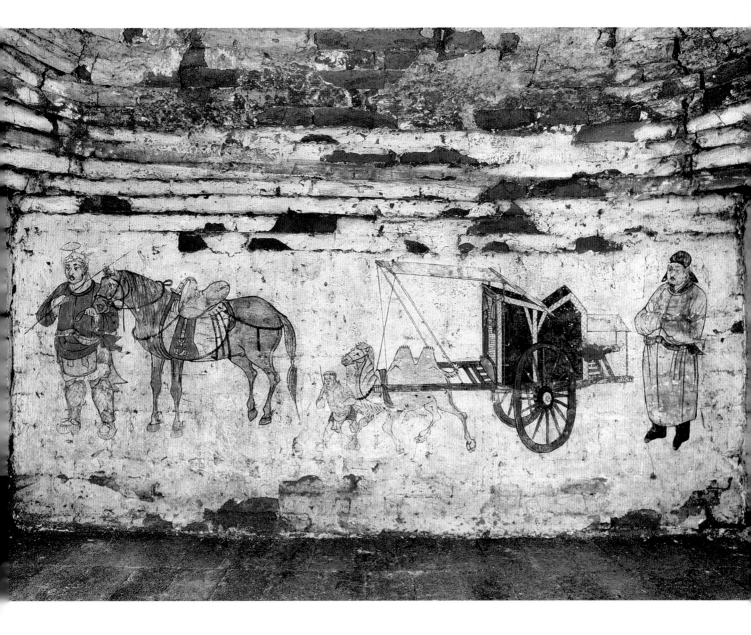

148.出行图

辽天庆元年（1111年）

高135、宽264厘米

1990年河北省宣化下八里4号韩师训墓出土。原址保存。

墓向178°。位于前室西壁。前面是马夫，右手执鞭，左手牵马。中间一驼夫，右手执鞭，左手握缰牵驼，驼车为朱轮方棚。车后立一男侍，拱手站立。

<div align="right">（撰文：郝建文　摄影：冯玲）</div>

Starting Travel

1st Year of Tianqing Era, Liao (1111 CE)

Height 135 cm; Width 264 cm

Unearthed from Han Shixun's Tomb (M4) at Xiabali in Xuanhua, Hebei, in 1990. Preserved on the original site.

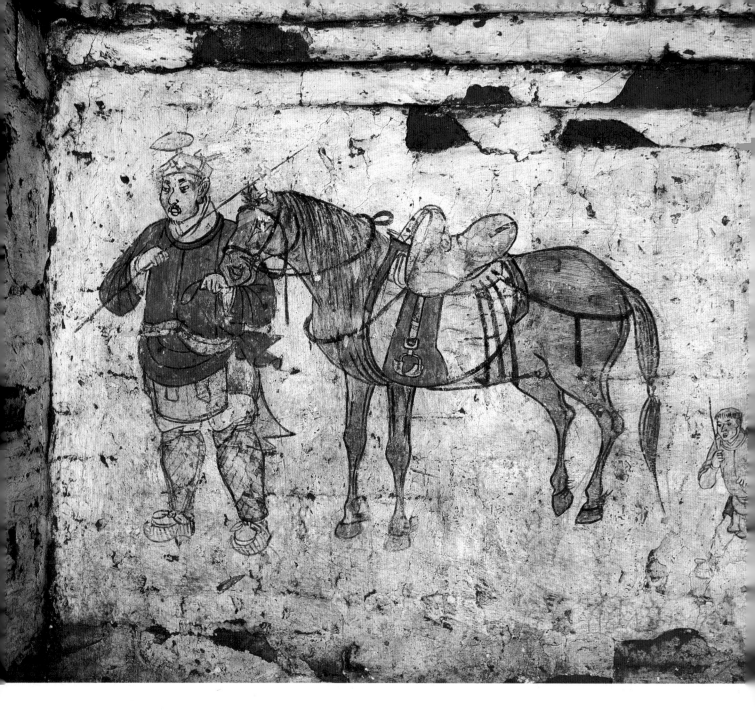

149. 出行图（局部）

辽天庆元年（1111年）

人物高约74厘米

1990年河北省宣化下八里4号韩师训墓出土。原址保存。

墓向178°。位于前室西壁左侧。是出行图的局部。画面主体为一匹枣红马，前一人牵马，头戴巾，身着皂色圆领窄袖袍，下着膝裤，麻鞋。右手执鞭，左手牵马。

（撰文：郝建文　摄影：冯玲）

Starting Travel (Detail)

1st Year of Tianqing Era, Liao (1111 CE)

Servant's height ca. 74 cm

Unearthed from Han Shixun's Tomb (M4) at Xiabali in Xuanhua, Hebei, in 1990. Preserved on the original site.

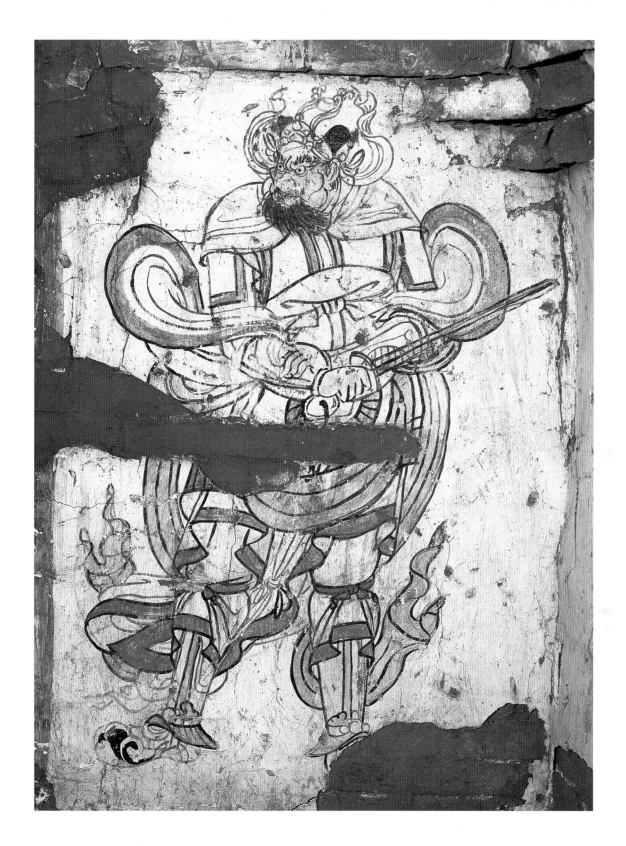

150.门神像

辽天庆元年（1111年）

高132、宽84厘米

1990年河北省宣化下八里4号韩师训墓出土。原址保存。

墓向178°。位于前室北壁拱门东侧。为郁垒像，顶盔贯甲双腿叉开，面向西怒目前视。左手搭在右手小臂，右手持剑。

（撰文：郝建文　摄影：冯玲）

Door God

1st Year of Tianqing Era, Liao (1111 CE)

Height 132 cm; Width 84 cm

Unearthed from Han Shixun's Tomb (M4) at Xiabali in Xuanhua, Hebei, in 1990. Preserved on the original site.

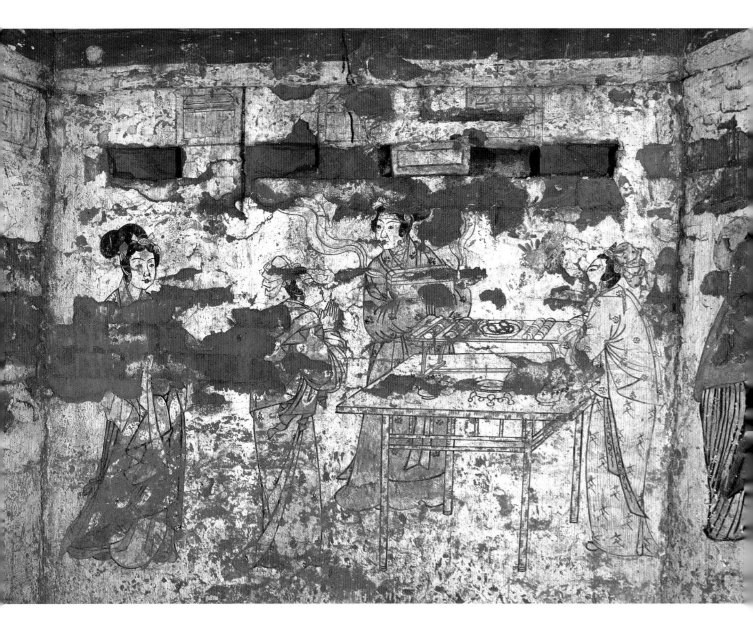

151.备经图

辽天庆元年（1111年）

高142、宽135厘米

1990年河北省宣化下八里4号韩师训墓出土。原址保存。

墓向178°。位于后室东北壁。画面共四个人物，左侧绘一头梳双髻的妇人（因剥落胸部和手已不存在），另外三人位于方桌旁，桌上放有经卷等物。正面的人物双手捧一长方盝顶盖函盒，两股云气从函中左右飘出。其他两人，左侧的侧身仰首，双手合什作祷告状；右侧的袖手躬身立于桌旁。

（撰文：郝建文 摄影：冯玲）

Preparing for Sutra Reading

1st Year of Tianqing Era, Liao (1111 CE)

Height 142 cm; Width 135 cm

Unearthed from Han Shixun's Tomb (M4) at Xiabali in Xuanhua, Hebei, in 1990. Preserved on the original site.

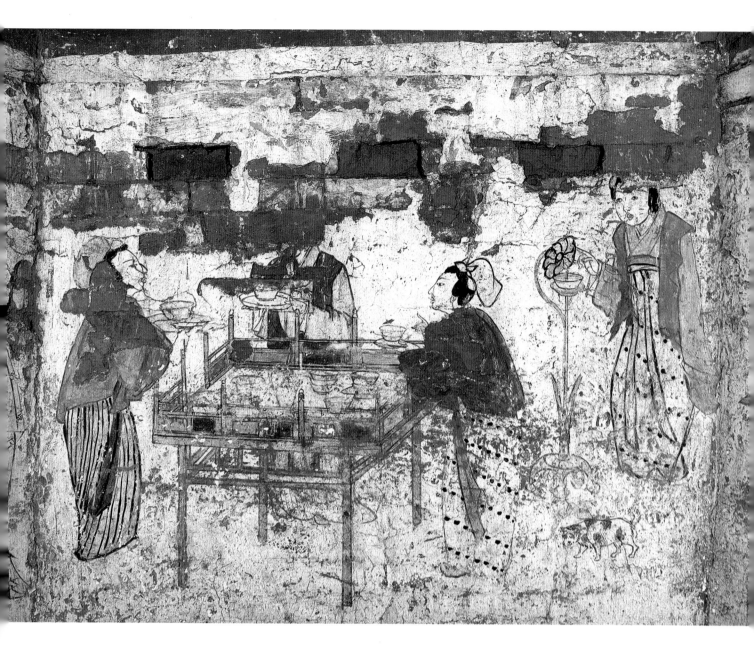

152.备茶图

辽 天庆元年（1111年）

高142、宽131厘米

1990年河北省宣化下八里4号韩师训墓出土。原址保存。

墓向178°。位于后室东南壁。表现的是一添灯侍女和三个围在祭案前备荐茶的侍女。祭案上放执壶、茶盏、托子等，四周有朱栏，柱间为云板，栏杆中开两个口，以便取物。

（撰文：郝建文　摄影：冯玲）

Preparing for Tea Reception

1st Year of Tianqing Era, Liao (1111 CE)

Height 142 cm; Width 131 cm

Unearthed from Han Shixun's Tomb (M4) at Xiabali in Xuanhua, Hebei, in 1990. Preserved on the original site.

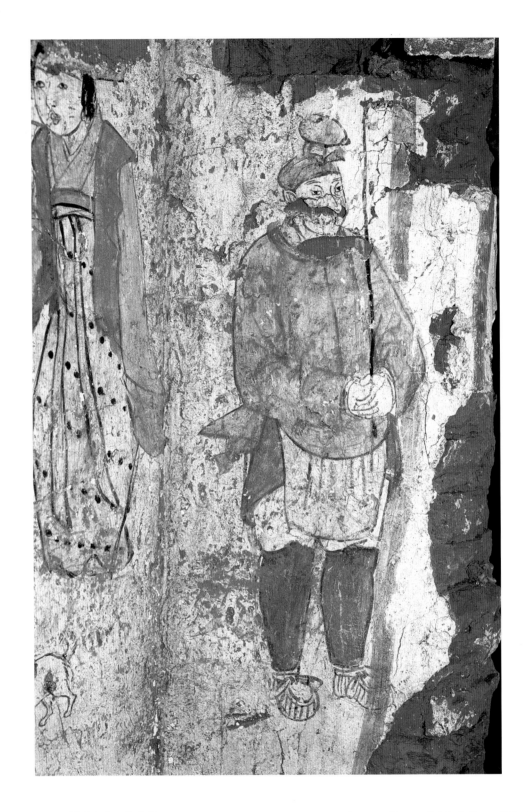

153.持杖门吏图

辽天庆元年（1111年）

高142、宽43厘米

1990年河北省宣化下八里4号韩师训墓出土。原址保存。墓向178°。位于后室南壁拱门东侧。门吏头戴软巾，着圆领窄袖袍，白色内衫，下着裤，圆口绊带麻鞋，双手抱前，持杖而立。

（撰文：郝建文　摄影：冯玲）

Door Guard Holding Stick

1st Year of Tianqing Era, Liao (1111 CE)

Height 142 cm; Width 43 cm

Unearthed from Han Shixun's Tomb (M4) at Xiabali in Xuanhua, Hebei, in 1990. Preserved on the original site.

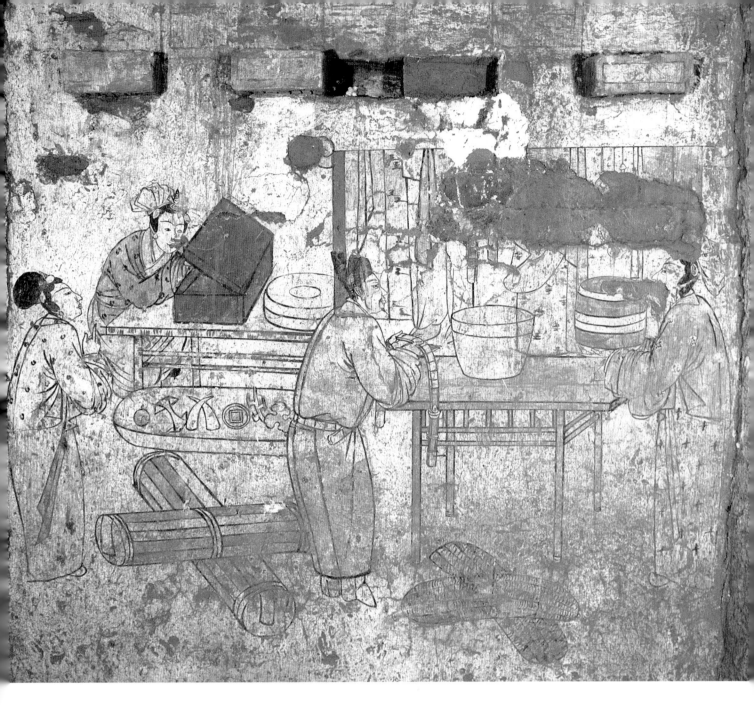

154. 荐献图

辽 天庆元年（1111年）

高142、宽142厘米

1990年河北省宣化下八里4号韩师训墓出土。原址保存。

墓向178°。位于后室西北壁。表现的是对墓主进行币帛衣财荐献场景。画面中间是一老者，双手托衣带，躬身而立。一侍女面向他，双手捧一漆盒，他们两人前面是一红色方桌，桌后有衣架。方桌上放有白色圆盒，桌前放两大件成贯的铜钱，很可能为楮币。老者身后是两名侍女，一个正在启箱，另一个右手抬起，似在指点。她面前地上有杂宝盆和两筒状币帛，盆内放宝珠、银铤、犀角等杂宝。

（撰文：郝建文　摄影：冯玲）

Treasure Presenting Scene

1st Year of Tianqing Era, Liao (1111 CE)

Height 142 cm; Width 142 cm

Unearthed from Han Shixun's Tomb (M4) at Xiabali in Xuanhua, Hebei, in 1990. Preserved on the original site.

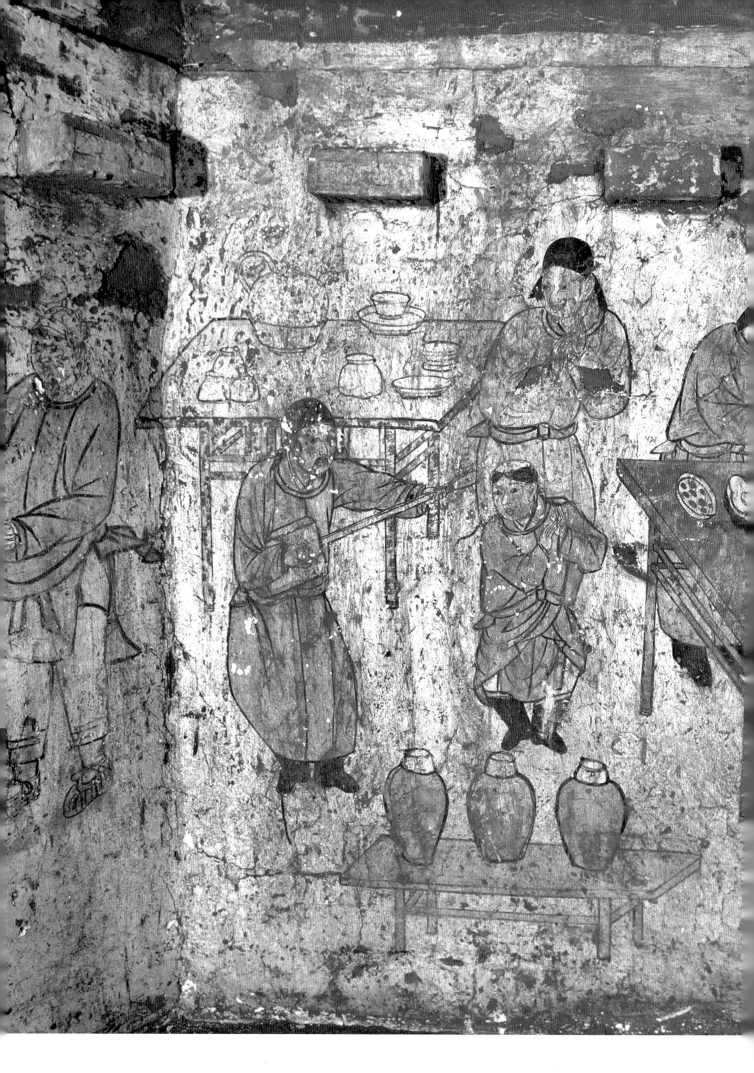

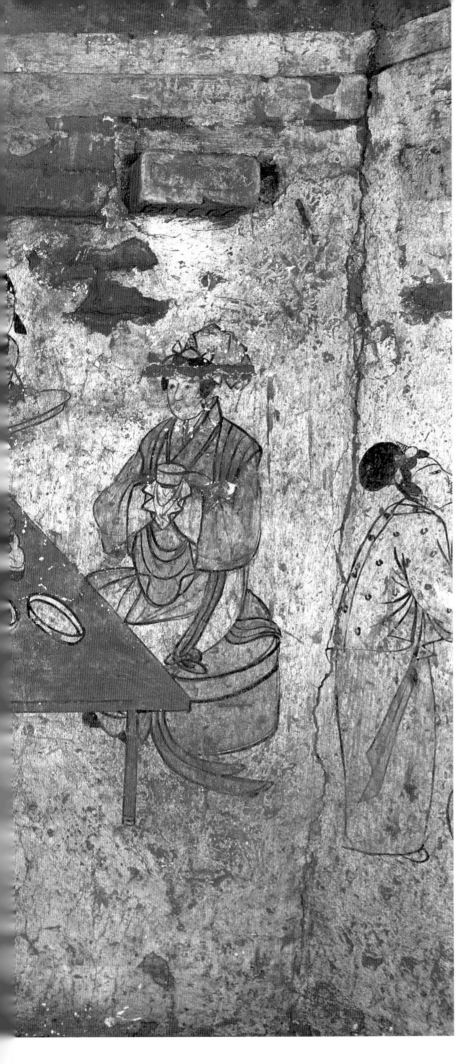

155.宴乐图

辽天庆元年（1111年）

高142、宽14厘米

1990年河北省宣化下八里辽4号韩师训墓出
土。原址保存。

墓向178°。位于后室西南壁。画面可分听琴
者和演奏伴唱者两部分。画面右侧在放着果盒
和漆盘的红色方桌前，一妇人白巾包髻，身穿
短袄长裙，坐在圆形座墩上，手捧托盏，在专
心地欣赏乐舞。妇人的身旁是一双手持盘的老
者。画面左侧有三人，舞旋者双手击掌，双腿
弓曲，随着琴声的节奏在舞蹈。旁边两人，一
长者在弹琴，另一长者，身子侧向女主人，而
回望弹琴者，双手击掌。乐舞者身后有长桌，
上置茶酒具，身前为带盖梅瓶并架。

（撰文：郝建文 摄影：冯玲）

Feasting and Performing

1st Year of Tianqing Era, Liao (1111 CE)
Height 142 cm; Width 14 cm
Unearthed from Han Shixun's Tomb (M4) at
Xiabali in Xuanhua, Hebei, in 1990. Preserved
on the original site.

156.门吏和妇人掩门图

辽天庆元年（1111年）

高142、宽171厘米

1990年河北省宣化下八里4号韩师训墓出土。原址保存。

墓向178°。位于后室北壁，画面有妇人启门和二门吏组成。因剥落严重，妇人形象甚残。其上着短襦，下着长裙，半身露于门外。门东侧侍者，头裹黑色软巾，身着绿色圆领长袍，脚穿黑色筒靴，拱手而立。门西侧侍者，头戴黑色软脚幞头，身着黄色圆领长袍，脚穿白色筒靴。叉手而立。

（撰文：郝建文 摄影：冯玲）

Door Guards, Woman Closing Doors

1st Year of Tianqing Era, Liao (1111 CE)

Height 142 cm; Width 171 cm

Unearthed from Han Shixun's Tomb (M4) at Xiabali in Xuanhua, Hebei, in 1990. Preserved on the original site.

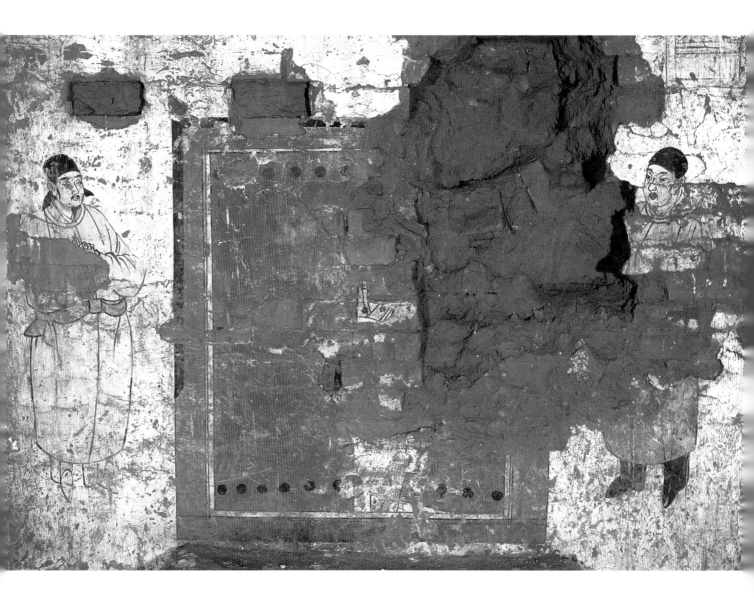

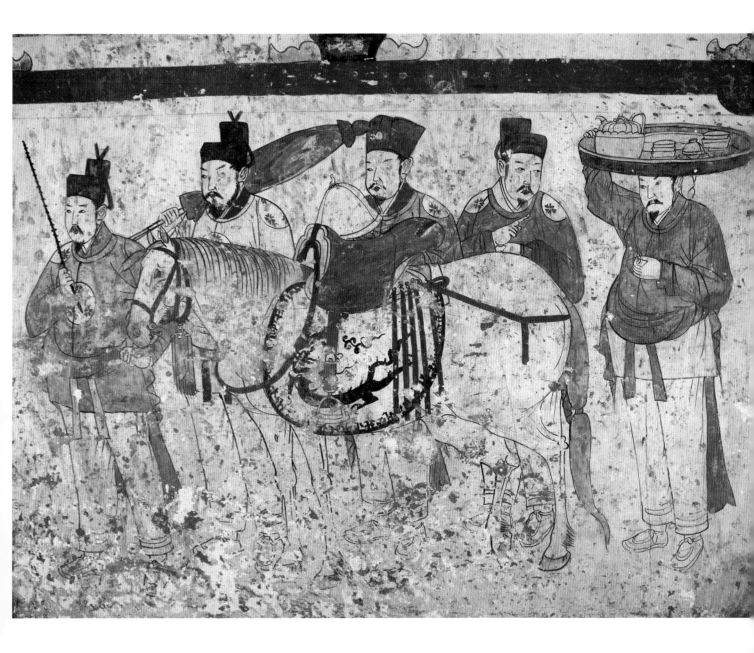

157. 出行图

辽天庆六年（1116年）

高约172、宽约250厘米

1974年河北省宣化下八里1号张世卿墓出土。原址保存。

墓向207°。位于前室西壁。画面由一匹备鞍鞯的白马和五个人物组成。由南向北依次为牵马执鞭、持伞、捧笠帽、持巾、和头顶大盘的人物。盘中放置酒器。人物除顶盘者外，全部头戴交脚幞头，身着蓝、红或白的长袍，前裾掖于腰部，下身则穿窄腿裤。

（撰文：郝建文　摄影：冯玲）

Procession Scene

6th Year of Tianqing Era, Liao (1116 CE)

Height ca. 172 cm; Width ca. 250 cm

Unearthed from Zhang Shiqing's tomb (M1) at Xiabali in Xuanhua, Hebei, in 1974. Preserved on the original site.

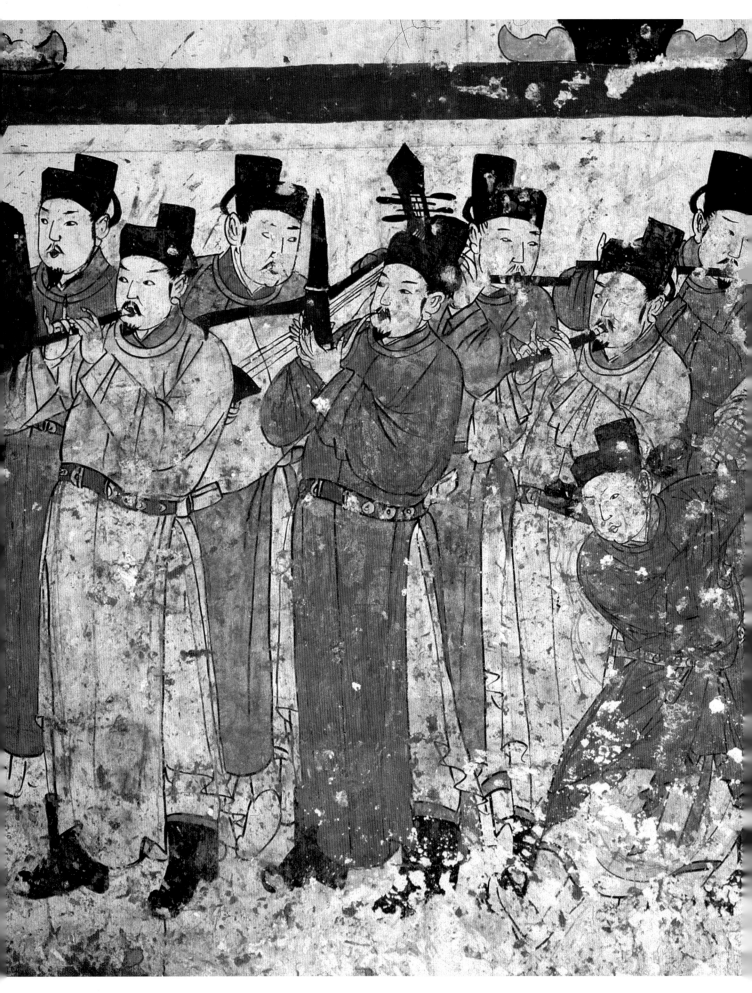

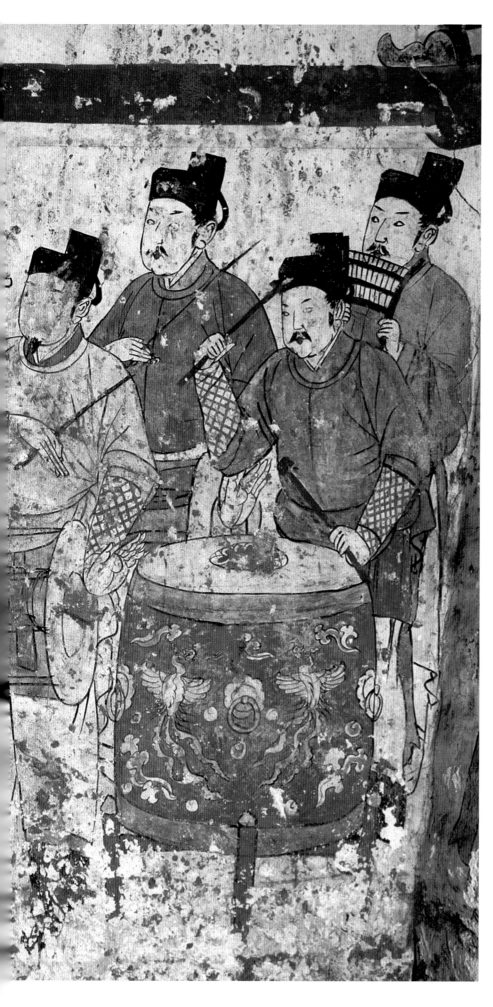

158.散乐图

辽天庆六年（1116年）

高约172、宽约250厘米

1974年河北省宣化下八里1号张世卿墓
出土。原址保存。

墓向207°。位于前室东壁。画面由一
舞旋色和11人的乐队组成。乐队分前后
两排。从左向右前排依次为觱篥、笙、
觱篥、腰鼓、大鼓；后排依次为拍板、
琵琶、横笛、腰鼓、排箫者。人物全部
头戴黑色交脚幞头，足穿黑靴，身着
蓝、红或浅黄色长袍。

（撰文：郝建文　摄影者：冯玲）

Music Band

6th Year of Tianqing Era, Liao (1116 CE)
Height ca. 172 cm; Width ca. 250 cm
Unearthed from Zhang Shiqing's tomb
(M1) at Xiabali in Xuanhua, Hebei, in
1974. Preserved on the original site.

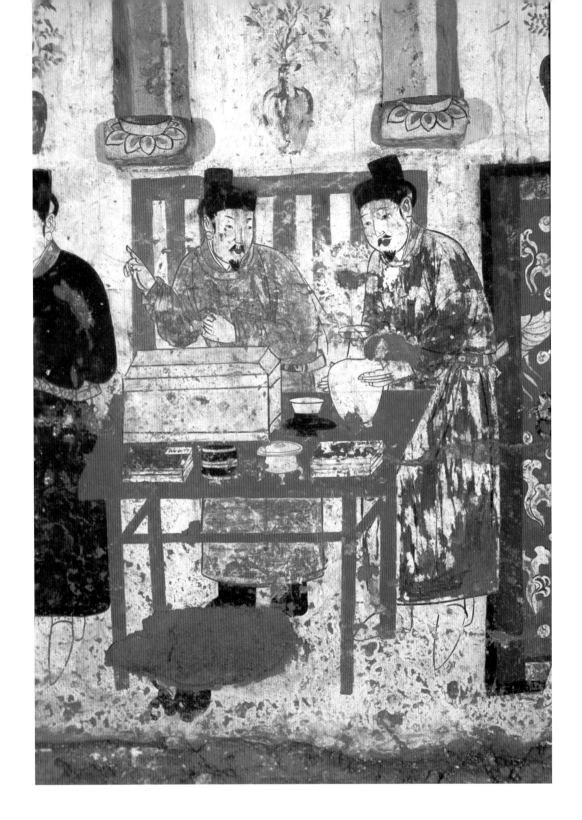

159.备茶图

辽天庆六年（1116年）

人物高约119厘米

1974年河北省宣化下八里1号张世卿墓出土。原址保存。

墓向207°。位于后室东壁。朱红色的桌子上摆放着托盏、汤瓶、香炉、奁盒和黄色函盒等，在桌子的外侧还放有《常清净经》和《金刚般若经》。两个人物头戴黑色交脚幞头，右侧人物着皂色长袍，双手扶大盘口汤瓶。左侧人物着赭色长袍，回首顾盼，右手扬起，似和南侧人物交谈。二人身后为直棂窗一扇。

（撰文：郝建文　摄影者：冯玲）

Tea Preparing Scene

6th Year of Tianqing Era, Liao (1116 CE)
Figure height ca. 119 cm
Unearthed from Zhang Shiqing's tomb (M1) at Xiabali in Xuanhua, Hebei, in 1974. Preserved on the original site.

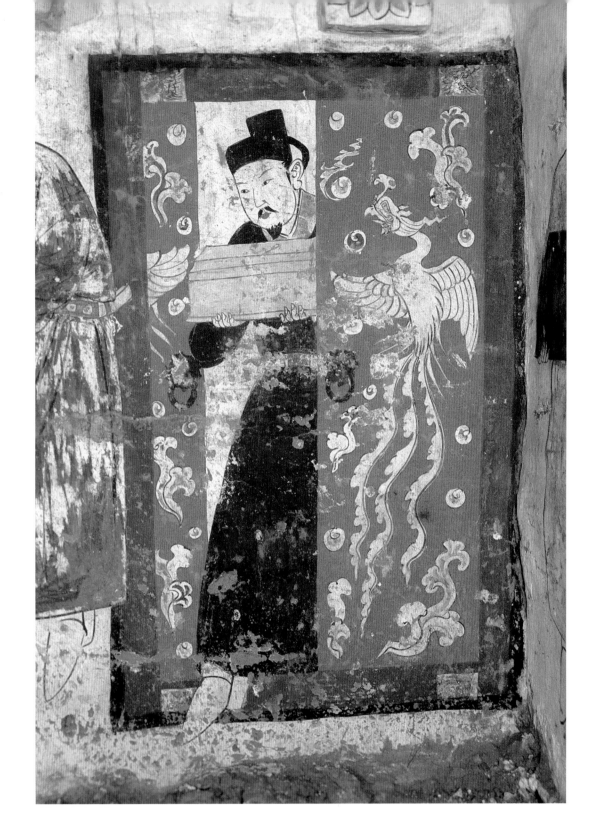

160. 启门图

辽天庆六年（1116年）

高约130、宽约76厘米

1974年河北省宣化下八里1号张世卿墓出土。原址保存。墓向207°。位于后室东壁。画中一头戴黑色交脚幞头，身着黑色窄袖长袍，穿白色筒靴的侍者，手捧黄色函盒，正迈步而入，门扇上绘一对凤鸟纹。

（撰文：郝建文　摄影者：冯玲）

Attendant Opening the Door Ajar

6th Year of Tianqing Era, Liao (1116 CE)

Height ca. 130 cm; Width ca. 76 cm

Unearthed from Zhang Shiqing's tomb (M1) at Xiabali in Xuanhua, Hebei, in 1974. Preserved on the original site.

161. 男侍图

辽天庆六年（1116年）

人物高约114厘米（穿蓝袍者）

1974年河北省宣化下八里1号世卿墓墓出土。原址保存。墓向207°。位于后室南壁东侧。画中并列站立两个人物，左侧人物髡发，身穿赭色圆领长袍，双手捧黑漆箱。右侧人物，头戴黑巾，身穿蓝色袄，下着裤，双手捧圆形骰盒子，内盛骰子。

（撰文：郝建文　摄影者：冯玲）

Servants

6th Year of Tianqing Era, Liao (1116 CE)
Height of the blue dressing servant ca. 114 cm
Unearthed from Zhang Shiqing's tomb (M1) at Xiabali in Xuanhua, Hebei, in 1974. Preserved on the original site.

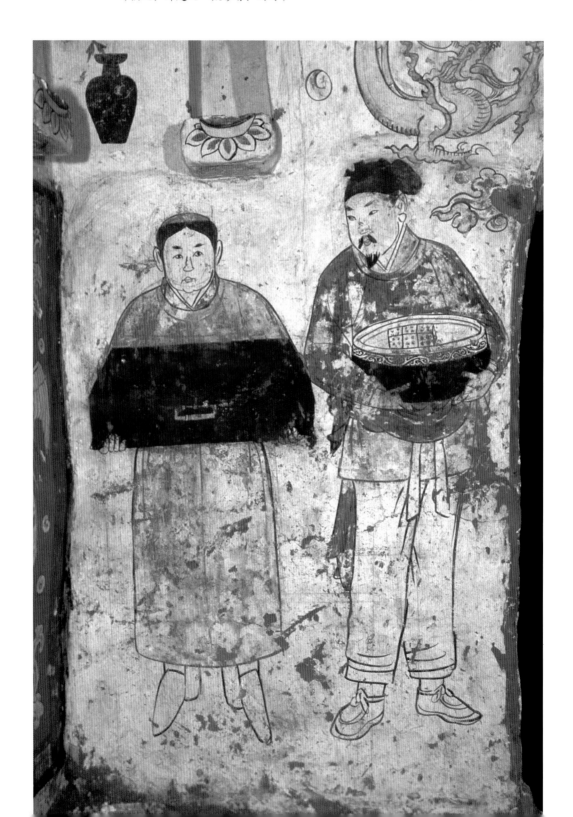

162.备酒图

辽天庆六年（1116年）

人物高约114厘米

1974年河北省宣化下八里1号张世卿墓出土。原址保存。

墓向207°。位于后室南壁西侧。画中绘红色方桌，桌上有长盘、酒盏、盘口瓶、执壶等，桌后站立的两个男子，左侧的身穿深褐色圆领长袍，双手捧一黑色劝盘，盘内有酒杯一对；右侧人物身着皂色圆领长袍，腰束带，手捧白色执壶与成套的温碗。桌前方绘木架，架上插放三个带盖梅瓶，上绘朱色"张记"印封帖。桌旁绘灯檠。

（撰文：郝建文　摄影者：冯玲）

Wine Preparing Scene

6th Year of Tianqing Era, Liao (1116 CE)
Figure height ca. 114 cm
Unearthed from Zhang Shiqing's tomb (M1) at Xiabali in Xuanhua, Hebei, in 1974. Preserved on the original site.

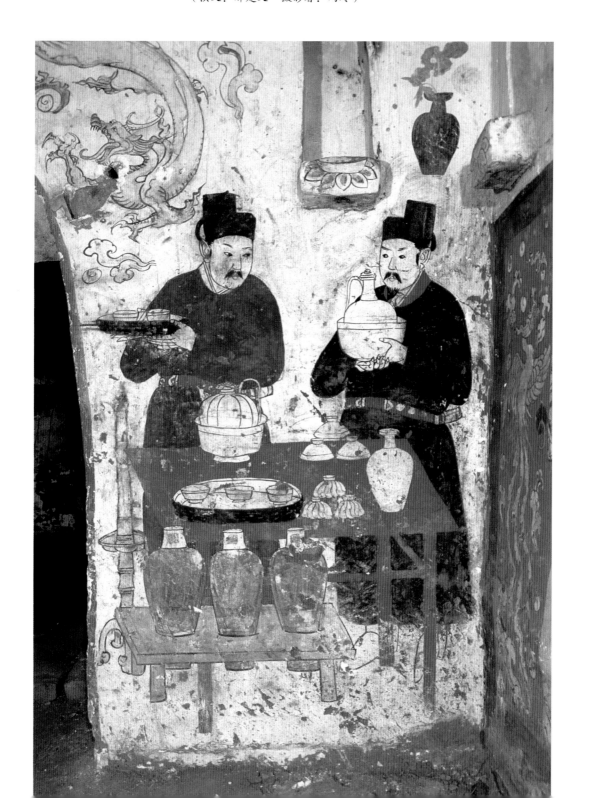

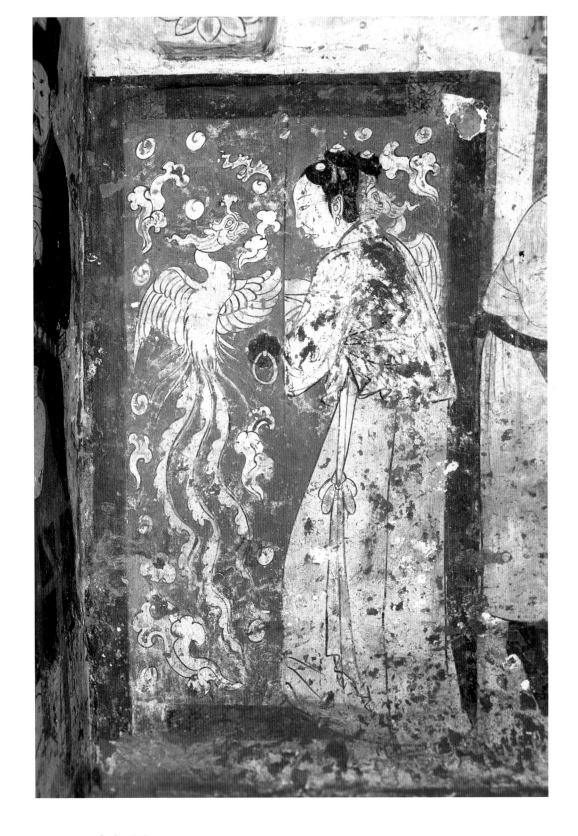

163. 妇人启门图

辽天庆六年（1116年）

高约118、宽约72厘米

1974年河北省宣化下八里1号张世卿墓出土。原址保存。墓向207°。位于后室西壁。画中一妇人头梳三丫髻，身着蓝色短袄，黄色长裙，穿尖头鞋，正捧物推门而入，朱门半掩，绘一对凤鸟纹。

（撰文：郝建文　摄影者：冯玲）

Lady Opening the Door Ajar

6th Year of Tianqing Era, Liao (1116 CE)

Height ca. 118 cm; Width ca. 72 cm

Unearthed from Zhang Shiqing's tomb (M1) at Xiabali in Xuanhua, Hebei, in 1974. Preserved on the original site.

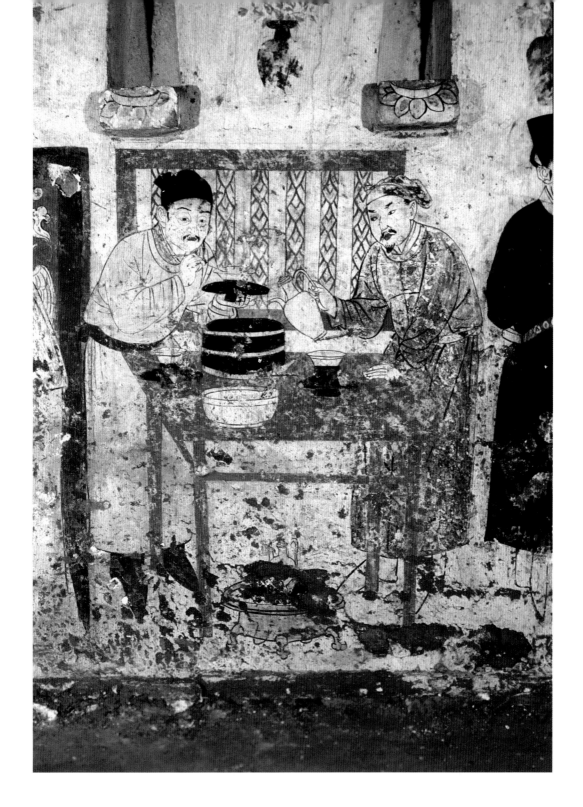

164.备茶图

辽天庆六年（1116年）

人物高约102厘米

1974年河北省宣化下八里1号张世卿墓出土。原址保存。

墓向207°。位于后室西壁。朱红色的桌子上摆放着茶盏，瓷盆、漆盒等，桌下有一圆形炭盆，炭火上放一汤瓶。桌旁是正在备茶的两个人物，左侧黄袍的老者，左手托黑托白盏的托盏，右手持茶匙拨动盏中的茶末。右侧的人物左手扶桌面，右手执黄色汤瓶，准备为老者点茶。

（撰文：郝建文　摄影者：冯玲）

Tea Preparing Scene

6th Year of Tianqing Era, Liao (1116 CE)

Figures height ca. 102 cm

Unearthed from Zhang Shiqing's tomb (M1) at Xiabali in Xuanhua, Hebei, in 1974. Preserved on the original site.

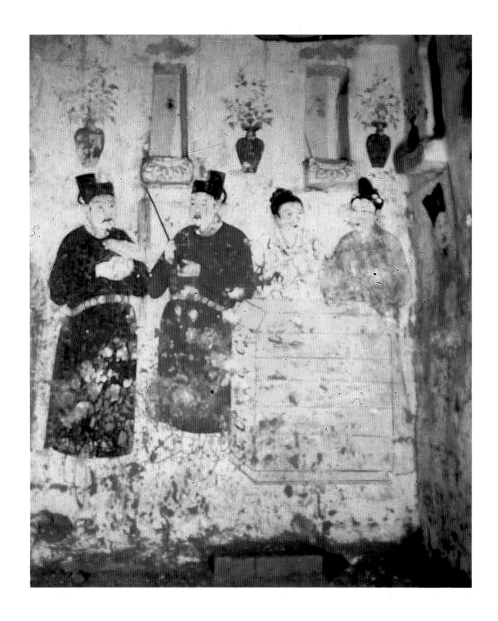

165. 侍者图

辽天庆六年（1116年）

人物高约102厘米

1974年河北省宣化下八里1号张世卿墓出土。原址保存。

墓向207°。位于后室西壁北侧。画面分两组。右侧为启箱侍女，她们头梳高髻，穿白色短袄的侍女右手抬起，指向身着赭色短袄、下拽长裙、双手褪于袖内的侍女，似正在交淡。左侧描绘的是身着皂色长袍，手持黄色渣斗的男侍和另一位穿棕色长袍，手执拂尘的男侍，相对而立。

（撰文：郝建文　摄影者：冯玲）

Servants

6th Year of Tianqing Era, Liao (1116 CE)

Figures height ca. 102 cm

Unearthed from Zhang Shiqing's tomb (M1) at Xiabali in Xuanhua, Hebei, in 1974. Preserved on the original site.

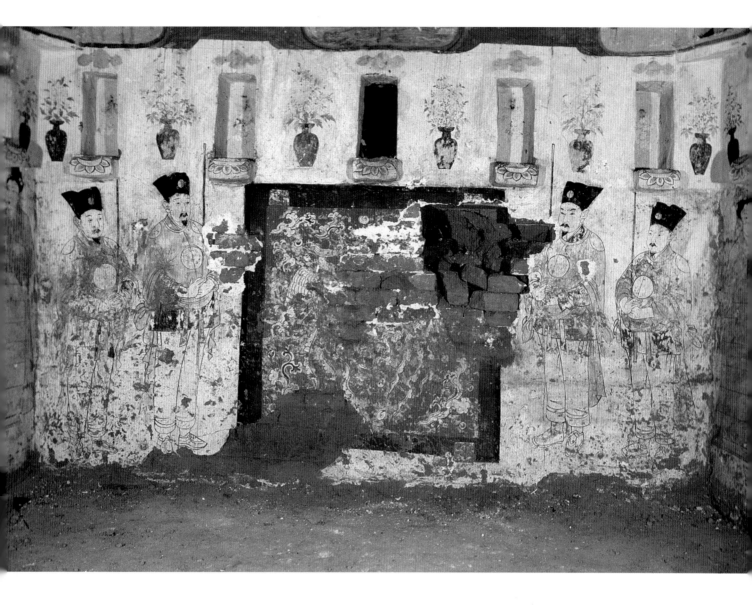

166.门吏图

辽天庆六年（1116年）

高170、宽302厘米

1974年河北省宣化下八里1号张世卿墓出土。原址保存。

墓向207°。位于后室北壁。中间绘板门，两扇朱门上各绘一只黄色凤凰。门额左右绘方形门簪，上饰兽头。门左右两侧各绘两位头戴东坡巾，身着赭色地团花窄袖衫，白色裤，面向内持杖而立的门吏。

<div align="right">（撰文：郝建文　摄影者：冯玲）</div>

Door Guards

6th Year of Tianqing Era, Liao (1116 CE)

Height 170 cm; Width 302 cm

Unearthed from Zhang Shiqing's tomb (M1) at Xiabali in Xuanhua, Hebei, in 1974. Preserved on the original site.

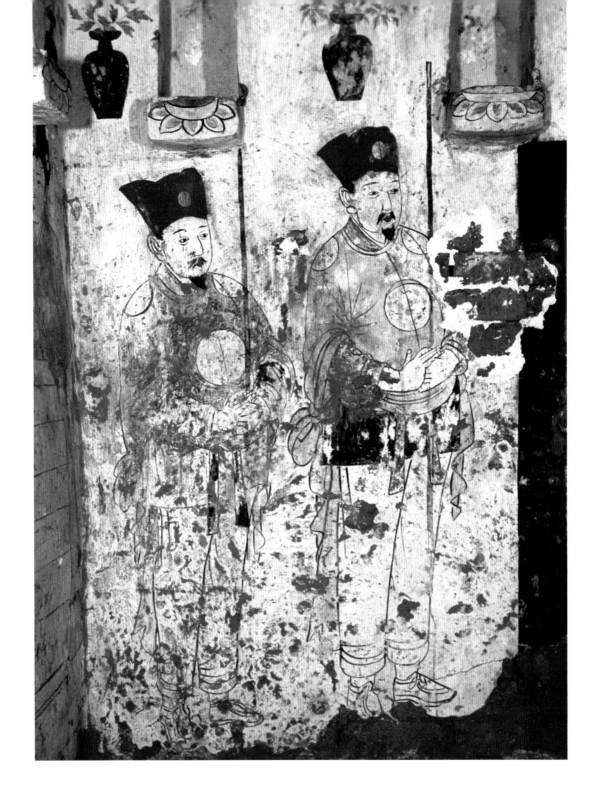

167.门吏图（局部）

辽天庆六年（1116年）

人物高约124厘米

1974年河北省宣化下八里1号张世卿墓出土。原址保存。

墓向207°。位于后室北壁西侧。两人装束相同，头戴东坡巾，身着淡赭色地团花窄袖衫，穿白色裤，面向内持杖而立。

（撰文：郝建文　摄影者：冯玲）

Door Guards (Detail)

6th Year of Tianqing Era, Liao (1116 CE)

Figures height ca. 124 cm

Unearthed from Zhang Shiqing's tomb (M1) at Xiabali in Xuanhua, Hebei, in 1974. Preserved on the original site.

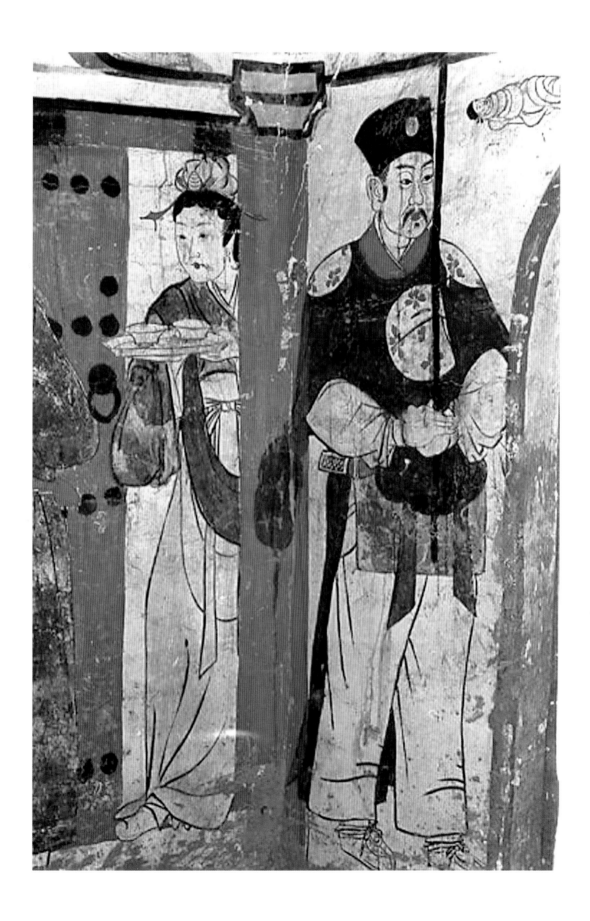

◀168.门吏和妇人启门图

辽天庆七年（1117年）

高158厘米

1989年河北省宣化下八里2号张恭诱墓出土。原址保存。

墓向165°。位于南壁和东南壁拐角两侧。画面右侧为南壁门吏，头戴黑色巾帻，着黑色红团花紧袖开胯长袍。下身穿白裤，脚穿圆口绊带鞋，双手持黑杖。左侧为东南壁启门而出的妇人，头束高髻，身着紫褐色宽袖短袄，黄色长裙。足登黄色尖头鞋，双手捧劝盏，内置二杯。

（撰文：郝建文　摄影：张羽）

Door Guard, Lady Opening the Door Ajar

7th Year of Tianqing Era, Liao (1117 CE)

Height 158 cm

Unearthed from Zhang Gongyou's tomb (M2) at Xiabali in Xuanhua, Hebei, in 1989. Preserved on the original site.

169.散乐图 ▶

辽天庆七年（1117年）

高167、宽154厘米

1989年河北省宣化下八里5号张世古墓出土。原址保存。

墓向205°。位于前室东壁。画面表现的是由五人组成的乐队。乐队分前后两排。前排从左向右依次为笛、觱篥和腰鼓共三人；后排从左向右依次为拍板和大鼓。人物均头戴交脚幞头，脚穿黑靴，身着开胯长袍侧身而立。

（撰文：郝建文　摄影：张羽）

Music Band

7th Year of Tianqing Era, Liao (1117 CE)

Height 167 cm; Width 154 cm

Unearthed from Zhang Shigu's tomb (M5) at Xiabali in Xuanhua, Hebei, in 1989. Preserved on the original site.

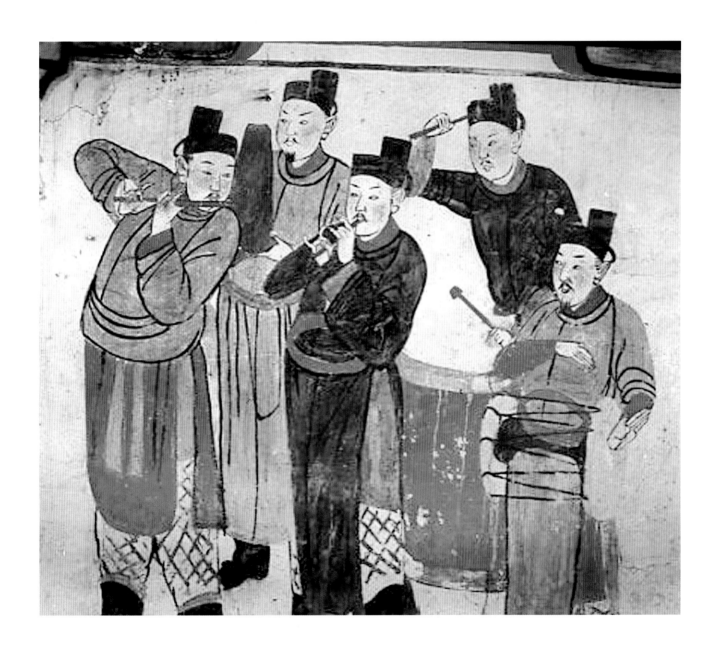

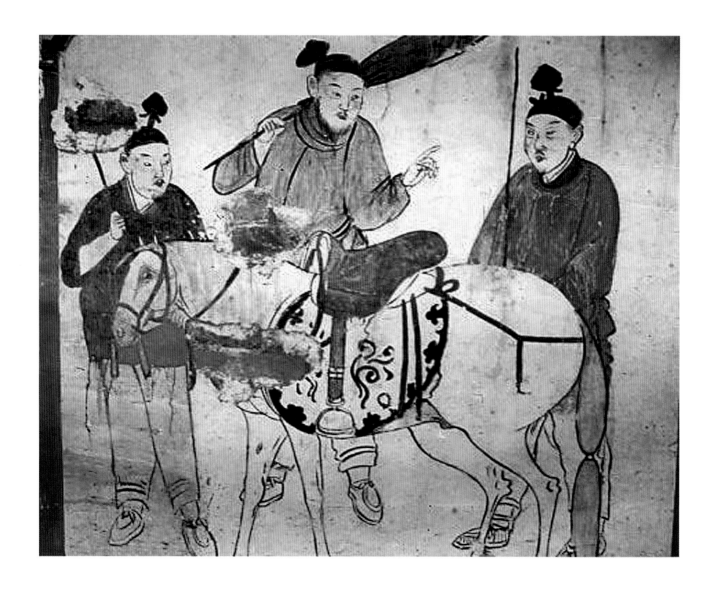

170. 出行图

辽天庆七年（1117年）

高167、宽154厘米

1989年河北省宣化下八里5号张世古墓出土。原址保存。

墓向205°。位于前室西壁。表现的是由三人组成的出行队伍。画面正中为一匹白马，马首一侧立一驭者，右手持鞭，左手执缰。马后为持杖人。中间为持伞人，右肩扛一柄蓝色伞，左手抬手，指向持杖人。三人头裹黑色扎巾，白裤白鞋。

<div align="right">（撰文：郝建文　摄影：张羽）</div>

Preparing for Travel

7th Year of Tianqing Era, Liao (1117 CE)

Height 167 cm; Width 154 cm

Unearthed from Zhang Shigu's tomb (M5) at Xiabali in Xuanhua, Hebei, in 1989. Preserved on the original site.

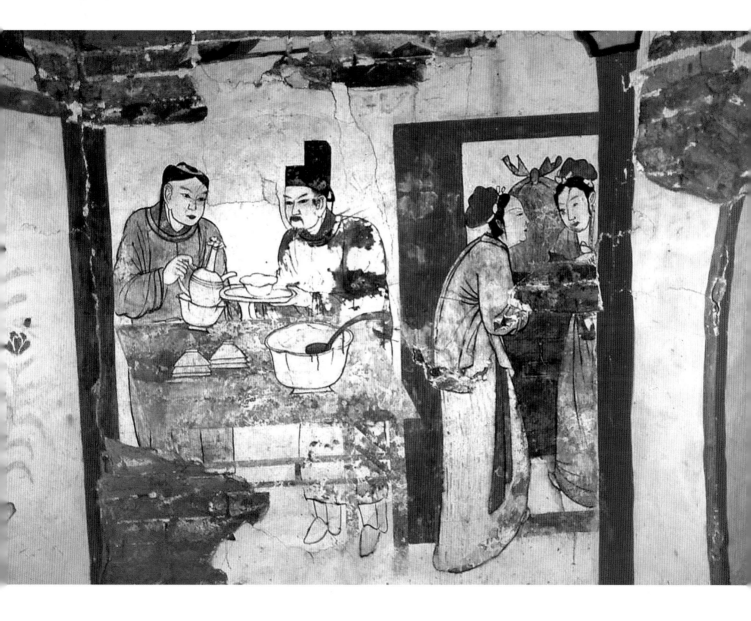

171. 备酒图

辽天庆七年（1117年）

高156、宽137厘米

1989年河北省宣化下八里5号张世古墓出土。原址保存。

墓向205°。位于后室东南壁。左侧绘在朱色方桌前备酒的一老一少，年轻的侍者髡发，穿蓝色圆领长衫，右手执凤首注壶，正在倾注。年老的侍者头戴交脚幞头，着蓝色圆领窄袖长衫，双手托劝盘与花口酒杯，躬身而立。右侧绘朱色门前的两个侍女。里面的侍女头戴软冠，着蓝色开胯短衫，穿百褶裙，倚门而立。外面的侍女，着蓝色短衫，褐色裙，她的身后是一深褐色的家具，上放一打结的大包袱。

（撰文：郝建文　摄影：张羽）

Wine Preparing Scene

7th Year of Tianqing Era, Liao (1117 CE)

Height 156 cm; Width 137 cm

Unearthed from Zhang Shigu's tomb (M5) at Xiabali in Xuanhua, Hebei, in 1989. Preserved on the original site.

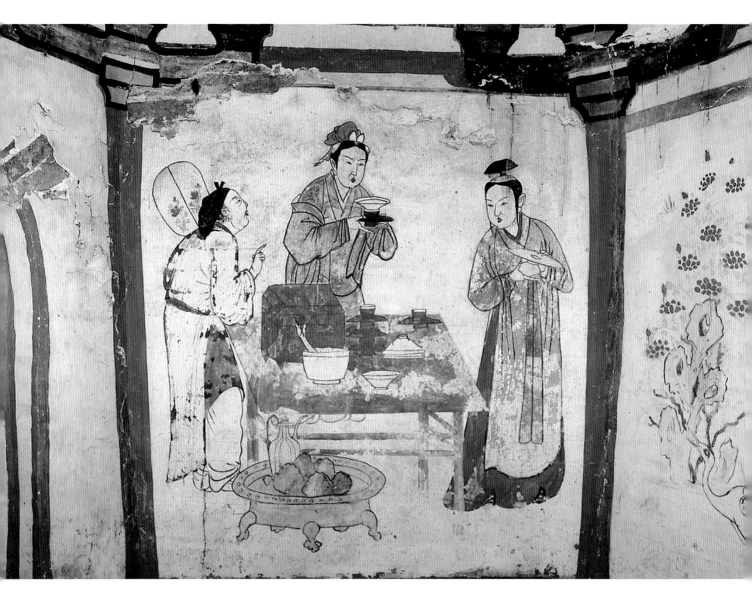

172. 备茶图

辽天庆七年（1117年）

高156、宽144厘米

1989年河北省宣化下八里5号张世古墓出土。原址保存。

墓向205°。位于后室西南壁。画面中间绘一褐色方桌，桌前放盛有炭火的火盆，火煨一白色带盖汤瓶。桌上摆满了茶具，有红色函盒、盏托和茶盏与茶筅等。桌后及两侧各绘一女子，桌后侍女头戴莲瓣软冠，褐色短衫，外罩绿色窄袖褙子，下身着绿裙，双手捧黑托白盏的茶盏。桌右侧侍女，头部装束很别致，似受契丹髡发影响。外穿绿色交领长衫，内穿紫红色长袍，穿黑色尖头鞋，双手捧渣斗。桌左侧绘一年长的侍女，外穿深绿色长袍，白色宽腿裤，白鞋。左手执团扇，右手抬起，翘指指点。从三人的面部表情看，似在交谈。

<div align="right">（撰文：郝建文　摄影：张羽）</div>

Tea Serving Scene

7th Year of Tianqing Era, Liao (1117 CE)

Height 156 cm; Width 144 cm

Unearthed from Zhang Shigu's tomb (M5) at Xiabali in Xuanhua, Hebei, in 1989. Preserved on the original site.

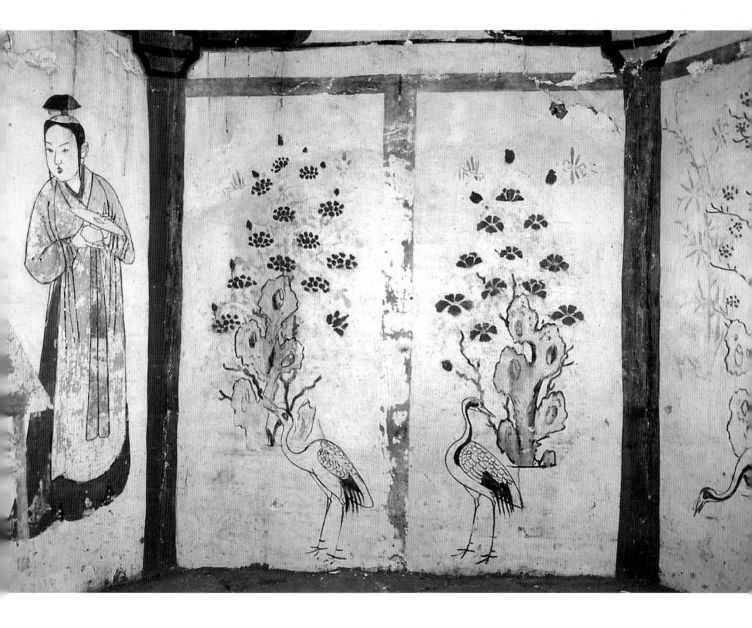

173.花鸟屏风

辽天庆七年（1117年）

高156、宽156厘米

1989年河北省宣化下八里5号张世古墓出土。原址保存。

墓向205°。位于后室西北壁。在面画中的仙鹤双足伫立，引颈长鸣，背景为太湖石和花卉。右面画中仙鹤回首伫立，背景为湖石和红色五瓣小团花。

<div align="right">（撰文：郝建文 摄影：张羽）</div>

Flower-and-Bird Screen

7th Year of Tianqing Era, Liao (1117 CE)

Height 156 cm; Width 156 cm

Unearthed from Zhang Shigu's tomb (M5) at Xiabali in Xuanhua, Hebei, in 1989. Preserved on the original site.

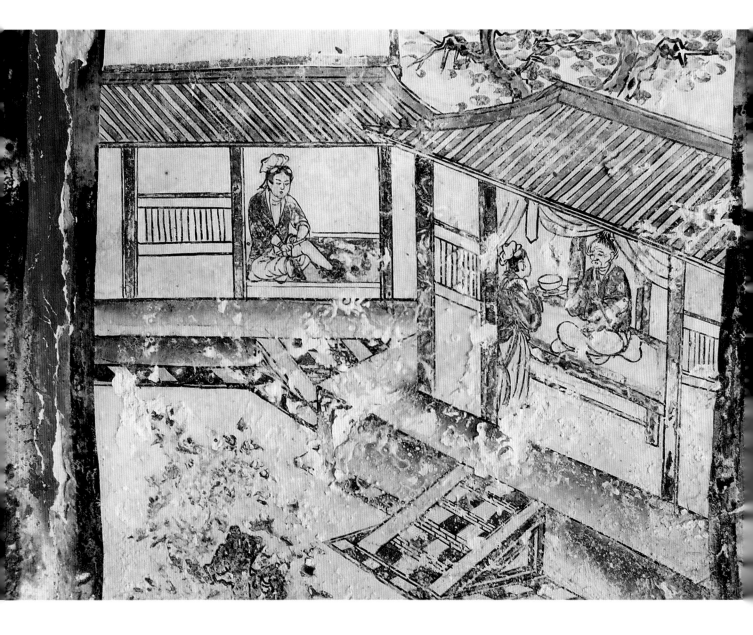

174.割股奉亲图

辽（907～1125年）

高110、宽70厘米

1998年河北省宣化下八里2区辽墓1号墓出土。原址保存。

墓向180°。位于墓室东壁北侧。画面绘出两处建在高台之上的房子，似四合院的正房，一老妪，短袄，白色裤，盘腿坐于木榻上，病容满面，木榻上方有重帐挽起。另一人，包髻，上身穿赭色短衫，白色裤，右手持刀，左手挽起左裤腿的样子，目视腿部。画面反映的是二十四孝中割股奉亲的场面。

（撰文、摄影：刘海文）

Wang Wuzi's Wife, One of the "Twenty-Four Paragons of Filial Piety"

Liao (907-1125 CE)

Height 110 cm; Width 70 cm

Unearthed from Liao tomb M1 at District 2 in Xiabali, Xuanhua, Hebei, in 1998. Preserved on the original site.

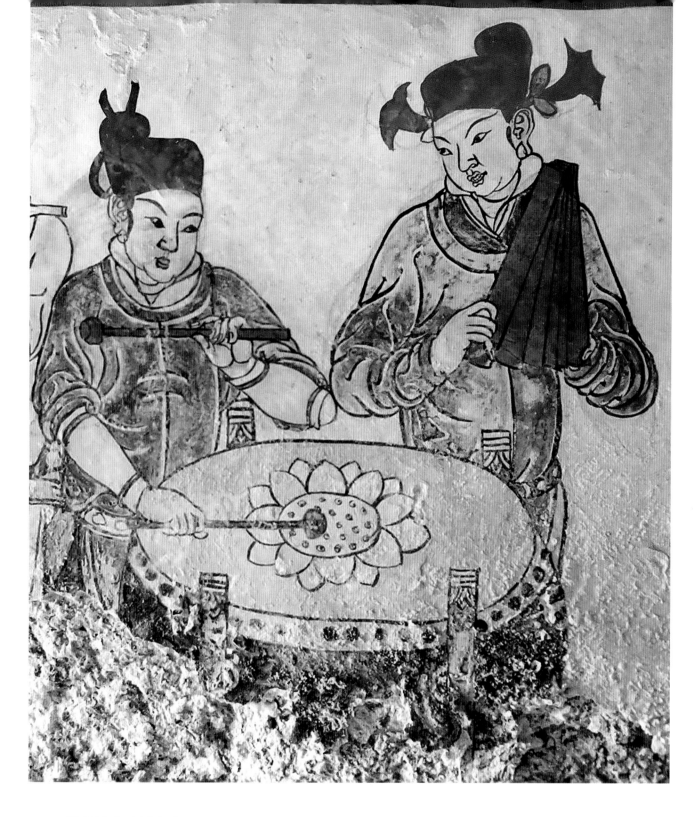

175.散乐图（局部）

辽（907～1125年）

1998年河北省宣化下八里2区辽墓1号墓出土。原址保存。

墓向180°。位于墓室西南壁。为整个散乐图右数第1、2人。大鼓：头戴交脚幞头，身穿圆领开胯长袍，腰系革带，袖子挽起，露鞲，手拿鼓捶，正在击打鼓面饰团花纹的大鼓。拍板：头戴花脚幞头，着圆领窄袖长袍，腰系革带。手拿拍板。

<div align="right">（撰文：柳青　摄影：刘海文）</div>

Music Band (Detail)

Liao (907-1125 CE)

Unearthed from Liao tomb M1 at District 2 in Xiabali, Xuanhua, Hebei, in 1998. Preserved on the original site.

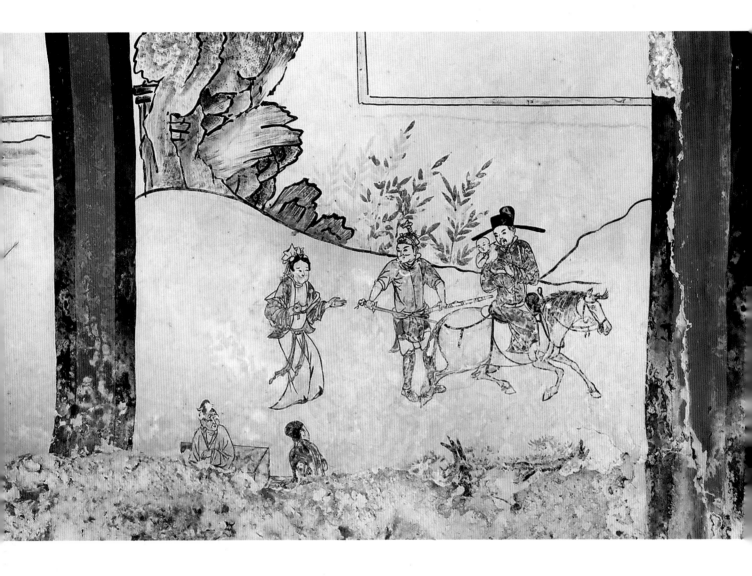

176.刘明达卖子图

辽（907～1125年）

高110、宽72厘米

1998年河北省宣化下八里2区辽墓1号墓出土。原址保存。

墓向180°。位于墓室北壁东侧。画面是一骑马者，头戴展角幞头，身着蓝色长袍，怀抱一婴儿，骑于马鞍之上，半侧身做回首状。马呈红色，做行走状。马后有二人，一人软巾混裹，留有"一"字胡须，上身着赭色圆领窄袖袍，胳膊和腰以下挽起，下穿白色裤、蓝色膝裤，系带鞋，左手拿剑鞘，右手持剑，眼神和动作似对身后妇人发怒。妇人梳包髻，绿披帛，赭色短袄退于肩下，白色曳地裙，黑色尖鞋，双手抬起，显示出一种无奈的样子。两人面前绘出二人，左边者，头梳髻，身穿白色交领衫，袖手而坐，右边者头裹黑巾，蓝色长袍。二人回首遥望。整个画面反映的是孝行故事中"刘明达卖子"的故事。

（撰文、摄影：刘海文）

Liu Mingda, One of the "Twenty-Four Paragons of Filial Piety"

Liao (907-1125 CE)

Height 110 cm; Width 72 cm

Unearthed from Liao tomb M1 at District 2 in Xiabali, Xuanhua, Hebei, in 1998. Preserved on the original site.

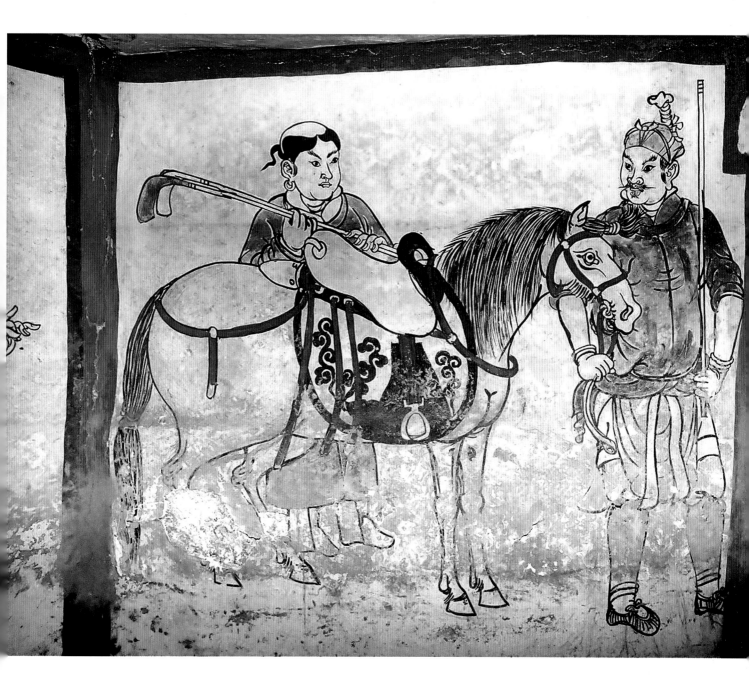

177. 出行图

辽（907～1125年）

高130、宽154厘米

1998年河北省宣化下八里2区辽墓2号墓出土。原址保存。

墓向180° 位于墓室东南壁。画面中部为一鞍马。前一人手持杖，身着圆领开跨长袍，束于腰部，内着短裤，下穿膝裤，足穿麻鞋。马侧为一童子，髡发，着圆领长袍，足穿靴，手持两支马球杆。

<div align="right">（撰文：柳青　摄影：刘海文）</div>

Preparing for Travel

Liao (907-1125 CE)

Height 130 cm; Width 154 cm

Unearthed from Liao tomb M2 at District 2 in Xiabali, Xuanhua, Hebei, in 1998. Preserved on the original site.

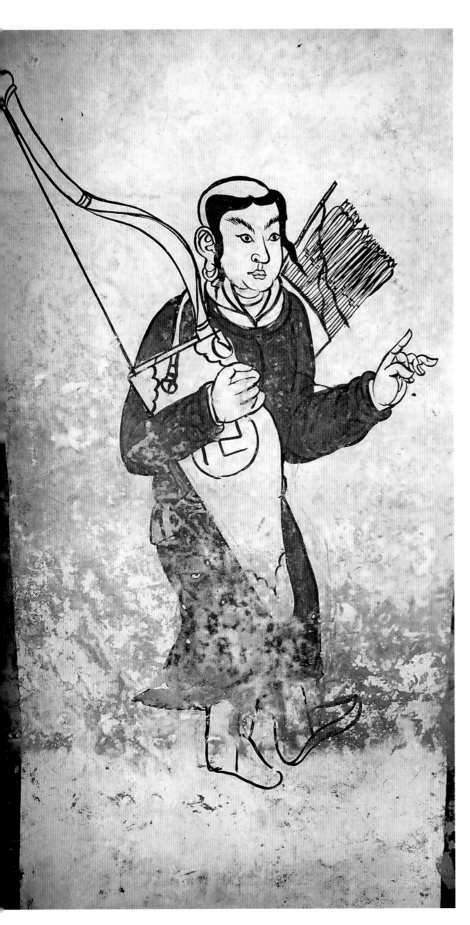

178.负箭持弓人物图

辽（907～1125年）

高130、宽75厘米

1998年河北省宣化下八里2区辽墓2号墓出土。原址保存。

墓向180°。位于墓室东壁南侧。髡发、大耳上戴圆形耳环，身着赭色圆领长袍，蓝色腰带，白色中衣，高筒靴，背佩箭囊，内装有十几根箭，右手抱弓，弓装于弓袋内，弓袋上画有"卍"字图案，左手抬起，翘指，目视前方。

（撰文、摄影：刘海文）

People Carrying Arrows and Bow

Liao (907-1125 CE)

Height 130 cm; Width 75 cm

Unearthed from Liao tomb M2 at District 2 in Xiabali, Xuanhua, Hebei, in 1998. Preserved on the original site.

179.备酒图

辽（907～1125年）

高130、宽75厘米

1998年河北省宣化下八里2区辽墓2号墓出土。原址保存。

墓向180°。位于墓室西壁南侧。画面一人头戴黑巾，身穿青绿色圆领长袍，赭色腰带，黑色鞋，左手拿一盘，盘中一碗，右手抬起，翘指，回首，目视身旁高桌。高桌呈红色，上置执壶、酒杯等器皿，高桌前又置一黄色小矮架，架中置一白色带盖梅瓶，画面反映的是一男侍忙于备酒的场面。

（撰文、摄影：刘海文）

Wine Preparing Scene

Liao (907-1125 CE)

Height 130 cm; Width 75 cm

Unearthed from Liao tomb M2 at District 2 in Xiabali, Xuanhua, Hebei, in 1998. Preserved on the original site.

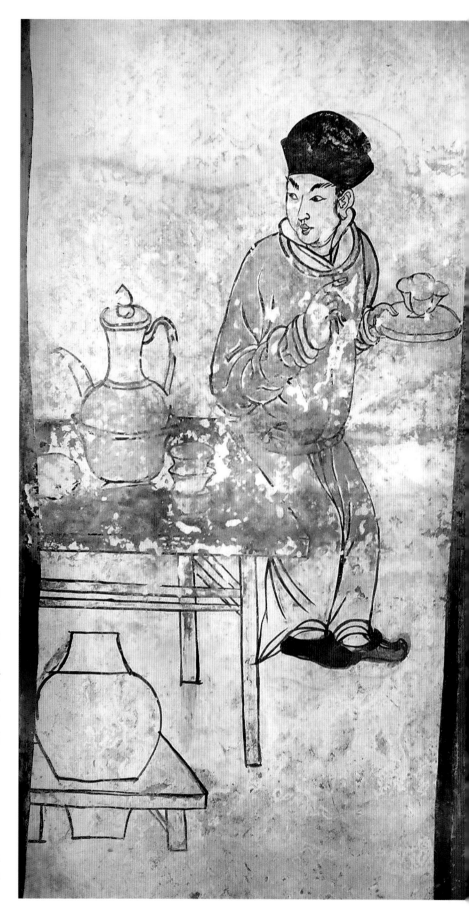

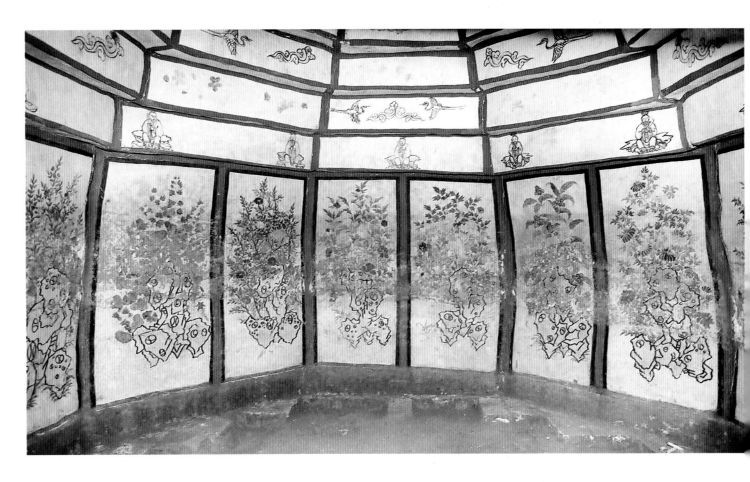

180.山石花卉屏风图

辽（907～1125年）

高130、宽164厘米

高130、宽158厘米

高130、宽168厘米

1998年河北省宣化下八里2区辽墓2号墓出土。原址保存。

墓向180°。位于墓室东北、北、西北壁。东北、北、西北三壁是以屏风的形式出现，图案由山石和花卉组成。屏风画以上的一栏似为道士图像，再上为云朵翎毛纹样。

（撰文、摄影：刘海文）

Lake Stone-and-Flower Screen

Liao (907-1125 CE)

Northeastern Section: Height 130 cm; Width 164 cm

Northern Section: Height 130 cm; Width 158 cm

Northwestern Section: Height 130 cm; Width 168 cm

Unearthed from Liao tomb M2 at District 2 in Xiabali, Xuanhua, Hebei, in 1998. Preserved on the original site.

181.山石花卉屏风图（局部）

辽（907～1125年）

高130、宽168厘米

1998年河北省宣化下八里2区辽墓2号墓出土。原址保存。

墓向180°。位于墓室西北壁。画面由山石和花卉屏风画组成。山石置于前，花卉盛开。屏风画中每幅画中的花卉各不相同。

（撰文、摄影：刘海文）

Lake Stone-and-Flower Screen (Detail)

Liao (907-1125 CE)

Height 130 cm; Width 168 cm

Unearthed from Liao tomb M2 at District 2 in Xiabali, Xuanhua, Hebei, in 1998. Preserved on the original site.

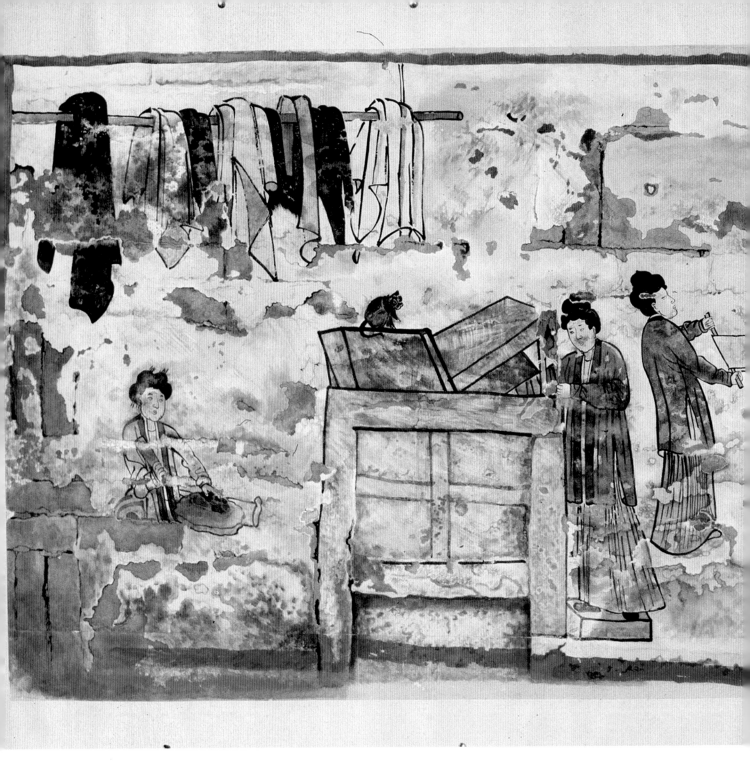

182.捣练图（摹本）

金—元（1115～1368年）

高约90、宽约230厘米

1960年河北省井陉县柿庄村6号墓出土。现存于河北省文物研究所。

墓向188°。位于墓室东壁。左侧一妇女在捣衣，其上方的衣架上搭满了衣衫。她的左侧是一大柜，一妇女踏着脚床正开启柜门取物，柜上蹲一小猫。其左侧是三个妇女熨练，二人左右拉牵白练，一人手持熨斗熨平白练。左侧是砖砌的灯檠，其右侧是一担水人。此壁画是柿庄几座壁画墓中绘制最优秀的一幅。

（临摹：黄均、陆鸿年　撰文：郝建文　摄影：冯玲）

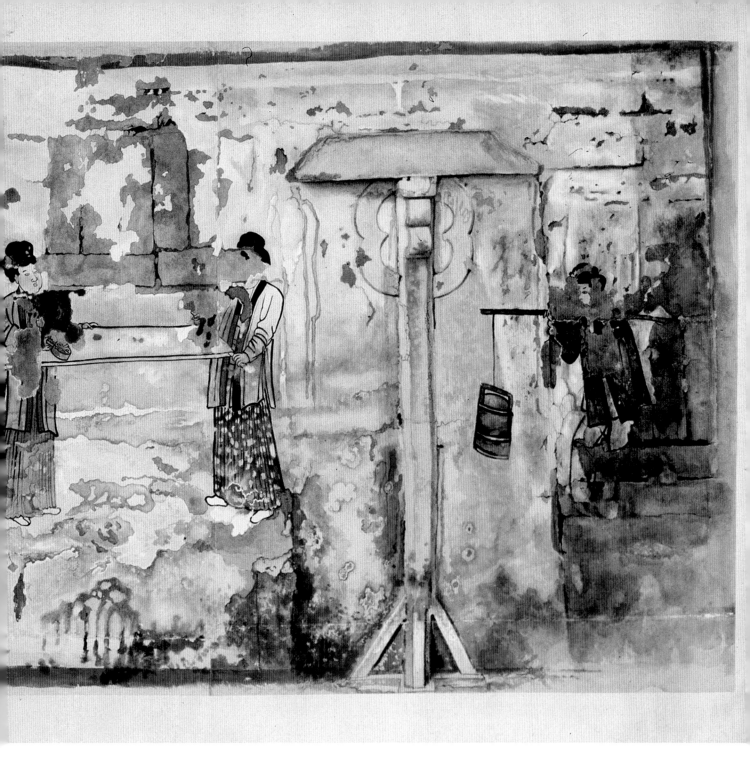

Processing Newly-woven Silk (Replica)

Jin to Yuan dynasty (1115-1368 CE)

Height ca. 90 cm; Width ca. 230 cm

Unearthed from tomb M6 at Shizhuangcun in Jingxing, Hebei, in 1960. Its copy is in the Institute of Cultural Relics in Hebei.

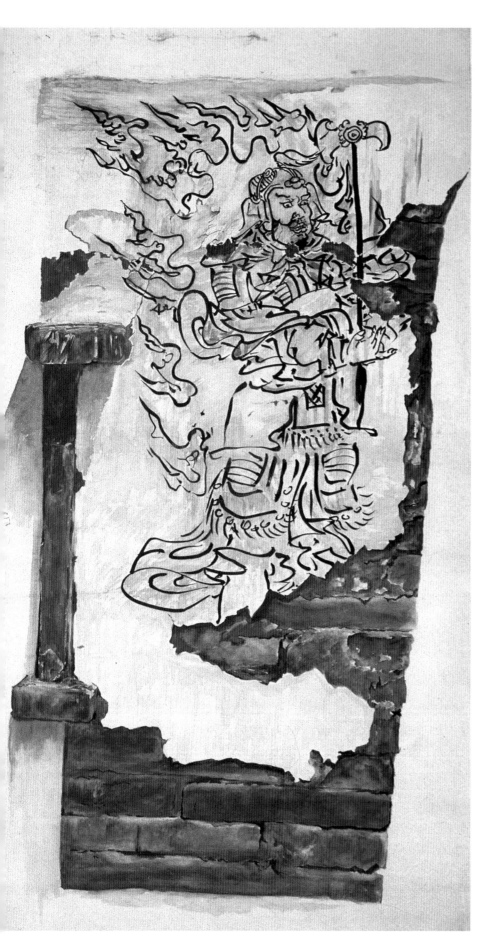

183.力士像（一）（摹本）

金一元（1115～1368年）

人物高约88厘米

1960年河北省井陉县柿庄村2号墓出土。现存于河北省文物研究所。

墓向195°。位于南壁券门东侧。武士头戴缨盔、身穿铠甲，手执钺斧，身体周围绘火焰。怒目圆睁，威风凛凛。身侧是砖砌的灯檠。

（临摹：陆鸿年、黄均　撰文：郝建文

摄影：冯玲）

Warrior (1) (Replica)

Jin to Yuan dynasty (1115-1368 CE)

Figure height ca. 88 cm

Unearthed from tomb M2 at Shizhuangcun in Jingxing, Hebei, in 1960. Its copy is in the Institute of Cultural Relics in Hebei.

184.力士像（二）（摹本）

金—元（1115~1368）

人物高约88厘米

1960年河北省井陉县柿庄村2号墓出土。现存于
河北省文物研究所。

墓向195°。位于南壁券门西侧。武士头戴缨
盔、身穿铠甲，身体周围绘火焰。其右手执刀，
左手按刀背，怒目圆睁，威风凛凛。身侧是砖砌
的灯檠。

（临摹：陆鸿年、黄均　撰文：郝建文

摄影：冯玲）

Warrior (2) (Replica)

Jin to Yuan dynasty (1115-1368 CE)

Figure height ca. 88cm

Unearthed from tomb M2 at Shizhuangcun in
Jingxing, Hebei, in 1960. Its copy is in the Institute
of Cultural Relics in Hebei .

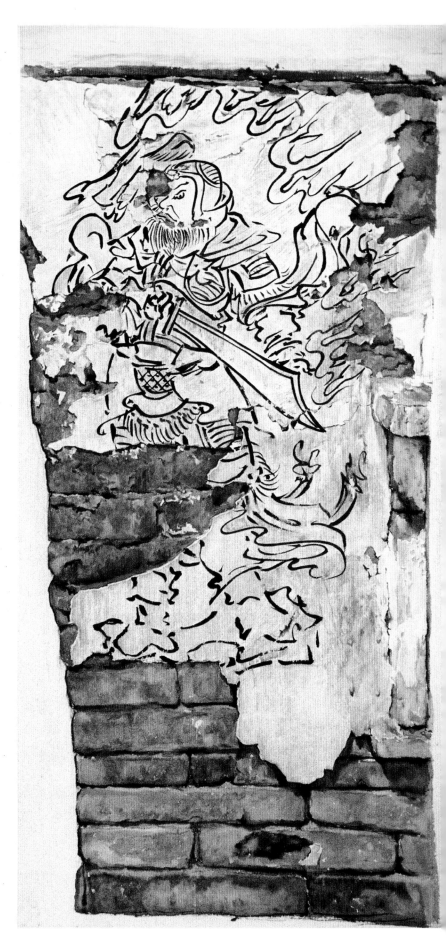

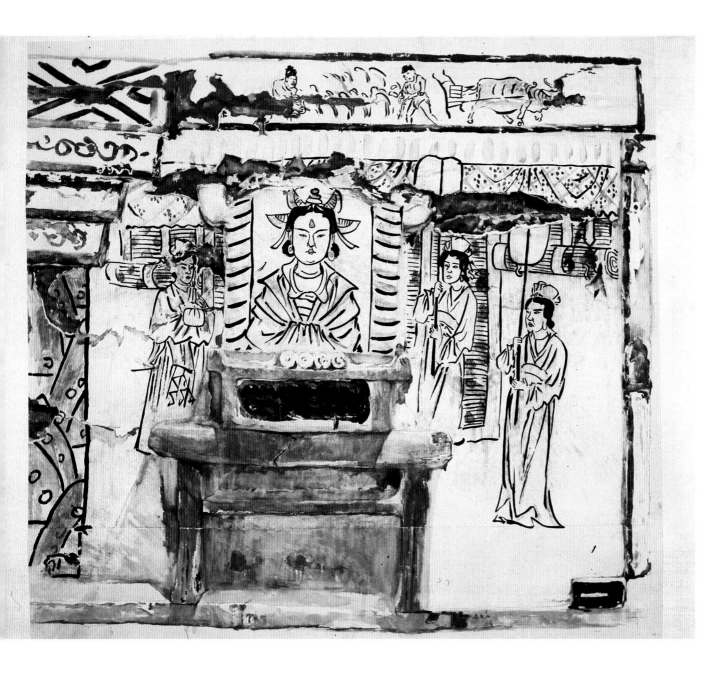

185. 人物图（摹本）

金—元（1115~1368年）

高约92、宽约104厘米

1960年河北省井陉县柿庄村2号墓出土。现存于河北省文物研究所。

墓向195°。位于墓室东壁南侧。画面中间为砖砌的供桌，桌后绘一端坐的妇人，可能为西王母或女墓主。右侧是站立的两位手举长扇的侍女，身后绘一垂一卷两个帘子。左侧是一双手捧物的侍女，其身后帘子卷起。其上部绘耕获图，一耕牛在前，一老一少正执镰收割。

<div align="right">（临摹：陆鸿年、黄均　撰文：郝建文　摄影：冯玲）</div>

Figures (Replica)

Jin to Yuan dynasty (1115-1368 CE)

Height ca. 92 cm; Width ca. 104 cm

Unearthed from tomb M2 at Shizhuangcun in Jingxing, Hebei, in 1960. Its copy is in the Institute of Cultural Relics Hebei Province.

186.家犬图（摹本）

金—元（1115～1368年）

宽约88厘米

1960年河北省井陉县柿庄村2号墓出土。摹本现存于河北省文物研究所。

墓向195°。位于墓室北壁。壁画残损严重，画面的中间绘窗，窗的上方绘悬幔，下面左侧绘一家犬，卧于地上。

（临摹：陆鸿年、黄均　撰文：郝建文　摄影：冯玲）

Domestic Dog (Replica)

Jin to Yuan dynasty (1115-1368 CE)

Width ca. 88 cm

Unearthed from tomb M2 at Shizhuangcun in Jingxing, Hebei, in 1960. Preserved in the Institute of Cultural Pelics Hebei Province.

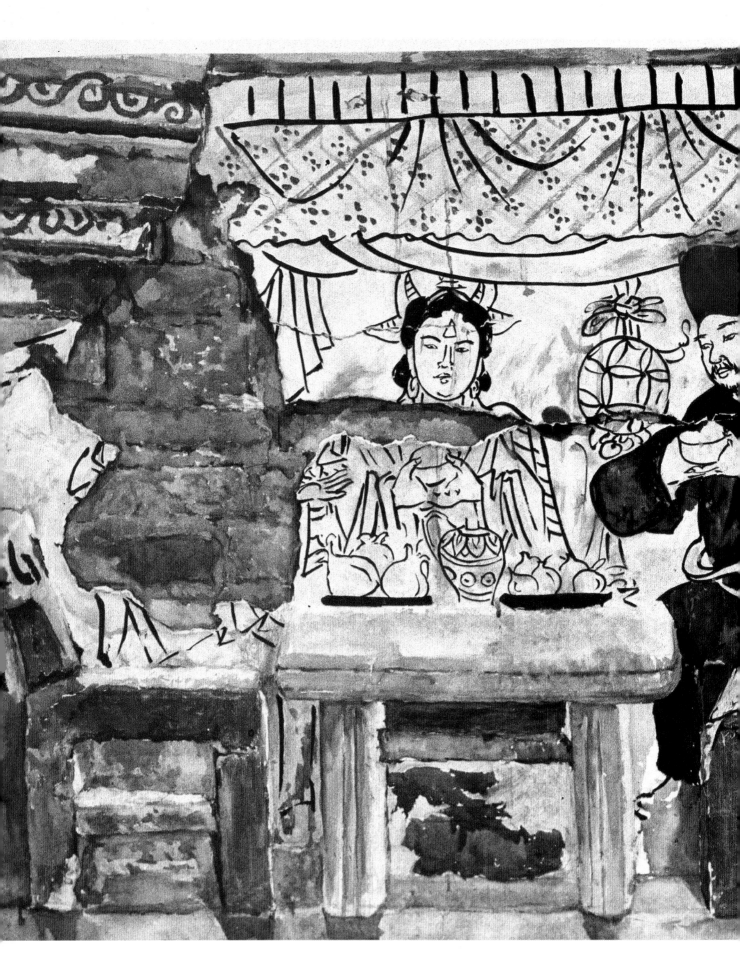

187. 夫妇对坐图（摹本）

金一元（1115～1368年）

高约80、宽约120厘米

1960年河北省井陉县柿庄村2号墓出土。现存于河北省文物研究所。

墓向195°。位于西壁南侧。画中有砖砌的一方桌和两把椅子。桌上绘果盘、注壶，盘内盛有桃、石榴等水果。桌侧右边椅上坐一男墓主，头戴黑巾，身穿圆领窄袖长衫，手端小盏。左侧壁画剥落，推测应为女墓主。桌后正位端坐西王母，亦双手捧一小盏。此墓的夫妇对坐图在传统构图模式的基础上，增加了与仙人会饮的新情节，表达了死后飞升的愿望。

（临摹：陆鸿年、黄均　撰文：郝建文

摄影：冯玲）

Tomb Occupant Couple Seated Beside the Table (Replica)

Jin to Yuan dynasty (1115-1368 CE)

Height ca. 80 cm; Width ca. 120 cm

Unearthed from tomb M2 at Shizhuangcun in Jingxing, Hebei, in 1960. Preserved in the Cultural Relics Institute Hebei Province.

188. 墓门内侧壁画

元至顺二年（1331年）

墓门通高119、宽94、进深58厘米，上方立面宽130、高23厘米，侧立面宽15厘米

2002年河北省涿州市华阳路元代壁画墓出土。搬迁异地保存。

墓向193°。墓门内侧壁画绘于门洞上方及两侧立面，门上方绘对称的红彩缠枝牡丹图案，其中左上角中心为细小的花蕊，右上角中心为蔓卷的花叶，整体给人以枝繁叶茂之感。两侧立面绘卷草花卉图案，局部漫漶不清。壁画总体保存较差。

<div align="right">（撰文：徐海峰　摄影：张羽）</div>

Murals inside Tomb's Doorway

2nd Year of Zhishun Era, Yuan (1331 CE)

Door: Height 119 cm; Width 94 cm; Depth 58 cm

Width of Upper front section 130 cm; Height 23 cm; Width of side section 15 cm

Unearthed from the Yuan Mural tomb at Huayanglu in Zhuozhou, Hebei, in 2002. Preserved in new site.

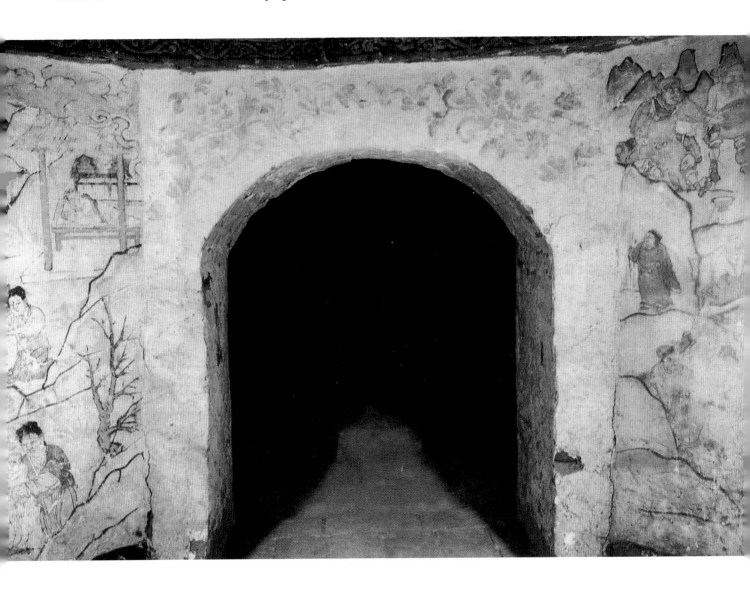

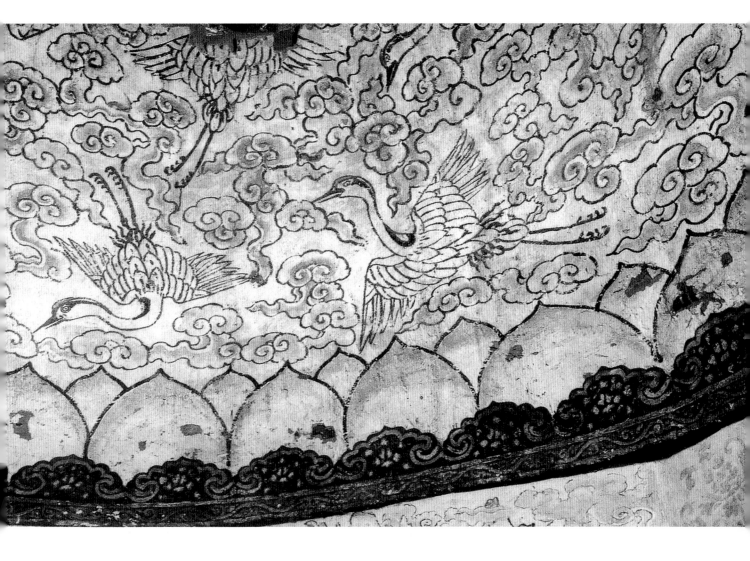

189.云鹤图

元至顺二年（1331年）

高40~45厘米

2002年河北省涿州市华阳路元代壁画墓出土。搬迁异地保存。

墓向193°。壁画底部为雕砖砌成的连续如意头形突檐，墨地白彩勾边。突檐上为双重仰莲瓣，墨线勾边，内涂橘红彩，其上以墨线勾勒云朵，内晕染黄彩、褐彩和橘红彩。云朵间以墨线描绘三只展翅飞翔的仙鹤，鹤姿态各异。最上方一只因墓顶中部塌毁只余伸展的双足，下方左侧鹤曲颈展翅盘旋，右侧鹤则昂首展翅伸足前行，极富动感。因墓顶中部坍塌，云鹤图中部被破坏无存，剩余部分保存较好。

（撰文：徐海峰　摄影：张羽）

Clouds-and-Cranes

2nd Year of Zhishun Era, Yuan (1331 CE)

Height 40-45 cm

Unearthed from the Yuan Mural tomb at Huayanglu in Zhuozhou, Hebei, in 2002. Preserved in new site.

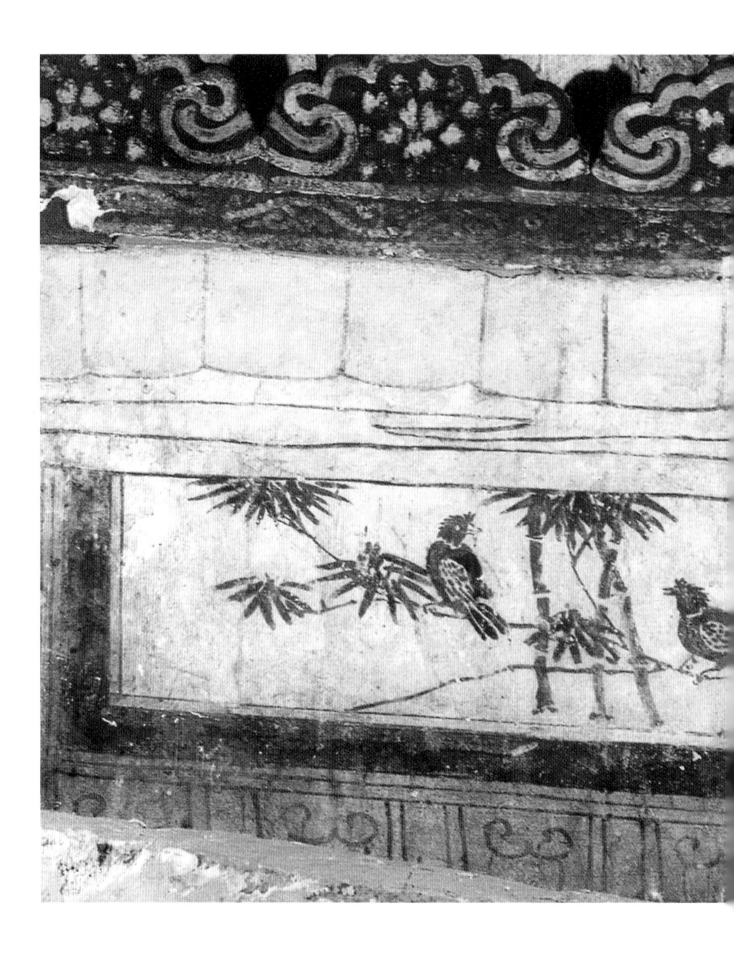

190. 竹雀图

元至顺二年（1331年）

高70、宽120厘米

2002年河北省涿州市华阳路元代壁画墓出土。搬迁异地保存。墓向193°。为三幅一组的水墨竹雀屏风画的主屏。屏心绘两只雀鸟静栖于竹枝间，回首对喙。画心上方为墨线勾绘的垂幔。边框为墨色平涂的宽大内框和褐彩勾连图案外框。保存较好。

（撰文：徐海峰　摄影：张羽）

Bamboo-and-Birds

2nd Year of Zhishun Era, Yuan (1331 CE)

Height 70 cm; Width 120 cm

Unearthed from the Yuan Mural tomb at Huayanglu in Zhuozhou, Hebei, in 2002. Preserved in new site.

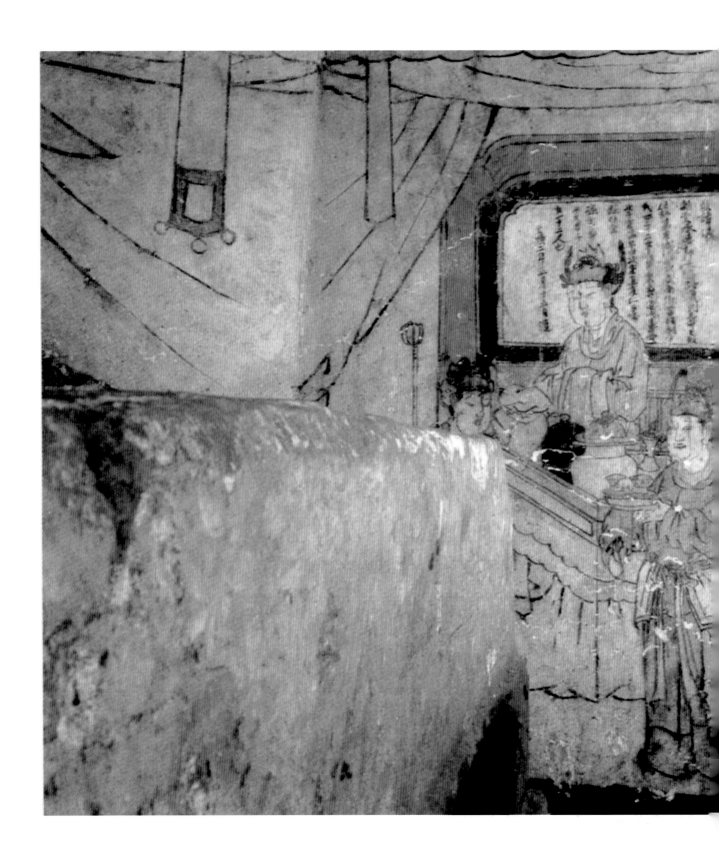

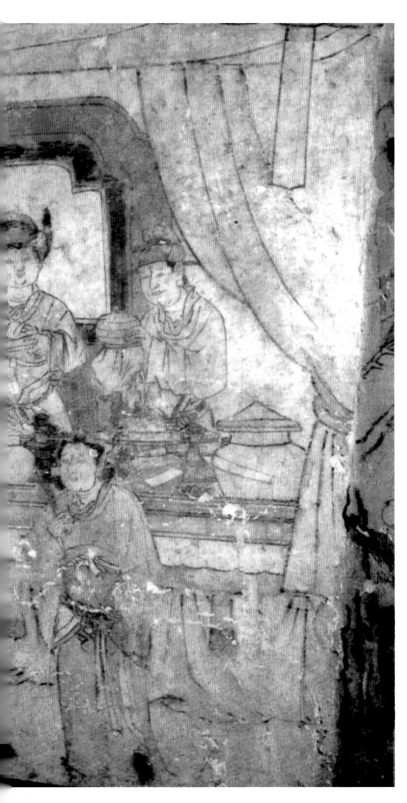

191.奉侍图

元至顺二年（1331）

高120、宽135厘米

2002年河北省涿州市华阳路元代壁画墓出土。搬迁
异地保存。

墓向193°。东壁奉侍图。上方墨线勾勒垂幔一周，
两侧绘挂起的帐幔。中部绘一方桌，桌面杂陈盛
食器皿；环桌一周站立6人，五男一女，除桌前端
（北）1人回首侧望、桌内侧中间1人昂首正视外，
余四人皆侧立斜视；桌前端一人执骨朵，内侧最前
面一人拱手侍立，余四人均作捧物侍奉状，每人执
物各不相同。男子除桌内侧最南端一人头戴展脚
幞头外，余皆头戴朝天幞头，身着盘领窄袖长袍，
腰围绣抱肚，束带；方桌内侧中部一人眉清目秀，
一脸稚气，似为年少者；女子梳双垂髻，着衣同男
子，右手握一簇花举过肩。桌内侧人物背后绘一立
屏，屏心墨书行书体题记。

（撰文：徐海峰　摄影：张羽）

Serving Scene

2nd Year of Zhishun Era, Yuan (1331 CE)

Height 120 cm; Width 135 cm

Unearthed from the Yuan Mural tomb at Huayanglu in
Zhuozhou, Hebei, in 2002. Preserved in new site.

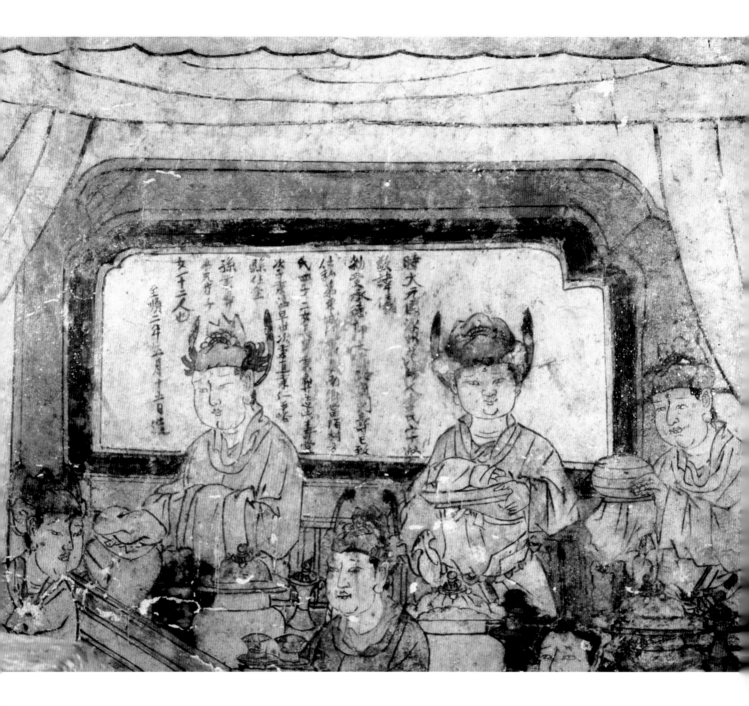

192.奉侍图及题记

元至顺二年（1331年）

高50、宽70厘米

2002年河北省涿州市华阳路元代壁画墓出土。搬迁异地保存。

墓向193°。东壁奉侍图局部。桌内侧两人，左侧一人头戴直脚幞头拱手垂侍，右侧一少年头戴上翘式牛耳状幞头捧物侍奉，二人均身着盘领窄袖长袍。身后是墨书题记，内容为墓主人夫妇简单生平。文为"时大元国涿州范阳人李氏字淑/敬讳仪/敕受承德郎大都路府判寿已致/仕私第东城□□妻南乡当陌村方/氏四子二女长男秉彝造此寿堂/次子秉温早世次秉直秉仁平峪/县□□/孙秉彝/弟兄等子/女一十二人也/至顺二年五月十五日造。"题记部分文字漫漶不清，保存较差。

<div align="right">（撰文：徐海峰　摄影：张羽）</div>

Serving Scene with Inscriptions

2nd Year of Zhishun Era, Yuan (1331 CE)

Height 50 cm; Width 70 cm

Unearthed from the Yuan Mural tomb at Huayanglu in Zhouzhou, Hebei, in 2002. Preserved in new site.

193.备酒图

元至顺二年（1331年）

高120米、宽130厘米

2002年河北省涿州市华阳路元代壁画墓出土。搬迁异地保存。

墓向193°。位于墓室西壁。构图同于东壁，中置一方桌，上满陈盖罐与玉壶春瓶等陈器皿，桌周围站立四人，为二男二女，桌前站立三人，右上方屏风右侧站立一人；桌前最北端一人手执骨朵，回首侧望，余均侧立斜视；桌前最南端女子手捧果盘；中间女子双手端托盘，内置玉壶春瓶和靶盏；屏风右侧一人身体被砖棺遮掩一部分，手捧盒，前方地上放案儿，几上置方斗，斗内盛满山峦状物品。中间女子头梳包髻，簪花，身着长裙、披帛；后一人梳双髻；余二人衣着皆同于东壁人物。人物上方仍绘一立屏，屏心亦有墨书题记。

（撰文：徐海峰　摄影：张羽）

Wine Preparing Scene

2nd Year of Zhishun Era, Yuan (1331 CE)

Height 120 cm, Width 130 cm

Unearthed from the Yuan Mural Tomb at Huayanglu in Zhuozhou, Hebei, in 2002. Preserved in new site.

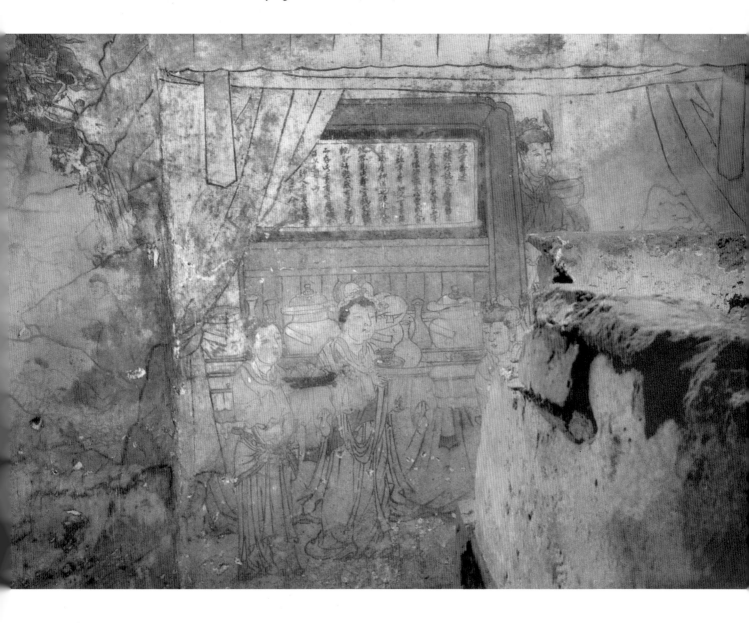

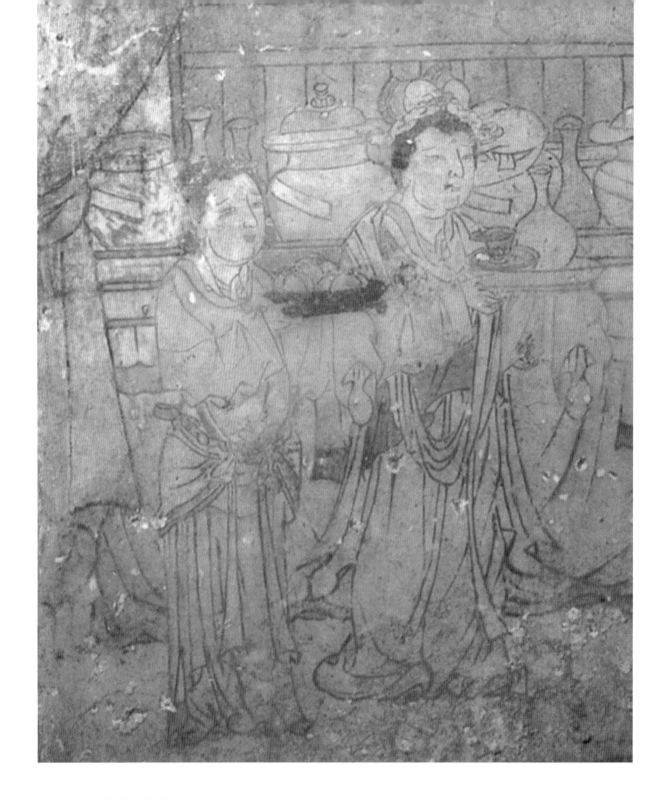

194.备酒图（局部）

元至顺二年（1331年）

2002年河北省涿州市华阳路元代壁画墓出土。搬迁异地保存。

墓向193°。位于墓室西壁。左侧女子头梳双髻，手捧果盘，右侧女子头梳包髻，簪花，身着长裙、披帛，双手端托盘，内置玉壶春瓶和靶盏。二人身后案几上有盖罐、玉壶春瓶等器皿。

（撰文：徐海峰　摄影：张羽）

Wine Preparing Scene (Detail)

2nd Year of Zhishun Era, Yuan (1331 CE)

Height 120 cm, Width 130 cm

Unearthed from the Yuan Mural Tomb at Huayanglu in Zhuozhou, Hebei, in 2002. Preserved in new site.

195.题记

元至顺二年（1331年）

高50、宽60厘米

2002年河北省涿州市华阳路元代壁画墓出土。搬迁异地保存。

墓向193°。内容为颂扬墓主人德行，祷祝成神及不毁此"寿堂"之因果报应。文为"李秉彝述/父积行志父正□宾节生/却三拾余年严齐正五九月/又常怀济众之心爱成人之美/事故秉彝知父百千年/后端居神道也后若或/偶然见此寿堂祝死所毁/既不所毁感有吉应见/而存此实有吉应端不/可以□有凶/神人李秉彝谨书/□□□□"。部分文字漫漶不清。

<div align="right">（撰文：徐海峰　摄影：张羽）</div>

Inscriptions

2nd Year of Zhishun Era, Yuan (1331 CE)

Height 50 cm; Width 60 cm

Unearthed from the Yuan Mural Tomb at Huayanglu in Zhuozhou, Hebei, in 2002. Preserved in new site.

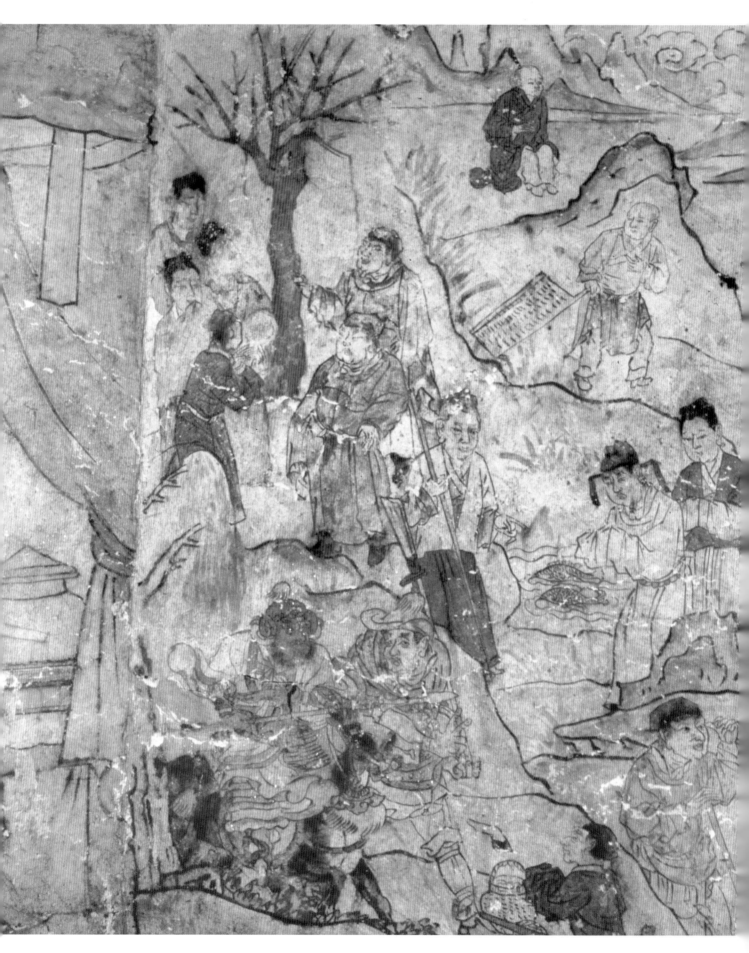

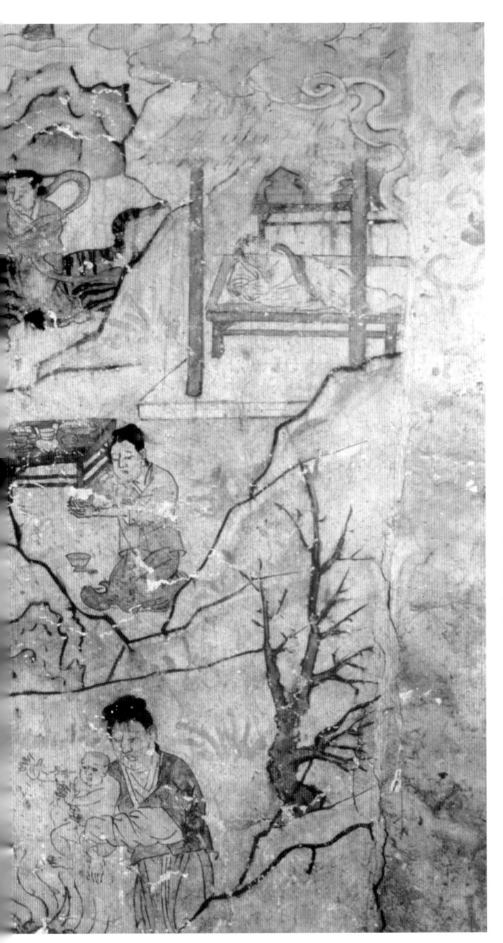

196.东南壁孝行组图

元至顺二年（1331年）

高125、宽135厘米

2002年河北省涿州市华阳路元代壁画墓出土。搬迁异地保存。

墓向193°。东南壁绘八幅孝义故事图，每个故事均以山峦、曲线自然相隔。由左及右、从上至下分别为"田真兄弟哭荆"、"闵子骞单衣顺母"、"元觉拖笆而行"、"杨香扼虎救亲"、"王武子妻割肉奉婆母"、"姜诗夫妇涌泉跃鲤"、"鲍山骑马对答"、"郭巨埋儿得金"故事图。

（撰文：徐海峰　摄影：张羽）

Filial Piety Stories on the Southeastern Wall

2nd Year of Zhishun Era, Yuan (1331 CE)

Height 125 cm; Width 135 cm

Unearthed from the Yuan Mural Tomb at Huayanglu in Zhuozhou, Hebei, in 2002. Preserved in new site.

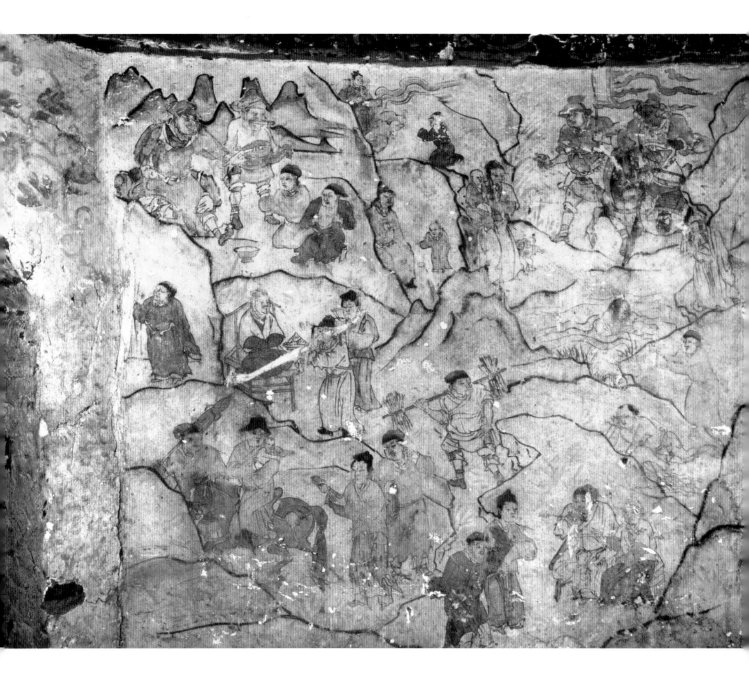

197.西南壁孝行组图

元至顺二年（1331年）

高120、宽130厘米

2002年河北省涿州市华阳路元代壁画墓出土。搬迁异地保存。

墓向193°。西南壁绘"孝行图"十二幅，构图同东南壁。由左及右、从上至下分别为"蔡顺拾葚供亲"、"董永卖身葬父"、"陆绩怀橘遗亲"、"鲁义姑舍子救弟"、"孟宗哭竹生笋"、"丁兰刻木事亲"、"曹娥沿江哭父"、"仲由负米奉母"、"曾参樵采以归"、"王祥卧冰求鲤"、"刘明达卖子孝亲"、"老莱子戏彩娱亲"故事图。

（撰文：徐海峰　摄影：张羽）

Filial Piety Stories on the Southwestern Wall

2nd Year of Zhishun Era, Yuan (1331 CE)

Height 120 cm; Width 130 cm

Unearthed from the Yuan Mural Tomb at Huayanglu in Zhuozhou, Hebei, in 2002. Preserved in new site.

198.马与侍者图

元（1206~1368年）

底部上线到阑额下边约70厘米

1999年河北省邢台市钢铁公司冶炼分厂墓出土。已残毁。

墓向173°。位于墓门的西侧（西南壁）。残存部分可见一匹马，用黑彩勾边，填以红彩。从马残存部分的形态上看，似作奔走状，推测或有控马者前方开引，或有墓主策缰其上。中部为柱，柱右面为前后并立的两位男侍，居前者身穿白色方领长袍，腰系带，下身穿白色小口裤，足登尖头靴，脸微向右侧，作拱手状。其身后者身穿红袍圆领袍服，腰系带，下身穿白色小口裤，拱手而立。这幅画面与南壁墓门西侧的控马图相配合，共同表现出行场景。

（撰文：秦大树、李军　摄影：李军）

Horse and Servants

Yuan (1206-1368 CE)

Height from the bottom line to the architrave ca.70cm

Unearthed from the Yuan tomb at the Smelting Plant in Iron and Steel Company of Xingtai, Hebei, in 1999. Not preserved.

199. "孟宗哭竹" 图

元（1206～1368年）

底部上线到阑额下边约70厘米

1999年河北省邢台市钢铁公司冶炼分厂墓出土。已残毁。

墓向173°。画面左侧为红色板门，右侧为柱，板门与柱间为一幅孝行图，画面中有三人及修竹一丛。最前者身穿白色窄袖圆领长袍，腰系革带，足蹬鞋，双眼平视，双膝跪地，右手握竹，左手抬至胸前，以袖拭泪状。此人身后绘两人并排半身像，前一人身穿红色窄袖圆领长袍，后一人身穿窄袖方领长袍，均拱手侍立于大石之后，眼视前方。这一画面表现的应为"孟宗哭竹（亦称孟宗泣笋）"的行孝故事。

<div style="text-align:right">（撰文：秦大树、李军　摄影：李军）</div>

Meng Zong, One of the "Twenty-Four Paragons of Filial Piety"

Yuan (1206-1368 CE)

Height from the bottom line to the architrave ca.70 cm

Unearthed from the Yuan tomb at the Smelting Plant in Iron and Steel Company of Xingtai, Hebei, in 1999. Not preserved.

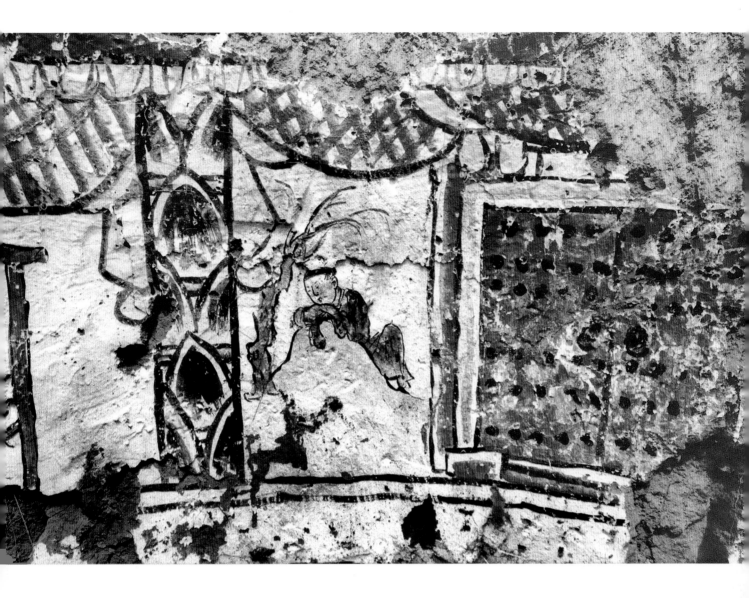

200.“闻雷泣墓”图

元（1206~1368年）

底部上线到阑额下边约70厘米

1999年河北省邢台市钢铁公司冶炼分厂墓出土。已残毁。

墓向173°。位于墓室东壁，板门与柱间为一幅孝行图，画面主体为一个坟丘，一男子伏于坟丘上哭泣。男子身着棕色圆领窄袖长袍，面部表情悲戚，坟边有枯树一棵，背景天空隐隐闪雷。这一画面应是表现王裒“闻雷泣墓”的孝行题材。

（撰文：秦大树、李军　摄影：李军）

Wang Pou, One of the "Twenty-Four Paragons of Filial Piety"

Yuan (1206-1368 CE)

Height from the bottom line to the architrave ca.70 cm

Unearthed from the Yuan tomb at the Smelting Plant in Iron and Steel Company of Xingtai, Hebei, in 1999. Not preserved.

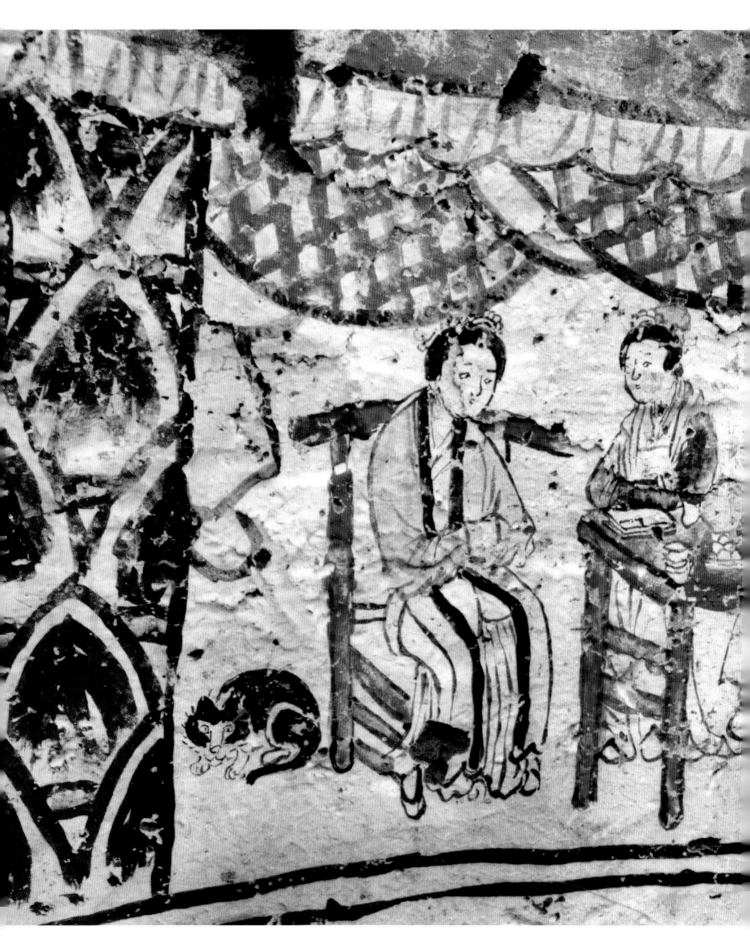

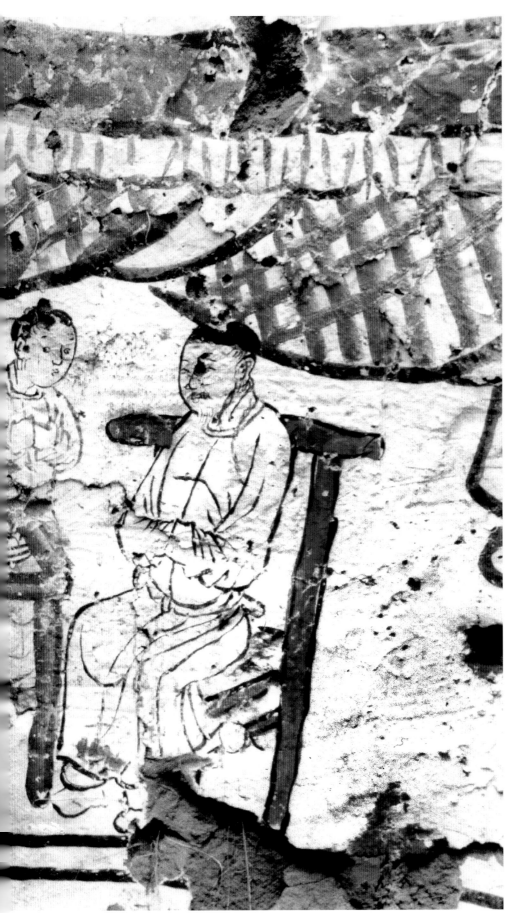

201. 夫妇对坐图

元（1206～1368年）

底部上线到阑额下边约70厘米

1999年河北省邢台市钢铁公司冶炼分厂墓出土。已残毁。

墓向173°。位于墓室北壁。整个空间表现"墓主人夫妇对坐"场景。中部为一红彩绘画的方桌，方桌上可辨茶盏并托一副，盖罐一只，平盘两只，盘内盛放有某种食品。墓主人夫妇分别坐于桌两侧的椅上。女主人在左侧，着绛红色开襟长襦，内着右衽交领衫，头戴花冠，下穿长裙，足穿方口鞋，袖手而坐；旁边站立女侍，面向女主人袖手而立，身着绛红色长袍，头束椎式髻，并饰有花饰。男主人亦袖手坐于方桌右侧，身穿白色立领窄袖长袍，腰束革带，下身穿白色裤，足蹬方口靴。身侧站立一男侍，身穿浅绛色圆领窄袖长袍，上身微前倾，脸侧向男墓主，双手揖于胸前。画面的左下角绘一只俯卧的黑猫。

（撰文：秦大树、李军

摄影：李军）

Tomb Occupant Couple Seated Beside the Table

Yuan (1206-1368 CE)

Height from the bottom line to the architrave ca.70 cm

Unearthed from the Yuan tomb at the Smelting Plant in Iron and Steel Company of Xingtai, Hebei, in 1999. Not preserved.

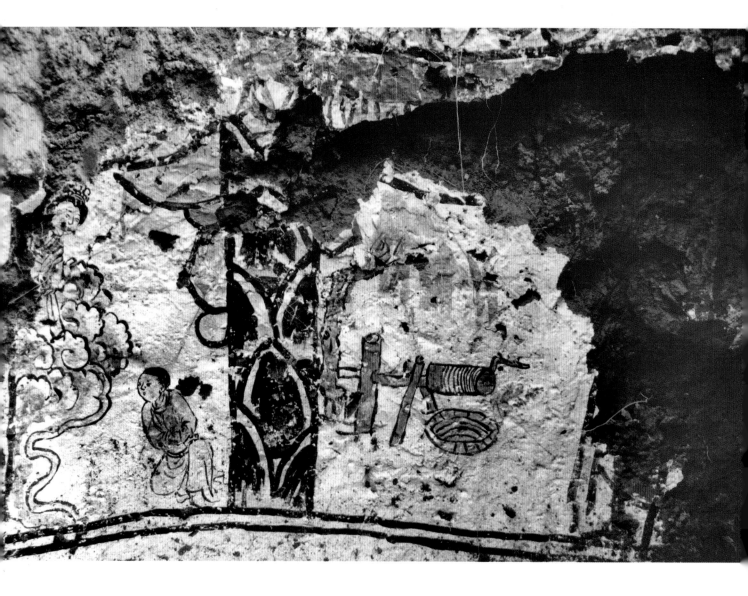

202. "董永遇仙"图

元（1206~1368年）

底部上线到阑额下边约70厘米

1999年河北省邢台市钢铁公司冶炼分厂墓出土。已残毁。

墓向173°。位于东壁南侧和南壁墓门东侧。东壁南侧为一幅孝行图 ——"董永遇仙"。画面左侧有自地面升起的云雾，仙女侧立云端，头戴花冠，回视右下方的董永。董永身穿淡绿色圆领长袍，单膝跪地，揖手仰望，是为"槐荫分别"的场景。南壁墓门东侧为黑彩绘画的水井和用红彩绘制的辘轳，水井旁有黑色树干，绿色枝叶的一株柳树。

（撰文：秦大树、李军　摄影：李军）

Dong Yong Meeting a Fairy

Yuan（1206-1368 CE）

Height from the bottom line to the architrave ca.70 cm

Unearthed from the Yuan tomb at the Smelting Plant in Iron and Steel Company of Xingtai, Hebei, in 1999. Not preserved .

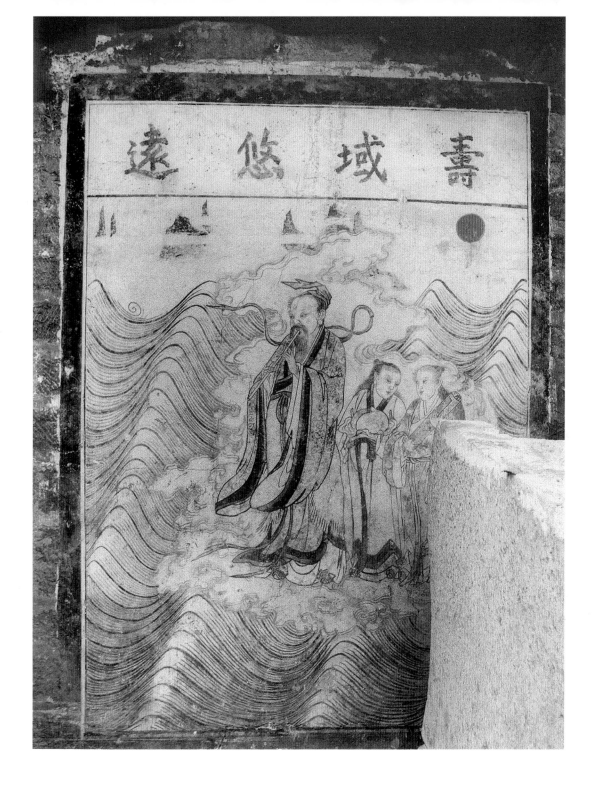

203.献寿图

明（1306～1644年）

高170、宽234厘米

2007年河北省邢台市临城县北街村明代墓葬出土。

墓向85°。画面中部仙人头上束髻包巾，身穿绿色黑边交领广袖长袍，双手持一箫，做吹奏状。仙人身后立两童子，均梳双髻，下部散发，身穿交领长袍。左侧童子手捧一蟠桃，目光看向下方；右侧童子手捧一经卷，双眼望向前方。人物周围有云烟环绕，似御风飞行。人物身后绘群山，远处似飘渺海域，右上角绘红日一轮。画面上方题"寿域悠远"四字。

（撰文：柳青　摄影：郝建文）

Presenting Birthday Gifts

Ming (1368-1644)

Height 170 cm; Width 234 cm

Unearthed from the Beijiecun Ming tomb at Lincheng in Xingtai, Hebei, in 2007.

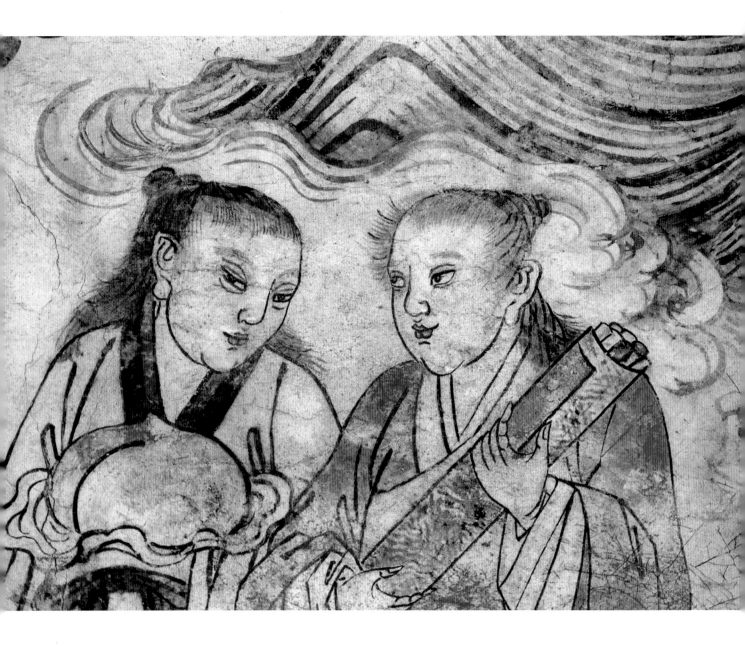

204.献寿图（局部）

明（1368～1644年）

2007年河北省邢台市临城县北街村明代墓葬出土。

墓向85°。画面中部仙人头上束髻包巾，身穿绿色黑边交领广袖长袍，双手持一箫，做吹奏状。仙人身后立两童子，均梳双髻，下部散发，身穿交领长袍。左侧童子手捧一蟠桃，目光看向下方；右侧童子手捧一经卷，双眼望向前方。人物周围有云烟环绕，似御风飞行。人物身后绘群山，远处似飘渺海域，右上角绘红日一轮。画面上方题"寿域悠远"四字。

（撰文：柳青　摄影：郝建文）

Presenting Birthday Gifts (Detail)

Ming (1368-1644)

Height 170 cm; Width 234 cm

Unearthed from the Beijiecun Ming tomb at Lincheng in Xingtai, Hebei, in 2007.